SPIRIT OF THE OJIBWE

IMAGES OF LAC COURTE OREILLES ELDERS

Spirit of the Ojibwe

Images of Lac Courte Oreilles Elders

Sara Balbin

James R. Bailey

Thelma Nayquonabe

Holy Cow! Press : Duluth, Minnesota : 2012

Cover and text design created by Marian Lansky and Lisa McKhann. The publisher is grateful to John Carr, Jan Zita Grover, Lisa McKhann, and Sara Balbin for their careful editorial attention and proofreading *Spirit of the Ojibwe*.

First printing, 2012.

10 9 8 7 6 5 4 3 2 1

This project is supported by a major grant from The Outagamie Charitable Foundation (Susan and James Lenfestey) and by gifts from generous individual donors.

"The crossed eagle feather design that appears in these pages is symbolic of the Lac Courte Oreilles spiritual leader, *oshkaabewis*, James "Pipe" Mustache Sr. He has been my mentor and namesake, *niiyawen'enh*. It was through Pipe's prophecy, Ojibwe heritage, bravery, acceptance, friendship, honor, integrity and love that this publication is a reality. With his teachings the internal diamond shape of the crossed feathers represents the four cardinal points on the Medicine Wheel and the Sacred Directions of Mother Earth." —*Sara Balbin*

Through the generosity of The Outagamie Charitable Foundation, elders of Lac Courte Oreilles living on and off the reservation can receive a complimentary copy of *Spirit of the Ojibwe* at the Lac Courte Oreilles Enrollment Office. A percentage from book sales of *Spirit of the Ojibwe* will go to the Lac Courte Oreilles Reservation Elders Association.

We would like to recognize "Dolores DeNasha, Enrollment Officer," the three LCO library Directors and the Lac Courte Oreilles Tribal Government for their support.

Library of Congress Cataloging-in-Publication Data

Balbin, Sara, 1949-

Spirit of the Ojibwe : images of Lac Courte Oreilles elders / by Sara Balbin, James R. Bailey, and Thelma Nayquonabe.
p. cm.

Includes bibliographical references.

ISBN 978-0-9823545-0-6 (alk. paper)

1. Older Ojibwa Indians--Wisconsin--Lac Courte Oreilles Reservation--Portraits. 2. Older Ojibwa Indians--Wisconsin--Lac Courte Oreilles Reservation--History. 3. Older Ojibwa Indians--Wisconsin--Lac Courte Oreilles Reservation--Biography. 4. Lac Courte Oreilles Reservation (Wis.)--History. 5. Lac Courte Oreilles Reservation (Wis.)--Social life and customs. I. Bailey, James R., 1949- II. Nayquonabe, Thelma, 1948- III. Title.

E99.C6B256 2011

977.004'97333—dc22 2011015660

H 977.004
BAL 8/7/12

Holy Cow! Press books are distributed to the trade by Consortium Book Sales & Distribution, c/o Perseus Distribution, 1094 Flex Drive, Jackson, TN 38301. For inquiries, please write to: Holy Cow! Press, Post Office Box 3170, Mount Royal Station, Duluth, MN 55803. www.holycowpress.org

CONTENTS

Foreword
VII

Statements of Tribal Leaders
XI

Preface
XV

Maps
XVII

Genesis of the *Hall of Elders* Oil Portraits and *Spirit of the Ojibwe* Book
Sara Balbin
1

Hall of Elders Portraits and Biographies
Oil Portraits by Sara Balbin
Biographies by Sara Balbin, James Bailey, and Thelma Nayquonabe
31

Odawasagaegun: A Brief History of Lac Courte Oreilles
Rick St. Germaine
189

Lac Courte Oreilles Photographs
Sara Balbin
213

The Ojibwe Language
John Carr and Sara Balbin
231

Glossary
John Carr and Sara Balbin
235

References and Suggested Readings
John Carr and Sara Balbin
243

FOREWORD: PLANTING STORIES LIKE SEEDS

It's stories that make this into a community. There have to be stories. That's how you know; that's how you belong; that's how you know, you belong.

Leslie Silko, from *This Song Remembers*

THIS GATHERING OF MATERIALS—the biographies, portraits, tribal history, and maps in *Spirit of the Ojibwe*—brings to life an era vital to the sense of who we are as *Anishinaabe* people. The lives of James "Pipe" Mustache, Saxon Grace St. Germaine, George Oshogay, and the other Lac Courte Oreilles elders whose stories rise off these pages to light our memories and imaginations are lives just beyond the reach of our own experience. Our parents, grandparents, elder aunties and uncles, our traditional teachers—they literally form a bridge from the present nano-cyber age to a time before technology paced our lives, to a time of village-based economies and a tribal or kinship patterned world. Amidst turbulent times and massive changes, these Native people kept intact a longstanding culture and worldview.

Accounts of boarding school experiences, the student walkout from Hayward classes, and the eventual founding of tribal schools; accounts of the flooding of Winter Dam, the displacement of families from their homes, the moving of old graves, and the creation of New Post—these are stories to give us strength as we face new challenges to the sovereignty and autonomy of our tribal nations. Memories of seasonal activities—harvesting wild rice, cutting ice, gathering berries, fishing, the sugarbush—together with reminiscences of extended family gatherings, community programs, historical pageants, powwows, and religious ceremonies—these form the foundation of our continuance. They weave together a pattern of relationships with place and elements of the natural world, with the spiritual realm, and with our relatives and fellow tribal members.

As I read the pages of this book, I feel deeply the reality represented. The "Billyboy" and "Babe" on these pages could easily be my own White Earth relatives with these nicknames. The elders who served in the military, took part in the WPA programs, worked in education, moved to and returned from urban areas, as well as those who stayed in the places of their birth—all of these people have stories I recognize, stories I have heard at home, stories I treasure as my legacy. Now the Lac Courte Oreilles stories are collected here, a legacy for this tribal nation, and for all of us, for generations to come.

Sara Balbin has created images and, together with James Bailey and Thelma Nayquon-abe, has gathered biographies to honor the lives of the elders, to celebrate both their highest accomplishments and their common workaday lives. She calls her paintings "allegorical," and together with the accounts of the individuals' lives, they do stand as symbols. Many of the portraits offer visual links to the clan membership of the individuals or to other important aspects of their lives; many of the stories offer lessons.

The Ruth Carley biographical sketch, for example, contains her heartfelt beliefs about tradition: "Tradition," she says, "means having your own language and own religion. Your own way of life." Marie Cloud Morrow's biography offers her motto: "*Midewiwin* every day. Being Indian, you live it." From Josephine Grover, who was the keeper of the "Song for Snow," to the woodcraftsman Henry "Hank" Smith, who invented the popular bucktail fishing lure, to Mary "Babe" Trepania, who passed on medicine teachings, the elders featured in this collection showcase many traditional aspects of Ojibwe living. Through the rich details offered, the recitation of family and place names, the use of *Anishinaabemowin*, they transport us to an older era, one in which "cast-iron kettles and oil lamps were cutting-edge technology."

Many of the elders were born in *wiigiwaaman*, the years of their births only approximate. Many offer accounts of early hardships that might include the loss of a parent or siblings. Most were reared among extended families and recall with warmth their relatives and the many shared activities of their youth—everything from dancing, to thrashing wild rice, to canoe journeys, to the constant task of gathering firewood. To some among them were passed tribal teachings—knowledge of ancient prophecies, traditional methods for attracting fish with herbs, stories of the *Chi dewe'igan*, or *Midewiwin* prayers and songs.

Through their stories these elders place themselves in a time before relocation moved Indians to urban areas, when the miles between the different Lac Courte Oreilles villages and settlements had to be covered by wagon, sleigh, or on foot and made the communities seem distant from one another. They also trace changes that have come through the years, grounding these alterations in the specifics of their own experiences. They offer accounts of the time before Indian citizenship when traveling Native dance troupes were locked in at night. They recall the introduction of CB radios for communication. Many tell of their family's loss when Wisconsin-Minnesota Light & Power Company constructed a dam on the Chippewa River and the village of *Paquayawong* disappeared beneath rising waters. Most elders recall details of their education—some at regional BIA schools, others at distant boarding schools such as Haskell, Carlisle, and Pipestone. Then as the life circle continues, the stories turn to marriages, their own family rearing, and their career accomplishments, which took many to faraway cities. Peter Larson's encounter with astronaut John Glenn is recorded in a photograph. George Taylor's bravery saved people's lives three times. Lucille Mustache Begay, together with her

husband Babe, was one of the founders of the Chicago Indian Center. Although embodied in varying ways, each story reveals courage and strength of purpose—loyalty to family, dedication to community service, steadfast adherence to tribal teachings.

In their later years, many of the individuals featured in this book found their way into the new tribal school and community college as founders, administrators, or cultural teachers. The school halls rang with stories of the Lac Courte Oreilles tribal past and the *Anishinaabe izhit-waawin*, once again building community. Now the historical details of the elders' lives given here will offer us models, the philosophy of these storytellers will feed our survival and cultural prosperity. In the oral tradition, each speaks—so that the telling may continue.

THIS ELDER LANDSCAPE

Northwoods stands of birch arc like smoke
rising skyward behind the hall of elders,
visions of floral beaded vests and crane companions.
Bear, fish, marten—these clan relatives, too
shimmer in reflected light from your hazelnut eyes.

Now *biboon noodin* rustles pine boughs
as Wisconsin drums sing the rhythm
of long ago old time stories—listen.

I hear Giizhigookwe and Waasegiizhig,
offer myself—an *oshkaabewis*
before scenes of violet skyscapes,
thunder beings and cranberry spirits,
before loon voices that still echo
from last century to this new age.
Bimikawe—you leave trail
fluted word signs like cascading fringe,
a succession of tribal faces
over your feathered right shoulder.
Manidoog, the ones to follow.
Bizindam.

KIMBERLY M. BLAESER
Oshki-dibikad Anangokwe
October 2011

STATEMENTS OF TRIBAL LEADERS

LOUIS TAYLOR
Former Chairman, Lac Courte Oreilles Band of Lake Superior Chippewa

REVIEWING THE PICTURES and biographies of our elders takes me back to a time in the village of Old Reserve, before new homes were built, before electricity and indoor plumbing, when visiting each other was our entertainment. It was a time of simple living; families were occupied with seasonal chores to meet their basic needs of food, water, and firewood. Ironically, although we didn't have much, sharing was more common and laughter more constant. And I remember well the laughing faces of the elders in this book.

We have traveled fast from that time to the present: from small, simple homes to five hundred new, modern homes; from creeks, pumps, and outhouses to water towers, lagoons, and sand-filtration sewer systems. By the time we have paused to take a collective breath, we regret not having preserved our elders' appearances and life stories in some manner.

Sara Balbin, however, has captured an era of our history through this book. She is a gifted artist and friend of the tribe who has worked many years to paint a time of kerosene lamps and smudge-pot summers. We appreciate her presentation of the spirit of the *Odaawaa Zaaga'iganiing Anishinaabeg. Chi miigwech*, Sara, for your years of dedication to this work of heart.

ALFRED TREPANIA
Former President, Great Lakes Inter-Tribal Council
Former Chairman, Lac Courte Oreilles Band of Lake Superior Chippewa

I WAS BORN AND RAISED on the Lac Courte Oreilles Reservation, where the great pines and pristine lakes provided a wealth of *Anishinaabe* tradition in our family. My parents, Walt and Frances, raised thirteen children during an era filled with hardship caused by government suppression of our traditional culture. Regardless of the many tribulations endured, love and laughter prevailed in our household. It was my mother, Frances, who filled our hearts with love for all our relations. "Love everyone and love all the animals and birds, Alfred," she used to tell me.

One morning, my brothers and I returned home with a washtub full of nice, big walleyes. To my surprise, our bounty brought mournful tears to my mother's eyes. "Boys," she said, "this is more than we need right now. You took too much from our Mother Earth." To this day, my mother's soft voice continues to remind me that it is our love, our respect for the Earth, and our humor that sustain the traditions carried forth by our elders.

As *Anishinaabe* people, we are blessed with a rich heritage woven from the fabric of our Mother Earth. Even today, with our modern lifestyles, you can see this connection in our elders. With eloquence, Sara Balbin, a gifted artist and dear friend to the Lac Courte Oreilles, has preserved this intimate relationship in the faces, in the hands, in the dress and stance of the elders portraits.

Like a young tree, I grew up with elders who now look back at me from the canvas transformed by Sara. Her sensitivity has sincerely captured their essence. The Lac Courte Oreilles elders book provides an intimate visit into the lives of those who endured the losses and brought forth the past into the future. Although they are a small representation of the many *Anishinaabe Ogichidaag* and *Ogichidaakweg* (Warrior Men and Women), we will forever hold this treasure dear to our hearts, a treasure we will pass on to our children.

GAIASHKIBOS
Former President, National Congress of American Indians
Former Chairman, Lac Courte Oreilles Band of Lake Superior Chippewa

THE *Anishinaabeg*, FIRST PEOPLE, of Lac Courte Oreilles, *Odaawaa Zaaga'igan*, have a rich cultural heritage, an historical tradition whose roots extend to the eastern shores of America at the Atlantic Ocean, long before the arrival of the first Europeans to this continent. After first contact with the French traders in the mid-1700s and later with United States Government representatives eager to negotiate treaties (1825, 1837, 1842, and 1854) of vast land cessions, the cyclical way of life of the *Anishinaabeg* came to an end.

Forced acculturation soon came to the 1854 reservation system, accelerated with missionary schools, and later became dominant with the forced removal of Lac Courte Oreilles youth to Bureau of Indian Affairs (BIA) boarding schools. Concurrent with these developments, other U. S. Government policies divested land title from the tribe to individual allotments and allowed the damming of the Chippewa River and flooding of our lands by Wisconsin-Minnesota Light & Power Company. Our health care was totally neglected and our traditional form of self-government was disregarded. Through it all, the people of Lac Courte Oreilles projected a quiet repose while silently suffering through abject poverty, despair, alcoholism, and social

disintegration. This, while others, land speculators and U.S. Government agents, enriched themselves through shady land deals. These developments reached an all-time low when in the 1950s the government sought to relocate our tribal members to the inner cities of large urban areas under an official policy of tribal termination.

Since the 1960s, great change and empowerment have come to the Lac Courte Oreilles people and to their Tribal Government. With the Indian Reorganization Act secured, followed by the adoption and implementation of the Indian Self-Determination Act of 1975, the tribe used federal programs and dollars to raise the standard of living on the Lac Courte Oreilles Reservation. This brought more of our people home.

In 1975, Lac Courte Oreilles students walked out of the Hayward Public School System to protest racism and mistreatment. The Lac Courte Oreilles Tribe then started and built a K-12 school system, including an early childhood education program. Beginning at that time, we also created new housing developments, a community college, a new health care facility, a 100,000 watt public FM radio station, a mini-mall and gas station, a cranberry marsh, a logging operation, and a new hotel-casino complex that today employs over four hundred people.

Lac Courte Oreilles was also concerned about a fifty-year lease for the Winter Dam, which had impounded the Chippewa River and flooded the reservation village of *Pokegama*. The lease was up for renewal in 1971, and we wanted Northern States Power Company, which had taken over operation of the dam, to be held accountable for some of the consequences of the flooding of our land. This time around, the Lac Courte Oreilles Tribe wanted to have a say-so in the negotiations. As a result, a protest was held at the Winter Dam in 1971, in which the American Indian Movement (AIM) became involved. This resulted, eventually, in a settlement with the power company, and more directly in the birth of the Honor the Earth Homecoming Celebration Pow Wow, which attracts thousands annually to the Lac Courte Oreilles Reservation, where they participate in the largest traditional powwow in the region.

It was fortunate for the Lac Courte Oreilles Tribe and the Lac Courte Oreilles Ojibwe School System that in 1979, Sara Balbin, along with Tribal Writer Mimi Trudeau, wrote and was awarded grants from the Wisconsin Arts Council and the National Endowment for the Arts. These coveted awards brought Ms. Balbin to Lac Courte Oreilles as an artist in residence with the Lac Courte Oreilles School System. From this project was born the mutual respect and enduring friendships that produced her profound works of art.

Sara Balbin is a gifted artist who has the unique ability to capture through her paintings the timeless spirit of the *Anishinaabe*, the revelations of the clan system, and the seasonal changes reflected in the portraits of the elders at Lac Courte Oreilles. These portraits will be a lasting legacy to future generations. I only wish that the Lac Courte Oreilles Tribe had had the

resources to have started the *Hall of Elders* project sooner. *Chi miigwech* to Sara for her dedication and friendship.

My special thanks to the following Tribal Chairs: Odric (Rick) Baker, Gordon Thayer, and Dr. Rick St. Germaine for their support and vision to preserve the legacy, for future generations, of the soul of the people. Thanks to the Tribal Councils that were ultimately responsible for providing support and funding to make this possible, especially the later works. Thanks to Rick St. Germaine also for his insightful history of the people of Lac Courte Oreilles, to Jim Bailey for his invaluable reviews, and to Thelma Nayquonabe for her narratives.

In the elders' day, life was often an arduous journey through difficult circumstances. Since then, we have striven to improve conditions so that tribal members can enjoy the conveniences available in the modern world. But it is also important to maintain our cultural values and our close relationship to the Earth that sustains us physically and spiritually.

My father, Louis Barber (Waasegiizhig), 1902-1995, once told me that the old people had predicted the technological advances that he witnessed in his lifetime. I recall making maple syrup with him one spring. I was very busy, but had found time to get out into the woods. I hung my cell phone up in the *wiigiwaam*, and it was not long before someone called. The expression on my dad's face was amazement; it represented a leap from the old to the new. I never brought the phone into the sugar camp again. It did something. It jarred the grace of the moment, the beauty of Mother Nature abundantly providing her gifts.

PREFACE

THE LAC COURTE OREILLES BAND of Ojibwe Indians, like other Native peoples of the United States and Canada, have persevered through repeated attempts by the Euro-American society and its governments to either isolate or assimilate them. This book tells the story of how they have survived as a people, restoring their language and maintaining their culture. An historical essay by tribal member Dr. Rick St. Germaine relates, for the first time in written form, how this area of northern Wisconsin came to be settled by the Ojibwe and how the reservation system that was imposed on them nearly destroyed their traditional way of life.

An essay by Sara Balbin tells how this book came to be written as a means to preserve tribal memories and explains many fascinating aspects of Ojibwe culture. This is followed by thirty-two elders oil portraits, painted by Balbin, and accompanying biographies by James Bailey, tribal member Thelma Nayquonabe, and Sara Balbin. These elders, among others, played leading roles in guiding the tribe through a time of severe economic hardship and concerted efforts to assimilate them into the Euro-American culture. If successful, these efforts would have resulted in the loss of the tribe's language, art, music, religion, and philosophy of life.

At this time, the Ojibwe and their culture have gone through a metamorphosis. Like the dragonflies that live in the underwater world in their larval stage, emerging to become winged masters of the air, the Ojibwe have evolved and surfaced as an Ojibwe nation. They may not all be able to speak fluent *Ojibwemowin* like their ancestors, who didn't have a written language, but today they have Ojibwe dictionaries and school courses that allow them to learn to speak and write the language. As a people, they have understood the importance of retaining their own tongue and traditions for self-identity. The Ojibwe have turned around the Euro-American education they received through forced acculturation to regain and strengthen their own culture, traditions, lands, and self-rule.

Poet Kimberly M. Blaeser, of the White Earth Band of the Ojibwe, who is professor of English at the University of Wisconsin–Milwaukee, wrote the insightful foreward to this book. Statements by Tribal Chairmen Louis Taylor, the late Alfred Trepania, and gaiashkibos, historical photographs, an Ojibwe language guide, and a comprehensive compilation of articles and books are offered for further study. The Ojibwe-language words in this book are printed in italics and are defined in the Glossary.

The thirty-two biographies offer brief studies of the elders' lives; they are not meant to be comprehensive. The biographies show similarities in the elders' youth, but vast differences in life circumstances, experiences, and accomplishments. Together, the elders' lives span an era that ranges from the late nineteenth century to the twenty-first century.

The elders portraits, biographies, and photographs are another means of using Euro-American methods to regain, strengthen, and secure a body of knowledge for future generations. As we interviewed the elders, their families, and friends, we obtained straightforward accounts of the circumstances of their lives, adaptations to conditions imposed on them, and creative responses to change. It is our hope that the biographies, through these memories, honor, respect, and protect the integrity of the elders documented in *Spirit of the Ojibwe*.

Some of the biographies are short, while others are longer. Some reflect the lives of extraordinary people whose heroic accomplishments will live on through their biographies and in oral stories. Others reflect the experiences of people who lived more ordinary lives, but helped to bridge the past with the present through acts of courage and quiet determination. All of the elders are leaders, whether in their small, intimate communities or on a national scale. Combined, they demonstrate the strength and pride of the Lac Courte Oreilles Band of Ojibwe Indians.

I am humbled, and thankful, for the elders' friendship and the trust they and their families have bestowed on me as an outsider of Cuban-born heritage. The portraits and biographies would not have been possible without their patience, time, and support. With gratitude, I welcome you, the viewer of the *Hall of Elders* portraits and reader of *Spirit of the Ojibwe*.

SARA BALBIN
Drummond, Wisconsin
October 2011

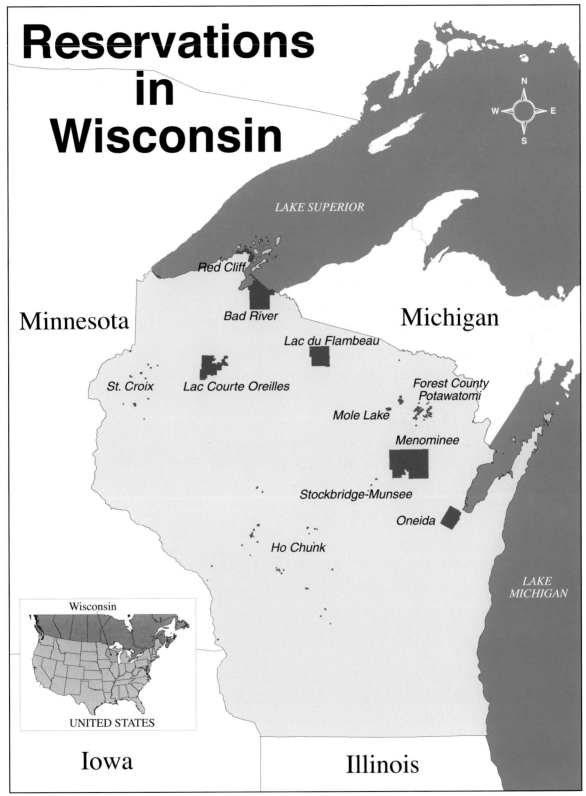

Reservations in Wisconsin

Minnesota

Michigan

LAKE SUPERIOR

Red Cliff

Bad River

Lac du Flambeau

St. Croix

Lac Courte Oreilles

Forest County
Potawatomi

Mole Lake

Menominee

Stockbridge-Munsee

Oneida

Ho Chunk

LAKE
MICHIGAN

Wisconsin

UNITED STATES

Iowa

Illinois

Map prepared by LCOOCC GIS Lab, designed by Sara Balbin.

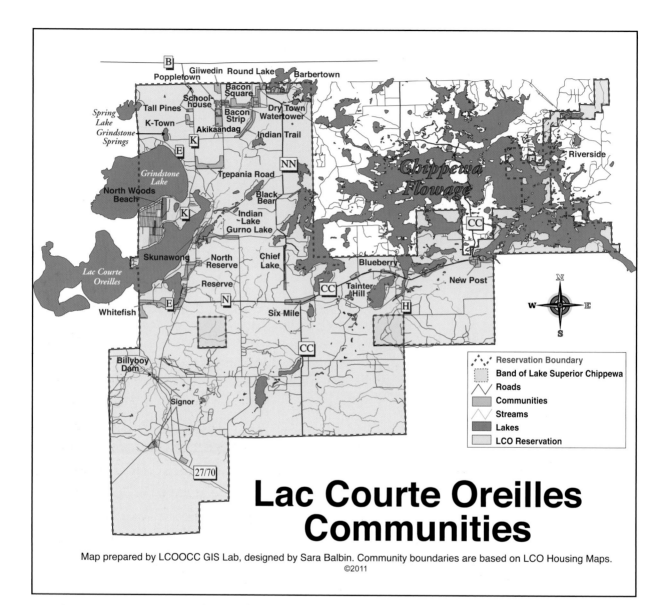

Lac Courte Oreilles Communities

Map prepared by LCOOCC GIS Lab, designed by Sara Balbin. Community boundaries are based on LCO Housing Maps.
©2011

GENESIS OF THE HALL OF ELDERS OIL PORTRAITS AND SPIRIT OF THE OJIBWE BOOK

SARA BALBIN

I N THE SMALL VILLAGE OF OLD HAYWARD, built by local developer Tony Wise, I opened my first seasonal art studio in the summer of 1973. Here, I first became acquainted with the local band of the Ojibwe, or *Anishinaabeg*, recognized by the United States Government as the Lac Courte Oreilles Band of Lake Superior Tribe of Chippewa Indians.

Old Hayward was comprised of twelve historic buildings, which included a church, a logging museum, a cook shanty, and, at the entrance, a depot complete with train. The buildings were utilized as studios and living quarters for artists and craftspeople. What made this intimate village unique were not only the talented artists but also the surroundings. North of the village was the Namekagon River, an ancient Ojibwe thoroughfare. To the east was a cluster of small cabins where James "Pipe" Mustache Sr.,* Frances Mike,* John Stone, William Belille, Lizzie Summers, Vivian Cloud with her children, and other tribal members lived. Also living in the cabins was a personality from Hayward's lumbering days, Katie Hicks, a ragtime piano player and singer who played at Old Hayward's Clark House, a saloon and dance hall.

A traditional Ojibwe village with *wiigiwaaman* was located to the south and was utilized by the *Anishinaabeg* of Lac Courte Oreilles for ceremonial gatherings, processing of wild rice, tanning of deer hides, bead work, and canoe building, and by entrepreneur Tony Wise as a showcase for visitors to the area. Directly across from the former village on County Road B lies an Ojibwe burial ground. To the west, the *Anishinaabeg* danced regularly at the *niimi'idiwin*, or powwow, ground. The rear of my studio sat only a few feet away from these grounds, where I first heard the singing of the Ojibwe and watched traditional dancing every Tuesday and Thursday evening. The power of their songs, dance, and culture attracted me from the beginning.

*Identifies, on first mention, an elder whose portrait and biography are included in this book.

The following photographs were taken by architect and photographer Fred Morgan at Old Hayward's Ojibwe village. They are from his book *Song of the Namekagon*, published in 1962, and are reproduced here courtesy of the Morgan family. The photographs exemplify the Ojibwe culture that existed in the village.

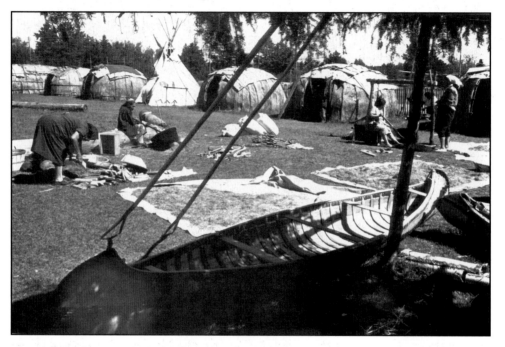

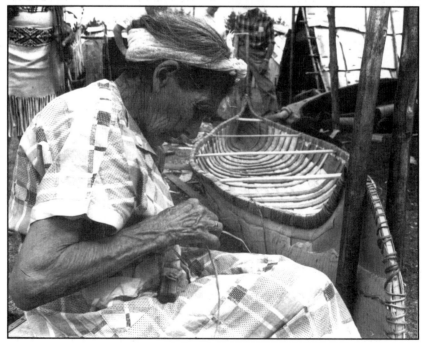

Above: Ojibwe village

Left: Ida White weaving a canoe support

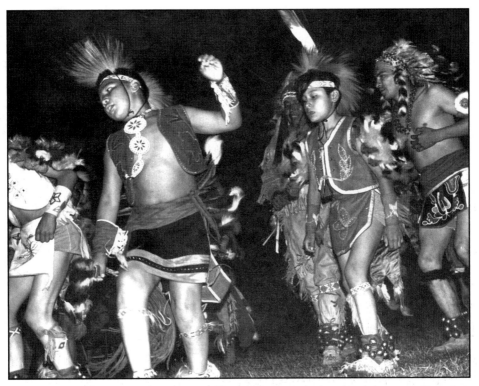

Powwow

In *Contemporary Great Lakes Pow Wow Regalia*, Marsha MacDowell and Arnie Parish discuss the spiritual, cultural, social, and economic importance of powwows. "In short, a powwow is a time and place to honor past and present community members, to celebrate life and creation, to give thanks, to enjoy the company of family and friends, and to pass on the knowledge of elders to youth."

In this rich environment, I became acquainted with many of the Lac Courte Oreilles tribal members living on and off the reservation. The *Anishinaabeg* would stop by for visits, and on occasion pose for sketches and paintings during the spring, summer, and fall months while I resided in Old Hayward. During the summer, Vivian Cloud's children would invite me to go swimming in the Namekagon River. It was here that I made the acquaintance of James "Pipe" Mustache Sr., also known as Omashkooz and Opwaagan and recognized as the *oshkaabewis*, or spiritual leader, of the Lac Courte Oreilles Reservation. Pipe befriended me and was my introduction to the people, customs, and culture of the Ojibwe. He enjoyed walking but occasionally asked if I would take him in my green 1967 Saab to the reservation, located about eight miles southeast of Old Hayward on County Road B. We spent a great deal of time driving to the different Lac Courte Oreilles communities, visiting with people and listening to the original Ojibwe music tapes that he had helped to create with the Badger Singers. As his hearing

was failing, I would see him reach for the car speakers to feel the music vibrations and then sing softly from the heart.

The *Gichigamiin Anishinaabeg* (People of the Great Lakes) are the end product of many generations of prehistoric and historic evolution and change. They are of the Algonquian speaking language stock, which today is separated by state jurisdictions and an international border. Nevertheless, they are *Anishinaabeg*, the original people.

For them, the arrival of Europeans challenged and threatened their culture and traditions. In *Education for Extinction*, David Wallace Adams writes: "The white threat to Indians came in many forms: smallpox, missionaries, Conestoga wagons, barbed wire, and smoking locomotives. And in the end, it came in the form of schools."

The Hayward Indian School, built and operated by the Indian Service of the Federal Government, opened its doors on September 1, 1901 and boarded approximately 180 students, primarily from the Lac Courte Oreilles Reservation. The elders in *Spirit of the Ojibwe* were significantly influenced by boarding schools and, in particular, the Hayward Indian Boarding School.

Carol Morgan, public relations director of the Hayward Area Memorial Hospital, located on the former grounds of the School, provided this written information on the Hayward Indian School compound, which was situated on six hundred acres of land:

> The complex began with a school house, two dormitories, a mess hall, employee's quarters and a warehouse. Later, a large barn, a rootcellar and other farm buildings were constructed and used to demonstrate modern farming methods to the students who spent half a day in vocational training.
>
> Administration buildings were added as needed, including offices, a dormitory and a residence for the superintendent. The work began on the hospital at the Indian School in 1929. This building served the government complex until 1953.

The Hayward Indian School was the dream of R. L. McCormick, who, with Anthony Judson Hayward, after whom the town was named, founded the North Wisconsin Lumber Company. McCormick had the money and political power to make his vision a reality, donating six hundred acres of land for the project and using his influence with the U.S. Congress to secure appropriations totaling about $100,000 (over $1,800,000 in 2009 dollars) for construction of the buildings. Operating funds were provided by the Federal Government as part of the nationwide Indian boarding school program.

According to Hayward historian Eldon Marple: "Under McCormick's pressure a bill came up in 1899 for a boarding school to serve the Lac Courte Oreilles reservation and was passed. It was to be located 'at or near' Hayward. The Indian Commissioner then decided that it would be located on the reservation near Grindstone Lake on the Charlie Patrick property. Again Mr. McCormick, by furnishing a masterful brief and by wielding his own great influence with educa-

tors and politicians, got this decision changed so that the school would be located off 'the reservation' a mile north of Hayward on lands donated by his North Wisconsin Lumber Company."

Although it seems that McCormick wanted to help the Ojibwe, he is, nonetheless, an enigma to this generation. Like many Euro-Americans of his time, his ignorance of and disdain for Indian tradition and culture was immense. This is revealed in an excerpt from his article "Evolution of Indian Education," which was first published in the *National Magazine* of Boston and then in the *Hayward "What?"* newspaper of June 19, 1901:

> The record of the mission Indian Schools in the West are filled with melancholy suggestion. Of the many that have ceased to exist, what are the results? In every case the Indian seems to have relapsed into barbarism and indolent savagery. His manly attributes are gone. The vices of civilization are implanted on his decadent paganism, and his last life is lower than the first.
>
> The argument against temporary efforts to teach the Indian seem to be conclusively convincing, and the only effective method to improve their condition will come from the continuous work of the non-reservation Indian boarding school, where the children are removed from the influences of the wigwam, dance, and the migratory habits of their race.

The school was built north of Hayward, approximately fifteen miles from the major settlement in the Lac Courte Oreilles Reservation, a location which required the young Ojibwe students to leave their homes and live in dormitories. This was done to minimize the influence of their parents and, for better or worse, to indoctrinate the students into the Euro-American way of life and to provide vocational education.

Although the living arrangements at the school relieved the problem of absenteeism, which had been encountered at schools located on the reservation, it required major lifestyle and cultural adjustments by the students and their families. Understandably, Ojibwe mothers and fathers were both saddened and angered, and many objected to the forcible removal of their children from their homes. At the same time, due to large-scale logging activities, they experienced decimation of the forests, limiting their ability to feed and shelter their families. For survival, many went to work for the logging companies. Some parents, struggling to maintain their families, thought the boarding school was beneficial because their children would be fed, clothed, and sheltered.

According to Eldon Marple, "When the institution was finally discontinued on July 1, 1933 because of a change of policy in Indian education which put their children in public schools in the area of their homes, about thirty children who had no other home stayed on and attended Hayward schools for one year." Lac Courte Oreilles elder Rita Corbine related: "Being half orphaned, I was allowed to go to school there. We were bused downtown to the public school in Hayward. And we rode in the back of a truck which they built—shelter for us with benches

on the side. We went back up to the boarding school where we stayed and had our lunch. Mr. Gregorson was the bus driver. He would listen to the radio and then take us back down to the public school. We were treated very well."

The new government school policy to relocate the children back to their homes on the reservation paralleled the end of the timber industry boom in northwest Wisconsin. Adequate provisions were not made to continue the Euro-American education of the Ojibwe children returning to their homes. Schools on the reservation were scarce or nonexistent and the public schools, such as those in Hayward, were distant and there was no transportation provided. Thus, for a period of time, many of the Lac Courte Oreilles children could not acquire a Euro-American education even if their parents wanted them to.

During the Great Depression of the 1930s, the Indian School complex, with the exception of the hospital, was taken over by the U.S. Department of Labor for the housing of transients. However, in 1934 the auditorium of the school building was the site of the Hayward Indian Congress, a significant meeting of Indian delegates from Michigan, Minnesota, and Wisconsin to advise the Federal Government on provisions of the proposed Indian Reorganization Act. The complex was closed by 1952 and the last of the residents moved out of the facility.

In addition to a vexing education situation, the Lac Courte Oreilles elders faced serious medical problems, with the 1918 influenza pandemic superimposed on an already existing respiratory-disease pandemic. Although Europeans had inadvertently brought smallpox and other diseases to the American Indians, with devastating consequences, tuberculosis and pneumonia may have existed in North America in the pre-Columbian era. With the dislocations and privations caused by the relocation of Indians to reservations, these diseases had reached epidemic proportions by 1900. From records of the Ashland, Wisconsin Indian Agency Office for the years 1912-1921 and 1926-1939, nearly fifty percent of Indian deaths in the area were caused by pneumonia and tuberculosis. Along with a high rate of stillbirths and of other infant deaths, this situation resulted in short lives for many of the Lac Courte Oreilles Ojibwe. According to anthropologist Robert E. Ritzenthaler: "Summing up the health situation of recent years, it may be said that the Chippewa have good reason to be concerned with the health problem. That with a high infant mortality rate and appallingly low life expectancy of 30.8 years [for 1931-1941] we are dealing with a people that has every right to awareness that something is radically wrong." But little was done to alleviate the situation.

In "Chippewa Preoccupation with Health," Ritzenthaler writes, "Previous to 1931 the Government at Lac Courte Oreilles depended largely upon Government Field Physicians and Nurses for medical care. More serious cases were transported to the Government Hospital at Tomah [two hundred miles away]. A government nurse was stationed on the Reservation for

ten years as a health inspector. She treated minor ailments, and arranged for the hospitalization of more serious cases."

The hospital on the Indian School grounds was completed in 1930 and had thirty-two beds. Service was provided free for any Ojibwe living on the reservation. However, with no telephone service or other means of communication, a journey of approximately eleven to twenty-six miles (depending on location of residence) to the hospital, often by walking, horse and wagon, or sled, compromised the medical service, especially during the winter months. For this reason many tribal members objected to the fact that the hospital was not built on the reservation. The hospital did, however, provide transportation for the more critical cases by either the Indian agent or by a field car sent from the hospital.

The hospital provided care for obstetric patients and those with most of the common diseases of the time. However, aside from palliative care, almost nothing could be done for patients with pneumonia or active tuberculosis, the leading causes of death. Effective treatments for these diseases had to await the general availability of penicillin and streptomycin after World War II and the subsequent development of multiple-drug and ambulatory treatment regimens. Also, more importantly for prevention, increased income, improved housing, and better nutrition reduced the incidence of respiratory diseases. At the time the hospital was built, a more effective approach may have been to allocate some resources to preventive measures, as had been successfully done on the Pine Ridge Reservation in South Dakota from 1897 to 1903, resulting in a forty-four percent reduction in deaths from tuberculosis.

Many Euro-American houses of this era had a "sick room," a bedroom on the first floor where the ill were cared for by family members and visited by physicians. While there was no hospital in Hayward for non-Indians, who often traveled to hospitals in Rice Lake and Superior, Wisconsin, the Indian Hospital was available to them for emergency care. The Hayward Memorial Hospital Association was organized by a group of Hayward businessmen in 1947 for the purpose of securing a hospital for the Hayward area. They acquired the Indian Hospital and opened it to the general public on July 1, 1953. According to Barbara Peikert, director of the Hayward Hospital, the Lutheran Hospital and Home Society of Fargo, North Dakota owned the facility from 1953 to 1986 and Regional Enterprises of Ashland, Wisconsin has operated an expanded facility since then.

The latter half of the twentieth century, particularly the 1970s, became a time of great flux and of self determination by American Indians. This activity followed and paralleled the African-American civil rights movement and the Vietnam War protests of the 1960s and 1970s.

During the fall of 1975, many of the children of Lac Courte Oreilles walked out of the Hayward Public School System because of racial injustices. According to Becky Taylor, at the

time a student at the Hayward High School:

> We walked out because there was a lot of prejudice. We didn't feel safe or welcome. Parents were behind us because they knew we were telling the truth. This was homecoming time. Right after we walked out we were meeting at the Reserve Community Center. This was during the first, second, and third quarters of my sophomore year in high school. Our high school classes were then held at the New Post Grade School gymnasium and basement. The space was blocked off with orange soft dividers that had once been in the Tribal Governing Building. There were bats flying in the gymnasium, and in the cold basement where my English class was held there were mice, spider webs, and bats. We had respect for all of them because they were there first before we moved in.

Sue Taylor, present director of the gifted program at the Reserve K-12 School, worked at the New Post School as a teacher during the 1975 walk out. She stated:

> After the December 1975 walk out, the Tribal Governing Board was determined to see that the students received an education. Adjoining the New Post School, in the middle of winter the ground was thawed by burning old tires and blocks of wood. They were able to lay the cement for the addition and put up wooden walls for three new class rooms. There were three original class rooms to the New Post School, an office, gymnasium, and basement. In January, after the holidays, we doubled up on the classes, other than kindergarten. In particular, grades one and two, three and four, five and six, seven and eight were combined. The high school students stayed in the gymnasium, basement of the school, and the community center, which was an old church building across from the school. The first high school graduation at the Lac Courte Oreilles Reservation was held at the New Post K-12 School in June of 1976. We have come a long way since the walk out.

The Tribal Governing Board, responding to the needs of the students, pursued the construction of a new K-12 state-of-the-art school in the village of Reserve, dedicated to a bicultural, bilingual education. The Reserve School was completed in 1978 and eventually the New Post School was closed.

For the dedication of the new school, tribal member John Anderson* invited me to exhibit the first oil painting of Pipe Mustache Sr., which had been created in the Old Hayward studio. Pipe stood proudly by his portrait during the dedication, and inspired the creation of the *Hall of Elders* portrait series.

In an effort to create and preserve a visual record of the Lac Courte Oreilles elders for future generations, the school administration and the Tribal Governing Board pursued and acquired two sets of grants from the Wisconsin Arts Board and the National Endowment for the Arts. The first grants, received in 1979, allowed for the painting of twelve elders. The second set of grants funded an additional six portraits. A total of eighteen elders allegorical

portraits comprised the original *Hall of Elders* series. Those to be honored in the *Hall of Elders* were selected by the Tribal Governing Board. Among the selection criteria were age, family heritage, contributions to the Lac Courte Oreilles community, and to the township in which they lived.

During the creation of the portraits, I became the first artist in residence at the Lac Courte Oreilles K-12 School. The studio arrangement in the art class offered the elders, students, and tribal members the opportunity to visit and observe the progress of the paintings. From live sittings, preliminary sketches on paper, with attention to faces, hands, and clothing designs, were created. Photographic sittings were also held in the studio or homes of the elders.

The studio was in a central location for the elders to share the history that would be the basis for the allegorical images in the portraits and for the written biographies. In this environment the students had the opportunity to observe and study the entire oil painting process. George Perry, a student whom I instructed during my residency, is one of the talented visual artists at Lac Courte Oreilles. Now adapting and using European methods of painting, Perry, Cleo White, and Marge Magnuson are the creators of the murals that grace the Lac Courte Oreilles K-12 School.

Across the hallway from my studio was the classroom of the cultural instructor Beverly Gougé.* The elders would visit Beverly's class for lunch, where traditional Ojibwe foods were cooked by her students, including *waawaashkeshi naboob, wazhashkiwi-*

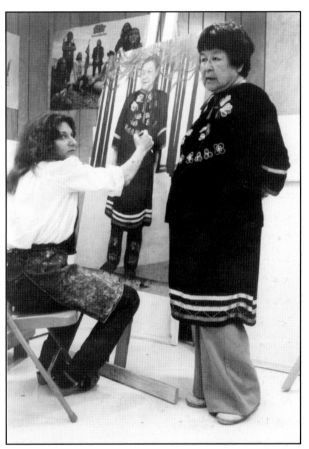

Sara Balbin, Lac Courte Oreilles' first artist in residence

The artist is seen painting Frances Mike at the Lac Courte Oreilles Reservation High School in 1979. The Wisconsin Arts Board and the National Endowment for the Arts sponsored the artist in residence program.

Photo courtesy of Lac Courte Oreilles School

iyaas, gaag, wewaagayin naboob, manoomin, zaasakokwaan, zhiiwaagamizigan, and other natural foods.

Throughout the year, Ojibwe garments, beadwork, and ceremonial objects were always in some stage of development in Beverly's classroom. The conversations, storytelling, and experiences we shared in her classroom often involved seasonal knowledge, traditional stories, and good-natured teasing.

Greater knowledge of the Ojibwe culture was obtained when I was invited to participate in the telling of Creation stories, during winter, in a *wiigiwaam* near New Post. I remember that the interior environment of the *wiigiwaam* was rich with delicate, earthy scents. At the entrance people presented a variety of hot dishes and breads for the evening feast. At the opposite end of the *wiigiwaam* there was a wood-burning stove where everyone sat quietly listening to Creation stories told by Jerry Smith, a storyteller, historian, and *oshkaabewis.*

As winter relented, spring offered spear fishing, the production of *zhiiwaagamizigan* and *ziinzibaakwad,* and the harvesting of fresh forest herbs and medicinal plants. The first time I followed Jerry Smith and Beverly Bearheart to their *iskigamizigan,* in New Post, they showed me several plants that I could harvest, including wild onions. When we arrived at their sugar bush, deep in the forest, they offered a hot maple syrup drink, made of partially evaporated maple sap, that quickly re-energized me after the trek in.

Many of my experiences became stories that I shared with Pipe when we visited. He was familiar with the families, and responsible for the networking needed to contact the elders, who did not have telephones. Each elder had to be contacted by a family member, or friends like Pipe Mustache Sr., Bill Sutton,* Beverly Gougé, and Saxon St. Germaine.* It would take several family members to pass the spoken message of my pending future visit for the portrait series. With everybody's networking, the trusting environment needed to acquire the necessary time for the subjects to pose and provide biographical materials for the portraits was established in the Lac Courte Oreilles community.

As the series progressed and the network was established, I ventured off on my own to visit the elders for the portraits. One of my fondest memories was my visit to the home of Henry* and Agnes Smith. It was in the short days of winter, so I ventured out early in the day to travel into the remote region of New Post. The subzero temperatures and depth of snow made it a risky venture. After arriving at the Smith's home, I realized that they used the rear door to the house in winter. As I walked on their shoveled path, I heard the howling of a solitary animal, which quickly turned into a chorus of howls. The sounds were loud and eerie, like a pack of howling wolves, but nothing was approaching.

I stopped in the narrow path, staring into the forest with senses attuned, and scanned for

possible danger. To my surprise, I made eye contact with multiple part-husky, mixed-breed dogs camouflaged in the forest near their small individual houses. By acknowledging the presence of the dogs and their howling, my fears eventually subsided. Continuing on the path I was warmly welcomed by Henry, who spoke fondly of his sled dogs that I had just experienced. The subsequent interview was filled with tales of historical interest. As I departed, I realized for the first time the different journeys my life had taken while working on the *Hall of Elders* portraits and how honored I was to be able to share time with elders like Henry and Agnes Smith.

Using the Lac Courte Oreilles system of networking and communication, the elders were always graciously ready for my arrival. On many occasions, an individual's citizens band (CB) radio was used to pass along messages through the community. The cooperation of the communities and families gave me the opportunity to become acquainted with the *Anishinaabeg* and learn first-hand the Ojibwe culture.

For a few years I lived primarily in a small cabin in the Chequamegon National Forest after closing the Old Hayward studio for the winter. The cabin was heated by a wood-burning stove and had no running water, electricity, or telephone because of its remote location. I ate every wild animal and fish brought to my home by neighbors, including porcupine. The friends who brought skinned animals would often hang them at the entrance of my cabin. When arriving home in the dark, I would unexpectedly walk into the skinned carcasses hanging in the entrance or bump into a bucket of fresh fish caught by neighbor Dale Jenson.

During the winter months it was not uncommon to be snowed in for many days because the town crew plowed the main roads first. Blizzards would force snow through cracks of the cabin window and create small drifts on the floor that needed to be shoveled. In a kettle over the wood-burning stove, I melted snow for drinking and learned about the sauna, or sweat lodge, for bathing from my friend and neighbor Kristi Wise. Having lived in this environment, Kristi understood the threat of winter and knitted a mohair blanket for me to stay warm.

The few residents living in the area would sometimes snowshoe to one another's homes for day or overnight visits. We would discuss techniques for preserving food, share intimate life survival stories, joke, and play pranks. For example, one winter day while I was visiting loggers Phil and Vi Levandoski, they pointed to four deer hooves sticking out of a bank of snow near their driveway. They asked that I help pull the dead deer out of the snow bank for butchering. We each grabbed a hoof, and pulled hard. I went tumbling over backwards with the hoof still in my hand. They laughed hysterically, as I had fallen for their deer prank. They sent me home with the four hooves as a gift.

During summer I collected rainwater in two steel ten-gallon milk cans for drinking and

washing. At night I would pitch a tent in the cabin to ward off mosquitos, bats, and rodents while I slept. At all times I kept my rifle near for fear of animal intruders, like bear. Submerging myself in this pioneer lifestyle, where daily living was a challenge, allowed me to better understand and communicate with the elders.

The elders' bicultural lives are documented in the portraits through their clothing, art, and cultural symbols. The *Anishinaabeg* of Lac Courte Oreilles live in the second-growth, mixed hardwood and coniferous forests, near the lakes, streams, and rivers of Wisconsin's North Woods. This environment establishes the foundation for their lives. The clothing depicted in the portraits reflects two coexisting cultures. Some are dressed in traditional Ojibwe garments (deerskin moccasins and apparel, beadwork, headdress, shawls, and ribbonwork), while others are dressed in Euro-American and lumberjack style clothing (cotton dresses and pants, flannel shirts, and suspenders).

David W. Penney writes in his article "Floral Decoration and Culture Change: An Historical Interpretation of Motivation":

> Native people found, perhaps, that dealings with their neighbors and white authorities ran more smoothly when their dress conformed to standards of white fashion. At the same time, the Great Lakes Indians nurtured a variety of special occasions and events in which Indian ethnic identities could be expressed and celebrated. Adoption and naming feasts, marriages, social dances, vitalized rites of the Midewiwin society, and, later, the Dream Drum, were all occasions for wearing and displaying finery. Dress clothing worn for such events tended to exaggerate the fashion signifiers of Indian ethnicity, and floral design was featured prominently. . . . Women artists applied floral motifs to moccasins, leggings, breech clouts, vests, shirts, sashes, garters, shoulder bags, and other categories of apparel that had never been decorated in the past.

For dress-up occasions like powwows, according to Cameron Wood and Stanley Peltier's essay in *Contemporary Great Lakes Pow Wow Regalia*, "As with Women's Traditional Dance regalia, Men's Traditional Dance outfits use only natural materials or those historically associated with European trade. Many traditional dancers incorporate family or clan colors and symbols. Because the dancer represents a warrior, the regalia may also reflect dreams or personal experiences." Also, according to Wood, "While the Men's Traditional Dance celebrates man's role as warrior or illustrates a story from the life of a particular individual, the Women's Traditional Dance exemplifies the Anishinaabe ideal of woman as lifegiver, caregiver, teacher, and guardian of Indian culture and heritage."

The Ojibwe developed many different types of designs. In *Ojibwa Crafts*, by Carrie A. Lyford: "Some of the oldest designs of the tribe are to be seen on their old cedar bark, rush mats, woven bags, and yarn sashes. Most of these old designs are [linear] geometric, controlled

in large measure by the processes of weaving involved." Typically, in later Ojibwe beadwork the clothing decoration consisted of more rounded appliquéd flower, leaf, and berry patterns. During a transitional period from the mid-eighteenth to mid-nineteenth centuries, clothing was hand made from cloth by women in European styles, but was an important site for traditional Ojibwe beadwork appliqué and ribbonwork. Later, manufactured Euro-American clothing was worn for everyday use, and traditional deerskin or cloth garments, decorated with beadwork, were worn for special occasions. The Ojibwe women are masters of the art of decoration, using glass beads, ribbons, and natural objects including quills, shells, bones, feathers, and fibers. A significant number of the elders portraits reflect the design and beadwork mastery of the Lac Courte Oreilles *Anishinaabekweg.*

The first beads used for this purpose by the Wisconsin Ojibwe were obtained from French traders. Later they were brought to the region by American traders, and were issued by the U.S. Government with annuities. Patterns in glass beadwork appear to be a translation of porcupine quillwork into beaded designs, rather than being derived from earlier kinds of beadwork. Beads were present in the prehistoric Great Lakes region, and to the east, but most of these were worn as jewelry.

Many of the designs in the beadwork display symmetry, which is a fundamental organizing principal in nature and in culture. Psychologists have determined that symmetry is a key element in visual perception; symmetric objects catch the eye and are perceived as coherent figures when displayed against a non-symmetric (asymmetric) background. As outlined by Bernadette Berken and Kim Nishimoto in "Symmetry and Beadwork Patterns of Wisconsin Woodland Indians," the four basic symmetries in Ojibwe design are translation, rotation, reflection, and glide reflection.

Translation symmetry consists of repeating a given design element (the leaf) along a line with equal spacing, as shown in figure 5. In nature, equally spaced water waves provide an example of this symmetry. The equally spaced repetition of the pattern of beats of an Ojibwe drum provides another example. According to tribal elder, *Oshkaabewis* John Anderson, the sound of drum music can be thought of as representing the primordial beat of a human heart.

In Ojibwe art, translation symmetry is displayed in the repetition of figures such as triangles, rectangles, and diamonds, and in the otter-tail design. An example of this is the repetition of the figures on the woven bag held by Elizabeth Schmock* (page 159).

Rotation symmetry is specified by the rotation of a particular design element with equal angular spacing around a central point, as shown in figure 6. In Ojibwe art, rotation symmetry is most often found in geometric and floral designs. An example of rotation symmetry can be seen in the three medallions on Pipe Mustache's regalia, each of which displays an eight-fold rotation (page 135).

Natural examples are provided by ray flowers, in which the petals extend in an approximately even pattern from the center, such as the ox-eye daisy, black-eyed susan, and yellow wood sorrel. The most ubiquitous example of rotation symmetry is provided by the nearly invisible snow crystal (of which snowflakes are composed), with six repetitions of a particular design around a point.

The concept of circular repetition is an important part of Ojibwe philosophy, as exemplified by the apparent rising and setting of the sun, moon, and stars, the seasons, and the cycle of life.

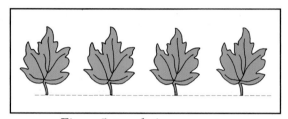

Figure 5: translation symmetry

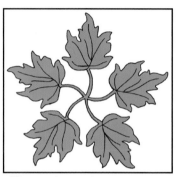

Figure 6: rotation symmetry

Figure 7: reflection symmetry

Figure 8: glide reflection symmetry

Reflection symmetry, often called mirror symmetry, consists of a design folded over a central line, as if reflected in a mirror, as shown in figure 7. In Ojibwe art, this symmetry is often found on opposite sides of vests and on belts and waistbands. An example is shown in the shoulder decoration in Saxon St. Germaine's portrait, in which the design is reflected about the center figure (page 151).

In nature, most animals exhibit reflection symmetry around a central line when viewed from the front or back. This is particularly true of faces, including human faces.

Glide reflection symmetry is a little more complicated. It consists of a reflection about

a central line, followed by a translation, or movement along the line, of the elements on one side of it, as shown in figure 8. In Ojibwe art, glide reflection is often found in bandolier-bag straps and border designs. An example of glide reflection can be seen on the regalia of Beverly Gougé (page 91). Often, the leaves on a vine or along a branch provide natural examples of glide reflection. Another example of glide reflection symmetry is provided by footprints in the environment.

Figure 9: symmetry breaking, design

Figure 10: symmetry breaking, color

Figure 11: asymmetry

Symmetry breaking consists of a break or change in an otherwise symmetric design, in terms of either design or color, as shown in figures 9 and 10. Color symmetry breaking is shown by one of the buds on the coat worn by Beverly Gougé (page 91). In Ojibwe art, symmetry breaking, such as a circular flower with a petal missing, is usually an intentional variation in design. These can be small or subtle, and thus hard to detect, inducing the viewer to look at the work more closely. A break in symmetry can be interpreted as an unexpected act of *Wenabozho*, disrupting the regular pattern of a person's life.

Asymmetry consists simply of a lack of symmetric pattern, as shown in figure 11. It is displayed in the floral designs on each side of the regalia worn by Tony Butler* (page 61). Examples abound in the irregular patterns of tree branches, clouds, and other natural phenomena. As Ojibwe art moved from woven cloth, quillwork, and loom-woven beads, which suggested symmetric patterns, to appliqué beads, in which individual beads or groups of beads were sewn onto a hide or cloth base, the change in technique facilitated the use of asymmetric designs. Also, according to J. L. Fischer, as a tribal society becomes more complex, so does its art, one characteristic of which is to move from symmetric to asymmetric design. Most contemporary Ojibwe beadwork is composed of both symmetric and asymmetric design elements.

The drawings present only the basic building blocks of symmetric design. The skill of the artist is revealed by the manner in which these basic components and others are imaginatively combined, using principles of color and composition, to produce an intriguing, elegant work of art.

As floral imagery is an integral part of Ojibwe dress and culture, it is important to consider the continued debate of its origins in American Indian beadwork. Some believe the patterns of flowers and leaves evolved from indigenous sources seen in Native porcupine quillwork and birch-bark art, while others speculate that floral forms came from teaching Indian girls embroidery and other needlework. In Richard Conn's essay "Floral Design in Native North America," he writes:

> It is not enough to point out that floral design existed in the Great Lakes before the first Swedish lumberjack cut down the first sapling. The most likely case for direct European influence comes from French Canada. In 1639, the Ursuline Sisters arrived at Quebec City to open their school and convent. Their charge from Louis XIII was to educate native girls in religion, French language, and domestic arts so they would be suitable wives for French settlers. It is certain that domestic arts included lessons in sewing and embroidery, using the floral design of 17th-century France. One student has even found evidence that the nuns made cut paper embroidery patterns and gave some of them to graduating students for future use at their home villages.

According to Andrew Hunter Whiteford, author of "Floral Beadwork of the Western Great Lakes":

> Long before the eighteenth century, birch bark provided a convenient medium for decoration. The designs were inscribed in the bark's dark spring coating, or else the bark was scraped off to create light-colored designs, both angular and curvilinear. The paper-thin inner bark was also cut into figures, some of complex designs that were used as patterns for beadwork. The inner bark is still used to make "biting patterns" by biting a folded square to produce indentations; when the bark is unfolded the designs usually resemble floral figures.
>
> These early creations are rare but they provide important evidence for an incipient foliate aesthetic in Native American art prior to the introduction of European education and aesthetic influence. The later development of complex foliate beadwork could hardly have derived entirely from these slender native roots, but these roots could well have provided a taste for some forms and concepts that facilitated the rapid acceptance of European foliate designs at the end of the eighteenth century.

It is important to note that *Anishinaabe* artists did not merely copy European techniques and designs, but adapted them to their own worldview and purposes. Over time, embroidery, per se, was eschewed, but appliqué was adapted for use with traditional glass trade beads. Likewise, floral designs did not consist of the domesticated flowers planted in French formal gardens, but of the wildflowers found in the Ojibwe's woodland home.

Floral designs are predominant in beadwork, and beadwork became the major art form at Lac Courte Oreilles and throughout northern Wisconsin. Outside this region, among the

Ojibwe of northern Minnesota, the adjacent areas of southwestern Ontario, and on the eastern shore of Lake Superior, another type of artistic expression developed. On the faces of cliffs scattered throughout this region, there are ancient paintings, some abstract, but most depicting human and animal spirit figures.

Apparently, the cliff paintings originated in these areas as a result of the availability of materials appropriate for their construction. While porcupine quills and, later, trade beads were available throughout Ojibwe country, the materials for rock paintings, the "canvas" provided by the cliffs and the "paint" in the form of red ochre, existed only in certain locations. The red ochre, or hematite, in particular, which binds to the granite rock at a molecular level to produce a long lasting stain, is available only in places with iron ore deposits.

Bead art, applied to clothing and other useful items, is produced almost exclusively by women. It is relatively small, portable, and perishable. In contrast, cliff art, produced mostly by men, and apparently often by *Mide* shamans, was somewhat larger, had fixed locations, and was more permanent. While the bead art emphasized relationships among its components through their astute placement and tendrils connecting them, the cliff art typically consisted of individual human and animal spirit figures, with any accompanying relationships expressed by the stories they represented.

The Ojibwe tradition of painting in Minnesota and Ontario, as exemplified by the work of Norval Morrisseau and David Beaucage Johnson, may have derived, in part, from the preexisting cliff paintings. When I, rather innocently, introduced Euro-American painting techniques at Lac Courte Oreilles, a new tradition of portraits and murals was introduced to this area.

The Ojibwe artists, who are innovators in the use of materials, fabrication techniques, and design are to be much admired, not only for their artistic innovations, but also for the message that they send to the non-Indian and Indian communities. That message is that Indian people should be free to explore and discover new methods of expression. Change is a natural part of life at the level of the individual as well as for a particular cultural group.

The clothing styles in the portraits change with the seasons, as there are great contrasts in the natural environment where the Ojibwe live throughout the year. In the winter months they are subjected to subzero temperatures, heavy snowfalls, ice, short daylight, and isolation. Families reunite at this time of year for the telling of Creation stories. In the warm, sunny, humid season, they live amidst thick, lush vegetation. Animals and insects are in abundance and the daylight is long. At this time of year the *Anishinaabeg* host communal social gatherings and powwows. The four main annual powwows hosted by the Lac Courte Oreilles Tribe are the Honor the Earth, Veterans, Contest, and Hand Drum powwows. The largest of these

is the Honor the Earth Pow Wow, which draws more than ten thousand people, and is always held the third weekend in July. According to Stony Larson, one of the organizers of the event, and an original member of the Badger Singers, "Powwows are the Indian Athletics, a time to showcase quality and excellence in music and dance. The Ojibwe culture is constantly changing. Between Pipe Mustache's generation and mine, the new Inter-Tribal style of singing and dancing developed, and is now more common at the powwows." Stony elaborated, "Tribes still have their own ceremonial styles. In the last twenty years there has been a differentiation between contemporary and original (elders' generation) Indian music."

The development of outstanding music begun at the Lac Courte Oreilles powwows continues. In 2007, the local group Pipestone Singers won the Record of the Year award for their CD, *Good Ol' Fashioned NDN Lovin'*, at the Native American Music [Nammy] Awards show in Niagara Falls, New York.

Weather and temperature extremes are a constant cycle in the lives of the Lac Courte Oreilles Ojibwe and are also depicted in the portraits. For example, in the portrait of Josephine Grover (page 97), she sits by a window with falling snow. Josephine was the keeper of the "Song For Snow," which was sung when the tribe was in need of a snow cover to protect the earth from frost or to aid in a successful hunt. According to Josephine, Tony Wise, the creator of the American Birkebeiner (the United States' largest cross country ski event), would ask her to sing the snow song to help the ski season at Telemark Resort, which he built in Cable, Wisconsin. Keeping the Ojibwe tradition alive, prior to her passing, she gifted a family relative with the song. In Josephine's portrait, the totemic system, or family clan system, is represented by the eagle feather in her hands. When the elders in the portraits acknowledged a clan, the symbols of their totem were portrayed through animal images or the environment in which the animal lived.

The following is an Ojibwe Creation story, describing the origins of the *Anishinaabeg* and the family clan system, told by William W. Warren.

When the Earth was new, the An-ish-in-aub-ag lived, congregated on the shores of a great salt water. From the bosom of the great deep there suddenly appeared six beings in human form, who entered their wigwams.

One of the six strangers kept a covering over his eyes, and he dared not look on the An-ish-in-aub-ag, though he showed the greatest anxiety to do so. At last he could no longer restrain his curiosity, and on one occasion he partially lifted his veil, and his eye fell on the form of a human being, who instantly fell dead as if struck by one of the thunderers. Though the intentions of this dread being were friendly to the An-ish-in-aub-ag, yet the glance of his eye was too strong, and inflicted certain death. His fellows, therefore, caused him to return into the bosom of the great water from which they

had apparently emerged.

The others, who now numbered five, remained with the An-ish-in-aub-ag, and became a blessing to them; from them originate the five great clans or Totems, which are known among the Ojibways by the general terms of A-waus-e [Fish], Bus-in-aus-e [Crane], Ah-ah-wauk [Loon], Noka [Bear], and Monsone [Moose Tail], or Waub-ish-ash-e [Marten]. These are cognomens which are used only in connection with the Totemic system.

Though according to this tradition, there were but five totems originally, yet, at the present day, the Ojibway tribe consists of no less than fifteen or twenty families, each claiming a different badge.

According to the *Encyclopedia of Indians of the Americas*, edited by Harry Waldman, "Clans and gens are basic units of social organization based on common ancestry. Clans (or matri-clans) describe descent through the female line, while gens (or patriclans) describe descent through the male line. Clans were not universal among North American Indians, but where they existed they usually formed the largest sub-units of the tribe." Although Ojibwe *doodem* are patrilinial, and thus gens by definition, they are usually referred to as clans. Among other tribes, matrilineal clans are most numerous in the United States.

The number of clans among individual North American tribes varies greatly. The Diné (Navajo) tribe claims eighty-six clans, not including sub clans. The Diné, the Apache, and many other tribes are not totemic. They use the names of natural features of localities, or from creation stories: for example, the Diné's Towering House Clan, which originates from their creation story, or the Juniper Clan among the White Mountain Apache.

The following is a description of the Ojibwe clan system by William W. Warren.

The first and principal division, and certainly the most ancient, is that of blood and kindred, embodied and rigidly enforced in the system which we shall denominate Totemic. The Algics [a group of tribes] as a body are divided into several grand families or clans, each of which is known and perpetuated by a symbol of some bird, animal, fish, or reptile which they denominate the Totem or Do-daim (as the Ojibways pronounce it) and which is equivalent, in some respects, to the coat of arms of the European nobility. The Totem descends invariably in the male line, and intermarriages never take place between persons of the same symbol or family, even, should they belong to differ-ent and distinct tribes, as they consider one another related by the closest ties of blood and call one another by the nearest terms of consanguinity.

Marilyn Benton, an Ojibwe cultural instructor at the Lac Courte Oreilles Community College, said: "Various characteristics are associated with the clans and passed down from generation to generation through oral stories." In *The Mishomis Book*, tribal elder and author Edward Benton-Benai discloses some of the clan characteristics. "The Crane and the Loon Clans were given the power of chieftainship. They were given the people with natural qualities

and abilities for leadership. Each of these two clans claim to be the original Chief Clan. They were both given the respect of chieftainship. By working together the Crane Clan and the Loon Clan gave the people a balanced government with each serving as a check on the other."

The following are clan characteristics as quoted first from William Warren, with later statements by Lac Courte Oreilles Tribal members Pipe Mustache Sr., Eddie Benton-Banai, Marilyn Benton, John Anderson, Jerry Smith, and Beverly Bearheart.

The *Awaazisii*, or A-waus-e, *Doodem*: **Fish Clan.** "This being is also one of the Spirits recognized in their grand Me-da-we rite. This clan comprises several branches who claim the Catfish, Merman, Sturgeon, Pike, Whitefish, and Sucker totems, and in fact, all the totems of the fish species may be classed under this general head." William Warren continues, "They also claim, that of the six beings who emerged from the great water, and originated the Totems, their progenitor was the first who appeared, and was leader of the others."

Pipe Mustache Sr. belonged to the *Name*, or Sturgeon, Clan and would sometimes refer to the Fish Clan as the Water Clan. According to Eddie Benton-Banai, "They were sometimes called 'star gazers' for their constant pursuit of meditation and philosophy."

The *Makwa*, or Noka, *Doodem*: **Bear Clan.** "In former times this numerous body was sub-divided into many lesser clans, making only portions of the bear's body their Totems, as the head, the foot, the ribs, etc. They have all since united under one head, and the only shade of difference still recognized by them is the common and grizzly bear. They are the acknowledged war chiefs and warriors of the tribe, and are keeper of the war-pipe and war-club, and are often denominated the bulwarks of the tribe against its enemies."

Eddie Benton-Banai elaborates: "The Bear Clan served as the police force of the people. They spent most of their time patrolling the outskirts of the village so as to ward off any unwelcome visitors. Because of the large amount of time they spent close to nature, the Bear Clan became known for their knowledge of plants whose roots, bark, or leaves could be used as medicines to treat the ailments of their people."

The *Ajijaak*, or Bus-in-aus-e, *Doodem*: **Crane Clan.** "They claim, with some apparent jus-tice, the chieftainship over the other clans of the Ojibways." William Warren continues: "The Cranes claim the honor of first having pitched their wigwams, and lighted the fire of the Ojibways, at Shaug-ah-waum-ik-ong, a sand point or peninsula lying two miles immediately opposite the Island of La Point." The island is now called Madeline, and is situated in north-ern Wisconsin's Bayfield County, in Lake Superior.

The *Maang*, or Ah-ah-wauk, *Doodem*: **Loon Clan.** "This family does not lack in chiefs who have acted a prominent part in the affairs of the tribe, and whose names are linked with its his-tory." According to Basil Johnston, in *Ojibwa Heritage*, all the leadership clans are birds.

The *Ma'iingan*, or Mah-een-gun, *Doodem*: **Wolf Clan.** "The Mah-een-gun, or Wolf totem family, are few in number, and resided mostly on the St. Croix River and at Mille Lac. They are looked upon by the tribe in general with much respect. The Ojibways of this totem derive their origin on the paternal side from the Dakotas." Contributing writer of *Spirit of the Ojibwe*, Thelma Nayquonabe is of the *Ma'iingan* Clan.

The *Waabizheshi*, or Waub-ish-ash-e, *Doodem*: **Marten Clan.** "Waub-ish-ash-e, Marten family, form a numerous body in the tribe, and is one of the leading clans. Tradition says that they are sprung from the remnant captives of a fierce and warlike tribe whom the coalesced Algic tribes have exterminated, and whom they denominate the Mun-dua."

Regarding the Marten Clan, Eddie Benton-Banai states: "They became known as master strategists in planning the defense of their people." Some French were honorary members.

The *Migizi*, or Me-gizzee, *Doodem*: **Eagle Clan.** "The small clans who use the eagle as their Totem or badge, are a branch of the Bus-in-aus-e." Dr. John Anderson, a member of the Eagle Clan, stated: "The Eagle Clan is the clan which adopts new members into the tribe. There were no orphans because of the clan system." He continued, "It is also referred to as the Bird Clan, and believed to be the spiritual leaders of the people. They had a sense of intuitiveness, a sense of knowledge like the elders in the past who thought they could predict the future."

The totemic system, or family clans, served several functions. A few of the important functions are prevention of genetic disease, safety, economics, and family solidarity. To prevent genetic disease, particularly when bands and tribes were smaller, no one could marry into his or her own clan and had to look for a mate with a different totem animal. This marriage rule was strong enough that it has survived into the present for some of those who still use their totem as a symbol of their clan.

Safety, or protection, was also provided by the family clans. Sometimes, a person was only as safe as his kinsmen could make him. In *Introduction to Wisconsin Indians*, Carol I. Mason writes: "The knowledge that a man had a large and powerful group of relatives who could avenge him acted as a form of protection. Kinship is a system of mutual rights and obligations and works best when relationships are face to face and can continue over time. Once the groups get large or scattered, it is harder to depend on kinship. The systems themselves often get larger but when they do, they weaken the obligation that members feel for each and every other member. The large kinship groups called clans are one result of increasing size, but even clans cannot always be as dependable as smaller, face to face kin groups."

The protection of the clans promoted trade and resulted in building the economy of the tribes. The clans are a network through which people can accomplish many useful things for

themselves and their extended clan family. Parents passed along clan skills to their children and clans offered opportunities for trade. People with large and powerful family groups had better chances in meeting basic needs for economic survival.

The identity of the kinship groups and family clans was strong. In *Ojibway Heritage*, Basil Johnston states: "The bonds that united the Ojibway-speaking peoples were the totems. The feeling and sense of oneness among people who occupied a vast territory was based not on political considerations or national aspirations or economic advantages ... but upon the totemic symbols which made those born under the signs one in function, birth, and purpose. It was through the totems that brotherhood and sisterhood were engendered. Speakers all commenced their speeches with, 'My brothers, my sisters.'"

Various characteristics are associated with the clans and passed down from generation to generation through traditional oral stories. It is my observation that there are still similar beliefs today regarding clan system characteristics among the various Ojibwe tribes or bands. However, these may vary geographically, in part due to their past seminomadic life style and the great distances between settlements.

As the spiritual leader, *oshkaabewis*, or messenger of the tribe who conducted traditional Ojibwe weddings, funerals, and other significant ceremonies at the Lac Courte Oreilles Reservation, it was important for Pipe Mustache Sr. to know which clan each tribal member belonged to. He would ask "*Wegonen gidoodem?*" Literally, what clan? When we discussed the elders' clans during the painting of the portraits, I understood the family ties. In 1979, I recall being introduced to Sam Frogg* of the *Makwa* Clan. Years later, when interviewing Mary Sutton* for her portrait, I learned that she also belonged to the *Makwa* Clan. When asked if she was familiar with Sam Frogg of the *Makwa* Clan, she said that he was her brother.

The clan traditions are still important for the elders and families who follow the traditional Ojibwe life. According to Jerry Smith, "The clan animal that you are born into offers spiritual help and guidance throughout your life. It is the animal which protects a child even before it is given a name. Family clan feasts are held to pray for the spirit they originated from."

Smith relates that, "The Ojibwe were seminomadic, and did not live in one village. Because of this, the rules for the clans were strict, but everyone was expected to use common sense for survival." For example, he added, "The Crane Clan family were the acknowledged orators and hereditary chieftains, but others from a different clan could also become chief of their tribe. What is certain is that the clans thought of themselves as one large extended family and, if visiting another village, the same clan would take care of you."

Culturally and spiritually, the members of a particular clan are directly tied to the animal after which they are named. This became apparent to me in 1991 when Pipe introduced me to

Jerry Smith, Beverly Bearheart, and their six children. When introduced, I neglected to ask what clans they belonged to. Later that winter, in error, I brought them bear meat as a gift. In a gracious manner, Beverly said, "I belong to the Deer Clan but my children, like their father, belong to the Bear Clan, and they can't eat the bear meat because it's a family member. However, I can share the meat with another clan family."

Jerry Smith elaborated on clan traditions: "The Deer Clan family is the exception, they can eat their own animal clan because it's a staple food." He also stated: "If an Eagle Clan member needs to harvest a bear for food, he needs to present an elder of the Bear Clan with tobacco and ask for permission. After harvesting the bear, a feast and presents are given to the Bear Clan members for taking the life of one of their relatives."

Clan relationships help unite families and the various Ojibwe bands. The Ojibwe people belong to separate bands, and as a whole to the Ojibwe nation. To share their rich culture, the Lac Courte Orielles School encouraged workshop presentations outside of the reservation. In 1981, Bill Sutton, Beverly Gougé, Mimi Trudeau, Thelma Nayquonabe, and I were invited to give workshops at the Concourse Hotel, adjacent to the Wisconsin State Capital in Madison. My presentation was on the *Hall of Elders* portraits. This was the first time I had the opportunity to work with Thelma Nayquonabe. As a traditional *Anishinaabekwe*, or Ojibwe woman, she wore a light-blue ribbon, two-piece outfit, and carried her infant son Johnny in her arms. This maternal image of Thelma in her ribbon dress at the State Capital demonstrated the pride, strength, and integrity of the Ojibwe culture, which has been nurtured at the Lac Courte Oreilles Reservation.

At this same time, the tribal elders were also encouraged to travel nationally and share their heritage with other communities. On one of their journeys, a few of the early elders paintings were taken to the Smithsonian Institution in Washington, D.C., where Pipe Mustache Sr. and several other elders of Lac Courte Oreilles gave presentations on the Ojibwe culture. This presentation and exhibit corresponded with the National Endowment for the Arts Grants that supported the *Hall of Elders* portraits.

In 1981, after the first eighteen allegorical portraits comprising the *Hall of Elders* were completed, I retreated to my cabin nestled in the Chequamegon National Forest. It was there that I met my husband to be, Gary Crandall, was married, and had two children, Eric and Melissa. In my new role as a mother, Pipe continued to educate me in the Ojibwe culture. He introduced me to the Ojibwe naming ceremony by honoring both my children in their first year of life with traditional Ojibwe names. I then continued participating in cultural events, including the annual Honor the Earth and Veterans powwows.

One fall, while visiting the Lac Courte Oreilles K-12 libraries and government buildings

Lac Courtes Oreilles Spiritual Leader James "Pipe" Mustache Sr. and Sara Balbin seated at her daughter's 1988 naming ceremony

Mustache was Balbin's mentor and visionary for the *Hall of Elders* portraits featured in *Spirit of the Ojibwe*.

Photo courtesy of Gary Crandall

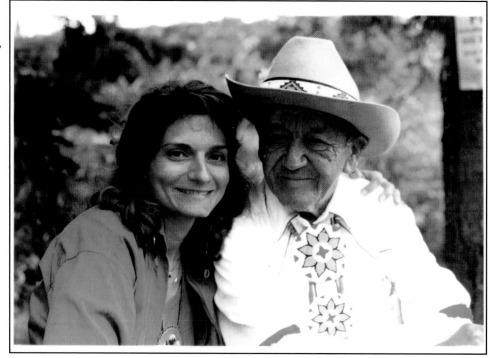

to inventory and document the identities of the portraits, I started reminiscing about the oral stories the elders had shared with me regarding their life struggles and accomplishments.

Later that winter, while teaching drawing classes in the high school library, where many of the portraits are displayed, I observed students proudly pointing to the portraits of their great grandparents or great aunties and uncles. However, because of their youth, they often had limited memories regarding the vastness of the lives their elders experienced. Using the portraits as a visual tool, the students and I shared stories of the elders, and, for a brief moment, the memories shared brought them to life. It was during this time that the importance of writing the biographies from the elders' stories, their relatives, and friends for future generations became clear. The biographies in *Spirit of the Ojibwe* are short studies of the elders' lives. We are hopeful that future generations will be able to utilize the biographies as a springboard for oral story telling, helping to keep an age-old tradition alive.

My interviews of the elders revealed that this was a transitional generation. The eldest generation of Lac Courte Oreilles had witnessed the arrival of the *chi mookomaan*, the introduction of English as a new language, and Christianity as a new religion. In addition, this generation witnessed housing developments on their land, rural electrification, the availability of commercially processed foods, expansion of telephone service, improved information dispersal through radio and television, improvements in transportation through the automobile and airplanes, technological innovations in computers and satellites, and even man walking on

the moon. The elder generation went from a gathering, subsistence society of day-to-day survival to a high-tech society, owning their own K-12 school, community college with library and cultural center, medical clinic, community radio station (WOJB), grocery stores, casinos, and numerous other industries. They have also lived to see much of their lost tribal land reclaimed. These accomplishments are a tribute to their flexibility, high intelligence, strong physical constitution, community goals, family values, strong leadership, and inherent ability for survival.

In addition to these accomplishments, the Ojibwe of Lac Courte Oreilles continue to respect their heritage of protecting the environment. The contentious construction of the Winter Dam on the Chippewa River in the early 1920s by the Wisconsin-Minnesota Power & Light Company, which formed the Chippewa Flowage and destroyed the Lac Courte Oreilles village of *Paquayawong*, is considered a tragedy by most tribal members. Turning this situation around to generate a positive outcome, the tribe has dedicated itself to preserving the environment of the lake resulting from the dam.

In this connection, the tribe formed a Joint Agency Management Plan with the Wisconsin Department of Natural Resources and the United States Forest Service to protect the Chippewa Flowage from environmental damage. For this accomplishment, of achieving cooperation among three sovereign governments, the tribe received an award of High Honors from the John F. Kennedy School of Government of Harvard University.

In 1990 I met with Tribal Chairman gaiashkibos of the Lac Courte Orielles Reservation to discuss my concern regarding the potential loss of the elders biographical history, that at one time they shared and had accompanied the *Hall of Elders* portraits. With technological advances, this form of traditional oral transmission of knowledge was being compromised. We discussed how to secure the history and how to create written biographies for future generations.

In 1992, Pipe was ready to pass on, or "go home." He moved to the home of Jerry Smith and Beverly Bearheart, who practice many of the traditional Ojibwe customs. In their home, he could continue with his Ojibwe traditions and religion until his death. For Pipe, the process involved a *miigiwe*, or give away, of all his worldly possessions. According to Paul DeMain, an *oshkaabewis* and managing editor and CEO of *News From Indian Country*, "Pipe started giving away all of his material property a year before, including his favorite beaded cane, made by Beverly Gougé, and given to Sara's mother, Corinda. Most items went to people very specifically who knew how to use, or would use, what he gave them, therefore giving away parts of his aura to others." Because Pipe was the spiritual leader of Lac Courte Oreilles, this "give away" also included passing on his knowledge of the *Midewiwin* belief and his personal spiritual history. It was part of this spiritual history that Pipe passed on to me a few weeks prior to his death during a traditional naming ceremony. Paul DeMain recalled, "Pipe had told me perhaps a couple of months before Sara

brought the tobacco to him, that before he passed away, he had only one name from a dream that he knew he still had to give out, and that it would be a name he would be giving to a woman. That name ended up being given to Sara."

For the naming ceremony, I was encouraged to create a deer-hide dress to give me a better understanding of Ojibwe culture and Mother Earth. The dress is made of three large deer hides. Two are used for the front and back, the length extending to my ankles. They are connected on the sides with long hide straps that weave through small holes. The third deer hide has a hole cut in the center to fit over my head, and drapes on the shoulders. For decoration, beads are strung on the hide fringe on the bottom of both garments. Ojibwe regalia like this are works in progress, and take many years to adorn with beadwork.

The ceremony was held at my home with members of the Lac Courte Oreilles traditional community and friends. Paul DeMain carried Pipe's frail body in his arms through the front door of my home and gently seated him next to his friend Tony Wise. A *migiziwigwan*, or eagle feather, was affectionately placed in my hair to represent *Gichi-manidoo*, or Great Spirit, watching over me. Pipe's ceremonial attendants, or *oshkaabewisag*, Paul DeMain, Jerry Smith, and John Anderson, along with Beverly Bearheart, were invited to assist Pipe with the ceremony. The traditional Ojibwe men laid out the feast for the spirits of Creation. In the *Anishinaabe* tradition, the food for the feast, *manoomin, waawaashkeshiwiwiiyaas, zaasakokwaan*, and other regional foods were placed on a blanket laid on the living room floor.

In his most eloquent manner, Pipe conducted the entire ceremony in *Anishinaabemowin*. A graceful and animated Jerry Smith translated Pipe's story, and acted out the origins of the name that had been given to me. The story revealed how a dream spirit had presented itself to Pipe after two days and two nights of fasting during his youth. It was this dream spirit whose name and presence I was given, to take care of me throughout my life. Pipe entrusted a part of his personal history, and I became his namesake, or *niiyawen'enh*. The Spirit's name shall remain personal to sustain its integrity and strength, used only by my *niiyawen'enhyag* and family. In the future it will be my responsibility to pass the name and dream spirit Pipe gave me on to another in honor of his dream and Ojibwe culture. I was honored to be the last person Pipe named prior to his walking on, and I felt as if I had become part of his extended family circle. Along with Pipe, the attendants became my *niiyawen'enh* or namesakes, during the ceremony. According to John Anderson, "They are friends who at different spiritual levels can validate the event and who can act as Ojibwe spiritual teachers or confidants." In celebration of the feast, and as an invitation to the Creators, John Anderson played the hand drum and sang an Eagle Song that he learned from a Ho Chunk woman. After the ceremony, several eagles flew over my home that day as confirmation of the blessing of this final ceremonial act by Pipe.

Recognizing that elders like Pipe were aging and passing on, the Tribal Government commissioned fourteen additional portraits for the *Hall of Elders*. In 1995, as I proceeded with the elders portraits, Louis Barber,* gaiashkibos's father and a respected elder, passed on. Once again, the interviews and consequent portraits were timely in preserving a segment of the history and integrity of the Lac Courte Oreilles culture.

It was at Louis Barber's traditional funeral that I was reunited with Thelma Nayquonabe. During the funeral feast I invited Thelma to join me in the writing of the elders biographies. I shared my vision of creating a book combining the elders allegorical portraits and biographies to better preserve their history and educate the children, the Lac Courte Oreilles community, and the public. At the time of the funeral, Thelma was director of the elders program at the Lac Courte Oreilles School. She believed in my vision, and assisted with several of the elders interviews, acquiring important biographical information.

For a period of time, we worked together in our determination to acquire the life stories of the elders and build the proud history of Lac Courte Oreilles. We envisioned distributing the book to the elders, their families, community-based institutions, museums, and regional libraries. For this purpose, Thelma contacted her friend and past professor James Lenfestey. They had met in 1969 at the University of Wisconsin–River Falls, where Professor Lenfestey was offering one of the first American Indian literature courses in the country. He was intrigued with the concept and networked to help us find a publisher. Lenfestey contacted publisher James Perlman of Duluth's Holy Cow! Press, with whom he had worked in the past. With a sincere interest, Perlman submitted a grant proposal for the book to the Outagamie Charitable Foundation, based in Appleton, Wisconsin. The acquisition of the Outagamie Charitable Foundation grant in 1998 allowed us to pursue the vision of publishing *Spirit of the Ojibwe*. However, when Thelma's school duties expanded, and her talents were needed as principal for the Lac Courte Oreilles K-6 grades, she found it difficult to continue with the biographical research. I continued with the interviews and, while researching biographical information on James Mustache Sr., I read an article in the *Sawyer County Record* newspaper written by James Bailey. His writing revealed that he was a well-versed observer of Ojibwe culture and an accomplished reporter. He had covered tribal issues for the local newspaper since 1984. His seven years experience working with the Lac Courte Oreilles owned community radio station, WOJB, also gave him an extensive body of knowledge. We met at the newspaper office. The project was explained, and Bailey agreed to participate with the interviews and writing of the biographies.

As the biographies were nearing completion, Dr. Rick St. Germaine, a tribal member of Lac Courte Oreilles and professor of history at the University of Wisconsin–Eau Claire, accepted an invitation to write an accompanying historical essay. Rick St. Germaine's contri-

bution has helped secure a treasured body of historical knowledge for his people.

The Ojibwe Glossary was composed by John Carr and Sara Balbin with the assistance of tribal members Cathy Begay and Ernie St. Germaine (Lac du Falmbeau Tribe). Researcher John Carr and I co-authored the Ojibwe Language section, using information provided by radio station WOJB. We also co-authored the References and Suggested Readings section. John Carr edited the entire book for composition and verified much of its historical accuracy. Managing editor of the *Sawyer County Record*, Paul Mitchell edited the biographies for composition.

The creation of the book *Spirit of the Ojibwe* has been a collaborative effort between the Lac Courte Oreilles Tribal Governing Board, tribal members, the tribal Enrollment Office, tribal radio station WOJB, the Wisconsin Arts Board, the National Endowment for the Arts, the Milwaukee Public Museum, the Outagamie Charitable Foundation, James Lenfestey, James Perlman, Thelma Nayquonabe, James Bailey, Dr. Rick St. Germaine, John Carr, Cathy Begay, Ernie St. Germaine, Paul Mitchell, and myself, Sara Balbin.

The Hayward and Spooner, Wisconsin public libraries provided substantial assistance in gathering research materials. Also helpful were the Lac Courte Oreilles Ojibwa College Library and the University of Wisconsin and University of Minnesota system libraries, particularly the library at the University of Minnesota Duluth.

On March 17, 2001 the tribal government offered a feast at the K-12 school to honor the collaborators and the book project that would help preserve the elders' history. The community was invited to review the first drafts of the biographies and to view the accompanying portraits, that now numbered thirty-two.

The tribal equivalent of a national flag, the Lac Courte Oreilles eagle feather staff, was placed center stage to honor the feast. Rusty Barber proceeded with the passing of tobacco to the approximately two hundred community members present. As the tobacco was being passed to honor the spirits, *Oshkaabewis* Jerry Smith relayed in English the story of how that morning six eagles had flown in a circle south of his home. One of the eagles broke away from the circle, and flew directly over the house. This was seen as a good omen, and special honor for the feast, as was the clear blue sky, which allowed for direct communication to the spirit world.

Jerry Smith first smoked his ceremonial pipe, and then presented the blessing of the feast in the Ojibwe language. Six members of the Lac Courte Oreilles Badger Singers drum group proceeded with an honor song. Tribal Chairman gaiashkibos then spoke on the importance of the portraits and biographies to the Lac Courte Oreilles community. Margaret Diamond, gaiashkibos, and Don Carley wrapped Thelma, Jim, and me with Pendleton blankets representing the circle of life as a gift for our efforts in creating the *Spirit of the Ojibwe*. The participation of the tribal members at the feast was a testament to the collaboration of the Lac

Courte Oreilles community.

A sincere *miigwech*, thank you, to past Tribal Chairmen gaiashkibos and the late Al Trepania, and to present Tribal Chair Louis Taylor for their important contributions to this book, and to the Tribal Governing Board for their continued support of the portraits, elders biographies, and *Spirit of the Ojibwe*.

Chi miigwech to the Lac Courte Oreilles Elders Association, dedicated to assisting elders and children. Ellen Martin, president, and Mona Ingerson, secretary-treasurer of the Association, will receive and allocate a portion of the proceeds from the sale of *Spirit of the Ojibwe* to advance the education of Lac Courte Oreilles youth.

The customs and traditions of the Ojibwe woodland *Anishinaabeg* are unique to the forests and lakes they live in. Their way of life, *Midewiwin*, and Big Drum Society reflect this environment as well. Pipe was the spiritual *oshkaabewis* to the elders and the medicine men and women of the Lac Courte Oreilles Reservation. It was through the trust people had in him, and the positions he held, that the *Hall of Elders* portraits became possible. At my naming ceremony, Pipe spoke of the *Anishinaabeg* in his youth who could see far ahead as prophets. I believe that Pipe was one of those, and encouraged my painting of the Lac Courte Oreilles elders to help secure a segment of their history in this rapidly changing world.

For him there was no separation between Mother Earth, man, animals, spirits, and *Gichimanidoo*, the Great Creator. With his knowledge of the *Midewiwin* way of life, he lived his life as a humble man who served his people. Returned to Mother Earth, Pipe is no longer with us, but his spirit, vision, and teachings are alive. When you look at the allegorical portraits and read the biographies, Pipe's legacy as *oshkaabewis* continues to secure the humanity, culture, and traditions for future generations.

There are no words in the Ojibwe language for "good bye." Instead, the *Anishinaabeg* use the words *mii iw, miigwech*, "That's all, thanks," and *giga-waabamin miinawaa*, "I'll see you again." As the artist of the *Hall of Elders* portraits, serving Pipe and the Lac Courte Oreilles community, I say it has been an honor.

Miigwech giga-waabamin miinawaa.

Hall of Elders
Portraits and Biographies

Oil Portraits
Sara Balbin

Biographies
Sara Balbin, James Bailey, Thelma Nayquonabe

DR. JOHN "LITTLE BIRD" ANDERSON

B. JANUARY 1, 1936

Dr. John, Bonajonce, or Little Bird, Anderson, a member of the *Migizi Doodem*, is a man of many achievements. He helped to found Native American studies programs at two colleges—the University of North Dakota in Grand Forks and The College of St. Scholastica in Duluth, Minnesota—and was a founder and first president of the Lac Courte Oreilles Ojibwa Community College, a post that he held for five years.

Even as a young man, his leadership potential was recognized. He was elected as Lac Courte Oreilles tribal chairman at the age of twenty-three, making him, at the time, the youngest tribal chairman in the United States.

He is also a dedicated athlete who played basketball in high school and lettered in college wrestling. At age forty-one, he took up running for health reasons, shedding forty-five pounds in the process. He still runs three to six miles when so moved. John has completed ten full marathons, including twice running the Boston Marathon.

Much of John's success in life can be attributed to the upbringing he received in the New Post home of his foster parents, a brother and sister named "Aunt" Nellie Oleson and "Uncle" Billy DeBrot. He was sent to live with them when he was only nine months old. Growing up with him in their home were his sister Bernice (Anderson) Begay and two first cousins, Clayton Wabschall and Dorothy (Wabschall) Prochaska. Together they lived at Billy and Nellie's place of business, Indian Post Resort, with six cabins and a sparklingly clean dining room replete with red and white checkered tablecloths. The resort was at various times a semi-permanent residence for the parish priest, an occasional fishing guide, and teachers serving New Post, like Rose Moudry and Tom Reed. All had their influences on John, his sister, and cousins.

Although he was not formally taught *Ojibwemowin*, Little Bird remembers hearing it commonly spoken around New Post. The fishing guides were all Indian, including Frank

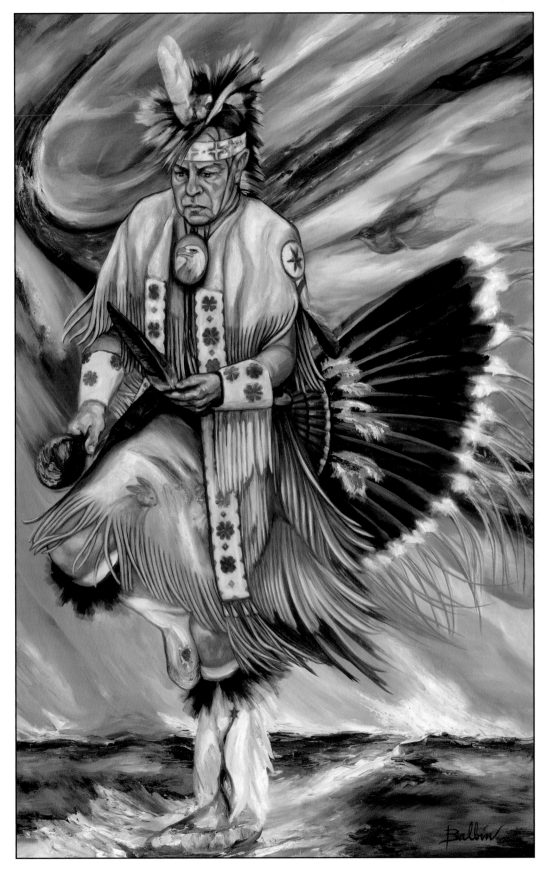

Dr. John "Little Bird" Anderson, oil on canvas, 30x48 inches, 2001, Lac Courte Oreilles Reservation

Denasha, Antoine Denasha, Jackie Hollen, Archie LaRush, George Thayer, Gordon Tainter, Ed DeMarr, and Charlie Wolf.

Nearly equal in influence to his foster parents over young John was the New Post parish priest, Father Paulinus. While presiding over the local St. Ignatius Church, Paulinus was one to set an example by the way he lived his life.

An unusually harsh winter had combined with the dismal economic state of the reservation to produce a food shortage in 1949–1950, so Father Paulinus took matters into his own hands. He went to Minneapolis and St. Paul and approached churches and civic groups for donations of food and clothing. John remembers vividly the astonishment he felt when just a couple of weeks later, large truckloads of sorely needed supplies began to roll into New Post. In response to Father Paulinus's request, so much food and clothing was donated that in the end they had to turn trucks away, directing them to others in need.

A social activist, Paulinus helped organize the villagers when federal money was made available to build an elementary school in New Post. Officials of the nearby Town of Hunter attempted to have the school built off the reservation. The priest knew that real power was to be had at the voting booth. He encouraged New Post residents to use the ballot to vote in a new town chairman, one more responsive to their needs. They were successful, gaining not only the much-needed school but also, for the first time, a paved road to the village.

When Father Paulinus was transferred from his New Post parish to Indianapolis, John wondered if the priest had been moved because of the courageous things he had done for his beloved Ojibwe friends.

John graduated from Hayward High School in 1953. After casting about for some direction, in 1954 he decided to move to Indianapolis. He saw it as an opportunity to expand his horizons. After locating and making arrangements to temporarily stay with his birth mother, who also lived in Indianapolis, John set forth with the help of Father Paulinus to make his mark on the world.

The priest was in the parish of St. Roch. Continuing in his pragmatically activist manner, he found a job for young John at the Merchant's Bank & Trust Company. Paulinus also arranged for members of his parish to give John business attire to wear to work. Although he entered his employment as a worker in the bookkeeping department, John was soon promoted to the position of teller.

Strangely enough, it was while he was in Indianapolis that John first began to take part in Indian drumming, singing, and dancing. Once again it was Father Paulinus who made a connection that helped the young man find direction. The priest knew of a local group of Boy Scouts which studied and practiced traditional Indian activities. John joined the group and

found to his delight that these non-Indian youths were dedicated to accuracy.

John heard a radio advertisement stating that a Chief Brown Eagle would be part of the entertainment at the state fair. John had a hunch about who Brown Eagle might actually be and, sure enough, it turned out to be Sam Frogg from Lac Courte Oreilles. An imposing figure in his white buckskin outfit and feathered headdress, Frogg had a distinguished career as a lecturer and entertainer. At last, John had an Indian acquaintance in Indianapolis. At John's request, Sam attended some of the Boy Scout meetings with him, sharing his knowledge of Indian culture. This was the beginning of John's lifelong pursuit of the Ojibwe culture and of his program of sharing his culture with *chi mookomaan* society.

America was fighting the Korean War at this time, and John was subject to the draft. On a trip back to New Post, he met Saxon St. Germaine, who urged him to go to college. She informed him of the Indian Scholarship Grant Program available in Wisconsin and arranged for him to be interviewed by its director, Alan Kingston. John decided to attend Superior State College.

John understood that if he attended college and enrolled in the Reserve Officers Training Corps (ROTC), he could enter the military as an officer. He worked diligently to attain an associate degree and a Rural and State Graded Elementary Education Certificate. He was involved in several student activities and distinguished himself as a wrestler, member of the student union board, vice president of the freshman class, and member of the Iota Delta Chi fraternity.

After attaining his degree John learned, however, that he had been mistaken. To be accepted as an officer in the military, he would have to complete four years of college and ROTC. When he learned there was a five-year period of service required after his graduation, he decided to go directly into teaching, taking advantage of the draft deferment available for teachers.

In 1962 he completed his bachelor's degree and went to Wausau, Wisconsin, where he taught for three and one-half years. In 1966 he returned to college in Superior, where he earned his master's degree in educational administration. Following that, he moved to Stoughton, Wisconsin, to take his first job as an elementary school principal, a post he held for three years. Once again he returned to the university in Superior, this time for specialized training in program coordination, which led him to a job at the University of North Dakota, where he administered the Future Indian Teachers Program.

From there, he accepted a position at the College of St. Scholastica in Duluth, Minnesota, where he founded the Native American Studies Program. He obtained a Bush Foundation Grant which allowed him to teach at the Red Cliff, St. Croix, Bad River, and Lac Courte Oreilles reservations. Next he was invited to work full time at the Lac Courte Oreilles Ojibwe School. First he worked as a physical education instructor, then as a guidance counselor, then

as the public information officer, and finally as director of education.

Having successfully established its own school serving all grades from kindergarten through twelfth grade, the Lac Courte Oreilles Band had educational momentum but was unsure what to do with it.

After much consideration, John decided that it was time for Lac Courte Oreilles to have its own college, as did many western tribes he visited. With the cooperation of the Tribal Governing Board, the Lac Courte Oreilles Ojibwa Community College was formed, with John Anderson as its founder and first president (1982–1987).

Following the landmark 1983 Voight Decision, which affirmed the rights of the Ojibwe to hunt and fish in ceded territories, John facilitated the creation of the Ad Hoc Commission on Racism, a joint effort of the Lac Courte Oreilles Band and the Hayward Lakes Resort Association. The brainchild of John and resort owners Moose Speros and Ken Toebe, the commission was an attempt to counteract anti-treaty rights protesters, who angrily opposed the seasonal harvest of fish by traditional American Indian methods.

The commission's cooperative strategy worked. Resort owners agreed to put brochures featuring the tribe's bingo parlor and commercial center in their motel rooms, lobbies, and restaurants. In turn, the tribe held drawings during peak business hours, giving away gift certificates good for free weekends at various resorts. The favorable publicity generated by this mutual aid was enough to convince tourists that they could still enjoy a tranquil vacation in Sawyer County, unlike the tense atmosphere prevalent in other areas of the state, where boat landing protests were common.

John then accepted a position at Mt. Senario College in Ladysmith, Wisconsin, where he headed the Native American Studies Program. Mt. Senario later conferred a Doctor of Law degree on John.

John Anderson and Ginger Wilcox, his life partner since April of 1987, travel the country sharing the beauty, heritage, and wisdom of the *Anishinaabe* people by making American Indian cultural presentations. They conduct naming ceremonies, weddings, veteran's honoring, funerals, *Anishinaabekwe* (woman) honoring ceremonies, healing ceremonies for post traumatic stress disorder, restoring the mourner, and tree planting ceremonies.

"God is everywhere," John explained, "and like my mentor James 'Pipe' Mustache Sr., I believe that Ojibwe spiritual and cultural activities can be shared in a meaningful way, and in a variety of locations—churches, community centers, homes, or any natural setting." As an *oshkaabewis* to Pipe, he continued, "All of creation is our relation. This echoes the Ojibwe spiritual belief."

John was a professor emeritus at Mt. Senario College, which closed in 2002. He continues

to take part in athletic activities, including spiritual walks and runs. He is the father of two sons—Peter, a teacher, and Bill, a songwriter and musician.

Anderson's participation in a recovery program has been an important part of his life since 1988.

JUDGE EDWARD "ED" BARBER

CIRCA APRIL 19, 1917 - APRIL 12, 2002

The Honorable Edward Barber served as tribal judge at Lac Courte Oreilles for more than twenty-five years. The portrait of this soft spoken, articulate man hangs in the Lac Courte Oreilles Ojibwa Community College meeting room.

Edward, known usually as Ed, was born to Thomas Edward Barber and Charlotte Nigoue Barber on April 19, 1917 in a *wiigiwaam* at the *iskigamizigan* on a hill near the village of Reserve. He had six siblings: John, Bill, Frank, Louis, Agnes, and half sister Josephine Carroll.

In those days, the Ojibwe people carried all their belongings and tools to the *iskigamizigan*, where they would gather and process the *wiishkobaaboo*. The family often spent several weeks in preparation prior to doing the actual work of the harvest. "They had to walk in with every-thing they needed," Ed recalled. "Food and other staple goods were packed in, and our family stayed at the camp for at least two months. There were cots inside the *wiigiwaam* and a fire in the middle where pots were hung." Due to the length of the *zhiiwaagamizigan* season, the birth of a child during encampment was not uncommon. "My parents made maple sugar with old Jack Butler and Kwewidog," Ed remembered. "They lived by the springs near the present commercial center."

Ed was a member of the *Awaazisii Doodem*, reflected in his portrait by a water scene. The buffalo images in his portrait signify an important dream he had in his youth. Tom Baker, his *Niiyawen'enh*, bestowed upon him the names Wenaboozhoo and Medweyaash.

Ed spent his first three years in the Barbertown area; his father died of complications of influenza during the devastating pandemic of 1918. "After the onslaught of the influenza," Ed said, "my mother hid me from the people. She was immune and didn't get the flu."

Later, his mother, Nigoue, met and married Paul Carrol (Bineshiinh) and they moved the family to the village of Round Lake. The couple had a daughter, Josephine. Ed's mother and

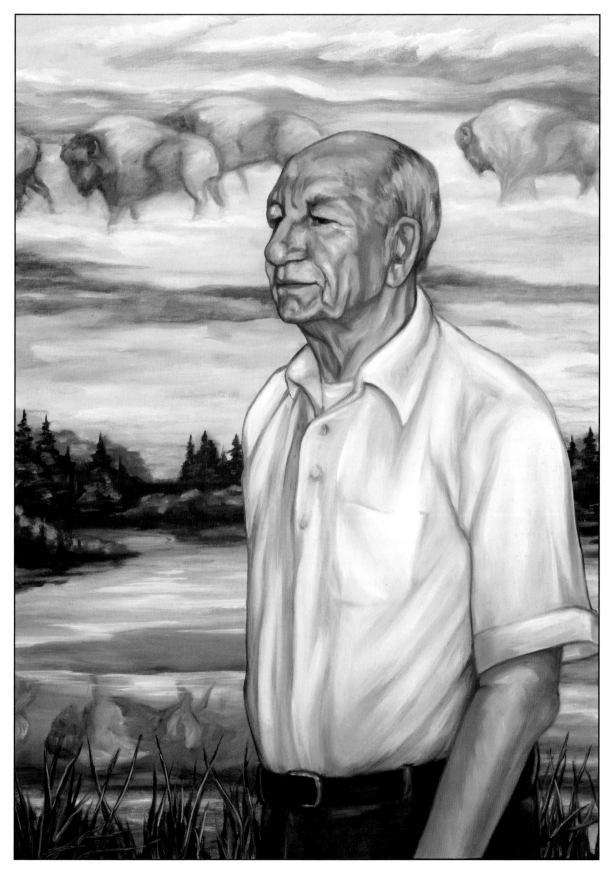

Judge Edward "Ed" Barber, oil on canvas, 21x30 inches, 1997, Lac Courte Oreilles Reservation

stepfather adopted and cared for many children throughout the years, including Buck Barber, Rose Barber, and Robert, Clara, and Louie Belille. Vernon Elk, who was also cared for by the Carroll family, was later erroneously listed on a tribal census as Vernon Carroll.

Nigoue did beadwork, handcrafted moccasins, tanned hides, and was an avid housekeeper. "My mother had a great knowledge of medicinal plants," Ed recalled.

Paul and Nigoue were dancers, and both belonged to the *Midewiwin* medicine dance society. Ed was initiated into the *Midewiwin* as a young child and was given a muskrat hide to show his status as a member.

Gathering of *manoomin* played a significant role in Ed's upbringing. "Paul and my mother always harvested wild rice every fall. I was just a child, so I played around and ate chokecherries. I still harvest the rice, and I have had some good years. I riced with my brother Louie until he couldn't rice anymore," he recalled.

Ed began his elementary education at the old Kinnamon School in the Four Corners area of the reservation, at the intersection of County Roads E and K. Some of the students who attended school with him at the time included his sister Agnes Barber, Mary and Jim Frogg, and Charlie Kagigebi. His teacher was kind, he remembered, and not one to punish the children for speaking *Ojibwemowin*. This tolerance may have been due to the fact that there were Germans among the staff who also spoke their native language. Both groups used English as their common tongue.

"We had to carry lunches of biscuits and fried potatoes," Ed remembered of his years at Kinnamon School. "If we were lucky, we had bacon." Beginning in the fifth grade, the practice of providing Kinnamon students with a daily nutritional treat—a water pail full of milk dispensed with a dipper—became the forerunner of providing full lunches for the elementary students there.

Perhaps the highlight of Ed's years at the Kinnamon School was the time when, in a sixth grade spelling competition, he became the victor for the entire Sawyer County area, winning a trip to Milwaukee.

After graduating from Kinnamon School, Ed was asked to attend the Indian Training School in Hayward, with the superintendent of schools offering him free boarding. The young man thought this was a good deal, a chance to gain what was at the time a higher education. "So I went to the Hayward Indian Training School. I came home on weekends, and my parents would often come and visit. My roommate at the time was Vernon Elk. The school curriculum included agriculture, science, and history. They wanted to make a farmer out of me. Then they did away with the Indian school that same year. I had no place to go, so I worked on various government programs. I was about fourteen at the time," Ed said.

He lost his government job when his employers learned how young he was. When he was seventeen years old, the Civilian Conservation Corps (CCC) hired him, placing him in Camp Irving, near Black River Falls, Wisconsin. Supervised by the U.S. Army, the CCC men were put to work mainly to stem soil erosion, which was the result of deforestation. Fortune smiled on Ed Barber when he was assigned to be the camp commanding officer's personal driver, a much-coveted post. Two months passed, and he was asked to take a classification test for promotion, following which he was informed that he should go back to school.

With the help of his commanding officer, he was accepted at the Haskell Indian School in Lawrence, Kansas, where he entered an occupational assessment program. After a year of exposure to various subjects, he expressed an interest in the field of electricity. However, there was already a long list of Indian men waiting to pursue the same career. Unable to pursue this interest, he returned to Hayward, enrolled in the local high school, and graduated in 1938.

With encouragement from both school and home, Ed enrolled at the Wisconsin State Teachers College in Superior. He found employment at the local YMCA and in a restaurant. Then he and some of his friends from college decided to form a housing cooperative; they sought and received assistance from the National Youth Administration. They were able to rent an empty CCC barracks and live there under the watchful eye of a camp commander and a housemother.

During this time Ed worked a part-time job as a model for an art teacher at the college. The money he earned provided clothing and other essentials. Later, Ed met a doctor who maintained his practice out of his home. In exchange for transporting patients, Ed lived in the doctor's home for two years. In his fourth year of college, Ed was assigned to a work-study program in the art department. Once again a part-time job, this time giving driving lessons, offered much needed financial support. He spent a semester practice-teaching classes in high school social studies, biology, and mathematics. On June 12, 1942, Ed graduated from Superior State Teacher's College. He recalled pensively, "There were no big crowds there to see me graduate."

Three days later, Ed received a notice from the draft board and reported to the reception center in Milwaukee. He took physical exams and was given two weeks to go home and take care of business. Ed recalled that honoring dances and celebrations were held for the young men who were leaving Lac Courte Oreilles for the military.

He reported to Ft. Sheridan, Illinois. "One morning," he remembered, "we were told that one hundred of us were going to Camp Robinson, Arkansas, as medics. We received basic training there. I was assigned to Army Administration as company clerk. Soon, they pulled us out of there because they said we needed more basic training. We began eight weeks of train-

ing for combat infantry. We were split into replacement GIs. There were many divisions. They loaded us onto trucks, and we were sent to a train depot. We had orders to report to Santa Barbara, California, and then to the South Pacific."

However, when Ed's train stopped in Kansas City, the Military Police (MPs) awaited his contingent. The MPs informed them they were on the wrong train and that they were actually supposed to be headed to New Orleans. Within three days, Ed found himself quite a bit east of New Orleans, reporting for duty at Camp Blandine, Florida, where he spent eight weeks being tested and trained. His administrative abilities were again recognized, and he was assigned to the registrar's office at the base's large hospital, where he kept track of the status of his fellow soldiers—the able bodied, the sick, and the dead.

Still the shuffle wasn't over. One more stateside assignment remained before the young go-getter from Lac Courte Oreilles would set foot on foreign soil. Ed was shipped to Camp Patrick Henry, Virginia, where he spent two months before finally marching up the gangplank of a naval vessel bound for the European theater of war. According to Ed, "We boarded a big ship, the Empress of Japan, and crossed the Atlantic Ocean in two weeks on high seas. We went through the Straits of Gibraltar to Morocco, in North Africa. I witnessed the city of Casablanca shining in the morning sun." And, while the morning sun shone, Barber and his fellow soldiers climbed out on the ship's nets, invading the country as tanks battled nearby. He continued:

> We fought our way into Bizerta, North Africa, and on to Tunis. We stayed there for two months and then got on the boats for Sicily, and on to Silverno, Italy. We went through Naples to Montecasino. From there it was on to Rome, which was a free city. We crossed the Po River Valley by boats, to Florence, Bologna. I saw the city of Pisa and the leaning tower. . . the fancy cathedrals of Florence. We fought with rocks in small towns. There was a beautiful lake called Lago di Garda. It was peaceful there until the enemy started shelling us. We went north for two weeks to Riva Ridge. There were lots of Germans there. We moved them out. Then on to Merano and Bolzano, which were both modern cities; then they continued on to a tunnel which led to Austria and Switzerland. I put one foot in Switzerland. We spent time in Innsbruck, Austria, where there were nice ski resorts. We did lots of skiing and met some Germans and Austrians. We moved again to Yugoslavia, and spent some time guarding an entrance to Italy. Then the war ended.

Actually, the war had only ended in Europe; the war in the Pacific raged on. The reverse shuffle began, with soldiers being shipped back to the United States but not released from active duty. Ed's unit went back to the United States via Naples, Italy. After thirty-nine months in the army Ed returned to Camp Patrick Henry. Christmas came and went, but the men remained in uniform and on base. "Every Christmas," Ed said, "we thought we were

going home. On a train to Chicago, we learned that they had dropped the atomic bomb on Hiroshima, Japan. The war was over." His company then spent time in Camp Grant, Illinois, tantalizingly close to home for Ed. But he had one last army post remaining—Camp Carson at Colorado Springs. After serving there, he was given a forty-five day furlough and finally released from active duty.

He was a civilian once again.

"I went back to Chicago and worked for the Bureau of Indian Affairs. There I met Alberta, and we were married. We stayed there a year, and in the springtime we went to live in Lac du Flambeau, Wisconsin, for a while," he recalled.

Ed applied for a number of jobs and found one in Grand Portage, Minnesota, as a principal and teacher at a salary of two hundred dollars a month. He worked there until the spring, when he gave up the job and returned to Lac Courte Oreilles, only to receive a letter inviting him to take a position as an elementary school principal in Red Lake, Minnesota. In addition, he taught high school English and mathematics, earning not only a salary but a residence in the basement of the high school.

The following spring he accepted a job as a teacher at the Pierre Indian School in South Dakota at a slightly lower salary. In 1952 and 1953 Ed and Alberta were blessed with two daughters, Valerie and Roseanne. In keeping with his quest to move on and up in life, Ed then transferred to Thunder Butte, South Dakota, where he combined the duties of principal, teacher, and government agent to work with twenty-three families.

In 1965 Ed received a telegram instructing him to report to a newly organized Job Corps Center in Clam Lake, Wisconsin, not far from Lac Courte Oreilles. He was told to quickly leave everything and report there within two days. "There was nothing there except piles of books, which I found in sheds. Our friends took care of our house and packed our things and sent them in a semi-trailer. I made a shed for my daughters, Roseanne and Val, so they had a place to keep their things. I commuted for a year between Lac Courte Oreilles and Clam Lake. My position there was head of the reading department and driver education instructor. In 1969 the camp was closed."

From Clam Lake Ed went to Blackwell, Wisconsin, where he again taught reading and driver education. He also attended reading workshops at Stanford University and Middle River State Teachers College in Missouri. Ed replied to a notice seeking a public health educator in Rhinelander, Wisconsin, and was hired immediately. By this time his daughters were in high school and college, a good thing since the new position required that he travel extensively throughout Minnesota, Michigan, and Wisconsin. Late Friday evening arrivals at home were a matter of course.

"From 1968 to 1971, I worked on a degree from the Parent Education Program at the University of Wisconsin–River Falls. I then worked as a student director to assist fifty students from Lac Courte Oreilles, Red Cliff, and Lac du Flambeau who were failing classes and might not graduate. At that time I was also serving on an advisory board at Mount Senario College in Ladysmith, Wisconsin."

By 1972 Ed had thirty years in government service. He gladly accepted early retirement. "Alberta got a job teaching *Ojibwemowin* at Lake School. I relaxed for about a month. Then I got a job as home school coordinator for the Hayward schools. I worked there for two years, until 1975. Then the Lac Courte Oreilles Tribe had a need for a court judge. They had no money to pay me, so I worked as an enrollment clerk for a while," recalled Ed.

Then Ed became the full-time court judge at Lac Courte Oreilles, receiving training in Denver, Colorado; Albuquerque, New Mexico; Seattle, Washington; and both Madison and Wausau, Wisconsin. From that point on he was known as the Honorable Edward Barber.

Ed served on the Board of Regents for the Lac Courte Oreilles Ojibwa Community College. Toward the end of his life, he focused his energy on his tribe's Constitutional Revision Committee. His final honor was a Doctor of Letters degree, bestowed upon him by the University of Wisconsin–Superior. Judge Barber also continued to hear cases in Tribal Court even after he officially retired.

His home was open to community members, who frequently contacted him in person or over the phone. Many people found wisdom when chatting with "the Judge."

LOUIS THOMAS BARBER

CIRCA JUNE 15, 1902 - OCTOBER 3, 1995

At the north end of Big Court Oreilles Lake, at the old Barbertown, Louis Thomas Barber, whose Ojibwe name was Waasegiizhig, entered the world around 1902, framed by a *wiigiwaam*. His parents were Thomas Edward Barber and Charlotte Nigoue Barber, who also reared his siblings John, Bill, Frank, Edward, Agnes, and half sister Josephine Carroll.

Young Louie Barber attended the Hayward Indian Training School through the sixth grade, after which he spent two years at the Bureau of Indian Affairs (BIA) high school in Tomah, Wisconsin. He had an excellent grasp of mathematics, excelling at trigonometry. His talent for tangents paved the way for his adult career as a forester and surveyor. He was foreman of the successful BIA Blister Rust Eradication Program for many years.

Louie, a member of the *Awaazisii Doodem*, was a keeper of traditional ways and was fluent in *Ojibwemowin*. One of his traditional talents was knowledge of the ways in which to attract and catch fish with herbs. He led his family in the harvesting of wild rice and cranberries, often reminding his children and others, "You take only what you need."

As a young man, Louie was frequently tested for bravery. One time his uncle discovered a beehive, and then told a group of boys that in order to show their bravery and strength, they should go and attack the bees. Louie was the only one of the boys who did so.

Another time of testing came when one of the boys caught a turtle. Their uncle cleaned it, cut it up, and instructed the boys to eat the raw heart. While the other boys were nauseated by the prospect, the valiant Louie took a piece, chewed on it, and swallowed it. Louie then learned the traditional teaching that eating raw turtle heart would keep him from being afraid of storms.

Louie's son gaiashkibos relayed the following story of how his father was tested for bravery and in his *Midewiwin* belief. "My dad was a young man working in the Eddie Creek area,

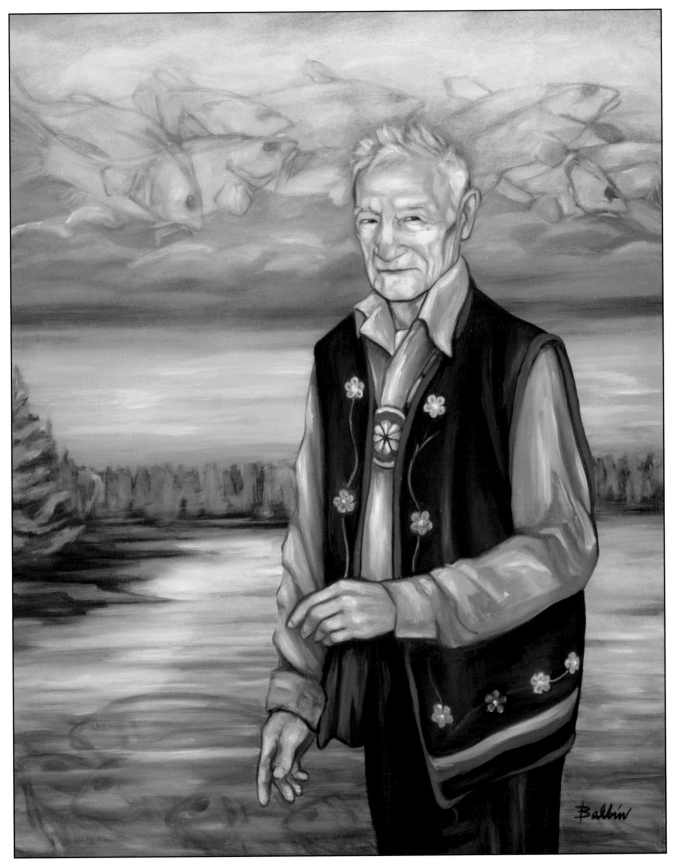

Louis Thomas Barber, oil on canvas, 30x38 inches, 1996, Lac Courte Oreilles Reservation

blowing up stumps with dynamite to clear the land for farming. This old man was watching him drop the sticks of dynamite and run from the blast. The old man asked him 'why are you running? You don't have to run; you are going to be around a long time. I had a dream of you and your hair is snow white.' Then the old man had him light a stick of dynamite in a stump and stand by the stump with him. The stump blew up and both were untouched by the blast."

There were other ways of testing, ways not quite so Indian. Louie played football with some of his friends in high school in Hayward. During one particularly tough game, Louie's team was close to the goal line. In the pre-play huddle, the team came up with an idea of how to score. The winning touchdown was made when Louie, the smallest team member, was tossed with football in hand over the opposing team and past the goal line by a teammate.

Louie recalled one trip up the Chippewa River with his father, a time when they ended up far north of the river's east fork. It was a journey by canoe to see if wild rice was ready for harvest at Fish Trap Lake. They made the return trip through the Lac Courte Oreilles village of New Post. Travel by canoe was a common mode of transportation when Louie was young. He made his first trip to Hayward when he was six, traveling with family members across Grindstone Lake. Travel by canoe, however, also meant portaging (carrying a canoe) across strips of land between bodies of water. This day they portaged from Grindstone Lake to Spring Lake, returned again to Grindstone Lake, then went across the west side of the lake to portage once more, this time to Windigo Lake. Near this spot on Windigo Lake there is now a historical marker located on State Highway 27, south of Hayward. The spot is known as "Portage Terrace."

Later, Louie and his family would make the trip to Hayward on land, following an old wagon path along Spring Lake that has evolved into County Highway E. Louie recalled how the Ojibwe would pause on their trip to Hayward, stopping at Spring Creek, where they would wash off the dust, change clothes, drink some tea, and be on their way.

When Louie was a boy of about twelve he participated in his first *Midewiwin* ceremony and was initiated into the lodge. At this time he experienced a vision, a dream that gave him certain healing abilities, though he chose not to use those gifts. Louie participated in the ceremonies when he could and was also a member of the Big Drum. He eventually became a fourth-degree member of the *Midewiwin*. Later recalling his first medicine dance, Louie said that it was then that he was shown his guardian spirit. It would be with him the rest of his life.

Louie married twice. His first wife was Julia Benton. They had four children together, Rose, Eleanor, Louis Jr. (Dick), and Wayne. Julia died shortly after giving birth to a fifth child, who did not survive.

In 1941 Louie married Elizabeth James. She was born December 30, 1921, in Post, the daughter of Alex and Annie Bluesky James, a member of the *Maang Doodem* and a descendent

of Chief Bluesky, who signed the 1854 treaty. Elizabeth was a member of St. Ignatius Catholic Church and had a sister, Lillian James, a niece, Elizabeth Abby, a brother, Simon, and a half brother, Bill Mustache.

Louie and Elizabeth had seven children: four boys—Louis (Giinggway, who has walked on), Robert, Allan (gaiashkibos, or gosh), and Darryl, and three daughters—Julie, Denise (Hootie), and Mary Lou (who died in infancy).

Julie remembers family outings to Two Boy Lake, when they always carried a frying pan, to cook the fish they would catch, and potatoes. One time, Julie lost their last hook while fishing, so Louie improvised with a safety pin and soon Julie hooked one. She was able to get it out of the water, but with no barb, it quickly slipped away. Louie said it was the biggest bass he had ever seen.

In addition to working at the New Post School, Elizabeth also worked with the Green Thumb Program and was a foster grandmother at LCO Head Start.

Toward the end of her life, Elizabeth had been working on a family quilt. With the help of artist and art therapist Sara Balbin, she took individual quilt squares and framed them as gifts for her family as a way to share her talent and memories.

Louie was a fiercely loyal and loving parent. One time when his son gaiashkibos was ill with whooping cough, Louie carried him all the way to the hospital in Hayward. The doctor at the hospital said there was nothing that could be done for him and that he would die. Not willing to just give up, Louie carried his son back home, where his mother, Nigoue, applied traditional medicines to her grandson. She told Louie that if the boy lived through the night, he would survive. Gaiashkibos did indeed live through the night, growing up to be a chairman of the Lac Courte Oreilles Tribal Governing Board.

The children remember Elizabeth as the family disciplinarian, while Louie taught the family about tradition, ceremonies, and awareness of the natural world, instilling in them the value of a strong work ethic. The lessons included cutting firewood with a double-bladed ax and a bow saw. After cutting wood by hand he would pack it out of the woods on his shoulder. He said he always wanted to stay one step ahead of "Old Man Winter." That ethic is seen in his children today: Julie is director of the Lac Courte Oreilles High School library; Hootie (Denise) works at the Lac Courte Oreilles Clinic; gaiashkibos, a member of the Lac Courte Oreilles Tribal Governing Board, is past tribal Chairman, and has been President of the National Congress of American Indians for two terms; Darryl works at Lac Courte Oreilles Development; and Bobby Gene is known as the official greeter in New Post.

As befitted his Indian name, Waasegiizhig, or New Day, the sky turned a vivid shade of yellow at the moment of his passing over to the spirit world.

LUCILLE "LUCY" MUSTACHE BEGAY

CIRCA MAY 26, 1907 - NOVEMBER 1, 2001

Lucy Begay has walked on, but in the Lac Courte Oreilles community and in the spirit world she is still known as Mizhakwad. She belonged to the *Name Doodem*, with her roots in the Round Lake area near the traditional burial ground, known today as Round Lake Cemetery. She was born to John and Josie (Carroll) Mustache, circa 1907, in a wigwam near the corner of that cemetery, which belonged to her grandfather, Maanameg Carroll. When she was just a year old her father, John Mustache, relocated his family to the Chief Lake area to help care for his aunt Zaagaate, who eventually handed down ownership of this land to her nephew John and his descendents.

Chief Lake, also known as *Akwawewining*, the place where they fish through a hole in the ice, is where Lucy spent her early years. She grew up eating fish, wild rice, deer meat, rabbit, and other traditional foods that helped her live for ninety-four years, a feat not too often achieved even now. The family consisted of her father and mother, plus sisters Elizabeth, Esther, and Nellie, and two brothers, Edward and Sam, who walked on while infants. Some of her close relatives include her sister's families and their descendents, such as the Mary and Sam Frogg families and Pipe Mustache's family.

True to their Ojibwe traditions, the family practiced the ways of harvesting wild rice, hunting, picking berries, maple sugaring, conducting feasts, and *Midewiwin* ceremonies. Although very poor in terms of European standards, Lucy's parents had high values and were kind and generous people. They would give you their own clothes off their backs to provide comfort, as witnessed by Bernice, Lucy's eldest daughter-in-law.

In her early years Lucy attended the Hayward Indian Training School, where she was boarded through the sixth grade. She then attended the Round Lake School in the seventh and eighth grades. Although many of her generation remember being punished for speaking

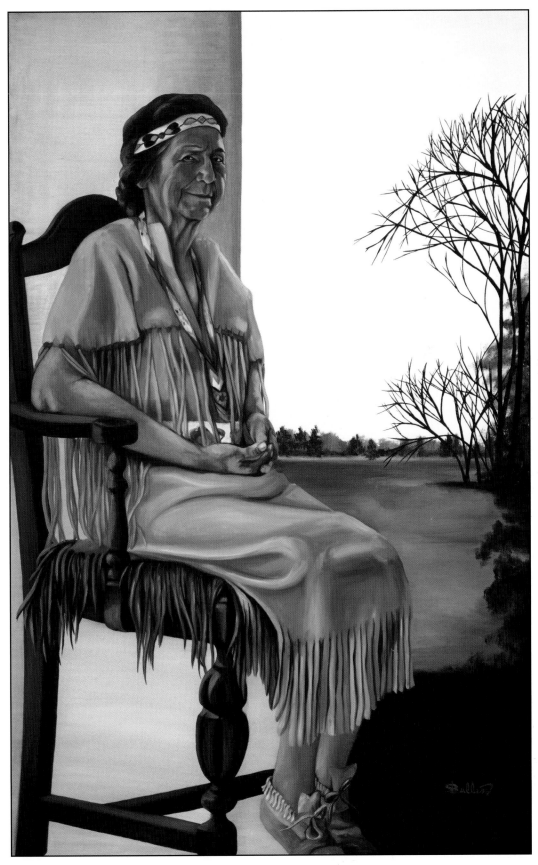

Lucille "Lucy" Mustache Begay, oil on canvas, 31x49 inches, 1980, La Courte Oreilles Reservation

Ojibwemowin, Lucy had no recollection of being punished for speaking the language. Like all of the rest, however, she quickly became adept at speaking English.

Lucy later expressed surprise that some Indian children of her generation were not able to retain the language of their ancestors. She said, "I never forgot my language. It stayed with me."

As a young woman Lucy went on to work as a housekeeper at area resorts. Then, at age nineteen she moved to Chicago where she met and married Bahe "Babe" Begay from Chinle, Arizona. They had two sons, Eugene and Duane, who became the center of Lucy's life. She educated them in both the Ojibwe and Euro-American cultures.

While living as urban Indians, Lucy and Babe became two of the founders of, and he was on the Board of Directors of, the Chicago Indian Center. The Center was also a place where Lucy and their sons could network and share experiences with other Indian families.

With their home base in Chicago, Lucy worked full time for decades as a professional industrial seamstress. When on vacations and holiday breaks from their employment, the Begay family traveled to powwows selling Southwestern Indian jewelry from Babe's Navajo community for extra income. The powwow gatherings offered their sons an opportunity to participate in championship dances dressed with the Ojibwe regalia that Lucy hand made. These experiences, combined with Lucy's *Midewiwin* belief, values, and discipline, provided the foundation for her son's future success in school. According to Eugene, they attended Lane Technical High School in Chicago, presently known as Lane Tech College Prep High School. This school is the largest high school in Illinois, and has had a superior learning tradition since it opened in 1908. When Eugene and Duane attended, it was a young men's school, but converted to a co-educational curriculum in 1971.

After high school, both Eugene and Duane continued their higher education. Eugene studied at the Illinois Institute of Technology, receiving a degree in mechanical engineering. His degree opened the way for him to become director of the American Indian Center in Chicago. Eugene established sobriety programs, detoxification centers, and half-way houses for North American Indians. He was also the director of the United South Eastern Tribes, stationed in Nashville, Tennessee. After moving back to his mother's homeland on Chief Lake, he developed the Web site Eagle Associates.com to provide consulting services to Indian people in business and government.

Eugene followed his mother's *Midewiwin* beliefs and became a fifth degree *oshkabewis*. He walked on at age seventy-two from complications of diabetes. His wife Bernice and their eight children honored his walking on with *Midewiwin* burial traveling ceremonies.

Duane became a non-denominational minister for the Moody Bible Institute in Chicago. He also practiced silver jewelry making, following his father's Navajo heritage. After acquir-

ing his teaching degree in grades K-12, Duane taught at the Lac Courte Oreilles School along with his wife Loretta, originally from the Fond Du Lac Reservation. Eventually, he relocated to Cass Lake Minnesota, where he became the superintendent of the Bugonegeshick Tribal School on the Leech Lake Reservation and helped to build the campus. His wife was an early-childhood teacher. Tragically, he, his wife, two children, and one grandchild died prematurely in a car accident. They are survived by their two youngest daughters.

According to Eugene's daughter Lynnell, "Both brothers were down-to-earth, yet extremely intelligent and complex." She continued, "Their accomplishments in the field of education, administration, and self employment are a reflection of Lucy's commitment to education."

Lucy and Babe eventually moved back to Lucy's ancestral homeland at Chief Lake with the help of her eldest son, Eugene. Upon returning to the Lac Courte Oreilles Reservation she became well known for her knowledge of *Ojibwemowin* and accomplishments in designing and making hand-sewn quilts and beadwork. She loved to teach, and shared her sewing, beadwork, and language skills with her children, grandchildren, and anyone who wanted to learn.

In memories of her youth, Lucy recalled a very different life for the people of Lac Courte Oreilles. Back then, a hereditary Wolf Chief was still a part of the traditional governing body of the Lac Courte Oreilles Tribe. She also remembered that *manoomin* was very abundant at harvesting time, and that the common practice then was to tie the wild rice into bundles prior to harvest. These bundles were tied in ways peculiar to each family and announced the ownership of that rice as assigned to the family by a rice chief. Powwows were also different then, with men and women always dancing separately. Each man had his own dance style.

Lucy's family members have said that she was typical of *Anishinaabe* mothers, showing undying love, care, and sincerity for the whole family. Lucy spent her elder years cooking, sewing, and reminiscing with old friends about times spent growing up together. She kept to the old Ojibwe customs, favoring traditional foods such as wild rice, berries, fish, and venison. Since she never learned to drive, her son Eugene often took her to feasts and ceremonies.

Being a traditional Ojibwe woman was a hard but rewarding path for Lucy. As a girl, she was reared to be obedient, her mother applying strict rules to Lucy's activities. A significant memory that she carried throughout her life was that of washing the body of an elderly woman who had walked on to the spirit world. During Lucy's youth the deceased were prepared for burial in a traditional, natural way and laid to rest in communal reservation cemeteries, many of which are still in use today. Because Lucy had such an upbringing, her values were straight and true. She followed the *Midewiwin* faith, and never drank alcohol or smoked cigarettes.

After Lucy retired (Babe was already retired), she and Babe spent many months with the families of Eugene and Duane. While living with Eugene's family in Sarasota, Florida,

Babe got sick, and as requested, the family flew him to Chinle, Arizona in 1975, where he was laid to rest in his homeland. Lucy proceeded to live at the Village of Chief Lake, where she spent her last years at her family's original homestead until she walked into the spirit world. With her son's children, Lucy's family grew to include twelve grandchildren and twenty-five great-grandchildren.

Lucy never gave up her desire to help others when they asked for assistance with Ojibwe language lessons or for her to sew something for them. She successfully perpetuated the old Ojibwe ways of living, teaching, and the *Midewiwin* belief. Cathy Begay stated, "My grandmother was an extremely spiritual person because that is the way she was raised. She was always praying."

A friend said of her, "Lucy is one of the cheeriest people that I know. She always has a sparkle in her eye and a merry laugh. She is truly a sweetheart. When Joe Shabaiash would come into Big Drum ceremonies, he always went over to Lucy, whose Ojibwe name means clear sky, and said 'Well, it's going to be a good day today.' She'd laugh like it was the first time she'd ever heard that, and then they would begin the ceremonies."

JAMES "JIM" BILLYBOY SR.

CIRCA JULY 20, 1912 - MAY 4, 1999

James Aanakwad Billyboy Sr. was a member of the *Awaazisii Doodem*. He was born deep in the woods in the Signor area, the son of William and Ann (Clendenen) Billyboy. James grew up in the immediate area of the Billyboy Dam, which is named for his grandfather, Dagiose, who was also known as Billyboy. He was one of five children, the others being Sadie, John, Elizabeth, and Mary. Other than the facts gathered from the Lac Courte Oreilles enrollment office, all other information in this biography was offered by James's sister, Elizabeth (Billyboy) Butler, and her son, Tony Butler Jr.

James spent most of his life in the area of his birth, and ventured frequently to the Whitefish community, about a two-hour walk from Signor, for *Midewiwin* ceremonies. He was known for his knowledge of ceremonies and songs, with many *Anishinaabeg* coming to him for these teachings.

The Signor community was named for a non-Indian man who built a saw mill in the area that benefited from the flowage created by the dam built upon Billyboy allotment land. James worked at a saw mill that operated later in the area until he fractured a wrist while working.

In *The Visitor Writes Again*, historian Eldon M. Marple reviews the history of Signor:

> When specialized industries are established at a location and later cease operation, a village which has grown up around the site often is also abandoned. The village of Signor, once housing the workers of the Signor-Chrisler Company on the Couderay River just above the present Billy Boy Dam, suffered this fate—not a single house nor a foundation remains today.
>
> The Company was formed in August 1903, by J. C. Signor and J. S. Chrisler to cut an estimated 100 million feet of timber on the Reservation. They built a mill beside the new Soo Line railroad and opened a store for their men. They began logging in October of that year and by December 10 they

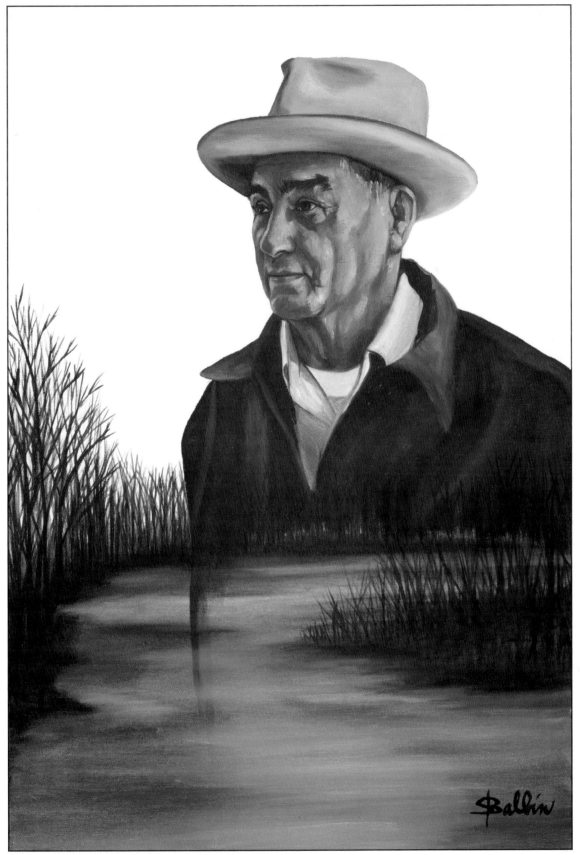

James "Jim" Billyboy Sr., oil on canvas, 17x25 inches, 1980, Lac Courte Oreilles Reservation

had 100 men working, mostly Indians. However, by 1909 they had ceased operations.

The village which grew up here lasted for many years, even after the logging was done. It was a station on the Soo Line and the store must have been kept until 1913 because a post office, established in 1906, was officially listed until then. The community is still called Signor by the older residents though there have been no homes at the site since before 1936 when the railroad was abandoned.

In the Signor community, according to his sister Elizabeth, "Those *Midewiwin* medicine dances were major events in their lives. In the old days there was no drinking at the dances, and no fighting. They were good dances for young and old, with everyone respecting each other."

"People like James lived simply. The seasonal activities of hunting, fishing, trapping, and gathering constituted the greater part of their lives. He used a long-barreled .30-.30 when he hunted," according to Tony.

James was a hard-working man, good at procuring life's necessities from the richness of nature. Like many Indian children, he attended a reservation school only as much as necessary until he was forced to attend the Hayward Indian Training School. As soon as he was able, he left the boarding school and returned to live in the Signor community.

He married Virgil Taylor from the St. Croix area. They lived in Signor; other families in the area included the Codys, Krafts, Coons, Guibords, Surettes, Mikes, and Dandys. Occasionally they ventured to other settlements up and down the Couderay River between Signor and the Bisonette settlement. They took their horses and wagons to the Spooner area to harvest wild rice, and on occasion to the Chief Lake and Totogatic Flowage areas for the same purpose.

"On those trips you stopped and spent the night wherever the darkness caught you," Elizabeth said. "A trip to Hayward could mean an overnight stop along the way."

The Billyboy family lived so far back in the woods that without an automobile, even a trip to old Highway 27 took several hours, and a walk to the Whitefish community for ceremonies consumed two to three hours. Do to the distance between communities and the means of transportation, separate Lac Courte Oreilles communities didn't mingle much with each other—people in New Post didn't have much connection with those in Reserve, and those in Signor were quite remote from the Round Lake community.

James is remembered for always being generous to his relations. Having no children of his own, he found joy in bringing what Christmas presents he could to nieces and nephews. Life was difficult, but he shared what he had. Tony Junior remembered there were years when, without his uncle's generosity, there would have been no Christmas presents at all.

James did sometimes travel away from Lac Courte Oreilles, working during World War II at a shipyard in Superior, a candy factory in Illinois, a local CCC camp in the 1950s, and later

at Tony Wise's Historyland. He was mobile enough, owning first a Model T Ford, and later the vastly superior Model A. That mobility allowed him to travel around Wisconsin harvesting various crops like beans, potatoes, and cherries. Like many other Lac Courte Oreilles people, he also found employment at the Shelton basket factory at Reserve until it was destroyed by fire.

Electricity didn't come to the Signor area until the early 1970s, and they had to work hard to get it, raising money by cooking and selling suppers at the nearby Signor Mission church. Telephone lines followed shortly thereafter, so they no longer had to travel to Stone Lake just to use the telephone. However, citizens band (CB) radios continue to be used as a means of communication, along with cell phones, for economic reasons.

James and Virgil lived away from Signor in their elder years. First in the Lac Courte Oreilles Whitefish community behind the church, later in Hayward, and finally in Hertel, which is a settlement on the St. Croix Ojibwe Band Reservation. Virgil was originally from the St. Croix Reservation, and after a long married life living with James's people at the Lac Courte Oreilles Reservation, she wanted to live out her life in the homeland of her own relatives. As a lasting union, they retired at the St. Croix Reservation.

TONY BERNARD BUTLER SR.

CIRCA NOVEMBER 10, 1917 – OCTOBER 14, 2003

Tony Butler Sr. was born in Signor, which he always referred to as Signor High Bridge Village, about November 10, 1917, to Tom Butler and Liz Bennett. He was of the *Ma'inngan Doodem*, and was given the name Opwaagan as an infant. His brothers and sisters were Elsie, Leonard, Agnes, Hazel, Roy, Raymond, and Lillian.

In the early 1920s, Tony attended the Hayward Indian Training School, where he met his future bride, Elizabeth Billyboy, sister of James Billyboy. They were married July 3, 1940, and made their home in the same Signor community where they were both born. Together they reared their children Mary Ann, Anthony, James, Dorothy, Donna, Sharon, Ruth, Gary, Larry, and Keith. James and Keith walked on at early ages.

Tony worked for a variety of employers in his lifetime. Around 1935, his first paid employment was with the Blister Rust Eradication Program. When northern Wisconsin was plagued with a disease deadly to the white pine, a species vital to the lumber industry, Tony was pleased to be a part of the huge labor force marshaled to halt the spread of the disease. The work involved cutting and burning diseased trees, and uprooting brushy members of the gooseberry family, a vector for the blister rust.

In 1936 he got his first guitar, paying eight dollars for it when he was earning ten dollars a month working for the eradication program. Tony enjoyed, and continued playing, the guitar throughout his life at various dances. He especially liked the square dances right across the river, held at the homes of Joe Lynk and Charles Smith. His son, James, took up the guitar as well, and played in a band.

Tony also worked for the Walter Butler shipyard, the Globe Elevator Company (both in Superior, Wisconsin), the Holcombe, Wisconsin-based Walter Brothers, various cranberry marsh operations in Wisconsin, the Signor Lumber Company, and as a night watchman at the

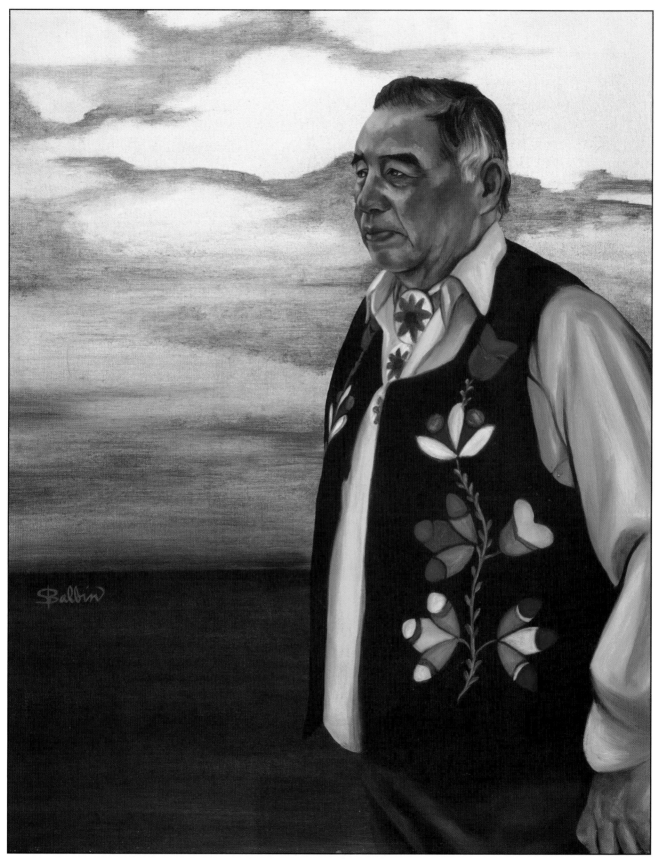

Tony Bernard Butler Sr., oil on canvas, 25x31 inches, 1980, Lac Courte Oreilles Reservation

Lac Courte Oreilles Ojibwe School.

At the time Tony was raising his large family there was still quite a bit of *manoomin* on the Couderay River near his home. Like many Ojibwe families of the time, for survival the Butler family harvested the wild rice, which was labor intensive. "He was always a hard worker," recalled his wife Elizabeth. The following is a description of the process for harvesting wild rice by Carol I. Mason:

> Harvesting took place before the grains matured and fell off the heads. In late August or early September, women went out to the rice beds and tied the standing stalks into bunches. Tying the stalks made it harder for the birds to get at the ripening grain, and it helped in the harvesting. It may also have been a way of claiming rights to certain rice beds and keeping more than one family from trying to harvest the same crop. Shortly after the tying, two people (nearly always women in the early accounts) went out in a canoe, one to paddle and the other to pull the stalks in and beat on the heads. The grains fell into the canoe, which had been lined with a mat or blanket to receive them.
>
> Since the rice was gathered before it was mature, it had to be ripened or "cured" by sun drying, smoking, parching, or a combination of the three.

After the curing process, the rice was placed in leather or blanket lined holes in the ground and threshed by the men. The women then blew the husks in the wind before storing the grain.

Understanding the importance of the *manoomin* to his people, Jim joined a state work program in which his group was employed to plant wild rice beds on the reservation and restore old ones.

In spring, Jim and his family participated in the making of *ziinzibaakwad* and *zhiiwaagamizigan*, a dietary staple in the past when coming out of winter. Most family maple stands, or *iskigamiziganan*, were permanent and utilized annually. According to Carol I. Mason, "In many respects they were like orchards, and as larger numbers of people came to use them, customary ownership became more and more common."

For the processing of the *wiishkobaaboo* into maple sugar and syrup, the immediate and extended family members usually divided the responsibilities. This included traveling to, and setting up the camp to live in with the necessary equipment, cutting and organizing the firewood, collecting the sap, tending to the rendering, and storing the maple sugar and syrup. In spring, the *wiishkobaaboo* is also used as a revitalizing drink, and considered to be a medicine, according to Art Tainter.

Later in life, Tony continued with a few Ojibwe seasonal activities and shared his traditional knowledge with family and friends. He spent his spare time gardening, hunting, fishing, and working where people needed him.

In his portrait, Tony is wearing the beautiful beaded vest that Elizabeth decorated with

treasured Ojibwe floral designs. Their daughter Mary Ann assisted by sewing a lining into the vest. Many Ojibwe men, including Tony, wore this type of vest to the religious ceremonies called *Chi dewe'igan*—Big Drum. Tony and Elizabeth belonged to John Stone's drum, where Elizabeth was an *ogichidaakwe*, a ceremonial headwoman.

Respecting his beliefs, a funeral traveling ceremony was held in honor of his walking on.

RUTH CARLEY

CIRCA MARCH 23, 1921 - MAY 4, 2004

Ogabegiizhigookwe, Ruth Carley, was born to Charlie and Frances Henion Coons in 1921. She stated, "I was born in the springtime up the hill near Reserve, where Uncle Henry Coons had a maple sugar camp." Both of young Ruth Coons's parents died when she was very young, her father when she was three and her mother when she was eight.

Ruth was a member of the *Makwa Doodem*, and was reared by her aunts, Maggie (Okwegan) Carroll and Mary (Jiingoo) Batiste. She had two brothers, Jim and Tony Barber, but no sisters. "I pretty much grew up alone, by myself." Ruth recalled. "I didn't have a sister to talk to or anything like that. The two sisters [her aunts] and I lived together, and they had no children. My brothers went to live with grandmother."

She was very ill with pneumonia as a child and was cured by medicines her aunts had been careful to learn about, gather, and preserve. Ruth was treated for all of her various childhood illnesses by her aunts, not by doctors. She felt safe and cared for by her aunts, who were always there for her.

The two aunts did not speak English, so Ruth learned to speak *Ojibwemowin* fluently. The women also taught her the art of tanning deer hides, the techniques of sewing, how to process *wiishkobaaboo*, and the harvesting of *manooman*. Her education also included the making of beadwork, including the process of loom work and the lazy-stitch method. She learned to assemble dancers' belts, make beaded headbands, and fashion moccasins, dresses, and shirts from leather and cloth.

She described the process for tanning deer hides:

The first thing you do is kill a deer and skin him out. The hide is soaked in water until the hair is nice and soft. After the hair is off, you take the fat off, and wash it real good. The brain of the deer is

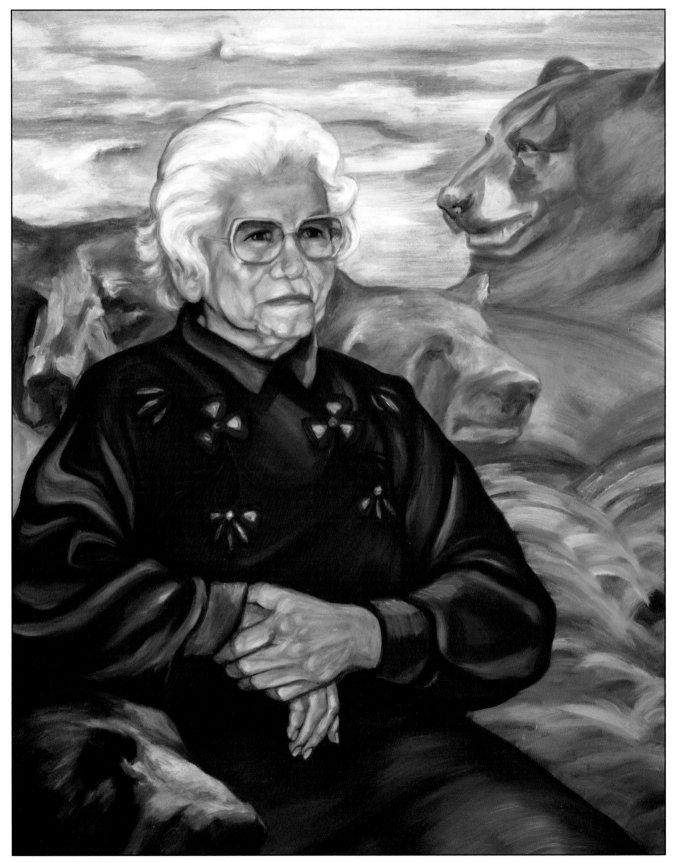

Ruth Carley, oil on canvas, 24x30 inches, 1997, Lac Courte Oreilles Reservation

added to the water, and the hide is soaked in it to make it soft. Then the water is wrung out, and the hide is put on a frame. Then you rub the hide until it dries, and it is soft. After it is soft, you sew it together and smudge it with smoke from a fire. It is hard work, and you have to have a lot of muscle.

Ruth was no stranger to hard work. Her daily chores included carrying water, washing dishes, washing clothes on a washboard without benefit of inside plumbing, and carrying in wood for the fire. The family also picked berries during the summer. "We would take a lunch out in the woods and pick berries all day," she recalled. "We would do that in July. We also had a garden. I raised potatoes, corn, carrots, and all the vegetables. We canned beans and meat in quart jars."

The many aspects of life for an Ojibwe child like Ruth included hunting and fishing, playing tag and hide-and-go-seek, swimming in the summer, skating in the winter, and keeping company with dogs and cats.

Then there was the matter of her schooling. "I went to the Hayward Indian Training School, and it was kind of strict over there. We would get punished for speaking the Indian language. They said they wanted us to be American. They made us sit in a corner if we spoke our language," she remembered. Her friends included Mary Martinson, Emma Stone, Bernice Corbine, Ellen Sharlow, and Dorothy and Patty Schmock. When she reached the ninth grade, Ruth stopped attending school.

Ruth married Burl Carley, and they had eight children: Evelyn, Jeanette, Jim, Richard, Leonard, Marjorie, Donald, and Thomas. Two of the children died in infancy. "Raising my children has been the most important job that I have done in my lifetime," Ruth said. "I must have done something right in the way that I brought them up." In her family today there are twenty grandchildren, twenty-six great-grandchildren, and six great-great-grandchildren.

After working in her home for many years, Ruth held jobs that included cleaning cabins at area resorts, harvesting cranberries, and working as a cook. She worked in the Shelton basket factory in the village of Reserve until the building burned down.

She was a teacher of *Ojibwemowin* for the tribal Head Start Program, day care, and St. Francis Mission School for many years. Ruth received extensive training in early childhood teaching methods and earned a Child Development Associate Degree from the University of Wisconsin–River Falls.

All her life, Ruth continued to fashion beautiful traditional leather moccasins and beadwork for friends. Some of her work can be found on display at the St. Francis Solanis Indian Mission, a tribute to her artistry and dedication to the crafts of the Lac Courte Oreilles Ojibwe.

Ruth also taught *Ojibwemowin* at the Lac Courte Oreilles Ojibwa Community College. Teaching was important to Ruth, especially when it concerned *Ojibwemowin* and Ojibwe cul-

ture. "My aunts taught me the values of Indian life," she said, "to be a good person. Our religion is *Midewiwin*. I still follow it. Language is important. We lost that a long time ago, and we are trying to bring it back. It's hard to learn, but if you listen real good, you can follow the Indian language. Tradition means having your own language and own religion. Your own way of life. No one can take my religion from me."

CHARLES COONS

CIRCA APRIL 18, 1888 - MAY 30, 1979

Charles Coons, Esiban, was a strong man known for his athletic prowess, work ethic, and love for his wife, Nancy. The strength of his character shows that self-discipline runs deep in the *Anishinaabe* way of life.

His parents were Samuel (Esiban) and Mary Winters Coons. Charles was a member of the *Makwa Doodem*, like his father. He was born in a *wiigiwaam* during the *wiishkobaaboo* harvest time, when the liquid is rendered into *ziinzibaakwad* and *zhiiwaagamizigan*. At the time of his birth the Ojibwe lived by the seasons. They did not have a written language, follow standard American time, or follow the twelve-month calendar year. However, he and many of the elders in *Spirit of the Ojibwe* were given birth dates by the Bureau of Indian Affairs (BIA) to acknowledge their existence.

Charles was reared at the village of Eddy Creek and lived to be ninety-one years old before walking on. He had a brother, Louie, and two half sisters, Sara and Charlotte. Like most children from Lac Courte Oreilles, he attended the Hayward Indian Training School. Like many, he was also sent away from his birthplace to a secondary school many miles away. In this case, that faraway place was the Carlisle Indian School in Pennsylvania, which he attended from 1910 to 1912. As in most Indian schools of its day, the emphasis at Carlisle was on a curriculum aimed at assimilating Indian youth into the white culture, a program that Charles would recall as sometimes enforced by the corrective use of a wooden paddle.

Nonetheless, Charles flourished. He took up the trombone, playing in the school band. He studied carpentry and meat cutting. Perhaps most importantly, he developed what would become a lifelong interest in coaching. He intended to become a physical education teacher. At Carlisle, he was a teammate of the soon-to-be-legendary Jim Thorpe on the track, baseball, and basketball teams.

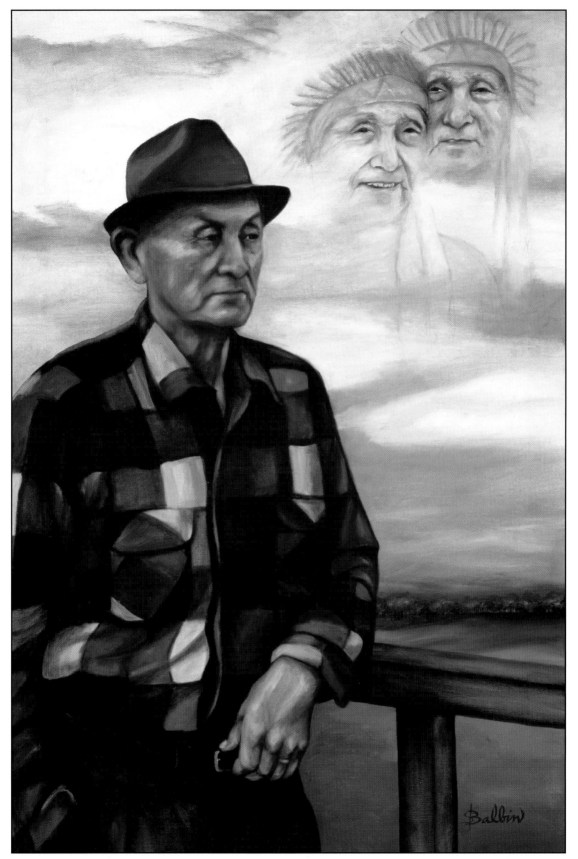

Charles Coons, oil on canvas, 25x37 inches, 1979, Lac Courte Oreilles Reservation

During that time he was made a track coach by the school's athletic director, Pops Warner, and had the honor of working with the future Olympian Thorpe, training him in events like the pole vault and the 100-yard dash. These events were part of the decathlon and pentathlon competitions in the 1912 Olympics, in which Thorpe won two gold medals, the first American Indian to do so. Yes, Charles Coons from Lac Courte Oreilles played a big part in the career of Jim Thorpe, one of the most talented athletes the world had seen.

Coons went on to be a counselor and to coach at Indian schools in Gallup and Santa Fe, New Mexico, and in Yankton, South Dakota. He also worked at an auto manufacturing plant in Detroit, Michigan, for a time, but he returned home to Lac Courte Oreilles as soon as he was able to.

During his travels he met his future wife, Nancy Runke of Green Bay, Wisconsin, who also worked for the Bureau of Indian Affairs. The BIA had strict rules against marriage between Indians and white people, but they gladly left their bureau jobs in order to become husband and wife in 1917. They moved to Hartford, Wisconsin, where Charles worked at Kissel Kar.

Returning to the Lac Courte Oreilles Reservation in 1921, Charles worked at seasonal jobs including logging, hunting, and fishing. He often went hunting for several days at a time, building a lean-to for shelter and sleeping on a bed of pine boughs. In the spring and fall, he used gas lanterns to fish at night in a modern adaptation of the traditional method, which had employed birch bark and pine pitch torches. His family also owned eighty acres of land near *Odaawaazaaga'iganiing*, where they processed sap from the maple trees into *ziinzibaakwad* and *zhiiwaagamizigan*.

With the help of friends John Scott and Pete Cloud, he built a log house near the site of the LaRonge Hotel, in which he opened a general store, selling groceries, tobacco, clothing, toys, pails, lanterns, rice, flour, sugar, and cheese. His son Daryl Coons remembers going into the store during tribal meetings and finding the air heavy with cigarette smoke. Charles obtained his supplies from the "blueberry train," which stopped in the village each day. The store was open from 1920 to 1942. During this time, he also took on the duties of postmaster for Reserve Township until it was gerrymandered out of existence in 1936.

Charles and Nancy Coons raised three children: Anona (LaRonge), Thaymar (Diamond), and Daryl, who went on to be a member of the Lac Courte Oreilles Tribal Council.

Charles played baseball for the Reserve team for many years, playing short stop. He was both manager and coach, and brought the team to countless victories over the years. Daughter Anona happily recalled, "We were the champs for five years or more." Charles had an old truck in which he would transport team members to games. Daryl remembers that his father loved the game of baseball so much that the family would stop and watch any small-town game in progress.

Around 1947, Charles was elected to the Tribal Council, where he served for fifteen years. At that time, the Bureau of Indian Affairs gave tribal officials a stipend of forty-eight dollars a year for their public service. He was also instrumental in building and maintaining the Presbyterian Church in Whitefish. Charles was a good dancer, and his family remembers him recounting a memorable occasion when he won a cake dance contest.

Although Esiban has walked on, his memory is part of the rich heritage of Lac Court Oreilles.

FRANCES DENASHA

CIRCA SEPTEMBER 16, 1913 - OCTOBER 5, 1995

Frances Denasha, whose Ojibwe name was Gaagiinh, was a member of the *Awaazisii Doodem*. She was born at home in the village of Post, the daughter of Sh'weenee and Thomas Naviosh. Frances recalled from her early years walking up the road to Post, and seeing the original St. Ignatius Church, which was a log structure. "I remember playing on the porch steps that led into the church." While she didn't remember much else about the church, she had vivid memories of the parish priest, Father Oedric. "I remember his beard. I think he baptized me."

"When I lived at old Post, I was very young. I stayed at Indian Jim's or at Esther Naviosh's," she recalled, referring to her Uncle Jim Naviosh and her Aunt Esther. In the days prior to the flooding of *Bakweyawaang*, Frances remembered there was a marshy bog across a small river where a lot of people, including Frances, went by boat to pick wild cranberries. "It was just down the hill from the church, and the river was narrow there, just about as wide as my house," Frances indicated with a wave of her arms. "As young as I was, I wasn't afraid to go across there in a boat."

Frances was a student at the Hayward Indian Training School when federal authorities condemned *Bakweyawaang*, built the Winter Dam, and in 1923 closed the floodgates, forever submerging the little village of her childhood. "I was in the Hayward Indian School, and I heard they were moving, they were getting flooded out. I heard they were moving over here," she sadly recalled from her home in New Post.

Her father died, and Sh'weenee later remarried, to Ed "Kibbie" Thomas. The family moved to Blueberry Lake, next to her sister Lizzie Waabanookwe DeMarr's house. "Kibbie was a hard-working, industrious man," said Frances's eldest daughter, Dolores Denasha. "He had a team of horses and plowed a garden on both sides of the road." The family worked in the garden, canned vegetables, picked blueberries, and collected maple sap in the hills south of New Post.

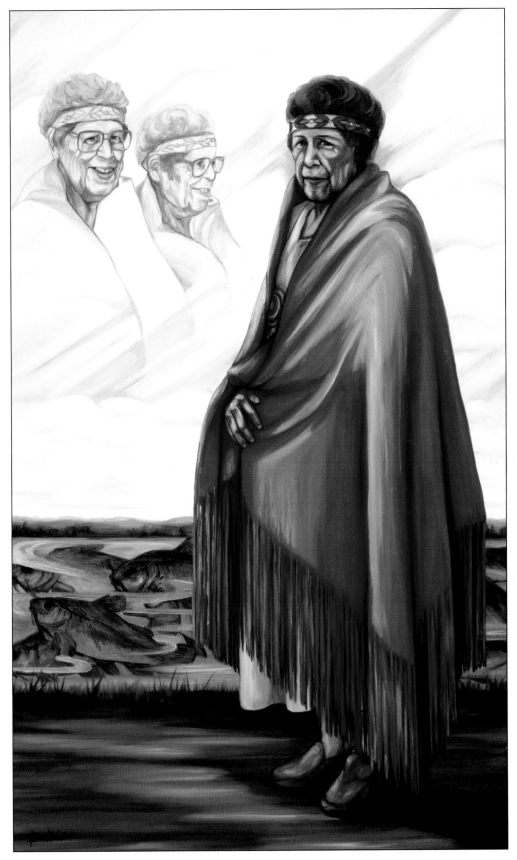

Frances Denasha, oil on canvas, 36x59 inches, 1996, Lac Courte Oreilles Reservation

Bill Denasha, Frances's son, recalled that Sh'weenee and Kibbie both spoke *Ojibwemowin*. "They knew English," he said. "They'd ask me something in Indian, and I'd answer them in English." "My mom was a nice lady," Frances stated. "She was slim, not like my sister Lizzie and I, but she was so slim. She picked blueberries a lot and loved to fish nearby in Blueberry Lake back in the 1920s." Frances recalled how they used to go up in the woods and camp out to produce *ziinzibaakwad*, and how one year loggers from nearby camps stole their cans and equipment.

Frances completed her education in New Post. "The school was a little white building close to the road," she noted, looking over toward the present grade school, "and one of the teachers was Antoinette LaRush." In 1933, at the age of twenty, she married Frank Denasha, a woodsman and fishing guide. Frank was the son of Ben Denasha, a logger. Bill Denasha remembers that old timers called his grandfather, Ben, "Bucko." He lived in a big white house next to Henry Smith's home. Bucko could speak both *Ojibwemowin* and French.

Frank Denasha was an avid hunter, trapper, and fisherman. In the 1930s there were few jobs for those not lucky enough to work for the Works Progress Administration. In the New Post area, many men, including Frank, hunted and fished to feed their families, according to Frances. "It was kind of tough during the Depression days," she noted sadly. "Some families would go hungry, and Frank tried to help by giving them meat. Sometimes Dad would go hunting in a boat. He would be out all night long, and in the morning he came back with a deer, every time." Dolores said that her mother, Frances, often canned deer meat and berries. "We grew up on deer meat."

According to Frances, "In the old days when we didn't have a car, we hired Bill DeBrot to take us to Hayward, and we would do our shopping for the month. It was a big trip in those days to go to town. Lard was five cents a pound and coffee was real cheap." Frances and Frank reared four children—Dolores, Bill, and Bob Denasha, and Myrna Thayer, in a log cabin in New Post.

Bill Denasha remembered gardens when he was young, and a cellar full of canned venison and bear steaks, vegetables, and berries, all put up by his mother. "My mom was a hard-working woman," he said. "She was a conscientious lady who never let the dishes go. I can still see her scrubbing the old wooden floor in the log house homestead."

In 1942, the Denasha family moved to Chicago, and stayed there for a year and a half. Frank worked in a defense plant, and Frances worked in a candy factory. Later she worked as a punch press operator in an airplane parts factory. "I almost lost my hands one time when I forgot to put the hand straps on and the machine came down real hard, like that," she said, striking the table with both hands.

When the summer heat became too much for them in Chicago, Frank took the family back

to New Post. He returned to his boat, guiding tourists on the same Chippewa Flowage that had inundated his homeland. The family often walked to Grandma Sh'weenee's house next to Blueberry Lake. "I remember seeing Grandma sitting by the kitchen window as we arrived," recalled Dolores with a smile. "She was always happy to see us coming, and we brought her ducks and fish. Sh'weenee loved to fish. I can still see her wading out there, her long skirts hiked up below her knees."

Frank suffered heart trouble during the 1940s, and Frances always cautioned him to take someone with him when he went out hunting and fishing. "One time when he was fishing alone, his heart gave him trouble and he fell over. His boat just went round and round in circles," Frances recalled. Frank died in 1953 and was buried in the New Post cemetery.

The Gus Whitebird family from Odanah was close to the Denasha family, visiting them often. "Gus said a little bird was pecking at the window on his house in Odanah the day Frank died," recalled Frances. "Gus knew that it was trying to get a message to him."

"Mom was a loving, caring person who took lots of people into her home." Bill Denasha noted about his mother. "She, Anna Homeskye, Aunt Peggy Tainter, and other women in New Post always made sure there was enough to eat when food was scarce. Everybody took care of each other to survive." According to Art Tainter, who was born and reared in New Post, "Every household had somebody like Frances Denasha who would take over for funerals and births, preparing the bodies for burial and conducting Ojibwe ceremonies."

Art Tainter continued, "Even though there were two schools in New Post, the women got involved in our educations and would tell us stories of how they lived in the village of old Post." He continued, "New Post was built on an eighty-acre plot, one-eighth square mile, after the flooding of old Post."

Frances worked with Father Laurus in raising funds for the Catholic Church through card games and dances at the New Post community hall. She helped to organize basket socials, cribbage tournaments, and other benefits for the St. Ignatius Church. Gus Whitebird came in from Odanah to show movies at some of the benefits.

"Things are so different today," Frances observed with great expression. "In the old days, our kids did not know about drinking, but today they stay out all hours of the night. I can hear them right here outside my window. Years ago, when Larry Tainter was a policeman, we used to have a curfew and the kids weren't allowed outside at night. I lost three grandchildren to car accidents," she said. Reminiscing of the death of Thomas Denasha, who was struck by an automobile on the Blueberry bridge: "If I gave advice to the kids nowadays, I'm afraid they wouldn't listen."

A little girl lying on the couch nearby interrupted, "*Koobide! Koobide!*" That means great-

grandmother. It took her a little while, but Frances counted twenty-eight grandchildren on her fingers. Then, after a short time, with modesty she said, "I've also got twenty-three great-grandchildren."

In her last year of life, while undergoing dialysis, Frances participated in art therapy sessions with artist Sara Balbin. According to Balbin, "Frances enjoyed sitting quietly by the kitchen window watching birds at the feeder and the passersby. She always watched for my arrival, was happy and ready for the sessions. During our time together Frances often reminisced about the village of Post. In time she drew a map of the village and surrounding area to preserve the history for her family."

CATHERINE "KATIE" DENNIS

CIRCA MARCH 31, 1891 - JANUARY 6, 1988

Catherine "Katie" Corbine Dennis, whose Ojibwe name was Biishaana Kwadookwe, was a member of the *Makwa Doodem*. Her parents were Alex Moses Corbine and Margaret Thomas of Reserve.

She attended school at the St. Francis Solanus Mission in Reserve, which at the time was a church and boarding school for grades kindergarten through sixth grade.

In her later years, she said that she had vivid memories of the fire that destroyed the church in 1921. She recounted that Nellie Belanger ran into the sacristy and saved the Blessed Sacrament, while others tried to retrieve some of the statues. Her recollections also revealed that Ben Gokey Jr. may have been the last person baptized in the old church.

As a small child, Katie lost her sight and never learned the cause, but the miracle of her regained vision "was like a gift from God." The bishop was visiting the church and asked to see Katie. Her mother carried her to the church in her arms, and then led her to the altar. Katie said that her mother held a bell tied to a rope that Katie held so she could lead her. Once at the altar, the bishop blessed Katie, and then she left with her mother for home. This time Katie asked to walk without the rope in hand. After a short time she began to see. The first thing she saw was her childhood companion, Carlo, a black shepherd dog with a white ring of fur around his neck.

Today it only takes a few minutes by car to get from the Lac Courte Oreilles Reservation to town. When Katie was young, she recalled, the trip took an entire day by horse and buggy. When it was cold, bricks were heated the night before the trip, wrapped in cloth, and used to keep feet warm on the journey. While they were in town, a store owner named Mr. Powers would reheat the bricks for the return trip to the reservation. They always carried a lantern, because when days were short, they would leave by four or five o'clock in the morning and

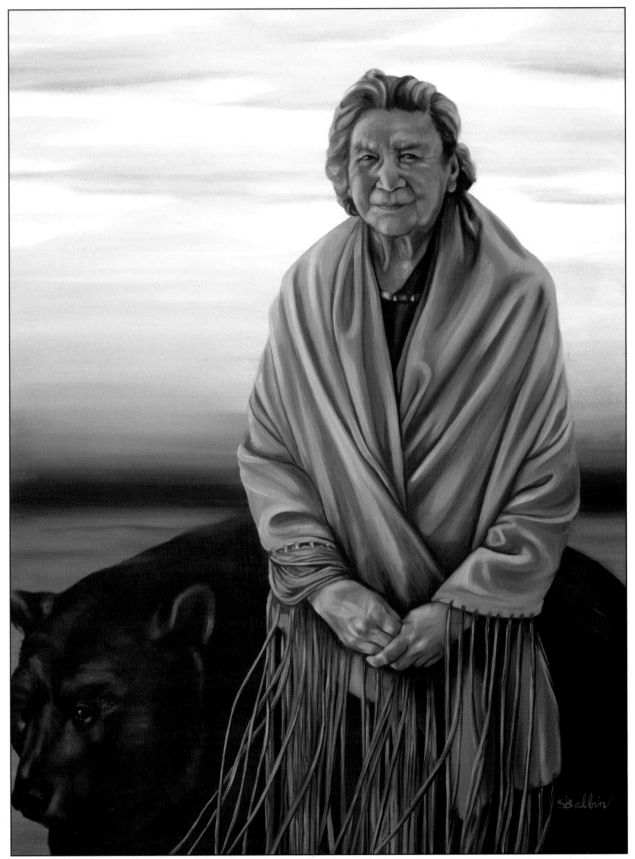

Catherine "Katie" Dennis, oil on canvas, 29x39 inches, 1980, Lac Courte Oreilles Reservation

return home after nightfall.

During the winter months, the men set snares on their way into town, stopping on the return trip to harvest rabbits. In the summer, when the days were longer, they often stopped to pick blueberries along the way. Not having canning equipment, they used pails sealed with pine pitch to store the blueberry crop.

Later in life, as her vision began to fail again, she found that doctors could do nothing for her eyes, which she described as "scratchy," so traditional Indian medicine was applied to try and help her vision. Herbs were commonly used as medicinal aids, and Katie recalled using her share as a child because she was sickly. She remembered going to the church swamp to pick goldenseal root. It was steeped and put into bottles to be used for sore mouths, sore throats, and canker sores. She and Susie Dennis would gather bark for kinnikinnick, which they dried to be smoked. Ginseng was another Indian medicine and was worth quite a bit of money. She remembered that ginseng was harvested near Connors Lake; after it was harvested, it was dried to be prepared for sale.

Another means of earning money was by weaving and selling baskets. Reeds were pulled from lakes, soaked in hot water, and then woven into baskets.

Katie worked for Joe Guibord, the section boss for the railroad that came through Reserve. Joe would let her and Susie Dennis take a handcar down to Edgewater, along with any passengers who wanted to buy liquor.

During this time, Katie met and married Louie Dennis. They were married in the nun's chapel by Father Oedrick. Together, they had six children: Monica, Irene, Margaret, Virginia, Rita, and Philip. When Louie died in 1927, Katie was left to rear the children alone. She lived near the church, close to the area where she was born, until late in life when she moved to the settlement of Drytown.

One of Katie's favorite stories was about an eagle raised by her grandfather. He either gave or sold the eagle to someone who lived in Chippewa Falls, and he walked with the bird from Island Lake to its new home. He talked to the eagle and explained that it would have a new home and must stay there. A few months later the eagle found its way back to Island Lake. Once again, Katie's grandfather walked to Chippewa Falls and told the eagle it must stay with its new owner. He said the eagle actually had tears in its eyes. He never saw the eagle again and believed it was eventually taken across the ocean and used for entertainment.

Katie was honored at a feast on July 20, 1985, during the Honor the Earth Homecoming and Pow Wow.

ELIZABETH WHITE DENNIS

CIRCA DECEMBER 30, 1902 - SEPTEMBER 20, 1996

Elizabeth White Dennis was a member of the *Ajijaak Doodem* and a lifelong resident of Reserve, a populous area of the Lac Courte Oreilles Reservation along the shore of Lac Courte Oreilles lake. Reserve is adjacent to the St. Francis Solanus Indian Mission, where Elizabeth attended school through the sixth grade. She was a devout Catholic and very active in her church.

Elizabeth was the daughter of James and Martha White, the sister of Connie and Joseph White, and half-sister of Charlie White. Elizabeth was born at home during the winter season. The family cabin was located on County Highway E, across from the country store and resort known as Little Bit of Sweden.

Her father died when she was young, and later her mother died tragically along with her brother, both frozen to death when a snowstorm caught them unawares while out picking pine boughs.

Lizzie, as she was called, married Willy Dennis, and they had two children, both of whom died when they were very young. Not long after, Willy also died. Lizzie then lived much of her life with Willy's brother, Charlie, in Reserve, near what is now the Elderly Center, a building of about twenty by twenty-five feet, sided with green roll roofing. Much of her life lacked modern amenities and electricity. She heated and cooked with a wood-burning stove, lit the house at night with kerosene lamps, drew water from a hand pump, and made use of an old-fashioned outhouse until about 1980.

Lizzie was a fluent speaker of *Ojibwemowin*. Her nephew Lewis White said *Ojibwemowin* was definitely her first language. After her companion Charlie walked on, Lewis used to visit her frequently, conversing with her in the native tongue. An *Ojibwemowin* language instructor himself, he credits his knowledge of the language to his exposure as a child to his aunt. Some

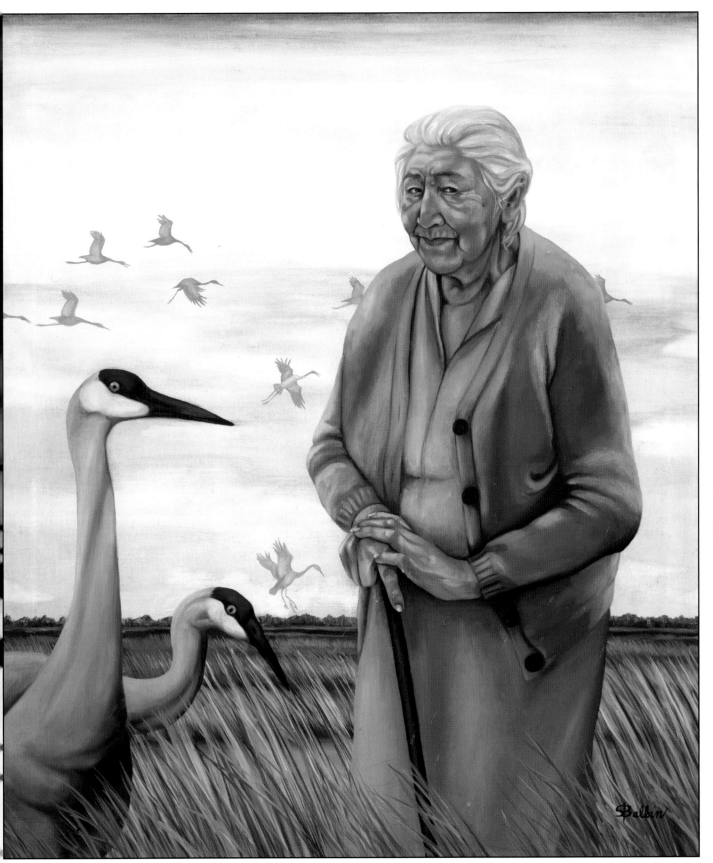

Elizabeth White Dennis, oil on canvas, 31x37 inches, 1980, Lac Courte Oreilles Reservation

people called her Opwaagan.

One of her favorite pastimes was weaving rag rugs from recycled pieces of fabric and selling these rugs to provide income. Lizzie loved her plants, filling her home with them after Charlie walked on. She also enjoyed reading a great deal, especially books with large type obtained through the *Reader's Digest*. Her fondness for literature is reflected in the fact that she liked writing as well as reading.

Lizzie preferred traditional foods, favoring venison, walleye, wild rice, and fry bread. This diet apparently worked well for her, for she lived into her mid-nineties. Other wild game that she prepared included bear, rabbit, raccoon, muskrat, porcupine, squirrel, and a variety of water and land birds. She maintained a garden until she grew too old to care for it. Lewis remembered tilling the garden for her each spring, being careful not to dig up her treasured rhubarb plants.

"She never complained, appreciating anything that was shared with her, and enjoying the company of friends and family," said her friend Rita Corbine.

SAMUEL JAMES FROGG

CIRCA JULY 5, 1898 - MAY 4, 1982

Samuel James Frogg was a member of the *Makwa Doodem* and a follower of the *Midewiwin* belief. He was born in a wigwam around 1898. As hunters and gatherers, the Ojibwe lived by the changing seasons, and did not use the Euro-American calendar. He was known by two Ojibwe names: Bashkwadaash and Ozhinin. His parents were John and Elizabeth Carroll Frogg, both members of the Pete Cloud Big Drum Society. The couple had nine boys, William, Sam, Peter, Jim, and five who died in infancy, and two girls, Jessica and Mary.

Sam learned to hunt and fish in the traditional way from his father. They made many trips into the woods together, where they trapped muskrat and mink for their furs, which they sold for cash. They also hunted deer for the table.

In keeping with the yearly cycle, Sam helped his parents make *zhiiwaagamizigan* and sugar cakes in the spring, and gather *manoomin* in late summer.

The Frogg family traveled by horse-drawn wagon or sleigh, depending on the snow cover. Sam was an eager learner and drove the rigs himself as soon as he was old enough. His sister Mary Frogg Sutton recalled vividly her lasting impressions of riding in the wagon or sleigh, with her brother tugging at the reins.

Sam attended the government's Bureau of Indian Affairs' Hayward Indian Boarding School, where like so many of his generation, he was punished for speaking *Ojibwemowin*. Though memories of that experience lingered throughout his life, he steadfastly continued to speak his native tongue until he died at the age of eighty-four.

Sam enjoyed the winter, exercising and shaking cabin fever at the same time by skiing through the woods to work throughout the long winter months. In his time off, he enjoyed ice skating.

His sister Mary recalled, "Sam loved all types of food and stressed that we should never

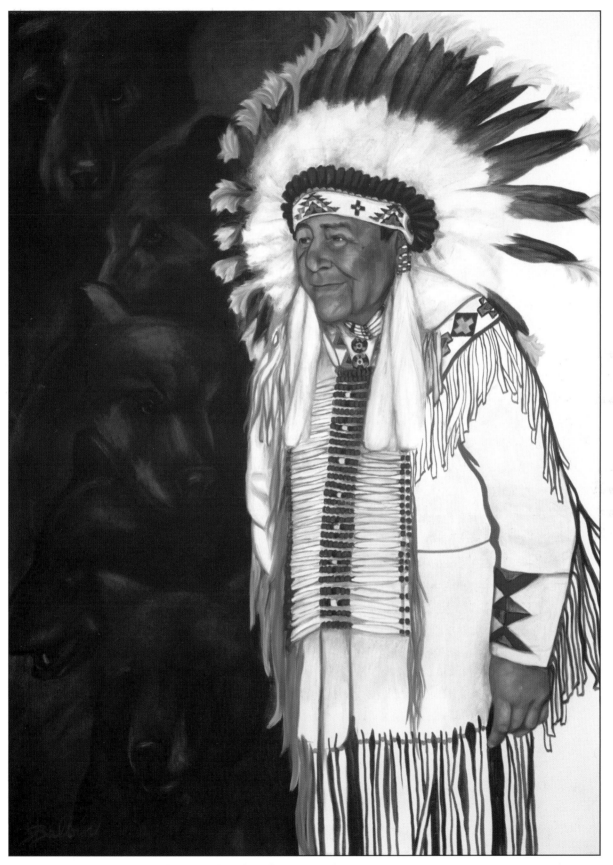

Samuel James Frogg, oil on canvas, 31x43 inches, 1979, Lac Courte Oreilles Reservation

turn down the offer of a meal." This was his way of reinforcing the Ojibwe tradition in which a visitor is always offered food and drink upon arrival.

During the fall trapping season, Sam often camped overnight with his good friend Fred Smith. Another of Sam's close friends was Joe Boston, who lived in an Ojibwe style long house. Joe often visited with the Frogg family, frequently accepting an invitation to spend the night.

Sam served in the U.S. Army during World War I. He married Maymie Cloud, and together they had nine children: Alvin (Skee), Naomi, Janice, Carole, Bonnie, Myron, Inez, Lona, and Helene Elizabeth.

He was an enterprising man who provided guiding and boating services to the tourists and local fishermen. His claim to fame, however, was his career as a performer. He spent many summers in the Wisconsin Dells region, where his face was synonymous with Indian culture for huge numbers of tourists. He also spent many hours on the sidewalks and in the storefronts of the Hayward area, posing for photographs with tourists, autographing postcards, and speaking with people on the streets.

He was a striking figure of a man, regally garbed in a white buckskin outfit and crowned with a Sioux-style feather headdress. He often used his hands to gesture and emphasize a point while he spoke, adding to his bigger-than-life persona. Groups of Boy Scouts and others eager to learn from him regularly sought Sam out for presentations. After one lecture, a young student wrote to him and asked innocently, "Have you always been an Indian?"

Traveling throughout the Midwest as well as Europe, Sam quickly became a prominent and recognized representative of the Ojibwe nation. He often performed at sports shows.

He was a great orator who was able to capture the attention of any audience with his wonderful stories, and when he told a story, it stayed with his listener for a long time. Once he told an eerie tale of a legendary serpent seen on rare occasions in Woman Lake and other area waters. His niece Ethel said, "I could sit and listen to him talk for hours. His stories were fascinating."

The multi-talented Sam was also a gifted painter, with over two hundred original works of art to his credit, many of these adorned with deer antlers, feathers, wood and other natural materials. "Once he discovered a three-tiered toadstool in the woods behind his house," recalled his daughter, Carole. "He used the toadstool as a backdrop on which to paint a delicate woodland scene, complete with a waterfall."

Sam's daughter-in-law Wanda said that she and Sam spent many hours discussing the philosophy of the Indian people. One day Sam held up a blade of grass for her to see and said, "What is this?"

When Wanda replied that it was a blade of grass, Sam said quietly, "It is *Manidoo*. What

are you? That blade of grass is as relevant to the Creator as you are." Wanda said this conversation confirmed her belief that Sam was a very spiritual person. She and many other people greatly admired him for his vast spiritual knowledge.

BEVERLY CADOTTE GOUGÉ

CIRCA OCTOBER 17, 1933 – MARCH 23, 2007

One of the most beautiful things a person can hear an Ojibwe elder say is, "I was born in a wigwam." It's a simple phrase, but it says so much. It points out the more grounded reality the elder generation brings to today's very different world. This is the generation that spans the gap between twenty-first century cell-phone toting youths and an earlier era when cast-iron kettles and oil lamps were cutting-edge technology.

Beverly Cadotte Gougé was born in a *wiigiwaam* far back in the woods in the settlement of Hauer. Her parents were Alice White Lynk Cadotte of Lac Courte Oreilles and Raymond Cadotte of Cass Lake, Minnesota. In Beverly's portrait, her mother Alice is portrayed ricing, and the image of a wolf in the sky represents her father Raymond's *Ma'iingan Doodem*. Raymond walked on when Beverly was just two years old.

She has been a highly respected teacher of Ojibwe arts and culture since 1975, when she first started teaching at the New Post School. Then, from the first day in 1978 that the Lac Courte Oreilles, Reserve K-12 School opened its doors, Beverly worked as a teacher of *Ojibwemowin* and Ojibwe arts and culture through 2006. The motto of the school is "Once we were all alone, now we are all together."

During the first year at the Reserve School, the tribe's community radio station, WOJB, operated from the second floor of the school building. Beverly made daily announcements in *Ojibwemowin* over the radio station, telling the tribe what the meal of the day at the school would be. Respect for her expertise extends throughout the community.

The preservation of and reverence for Ojibwe culture has separated the Lac Courte Oreilles Ojibwa School from the area's public schools, and Beverly was a personification of those traditional teachings. She has instructed students in the arts of beadwork, jewelry making, traditional regalia, tanning hides, weaving baskets, and *Ojibwemowin*. Eventually she went

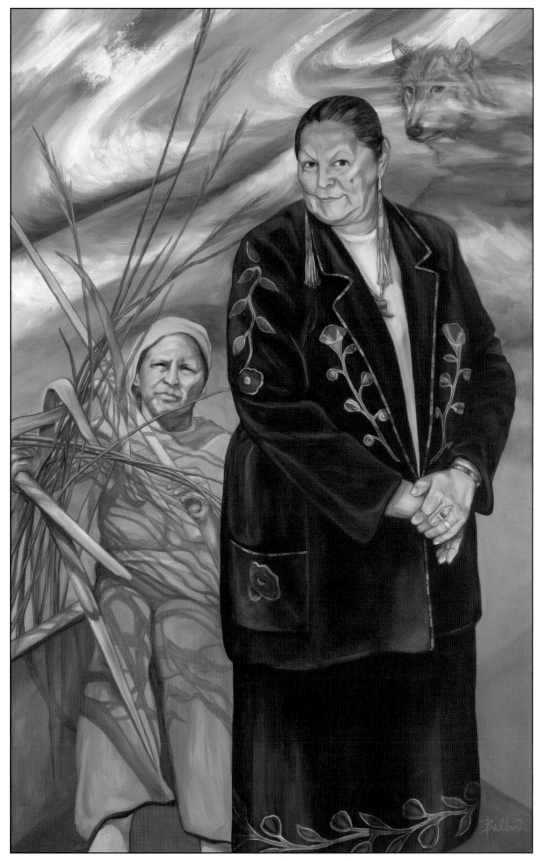

Beverly Cadotte Gougé, oil on canvas, 30x48 inches, 2000, Lac Courte Oreilles Reservation

to Mt. Senario College in Ladysmith, Wisconsin, taking part in a teacher training program and graduating in 1987.

Beverly was reared by an extended family which included her mother, Mizhakwad, her mother's parents, Frank and Susie Lynk, and her great-aunt Mary Butler, Chinini, or Waabooz. She has taught family values by example through her marriage to Louis Gougé.

It was a source of great happiness for Beverly that her grandchildren are enthusiastically interested in Ojibwe traditions. Her son Louis Jr. (Tiger) and his wife Marcy have three children, Heather, Stephanie, and Christopher. Both Heather and Stephanie have been honored by tribal members for their achievements and their traditional regalia. Heather has been the Junior Miss Honor the Earth Princess and the LCO Elementary School Princess, and Stephanie was the Honor the Earth Princess Miss Tiny Tot.

Heather is teaching her young brother, Christopher, *Ojibwemowin* by using her own homemade flash cards.

It may be hard for her grandchildren to imagine, but Beverly thought it was quite ordinary to walk three miles to get the school bus when she was in elementary school. When necessary, her mother walked ahead of her, breaking a trail through deep snow. As the only girl in her family, she remembered being something of a "tomboy" in her youth, when her grandfather made a bow and arrows, a slingshot, and snowshoes for her.

She carried the ability to use these items into adulthood and often went hunting with her husband, Louie, both of them on snowshoes. They also speared fish together in the spring and went bird hunting together in the fall. Bev and Louie enjoyed a friendly competition when hunting partridge together, each attempting to bag more of the well-camouflaged game birds than the other.

In keeping with the *Anishinaabe* way of sharing the bounty of the hunt, Beverly and Louie gave the delectable white meat from the partridges to other elders. She kept the tail feathers to make fans that are a lovely accent to traditional women's regalia.

Both the *Midewiwin* religion and Christianity were part of her early life. When the seasonal *Midewiwin* ceremonies were held at the Whitefish settlement, Beverly, her mother, and her grandparents went there and set up camp, putting them in the heart of the activity day and night. These gatherings were also social events, times when *Anishinaabe* people from settlements near and far gathered together.

As with many Indian people, Beverly's family mixed Christianity with the traditional *Midewiwin* beliefs. Many Christian sects built missions at Lac Courte Oreilles; the one nearest to Couderay was the Assembly of God church. In addition to family gatherings and school, activities at the Assembly of God church were important to the social life of Couderay. Bev-

erly fondly remembered a particular Christmas pageant in which she played the Virgin Mary and Charlie Quagon played Joseph. Afterward, the children were all given Christmas presents and candy. When she was older Bevery taught Sunday school at the church, her first teaching experience.

A half-hour walk from that church, Beverly's Grandma Waabooz lived in a two-story log house which was functional and comfortable, but had neither electricity nor running water. They gardened and hauled water and firewood by hand; kerosene lamps lit their nights. In the middle of the living room floor was the entrance to a cellar where they kept potatoes, carrots, squash, onions, and beets. Electricity did not come to her village in Couderay Township until around 1974.

Beverly remembered times when her Grandma Waabooz would trudge off into a nearby swamp to gather firewood. The elder woman then used a small sled and tumpline to haul the wood home. The tumpline, invented by Indian people, consisted of a padded strap worn across the forehead that was connected to the sled by ropes. To use it, Waabooz would lean forward into the tumpline and slowly drag the load home.

In the first part of March, which was more late winter than early spring, it was time to set up camp in the sugar bush. Waabooz first covered the *wiigiwaam* skeletons with birch bark that she carried from home, after which she hauled kettles up to the sugar camp. At that time she used birch bark baskets to catch the sap, as well as traditional wooden taps made of cedar to guide the flow of the sweet sap into the baskets. Wisdom from early generations was passed down to Beverly, like the use of a balsam bough, dipped into the steamy kettle, to stem the overflow of the boiling liquid.

She attended the first through eighth grades at the old Couderay grade school. She then went to Haskell Indian Boarding School in Lawrence, Kansas, through her graduation from the twelfth grade in 1951. Not content with that achievement, she continued her education at Haskell for an additional year, studying vocational training in home economics. Unlike the boarding school experiences of her parents' generation, Beverly's time at Haskell was pleasant. She enjoyed the educational process and the staff at Haskell was kind.

In July 1955, not long after her return to Lac Courte Oreilles, Beverly married Louie Gougé. Early efforts at creating employment brought the Shelton basket factory to Lac Courte Oreilles. It was on the eastern edge of Lac Courte Oreilles lake, in a building that had been a community center. Beverly worked there in 1961 and 1962. It was her job to start the baskets by setting up the bottom of them so others who were less adept at basket making could finish them. Unfortunately, the factory was destroyed by fire. The Reserve Elderly Center now stands where the basket factory was located.

Recently, Beverly lived in a modern, comfortable home not far from where she lived as a child. In this home she and Louie reared their son Tiger, along with twenty-seven foster children who spent varying amounts of time with them. Their move to this house in 1974 marked the first time she lived in a home with electric service.

Beverly was a generous soul. Her sense of humor was infectious, her laughter spontaneous. She enjoyed telling stories, which seemed fresh each time she shared them. The following is one of the stories:

> My cousin would always be fighting with the girls, you know. So one time we got off the school bus and he was fighting us, using his fists and everything. Tom Butler came running out from the house cause he lived closer to the road than we did. He came out and asked us what he was doing. We told him that he was fighting us and using his fists and everything. He went in the house and got a gunnysack. Then he caught my cousin. It was Joe Hart. He caught him and put him in the gunnysack and hung him in a pine tree. [She laughs.] He said, 'Now you girls won't be bothered by him. Let him hang in the pine tree a while.' That old gunnysack, it was just going like that [motioning] while he was trying to get out.

Stories like these endure in the Lac Courte Oreilles community. They are part of the continuous nature of the generations, a testament to the gems of wisdom and humor that the elders possess.

In 2005 Beverly fell at home and was airlifted to St. Mary's Hospital in Duluth, Minnesota. A brain tumor had caused her fall, doctors determined. Surgery was successful; Beverly recovered and continued the teaching of her Ojibwe artistry and culture with her family, friends, and community until passing on March 23, 2007.

Her service was held at St. Francis Solanus Indian Mission Church in Reserve, where she was put to rest near Lac Courte Oreilles lake. Throughout her life Beverly's spirituality was a blend of Catholicism and *Midewiwin*. As seen in the Lac Courte Oreilles Photographs section (Interior of the St. Francis Solanus Indian Mission Church, page 217), she and her mother, Alice White Lynk, constructed a *wiigiwaam* repository on the altar of the Mission with twenty-one of their hand-tanned deer hides and beadwork. A beautiful and meaningful legacy of both faiths.

JOSEPHINE CROWE GROVER

CIRCA DECEMBER 15, 1898 - JUNE 29, 1995

Josephine Grover, a member of the *Migizi Doodem,* was born around December 15, 1898 in the Burnett County town of Balsam Lake in a St. Croix settlement. Her parents, James and Rose Hart Crowe, were originally from the Lac Courte Oreilles Reservation.

Josephine attended the Hayward Indian Training School for several years. In 1916, at the age of eighteen, she married William M. Grover, a carpenter. The couple had four children of their own—a son, LaVerne, and daughters Mildred, Betty Jane, and Eula. They adopted two other children, Betty Mae and Muriel. During her lifetime, Josephine was blessed with twenty-six grandchildren, sixty-seven great-grandchildren, and six great-great-grandchildren.

In addition to her own children, Josephine also cared for many foster children—as many as seventeen at one time, welcoming them with open arms. Most eventually left Lac Courte Oreilles through the relocation policy, which encouraged assimilation by relocating American Indians to urban centers. During this time, the government, pressured by so-called "reformers" to eliminate federal services to tribes, encouraged individual tribal members and entire families to leave their reservations for large cities. Many were promised job training, housing assistance, and social services which they were never given.

To her advantage, Josephine possessed a disciplined, organized nature which enabled her to juggle the many tasks of farm life along with the responsibilities of raising so many children and foster children.

Josephine never turned anyone away, receiving frequent visits from grown foster children returning from the cities as well as other friends and relatives. If she had company, she made sure they were well fed. The Grovers lived on a small farm where they raised chickens, cows, and had a vegetable garden for staples. William generally rose at 4:30 a.m. to start the chores for the day and was joined by the children who shared the tasks. Each winter, ice was har-

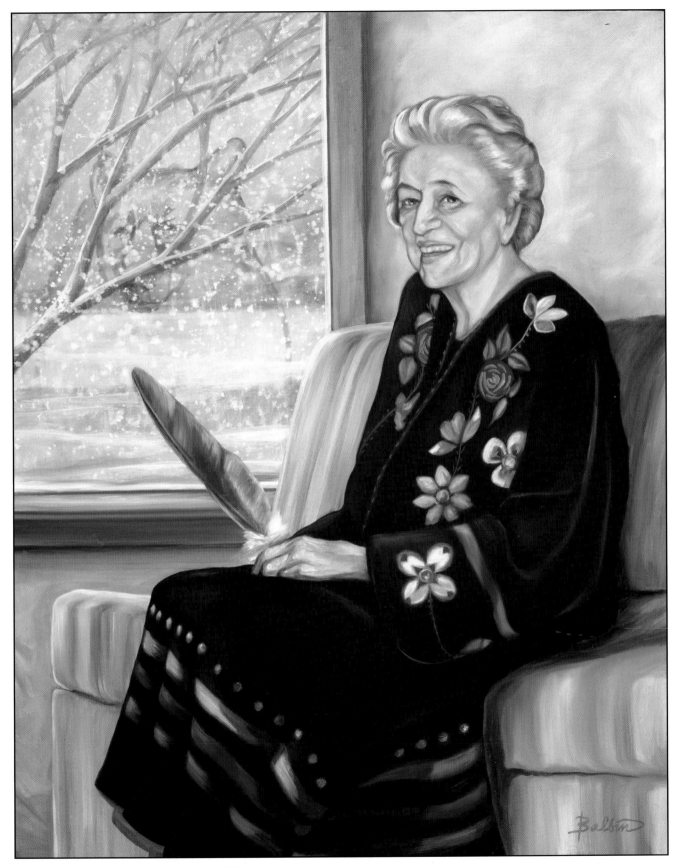

Josephine Crowe Grover, oil on canvas, 30x37 inches, 1996, Lac Courte Oreilles Reservation

vested from Big Lac Courte Oreilles lake and stored in an icehouse, lasting into the middle of the summer.

Josephine and William's daughter Mildred still lives in the original Grover home on Potato Road in Whitefish. William, a World War II veteran, walked on in 1958.

Josephine was an avid story teller, often telling scary stories to discourage children from staying out after dark. She also passed along information about the family's ancestry through her stories, tracing her ancestors back to the time when all the names were in Ojibwe. Today her children continue to keep her memories alive by retelling the stories that she told during her lifetime.

She spoke both English and *Ojibwemowin*, passing the traditional culture along to her family through example. Josephine also sang in *Ojibwemowin*, and was recognized by a few tribal members as the keeper of the "Song for Snow." Whenever tourism entrepreneur Tony Wise, founder of the Telemark ski area in Cable, Wisconsin, felt that the area lacked sufficient snow cover, he would ask Josephine to sing the snow prayer song. The many Lac Courte Oreilles tribal members who were employed at Wise's Telemark Resort did not find this disingenuous. They knew that he truly revered the cultural beliefs of his *Anishinaabe* neighbors.

The traditional medicines and seasonal harvests were also part of Josephine's life. "She often had us digging, or looking for medicines," her grandson Steve recalled. The annual harvesting of wild rice was another way she perpetuated the Ojibwe culture. The harvest included parching the wild rice in a tub and having her husband and son LaVerne dance on it with their moccasins to loosen the chaff from the kernel.

Her cultural teachings earned her an honorary associate degree of American Indian Studies from the Lac Courte Oreilles Ojibwa Community College. In 1992, at the age of ninety-three, she was named *Anishinaabekwe*, Indian Woman of the Year, by the Honor the Earth Education Foundation.

As she aged and was less able to get around, care was provided by her live-in granddaughter Dana Quaderer and other supportive family members.

The Lac Courte Oreilles Tribal Governing Board also honored Josephine by inviting her to participate in the *Hall of Elders* portrait series. For the portrait, she chose to be painted in an elegant black velvet beaded dress she had created. This dress is now treasured by her surviving family. Artist Sara Balbin, after painting Josephine's portrait, was invited to conduct art therapy sessions with Josephine prior to her walking on. Balbin remembers her as a gentle, gracious woman who always had a smile, a great sense of humor, and a willingness to work with her hands.

JAMES HART JR.

CIRCA FEBRUARY 1, 1915 – DECEMBER 14, 2002

In northern Wisconsin, days get longer after the winter solstice, but for several months temperatures remain dangerously low. James Hart Jr. was born in a *wiigiwaam* during these cold days of winter in the community of Reserve to Annie Papish, from the Bad River Reservation, and Jim Hart Sr., of the St. Croix band. Following his father's heritage, Jim was born into the *Makwa Doodem*, and was reared to speak *Ojibwemowin*. A younger brother died while in Washington, D.C., at around age fifteen, and was buried there because the family couldn't afford to bring him home for burial. He also had a half sister, Nancy Hart Benton, and half brother, William Hart Johnson.

Shortly after Jim's birth, the Hart family moved from their *wiigiwaam* in Reserve to a small one-room rustic log cabin in the community known as "Forty-Nine Hill," which was located on Old Highway 27. The historic village got its name from the "Forty-Nine Dance," which is a type of social dance that paid tribute to fallen warriors. After living there for several years, they moved to the town of Stone Lake, Wisconsin, not far from the Lac Courte Oreilles Reservation.

When Jim was about six years old, his family traveled from Stone Lake to the Bad River Reservation to visit his mother's family. While there he had his first close brush with death. Jim tripped and nearly fell from a swinging bridge into the swift current of the Bad River near Odanah. Somehow he managed to hold onto a rope long enough for his mother to catch his arm as he dropped.

The following year, when living back in the Village of Reserve with his family, he had his second brush with drowning. One early spring morning Jim and his brother were getting water from the Couderay River when, without warning, his brother pushed him off the ice into the river. "I remember looking up," Jim recalled, "and I was under water. My mother came

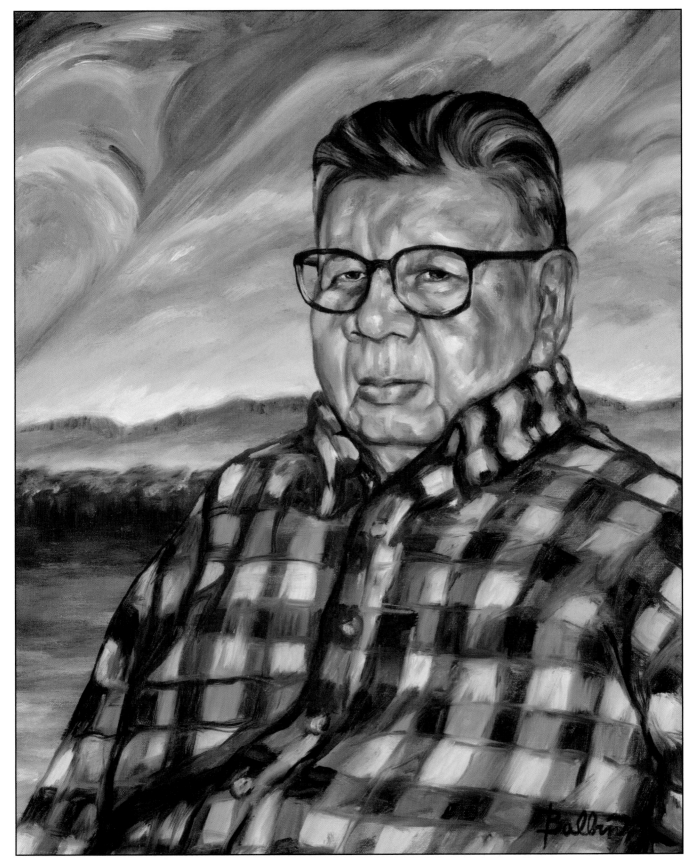

James Hart Jr., oil on canvas, 18x22 inches, 1996, Lac Courte Oreilles Reservation

running out there, and she got a pole and fished me out of there. It was cold. I nearly froze by the time I got up to the house. I was seven at the time." Getting water from lakes, rivers, and streams was a common practice.

While living in Reserve Jim attended the Kinnamon Indian Day School, grades K-6, located on the corner of County Roads K and E. The Lac Courte Oreilles children attended the school and learned the ways of white culture during the day, going home to their parents who lived the Ojibwe culture and spoke *Ojibwemowin*.

According to David Wallace Adams, author of *Education for Extinction*, there were three types of Indian schools—the reservation day school, the reservation boarding school, and the off-reservation boarding school. Adams explains:

> The day school approach offered several distinct advantages. First, it was relatively inexpensive to operate. Second, it seemed to engender the least opposition from parents. . . . neither tribal elders nor parents looked favorably upon the idea of having young children forcibly removed and sent off to boarding school, sometimes a great distance from the village camp. Finally, the day school held out the possibility that the child might become a daily messenger of civilized ways to his parents. In time, the argument went, parents might come to appreciate the fact that their child was acquiring valuable and useful knowledge from the white schoolteacher, knowledge from which they as well might benefit. What day school advocates hoped for, then, was a reversal of the traditional educational configuration in the parent-child relationship; the Indian parent, it was said, would come to sit at the feet of his wiser off-spring.

However, the Bureau of Indian Affairs agents thought the day school was not an efficient instrument for assimilation. According to Adams:

> By the late 1870s most policymakers freely acknowledged that the day school was of limited value as a mechanism for weaning young Indians from their native ways. Secretary of the Interior Carl Schurz reported to Congress in 1879, 'It is the experience of the department that mere day schools, however well conducted, do not withdraw the children sufficiently from the influences, habits, and traditions of their home life, and produce for this reason but a . . . limited effect.' This problem, the need to insulate the child from tribal influence during the civilization process, contributed to the rise of a second model, the reservation boarding school.

Again, policy makers didn't believe that this type of school was assimilating Indian children enough, and so the off-reservation Indian boarding and training schools were established. According to Adams, "If Indian children were to be thoroughly civilized, it was reasoned, a more radical solution was called for. 'On the reservation no school can be so conducted as to remove the children from the influence of the idle and vicious who are everywhere present,'

concluded one agent. 'Only by removing them beyond the reach of this influence can they be benefited by the teaching of the school master.' In uttering these words, P. P. Wilcox, the agent to the San Carlos Apache, was offering his support for still a third model of Indian education, the off-reservation boarding school."

For Jim, the Kinnamon Indian day school experience would soon end as he was removed from his parent's traditional Ojibwe home and sent to the Hayward Indian Training School with approximately 160 other Indian children.

As early as 1856, Ojibwe children were taken from their homes and placed in government boarding schools, where school officials discouraged them from speaking their traditional language or practicing their traditional faith and customs. Through much of the late nineteenth and early twentieth centuries, Ojibwe parents had no say in which schools their children would attend. The schools followed government policy to assimilate and acculturate the students into European white culture. Jim recalled that he studied all week and worked in the kitchen on weekends. Going home to visit his parents was nearly impossible. His mother visited him at the boarding school when she could, but his father was not able to visit due to an injury he suffered while working on the railroad. "The Indian children were promised they could return home for the Christmas holiday," Jim remembered. "Then they were not allowed to go home, so they ran away. Most of them didn't quite make it home. They were caught and penalized, with no recreation for a month."

Jim was about fourteen years old when he attended the Hayward Indian Training School and his parents separated. He recalled that their separation was a trying situation for him, but he chose to live with his mother to complete his last year at the school.

Not much interested in the traditional pursuits of hunting or fishing, when Jim returned home he nonetheless enjoyed helping his family make *zhiiwaagamizigan* in the springtime. They didn't have horses, wagons, or sleds to haul the materials, so it was necessary for Jim's family members to pack loads on their backs in order to get the camp set up in the woods. There they would remain for weeks before reversing the process.

It took a great amount of time, patience, and hard work to process the *zhiiwaagamizigan* into *ziinzibaakwad*. "It was a rough life," Jim said. "After making the maple sugar, we carried the heavy loads back to our homes."

This held true as well during the harvest of *manoomin*, when Jim and his family walked for days with back packs and camped at Long Lake. *Manoomin*, also known as "food that grows on water," is harvested in late summer. A few weeks before the harvest, Ojibwe families bound together bundles of rice stalks. Each distinctive bundling marked a section of the bed as belonging to a particular family. Although there was no formal system of private property,

families returned to the same sections of rice beds year after year. Through the harvest, they reseeded their areas so they would have a crop the following year. This manner of harvesting wild rice is still practiced by some Lac Courte Oreilles families who depend on the bounties of Mother Earth.

Another family chore for Jim was cutting firewood to heat the family home and to cook with. Often the same stove was used for both purposes. Using his knowledge of harvesting wood, as a young adult he worked in logging camps. He also held a variety of odd jobs during and after the Great Depression of the 1930s. Although his life was difficult, Jim said he had no regrets about any of the events that occurred.

He was married to Eileen White, and their union produced four children: Joseph, Joan (who died in the Chicago area, date unknown), Ray, and Beulah Hart Tosland. Joseph, who died December 19, 1999, had three sons, Dan, Todd and Troy. Ray, who continues to live on the Lac Courte Oreilles Reservation, has a son Ray Jr. Beulah also lives at Lac Courte Oreilles and has four children, Jolene, Larry, Mary Jane, and Laurie Ann.

Jim continued to work as a logger, while Eileen tanned hides and did beadwork. They both collected rocks and agates for sale.

Tragically, shortly after their fourth child was born, Eileen died from complications of childbirth. According Eileen's niece Beverly Cadotte Gougé, "For as long as she could, my mother Alice White fostered her sister's children after she died. Then the government stepped in and Joseph, Joan, and Beulah were sent to foster homes. Ray Hart stayed with my mother and was like a brother to me. He now lives in the Bacon Strip community."

Jim eventually settled in Rice Lake, Wisconsin, where he worked for many years at Stein Brothers, a salvage yard and steel fabricator, until he retired in 1970 after being injured. Later in life he reunited with his children. His home in Rice Lake was always open to his family, and granddaughters Mary Jane and Laurie Ann lived with him for many years.

Prior to his death, Jim's daughter Beulah said, "My father's greatest contribution to our family is the fact that he is looking out for our future. He wants to leave money to his grandchildren if anything should happen to him. He doesn't speak much about himself. Life was sometimes hard, but he has no complaints, he just looks ahead. He comes here often for powwows and to spend time with his family and friends."

Jim's generosity also included helping others outside of his immediate family. "My father is very generous," Jim's son Ray said. "He often gives people a little *zhooniyaa* to help them out during hard times." He continued, "Growing up, I didn't really know my father real well because I was raised by my aunt Alice Lynk after my mother died. Now we spend time together when I pick him up in Rice Lake and drive to Minneapolis to play cards with friends.

Sometimes my father and I spent the whole night there playing poker."

Jim's grandson Dan was able to spend time with his grandfather as a young adult. He said, "Around thirteen years old, during my waking up time, I realized that he was my grandpa, and I traveled with him." He continued, "Then, when he was elderly, I used to pick him up and drive him around. He used to love to go to the powwows for socialization."

As separated as Jim was from his immediate family after his wife Eileen died, in his later years Jim's life revolved around spending time with his children and grandchildren, sharing his family's history and attending community events at Lac Courte Oreilles. His elder friends attest to the fact that Jim was a fluent speaker of *Ojibwemowin* and knowledgeable of Ojibwe culture and traditions. They enjoyed visiting with him for the opportunity to speak the language. To most who met him, Jim was a pleasant person with an easy going manner and a quiet determination.

JOSEPH LARSON

CIRCA APRIL 7, 1892 – AUGUST 22, 1984

Like so many others of his generation, Joseph Larson was born in a *wiigiwaam*, connected with the earth and all it can provide. With beds of evergreen boughs and floors covered with skins or mats, *wiigiwaaman* provided a connection to the earth and were infused with its scents. In this intimate setting, Joe was born to Mary Homesky (Mandaamin, also called Mary Giwegijig) and Nelson Larson (a non-Indian) during the *ziinzibaakwad* season. Joseph and his sister Olivia were the only two children born of this union. Traditionally, in March and April, families moved from their winter locations to their *iskigamiziganan*. They moved themselves and their belongings from one place to another by walking for miles. Once at the sugar bush location, *wiigiwaaman* were erected for shelter, and the seasonal settlement once again bustled with the activities of processing *wiishkobaaboo* into *ziinzibaakwad*.

The Larson family lived for many years near the Chief Lake community at a spot known as Pat's Landing, near the Lac Courte Oreilles Tribe's current cranberry marsh. At around age ten, Joe was removed from his home by the Bureau of Indian Affairs (BIA) and sent to the Hayward Indian Training School, where students were assimilated into the dominant white culture by learning academic subjects and undergoing occupational training.

As a young man, Joe married Catherine Rabideau from the Bad River Reservation, and eighteen children were born to this marriage, including three or four sets of twins. Peter Larson, also included in this book, was one of those children. Joe and Catherine first homesteaded a place on the Chippewa Flowage on family land near Pat's Landing, and then a second place on the top of what came to be known as Larson Hill, the site of the Larson family allotment acreage. Joe was one of the few Lac Courte Oreilles people for whom a geographical feature is named. Larson Hill, at 1,466 feet above sea level, is the highest point in Sawyer County and the spot from which WOJB, the tribe's 100,000-watt FM radio station, broadcasts to most of northern Wisconsin.

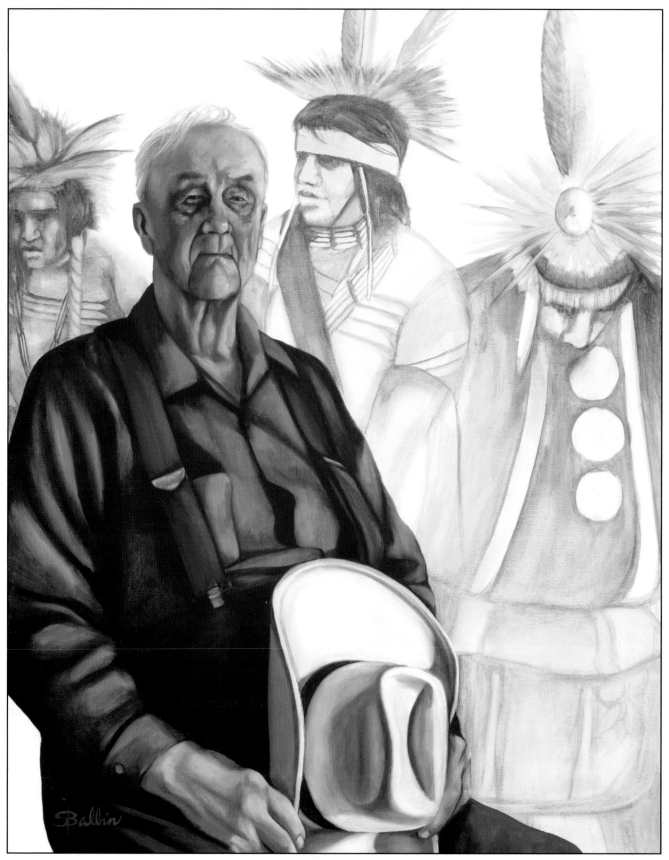

Joseph Larson, oil on canvas, 29x37 inches, 1979, Lac Courte Oreilles Reservation

While still living at Pat's Landing, the family walked several times a year from there to the town of Winter in order to stock up on provisions. The trip to town could take two or three days. With a constant need to provide for their large brood, they also traveled northward to Lake Superior and camped on Madeline Island, where they harvested the blueberries that were abundant there, a custom practiced by the Ojibwe for generations. During the winter and spring seasons, when there was little to harvest, Joseph worked as a lumberjack and carpenter. Although he was a self-taught carpenter, his skills were taken from the pages of the many library books he diligently studied. His work was highly respected by those who knew him. Many of his children and grandchildren learned carpentry skills from him.

For two and a half years during World War II, he worked in Alaska as a civilian employee of the Federal Government, helping to supervise the construction of a military base.

Joe built many homes and barns in the reservation area, including his own home on Larson Hill. He also applied his talents by helping to build Williams Resort. Structural carpentry wasn't his only area of expertise with wood. Joe's artistic *Anishinaabe* side shone forth when he built beautiful wooden skiffs, well adapted to gathering wild rice and guiding clients to the perfect fishing hole.

He also enjoyed making traditional Ojibwe household items for his family. His grandson Stony recalled a time when he asked Joe to build a cradleboard for his son Ahsinees, who was born in 1976. Joe went into the woods, found a big hickory tree, cut it down, and sawed out a section. He fashioned the traditional cradleboard by hand, and it saw plenty of use in Stony's household.

Stony also remembered the advice that Joe gave him about being prepared for survival when walking in the woods: "Always take some birch bark from a tree and carry it with you so that you will be able to build a fire by using it as tinder." Birch bark is waterproof, and will burn even when wet. This type of knowledge was important because life on Larson Hill was never easy, with no electricity or telephone. The family lit their nights with kerosene lamps and gas lights, hauled water from the outside hand pump, and heated with firewood. The Larsons had horses, cows, and chickens, and grew potatoes, corn, and a host of vegetables in their garden.

One time Joe was coming in from the potato patch at dusk, and he stumbled onto a cantankerous female bear with her cubs. The sow rushed at him, and he found himself fighting for his life armed only with the potato knife, which he luckily still held. Although the bear injured him severely, he wrestled with it, slashing and stabbing at the bruin until he finally killed it. After he was safely home, Joe decided to gift another family with this bear, even though he loved to eat wild game.

Joe was a tall, physically strong, and healthy man who lived to be ninety-two years old.

Catherine, however, walked on at the early age of forty-three. As his children grew into adulthood and moved away, Joe remained on the hill-top farm, eventually living alone. Reluctant to give up his familiar surroundings and way of life, Joe made do with the simple ways that had served him well for so many years.

The only change he embraced was the coming of radio communications between the farm and other reservation communities. With no telephone service available on Larson Hill and in other outlying Lac Courte Oreilles communities, citizens band (CB) radio was enthusiastically embraced on the reservation. Being up on high ground gave the Larsons real reach with their five-watt CB transceiver. With no call letters required, users of CB radios usually operated under nicknames or "handles." The farmhouse became "Gaslight Base" and the radio in the car became "Gaslight Mobile." In the late 1960s, when Joe's son Peter moved to a community near Reserve known as Skunawong, Peter and his wife Marjorie used "Skunawong Base" as their handle and Marjorie used the handle "Skunawong Mama" when speaking to her son Stony on his truck's radio.

Even with such communication available, a point came in Joe's life when his family felt that he shouldn't be living on Larson Hill alone. His son Pete had moved back from Milwaukee to the Lac Courte Oreilles Reservation in 1967 and settled in Skunawong. Pete and Marjorie convinced Joe to move in with them. But Joe kept yearning to be back on Larson Hill. Many times he headed out to hike back to his hill, without telling anyone. On one such winter occasion when Marjorie arrived home and Joe was nowhere in sight, she set out on foot to look for him. She made the five-mile hike to the farm and back to Skunawong, not seeing Joe anywhere along the way. After going back inside her house, she looked out the picture window overlooking Gurnoe Lake and saw Joe walking back across the ice. He had decided to take a shortcut.

After Joe was too old to do much hunting or fishing, he continued to spend hours recalling the many interesting things that had happened to him. He particularly enjoyed himself whenever Marge, Pete, or Joe's friend Elmer, were able to drive him around to look for deer and other animals.

In his final years, failing eyesight and hearing made it hard for Joe to converse. Despite his traditional ways, he enjoyed watching professional wrestling on television. With the volume turned up, he became engaged in the wrestlers' performances, sometimes leaping from his seat, waving his arms, and yelling "Kill the S.O.B.!" On one special occasion, Pete and Marge took him to a live professional wrestling performance in Spooner, and Joe thoroughly enjoyed the outing.

In his senior years it was difficult for him to acknowledge that he needed assistance to move about and sometimes had to be lifted. Marge's brother Jeff Bullis took up residence in

the Peter Larson household to do what Pete and Marge couldn't.

Out of Joseph Larson's original eighty-acre allotment, he willed half to his son Peter, and the other half to Pete's sister Lillian Jensen. Larson descendants live on that land to this day.

Electricity finally came to Larson Hill around 1980, just a few years before Joe walked on, when the Lac Courte Oreilles Community Radio Station, WOJB, became licensed and constructed its transmitting facility there. The environmental, cultural, and traditional changes that Joe witnessed in his life time were phenomenal.

PETER GEORGE LARSON

SEPTEMBER 8, 1920 - JUNE 24, 1992

Peter Larson, the son of Joseph and Catherine Rabideau Larson, was born in the Stone Lake area, and given the Ojibwe name of Agongos. Peter was a member of the *Gekek Doodem*, and a direct descendent of Chief Akiwenzi, who signed most of the treaties to which the Lake Superior Chippewa were signatory.

He attended the Flandreau Indian Vocational School in South Dakota to receive his education, and graduated from the high school, which is still in operation. Flandreau is the oldest continually operated federal Indian boarding school maintained by the Bureau of Indian Affairs (BIA).

Peter met his future wife, Marjorie, in June 1945 while he was serving in the Armed Forces. The war had just ended in Europe, where Peter served as an infantry sergeant, fighting in France, Germany, and Central Europe. When he and Marjorie met, he was in Milwaukee awaiting his discharge from the military.

Marjorie and Peter were married in December 1945, after which Peter was sent to Texas to be discharged. When he returned, they settled south of Milwaukee in Caledonia and began their family, which eventually included four sons: Frank, Peter Jr., Steve, and Stony.

Peter found work at the Chain Belt Company in Milwaukee, where he scored remarkably high in their aptitude tests for electronics. He also worked nights as a machine operator for three years while studying electronics. When the employees at Chain Belt went on strike, he went to work for General Motors as an electrical and mechanical technician in their AC Spark Plug division. While with AC Spark Plug he rose to the rank of electromechanical technician, senior grade.

In 1947 the Larson family moved to Oregon where Peter worked as a machine operator for AC Spark Plug for three years. Peter Jr. was born in Oregon, and in 1950 the company

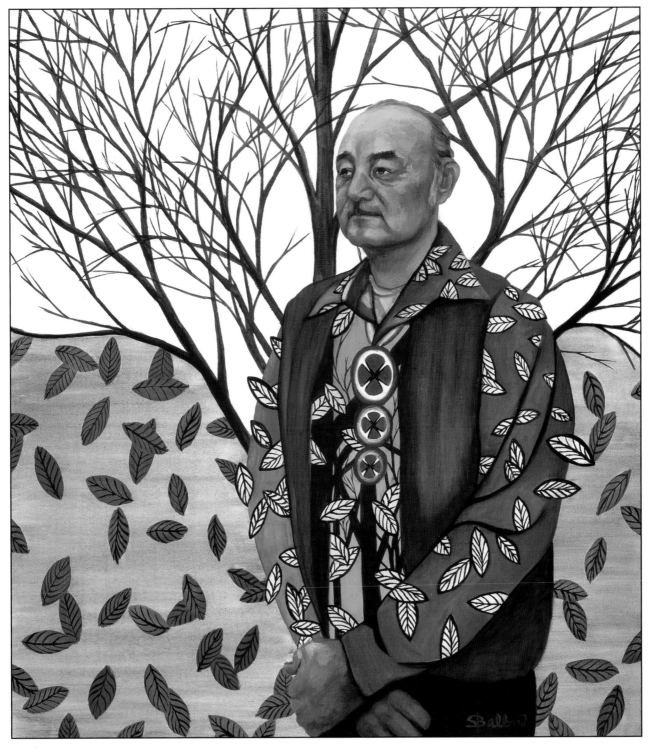

Peter George Larson, oil on canvas, 17x31 inches, 1980, Lac Courte Oreilles Reservation

transferred Peter back to Milwaukee. During this period of time, he was elected chairman of the Consolidated Tribes of American Indians for three consecutive terms. This mostly social aggregation of Indian people in urban Milwaukee was the first of several American Indian organizations which he served.

In 1962 the Larsons moved to Massachusetts, where they remained for four years. During this time Peter worked at the Massachusetts Institute of Technology, applying his skills to the school's involvement in the Apollo Space Program. Not long before the United States sent its manned mission to the moon, Peter had his photograph taken with pioneering astronaut John Glenn.

As a reflection of his educational background, professional experience, and innate problem solving abilities, Peter earned a reputation as an inventor, often working to improve things so they worked better. His resourcefulness came into play, for example, when his son wrecked the family's Volkswagen. In order to work on the car, Pete made special tools that fit the unique needs of repairing the German-made automobile. He often worked on cars, and there weren't many things Peter could not fix.

Due to declining health, Peter retired in 1967 and returned to the Lac Courte Oreilles Reservation. His physical health was compromised with a diagnosis of arteriosclerosis, particularly in the legs. Although he was told that he would probably lose the ability to walk, he opted to try a surgical remedy, which was a success. He fought his way back to health and was quite active for the next twenty years.

At Lac Courte Oreilles, Peter was involved in tribal business, working through the federally funded Community Action Program as a community planner, youth coordinator, and newspaper editor. He was recognized statewide for his work with poverty reduction programs at Lac Courte Oreilles.

In 1968 he was elected to a two-year term as chairman of the Great Lakes Inter-Tribal Council (GLITC). According to Marjorie, when they moved to the reservation she worked for GLITC. Peter often accompanied her as she traveled to meetings. She remembered one meeting at the Red Cliff Reservation where he spoke forcefully and at length about several matters of concern, especially the newly emerging issue of Indian self-determination. He was elected on the spot to the GLITC chairmanship.

At the same time, Lac Courte Oreilles Tribal Councilman Henry Smith resigned, and Peter was selected to finish out his term. Altogether, Larson served on the Lac Courte Oreilles Tribal Governing Board for fifteen years, including one term as vice chairman.

During his years of tribal service, Peter was a moving force in the tribe's reclamation of land along the Chippewa Flowage and in the negotiation of a new lease agreement with

Northern States Power for the Winter Dam. When it came time for the renewal of the lease, Larson helped negotiate conditions where Lac Courte Oreilles gained control of the dam and got its own hydroelectric plant there.

Peter was known for his concern about honesty and ethical conduct within tribal government. Elected officials can never please everyone, Peter believed, but must act for the greater good of the majority of the people. According to former Tribal Chairman Dr. Rick St. Germaine, for a period of twenty years nothing of substance was created at Lac Courte Oreilles unless it was first reviewed by Peter Larson. He was the only tribal council member who didn't campaign—because he didn't have to. Consecutively elected to the tribal governing board, he often turned down offers to serve as an officer of the board, leaving the glory to the younger, more ambitious council members.

St. Germaine wrote that Peter Larson was a father figure to younger council members, a sage man whose quiet advice usually won out when the dust had settled and the votes were taken. Newly elected council members were sent immediately to his office for orientation. He made significant contributions to all of the major construction projects that marked the period of the Lac Courte Oreilles Tribe's surging growth during the late 1970s and early 1980s, including the tribal government center, K-12 school, community college, commercial center, health center, community radio station WOJB, 88.9 FM, and cranberry marsh.

When he retired from public service in June 1985, the tribe honored him with a Peter Larson Day Celebration. Humorous memories were recalled, speeches were made recognizing his long service, a message from Wisconsin's governor was delivered, and he was given an eagle feather. The main meeting room of the Lac Courte Oreilles Government Center was named for him, and his portrait hangs there to this day.

When he walked on in 1992, he and Marjorie had been married for more than forty-six years. They had eight grandchildren and six great-grandchildren.

ELSIE SLATER LEE

CIRCA JANUARY 3, 1893 - MAY 8, 1982

"Elsie Slater Lee had a soft and gentle manner and was very poised and ladylike," observed Lac Courte Oreilles historian Dr. John "Little Bird" Anderson. She sang soprano in the choir at St. Ignatius Church in New Post. "Elsie once told me that happiness to her meant being alive and knowing she was loved. To demonstrate her friendship, and because she knew of my love for music, she presented me with a book of songs."

Elsie was born and reared in the original, pre-flood settlement of Post, one of the oldest settlements at Lac Courte Oreilles. Like other tribal members of her time, she was born in a *wiigiwaam*. The oval or round *wiigiwaam*, approximately twelve to fifteen feet across and six feet high in the center, with an overhead smoke hole, was the primary house style for Native Americans throughout the northeast. The framework was made of saplings with the ends stuck into the ground and covered with cattail leaf mats, sewn rolls of birch bark, or sheets of elm bark. The wigwam design was easy to construct with natural materials and suited a migratory life style.

Her relatives included the Cloud family and the Bluesky family. Elsie had a brother, Edward (Eskie), and two sisters, Mary and Nellie. Mary did not have children. Nellie had a son, Henry Cloud Jr., and two daughters, Sandra and Sharon. Edward had one daughter, Norma.

Like other children of the Lac Courte Oreilles Reservation, Elsie attended the Hayward Indian Training School. Throughout the late nineteenth and early twentieth centuries, the United States Government kept up its efforts to force assimilation. Native forms of worship were forbidden, and in order to obtain an education, Indian children were forced to leave their families and attend boarding schools. Most Ojibwe children attended one of three government-run schools in Wisconsin: Hayward, Tomah, or Lac du Flambeau. Other Ojibwe children were sent as far away as the Carlisle Indian Boarding School in Pennsylvania. Most of

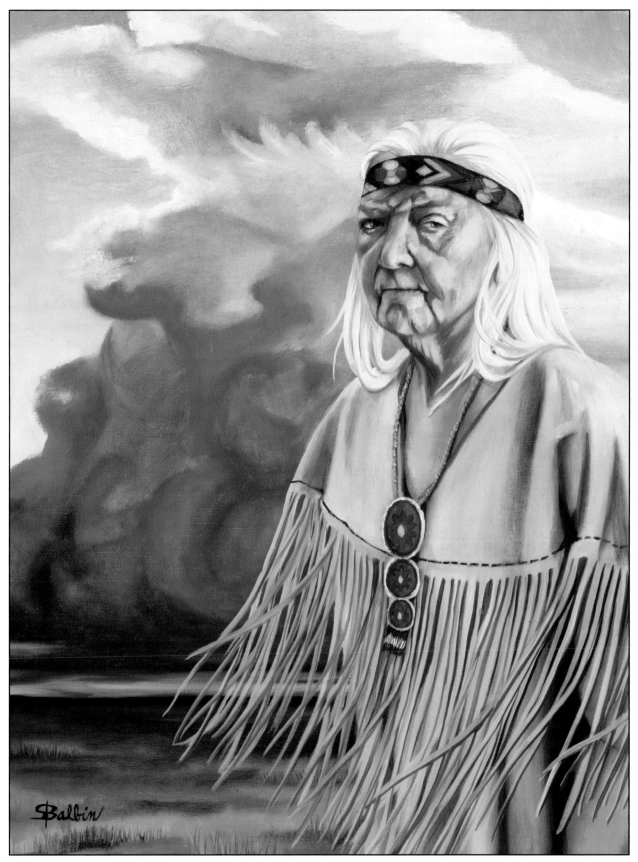

Elsie Slater Lee, oil on canvas, 19x25 inches, 1980, Lac Courte Oreilles Reservation

the schools in Wisconsin patterned themselves after the Carlisle model, providing a half-day of academic instruction and a half-day of occupational training.

Having acquired a Euro-American style of education, Elsie left the reservation seeking employment. She found work as a stenographer in Chicago, where she met her future husband Chris Lee, a policeman. After they were married, they moved back to the Lac Courte Oreilles Reservation and were the original owners of Herman's Landing Resort on the Chippewa Flowage. It was a thriving business crowded with tourists eager to rent boats, engage Indian guides, and stay in the Lee's guest cabins.

As a resort owner, "Elsie was a gracious lady," stated Phyllis DeBrot. "She lived a quiet life. When my children were stricken with polio, she was very concerned about them. She came over with books to read. I also remember that she was a wonderful writer. Elsie wrote a very nice poem that she called 'My Million Dollars.'"

As Elsie grew older, she eventually lost her hearing, but continued to help her people by teaching *Ojibwemowin* and the Ojibwe culture she learned in the village of Post. According to John Anderson, "Elsie was a very intelligent lady with a fine sense of humor. Historian Eldon Marple often consulted with her on Lac Courte Oreilles history and reservation photographs."

As a way of perpetuating her culture, when Elsie learned that her portrait was going to be painted for the *Hall of Elders* series, she confided with artist Sara Balbin, "I will accept the compliment of having my picture painted. My one request is that the picture be painted with me in a buckskin dress and a headband. I want people to know that I'm an *Anishinaabekwe* and not the Queen of England." For the portrait, she wore a handmade buckskin dress created by her friend Mary Sutton.

Buckskin, or deer hide, was the traditional fabric used for garments before the Ojibwe gained access to trade cloth and blankets. Today, there are still tribal members who tan hides in the traditional manner. The process requires patience and expertise. The final result of the hides depends primarily on the skills of the women, and the age, sex, and condition of the deer.

Elsie lived comfortably with both the Ojibwe and Euro-American cultures. She considered herself a Christian woman but also taught the traditional ways of the Ojibwe people, including the history of the *Chi dewe'igan*. Elsie often said the Big Drum was a way of helping other people.

EDWARD "SCOOP" MARTIN SR.

CIRCA AUGUST 24, 1912 - MARCH 27, 1999

There wasn't much that happened at Lac Courte Oreilles that escaped the notice and the note-taking pen of Edward Martin Sr. Known to many as "Scoop," Ed wrote his "Lac Courte Oreilles News" column in the *Sawyer County Record*, the Hayward area's weekly newspaper, for twenty-two years. His chronicles of daily life at Lac Courte Oreilles were also published in the *LCO Community Journal*. He did not, however, become a local columnist until after he had retired from a long and varied career, which included working in seven different cities in the Midwest and serving in the U.S. Army in Europe during World War II.

Ed was born at home on August 24, 1912 to Edward and Julia (Smith) Martin, one of thirteen children born to the couple. According to Ed, "I was born premature, and was a very tiny baby. Because of my size and low birth weight my life was at risk. My mother didn't want to put me in jeopardy by making the long journey to a hospital, so she laid me in a cotton-lined shoebox. Then she placed me in one of the cabinets above the family's wood cooking stove to keep me warm. My mother fed me with an eyedropper. Thanks to her nurturing, I survived." Throughout his life he was fond of telling this story, and was grateful for his mother's inventiveness, care, and determination to save him. He lived to see his other family members walk on, beginning with the loss of his father when Ed was only five years old.

When asked what his favorite activities were as a youngster in Reserve, he stated:

> There were quite a few things I used to do. I never did hunt and fish or trap very much. When I was a teenager, my only weapon was a slingshot. I used to hunt squirrels. A bunch of us kids used to roll old tires around. And we used to make whirligigs and fly kites. I also used to hitch up my dog to a sled and ride around behind him in the winter. All of these things were a lot of fun.

> We lived in the middle of Reserve, which was smaller than it is today. We didn't have these outlying communities then.

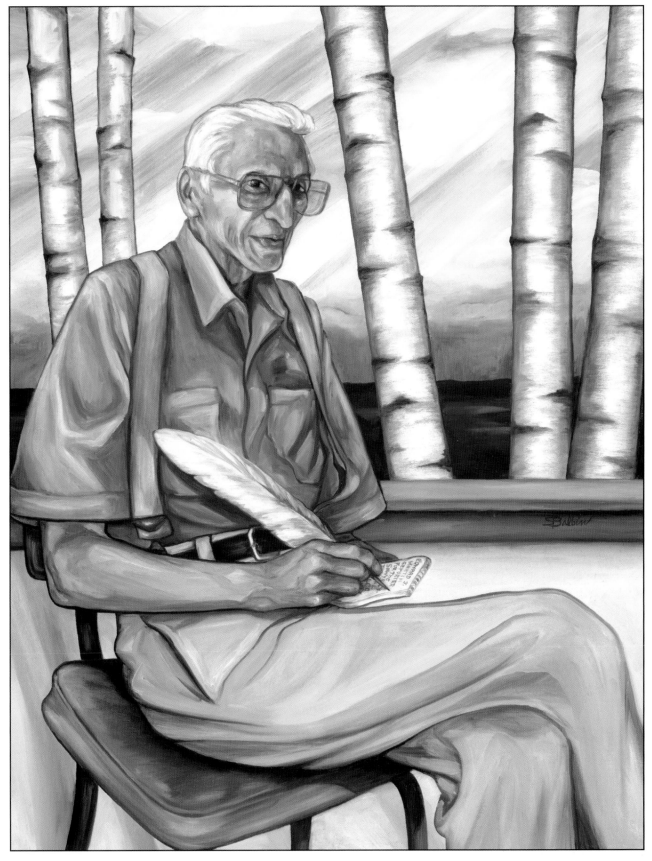

Edward "Scoop" Martin Sr., oil on canvas, 32x42 inches, 1996, Lac Courte Oreilles Reservation

He was referring to communities like K-Town, where he lived until the end of his life.

Ed studied at various schools, first attending the St. Francis Solanus Indian Mission School in Reserve. Then he was a student of Sister Sirella, who reopened the Mission school, which had been closed for an extended period of time. According to Ed, "She had three students: me, Irwin Isham, and my sister Veronica." Ed continued, "I also attended schools at Odanah, Drummond, and Tomah, all in Wisconsin, the Haskell Institute in Lawrence, Kansas, and a vocational school in La Crosse, Wisconsin."

A harbinger of things to come, his graduation from high school at the Haskell Institute came with a vocational specialty in printing. The building in which Ed lived at Haskell was named for the community of Osceola, a name that he used when he penned the "Osceola News" as the correspondent from this building. The groundwork was laid for his later calling as a community journalist.

Not all of Ed's post-academic pursuits were of a journalistic nature. One of his first jobs was with the Civilian Conservation Corps. Before World War II, he labored at pulling out and killing gooseberry vines in the woods in order to break the life cycle of blister rust, which had decimated Wisconsin's white pine population. Before he entered the military, Ed also worked at other jobs, including slaughtering hogs in St. Paul, slaughtering chickens in La Crosse, and polishing cabinets at a factory in Superior, Wisconsin.

Ed was the first member of the Lac Courte Oreilles Band drafted into the armed services during World War II. "I got the number 158, the first number put out in the lottery," he recalled. "Then, when they called me in, all of those age twenty-five and over, including me, were discharged."

A few months later he was called in again. "I always tell everybody that when things got tough, they called me back," he said with a chuckle. "I stayed in the states for quite a while. I used to stencil overseas bags for boys that went over. I finally had to stencil my own bag for me to go over." He served in the Quartermaster Corps in the European Theater for one and one-half years, seeing duty in Germany, France, Belgium, Holland, and England.

"We used to haul supplies for General Patton's army," he said. "That was kind of a tough, dangerous job, too. People thought that it was a soft job, but it wasn't. Those Germans were after the supply lines, so we were right in it. We had some guys killed while I was there. When they had the Battle of the Bulge, I was right in that city that they were after, Liège."

As the war dragged on into 1945, Ed and hundreds of thousands of other American soldiers were scheduled to invade Japan. The dropping of atomic bombs on Hiroshima and Nagasaki that August, however, ended the war and Ed was able to come home.

By the time he was discharged from the service he had attained the rank of sergeant. After

the war, he continued serving his country as a member of the Wisconsin National Guard in Hayward under the command of Captain Tony Wise.

At age thirty-six, the veteran soldier married nineteen-year-old Mary Gokey. They had seven children—Allen Roy, Linda Marie, Edward Jr., Gerald (Chicky), Melvin, Julie, and Lu Ann.

As a civilian, Ed worked many different jobs, including hog slaughtering and working as an orderly in a mental hospital in cities including Chicago and Milwaukee. He was forced to retire at the age of sixty due to a lung ailment, however, and he returned to Lac Courte Oreilles.

It was 1972, and he became a regular reader of the *Sawyer County Record*. He noticed there were local columns covering a number of communities in Sawyer County, but none which covered his own community of Reserve. He approached the *Record* about writing a column and was given the go-ahead. On March 15, 1973 Ed's first column appeared under the heading "Reserve News."

The first column was, more or less, similar to those which followed for the next twenty-six years. He wrote about Sister Sirella, his former teacher, returning to LCO for a visit after living abroad, where she did mission work.

He wrote that the LCO Athletic Club would sponsor a St. Patrick's Day dance, featuring a local band called "The Ojibways." And in that very first column he was in the middle of writing about housing at LCO when the column ended abruptly, apparently due to a layout error on the part of the *Record*.

Apparently Ed got over the shock of being cut off mid-sentence his first column out, because his next column appeared two weeks later on March 29 and continued to appear until he walked on in 1999. Eventually, to be more representative of all the smaller communities that developed at Lac Courte Oreilles, Ed started calling his column the "LCO News."

As the years advanced, Ed found that he couldn't be everywhere to cover the news, so he'd ask others to take notes for him at different events, which he would use to add to his weekly column. "I have different ways of getting news," he said in a 1995 interview with the *Record*. He said that people would call him with news items or he'd "scribble" notes when he attended events. "I like to write the names down of those who help." When someone would relate an interesting story from the past he'd tell them, "Write that down and I'll put it in the paper."

Known throughout Lac Courte Oreilles as "Scoop," Ed's beat included news from the café at the LCO Commercial Center, WOJB community radio, the LCO Medical Clinic, and the LCO Housing Authority. As the years passed, the Reserve Elder Center, where Scoop spent much of his time playing cribbage, figured more prominently in the column.

While taking a class at the senior center on *Ojibwemowin*, Ed was given the name Ozhi bii ige wi inini, Man Who Writes.

When Ed walked on in 1999 he was the longest-standing local columnist to have penned for the *Record*. The responsibility for writing the weekly "LCO News" column was passed to his good friend, Mary Wolf, who volunteered to take up where Ed left off.

In the "LCO News" she remembered him in this way: "It is with sadness that we have to let go of Ed, but we're happy he is soaring free.... You will live on in our hearts, Ed."

FRANCES KATHERINE MARTIN MIKE

CIRCA SEPTEMBER 20, 1914 - JULY 21, 1994

F rances Mike was born during the harvest of *manoomin*, in the village of Reserve, to Nancy and Frank Martin. Frances recalled being told that she was born at home sometime during the "Ricing Moon." She belonged to the *Waabizheshi Doodem*. Her sisters and brothers included Veronica, John (Johnny Cake), Eddie, a stepsister Bernice, and stepbrothers Ott and Jim.

Frances was reared by her parents in the Ojibwe culture. They survived primarily by harvesting the fruits of each season. Work available outside of the Reserve settlement was seasonal and scarce. Like her peers, she was removed from her home around age eight or nine and sent to one of the regional Indian boarding schools. Not all Lac Courte Oreilles children attended the Hayward Indian Training School because of its occupancy limits. Frances was not certain of which Catholic boarding school she attended, but recalled that the German nuns spoke *Ojibwemowin*, and that they were mystified as to why Indian children were forbidden to speak their native language. The bilingual aptitude of the nuns encouraged the Indian children to retain their first language while learning English for assimilation.

While attending the school and working in its cafeteria, Frances remembered becoming ill one winter. She was taken to her room and did not regain full consciousness until the spring. From that lost time, she had only vague memories of an elderly nun who cared for her. After her recovery, Frances continued with her studies at the school and learned much from the nuns' European culture.

Eventually Frances moved back to Lac Courte Oreilles to live with her family. There she met and married Joe Mike, from the Signor area. The young couple made their home on the reservation by the Billyboy Dam and had nine children: Sylvester, Joseph (Buster), Jerome, Patsy, Bob, Sharon, and Linda. Two infants, Evelyn and Gregory, died shortly after birth. To date, there are thirteen grandchildren and twenty-one great-grandchildren. She was especially

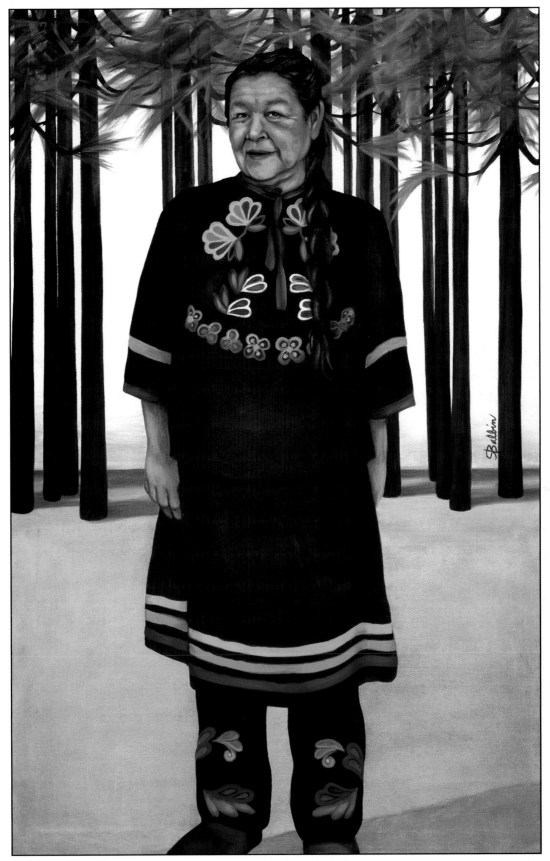

Frances Katherine Martin Mike, oil on canvas, 31x49 inches, 1979, Lac Courte Oreilles Reservation

fond of her grandson Greg, who was named after the son she lost.

When she and Joe lived in Signor, seven families resided there. According to Frances, everyone had gardens, and the women picked blueberries in groups. They enjoyed those outings, never worrying about being bothered by bears because the parents and the children made so much noise that the usually shy bruins kept their distance. Another annual excursion was made when Joe and Frances, along with Joe's sister Lucille (Mike) Kingfisher, and her husband John went fishing together below the Billyboy Dam during summer months.

Her youngest daughter Linda recalled many happy times when neighbors gathered to play ball with the children. Everyone played together—elders, young adults, and children, many of whom were members of the Blackdeer, Ricehill, and Belille families.

Frances lived most of her life at Lac Courte Oreilles, although she lived briefly in both Minneapolis and Chicago in her adult years pursuing employment for her family. After returning to Lac Courte Oreilles at age fifty, she went back to school and completed her high school equivalency diploma. She was then employed by the Lac Courte Oreilles Ojibwe School to teach with Beverly Gougé in the Ojibwe cultural class.

At this time she and artist Sara Balbin were introduced. According to Balbin, "Frances did live modeling for me. She had beautiful black/brown straight hair in a single braid past her waist on her back. Frances was a noble *Anishinaabekwe* who was committed to teaching the traditional Ojibwe arts and culture."

Frances was best known for her woodland floral beadwork artistry and was often asked to make moccasins or ceremonial vests for members of the Big Drum Society. She and her daughter Linda were also commissioned to make a vest for Tommy Thompson, then governor of Wisconsin. Historically, the intricate floral glass beadwork patterns which Frances designed are a transition from porcupine quillwork, rather than being derived from earlier kinds of beadwork. Porcupine quillwork was one of the most widespread of the earlier decorative techniques among the Ojibwe. At first, the beadwork followed the older geometric quillwork patterns. However, the designs quickly became more curvilinear with the use of the small glass beads, which can be sewn in intricate patterns. Some speculate that the German nuns that Frances studied with were skilled in the art of embroidery and influenced not only her designs, but also the beaded floral designs regionally.

Frances was respected for her adaptability, her quest for learning, and her traditional practice and teachings of Ojibwe arts and culture. One of her favorite sayings was "You can't wish for something you never had," a phrase she repeated often during or after a hard winter. This phrase was indicative of how she tried to cope with circumstances not under her control and managed to live a positive, productive life without regrets.

MARIE CLOUD MORROW

CIRCA AUGUST 3, 1922 - JULY 11, 1989

Marie Cloud Morrow, or Naawakwe Giizhigookwe, lived the traditional Lac Courte Oreilles lifestyle as a member of the *Ajijaak Doodem*. Rearing a family utilizing the bounty given by the Creator, *Gichi-manidoo*, and the loving, nonjudgmental ways of Indian spirituality came naturally to her.

She was born in late summer to Anna Baker and Frank Cloud in the Chief Lake area. The couple had four girls: Marie, Helma, Josephine, and Sarah. One month before her tenth birthday, Marie's father died. Her mother later married Alec Sharlow and together they had four children: Kenneth, Alex, Howard, and Susan Sharlow.

Marie was reared in a traditional Ojibwe household where *Ojibwemowin* was spoken. By the time she was old enough to attend the Hayward Indian Training School it was preparing to close. Her daughter Kathy said that Marie attended school in Whitefish through approximately the fifth grade, when she left school to help at home. The home environment offered Marie an education in the Ojibwe culture, traditions, and *Midewiwin* belief.

Marie met her future husband, Francis L. Morrow, in 1952 when he visited his brother, George Morrow, who was married to Marie's sister, Sarah Cloud. Marie and Francis reared five children: Bill, Kathy, Lori, Dorothy, and Sharon. The children attended the Kinnamon School, located at the intersection of County Roads E and K, on the Lac Courte Oreilles Reservation. "The Kinnamon School had two rooms on the main floor," Kathy recalled. "In one room they had first through third grade, and in the other room, fourth through sixth grade. In the basement, there was a kitchen and a gymnasium. Our home was about seven miles from the school so we were taken to school by bus."

The couple's first home was a simple two-room dwelling in the Chief Lake area. According to Kathy, "The larger room was approximately sixteen feet by twenty feet. In this room

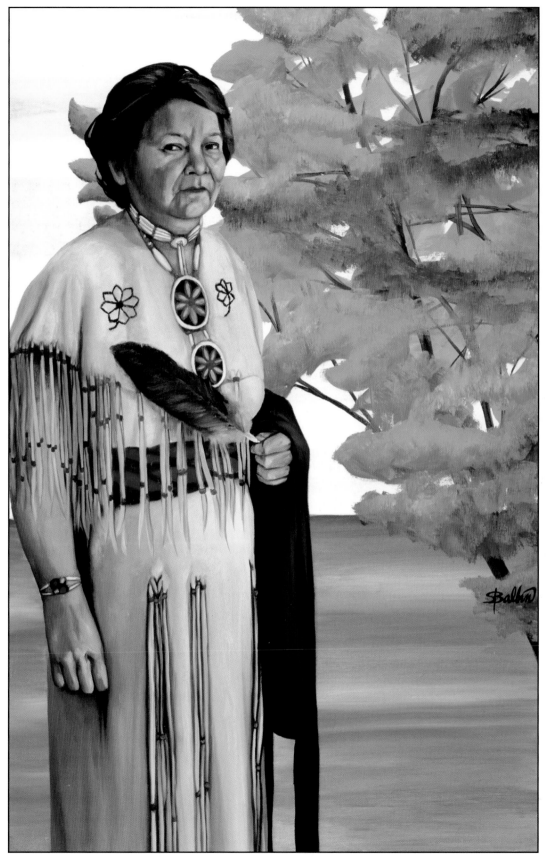

Marie Cloud Morrow, oil on canvas, 25x39 inches, 1980, Lac Courte Oreilles Reservation

there was a pail of drinking water (brought in from an outdoor hand pump), a wash basin, a wood-burning cook stove, and a kitchen table with a few chairs. The smaller room was large enough for just a double bed and a cot where my father slept. When our home was eventually wired for electricity, a freezer was squeezed into the bedroom. Outside the house we had an ice box, kept cold with snow and ice, for keeping fish." Marie's daughter Lori recalled, "Although the house was small, there was always room for company, even if it meant making up beds underneath the kitchen table."

With no electricity, the family lived without benefit of electric lights, running water, refrigeration, an alternate heat source for cooking and heating, radio, and television. "When we got hot running water in the house," Kathy said, "Lori and Dorothy would do dishes all of the time, just because there was no heating of the water and filling of two dish pans—one for washing and one for rinsing the dishes." Living without electricity was standard on much of the Lac Courte Oreilles Reservation through the 1970s and into the 1980s.

Later the family added two rooms, making it a four-room house where they lived until Francis and friends of the family built a different home with running water, four bedrooms, a kitchen, a bathroom, and a combined living and dining room.

Kathy wrote, "The plan for our house was created by Roland LaSieur, Susan's husband. Dad built it with a little help from some friends, but he did most of the work himself." This took place during the era when the tribe began to receive money from the U.S. Department of Housing and Urban Development.

Before they had benefit of electricity, the family lived without a telephone. Instead they utilized a citizens band (CB) radio for communication, a common practice in the 1970s, still employed today due to access and affordability. Entrepreneur Tony Wise eventually had a telephone installed at Marie's house because he wanted Marie to know when her niece Vivian Cloud delivered his daughter, Angel Cloud.

As a sister, aunt, and mother, Marie could always be counted on. She never sat still, Kathy remembered, and was always doing something to support the family, such as harvesting berries, baking, doing beadwork, or cleaning *manoomin*. The family built a shed behind their house where Marie would fan away the husks after the wild rice had dried in the sun. For a long while the family survived by harvesting and hunting what was in season. Marie snared rabbits and could quickly skin them with a sharp knife by making a few cuts around the rear legs and then peeling the skin off the carcass. She baked a great deal, always having freshly made bread, cinnamon rolls, and cakes when her children came home. Francis was equally involved in rearing and supporting their family. Aside from harvesting, fishing, and hunting, he cut firewood with a small crosscut saw for the family to heat and cook. He was employed by the Bureau of

Indian Affairs and worked with a construction crew. He also worked part time at the Hayward Police Department as a dispatcher.

As a mother and *Anishinaabekwe*, Marie taught her children the ways of her people. She belonged to both the Big Drum society and *Midewiwin* faith. She taught by being a stable and loving role model. "My mother practiced what she learned," explained Lori. She taught the children to hold their tongues when they were angry, Lori remembered, and to treat others the way they would like to be treated. She embodied the *Midewiwin* faith and integrated it into her life. Her motto was "*Midewiwin*, every day. Being Indian, you live it."

Lac Courte Oreilles spiritual leader James "Pipe" Mustache Sr. spent time with Marie as she prepared to walk on to the spirit world, staying up all night and seeing her through the dying process at her home. He later presided over a traditional *Midewiwin* burial ceremony for her. Artist Sara Balbin was privileged to be present at that ceremony, and remembers the large number of relatives and friends who came to honor Marie's life, pay their respects, and celebrate her walking on.

JAMES "PIPE" MUSTACHE SR.

CIRCA NOVEMBER 18, 1904 - APRIL 11, 1992

There are some people who touch the spirit in others just by meeting them. These people, at once simple and complex, are fully aware beings. They never stop teaching. James Opwaagan "Pipe" Mustache was such a man. He could sing and transport his listeners to heaven if they listened in a good way. Pipe could use life's everyday chores to illuminate the meaning of life itself with an impish sense of humor. He was the ambassador of the *Anishinaabe* (Ojibwe) people to other American Indian communities. He spoke for *Anishinaabe* people to white people and their governments.

James was born in a *wiigiwaam* in the Lac Courte Oreilles community of Signor. He was of the *Name Doodem*. His given name was Omashkooz, which he translated as "Running Elk." Because his mother died early in his life, he was reared by his maternal grandparents. Traditional practitioners of the *Midewiwin* belief, they gave to their grandson, little James, the core principles of the *Midewiwin*, which are balance, respect, tradition, and gratitude for and certainty of the presence of *Gichi-manidoo*, or Great Spirit, who is everywhere, in all things.

James was an intelligent, inquisitive child who was constantly asking adults, "why?" He would peek into *wiigiwaaman* where spiritual ceremonies were being held. The adults would bring him in and say, "You will become a student. It will not be easy. You will listen to what we tell you and learn it. You will do gladly the tasks which we give to you."

The young man was a good student, as good as an irrepressible boy can be. He learned only in his native language—the songs, the names of medicines, the ceremonies, the thoughts that could be formed only in *Ojibwemowin*. One of his teachers was a man called Zhooniyaa-giizhig, also called Pipe. In time, James became known as Little Pipe, an honor that he earned by being a good student.

The early part of the twentieth century was a time of massive upheaval for American Indi-

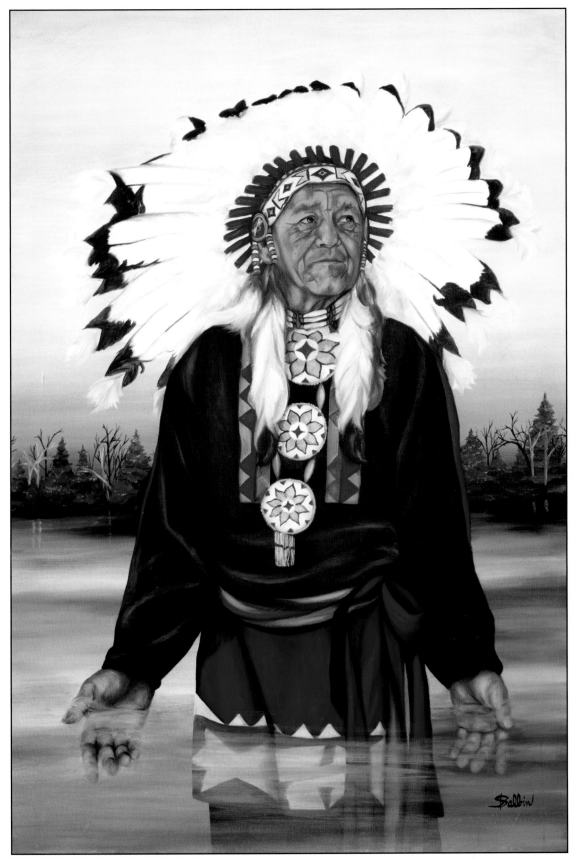

James "Pipe" Mustache Sr., oil on canvas, 28x41 inches, 1979, Lac Courte Oreille Reservation

ans. The treaties signed fifty to seventy-five years earlier had resulted in the wholesale timber harvest of the great northern forests. Mining had taken over the landscape. James later talked of conversations he heard when he was eye-high to the kitchen table, discussions among the elders who were debating in *Ojibwemowin*. They were talking about whether the treaties really had included the mineral rights to the land they had ceded. Many contended that the translations they had been given said they relinquished rights only as deep as the plow could till. They talked about the impact of lumbering. Many of the elders cried when the forests disappeared; going to the edge of the reservation, they could see for miles.

This was in the early days of the United States Government's Bureau of Indian Affairs (BIA), and James was soon forced by the BIA into the local Catholic school. This is when the idyllic beginnings of his life ended. The nuns, who ran the St. Francis Solanus Mission, strictly forbade the expression of Ojibwe culture. No *Ojibwemowin* was to be spoken, only English, and corporal punishment was applied to enforce this rule.

Worse yet, the nuns cut his braids off. His long hair was gone, and his grandmother cried for two weeks when she found out. In the Ojibwe culture, the growth of long hair was a symbol of spiritual strength. Only in mourning was the hair cut off. Young Pipe went to that school for just a year and then refused to go back. Later, he entered the Hayward Indian Training School, where he proved to be questioning and rebellious. He saw little good in these ways of teaching.

Eventually James was sent to a boarding school in Tomah, Wisconsin, where more white teachers failed to take the *Anishinaabe* spirit out of the young man. To avoid corporal punishment, he stopped speaking his language out loud, but he never stopped praying and talking to his maker in *Ojibwemowin*. He could still go to nature and talk to the trees, water, and sky. He could still give thanks when he saw an eagle overhead.

In his mid-teens, James ran away from that boarding school, beginning his travels. Although in the ensuing years he often returned to Lac Courte Oreilles, he also traveled to other Ojibwe reservations—the St. Croix, Red Cliff, Bad River, Lac du Flambeau, and Mole Lake Sokaogon. He also visited the other tribes in Wisconsin—the Potawatomi, Oneida, Ho Chunk, Stockbridge-Munsee, and Menomonie. James went west and made contacts in the Sioux nation. He even went to the Southwest and visited Navajo and Hopi lands.

James didn't stick to Indian communities. He learned to feel at home with all different aspects of society. He rode the rails, traveling the continent with his suitcase in hand. He is said to have had no fewer than ninety-seven different jobs during his life. He dug potatoes, had a milk route, and was a chauffeur in California when the stock market crashed in 1929. When a professional boxer came to Hayward and needed a sparring partner, James proved his

prowess by holding his own in the ring. It was just another job.

Although he traveled extensively, James always returned to Lac Courte Oreilles. He established a home in the Whitefish community, continuing to participate in *Midewiwin* ceremonies. Growing in stature within the Lac Courte Oreilles Band, he took on the rugged attribute of his namesake. He came to be known simply as Pipe.

In the wake of World War II, Pipe connected with Hayward-area tourism entrepreneur Tony Wise. A decorated veteran with a freshly earned master's degree from Harvard, Tony had returned from the European theater of war with a vision for Hayward. It involved skiing and the promotion of the region's historical heritage as ways to develop the impoverished area. Born and raised in Hayward, Tony had grown up with the people of Lac Courte Oreilles. He knew of their needs and was sure that tourists would find them vastly—and profitably—interesting.

Tony developed Telemark Resort, Historyland, and Old Hayward. To his credit, he immediately included Pipe Mustache, John Barber, Jim Billyboy, Bill Baker, and other elders in the creation and operation of all three enterprises. Together these men, and *chi mookomaan*, created the modern tourism industry in northern Wisconsin. Pipe, in his traditional regalia, adopted a feathered Sioux headdress for these public events—evidence of his public relations savvy.

He and his contemporaries actually created what has today become known as a "traditional" powwow. Before modern transportation and communication, the massive intertribal gatherings seen today didn't exist. Before the 1950s, Indian unemployment was so high that there was no way they could have come by the thousands from all over the continent for such gatherings. Tourism made that possible.

Members of the Lac Courte Oreilles Tribe eagerly gathered around their radios to hear Pipe announce, first in *Ojibwemowin*, then in English, that there would be a gathering of many Indian nations over the Fourth of July weekend at Historyland. This was in the mid-1950s, and there was only one radio station in the Hayward area at the time, WHSM-AM. To the best of anyone's knowledge, this was the first time that radio waves carried the Ojibwe language through the Northwoods.

Throughout all his years, Pipe kept his growing celebrity in perspective. He continued to be active in his religious pursuits, participating in *Midewiwin* ceremonies and keeping in touch with the leaders and people of tribes all over Indian country. He gave council and healing to Lac Courte Oreilles and beyond. All the while, he worked at whatever job caught his fancy and maintained a household. His residence in Whitefish was a hub of activity. People came to him with offerings of tobacco, eager to have the benefit of his knowledge. As is the Ojibwe way, he told traditional stories to share his knowledge. Pipe knew all of the old songs. He instructed seekers of medicine in what plants to use for healing. He spoke in parables,

sometimes employing a contrary approach, pushing people to face their shortcomings, but all the while he did so with great humor. For example, one time the Civilian Conservation Corps attempted to teach the Indians how to plant trees. They gathered some elders together and showed them a metal planting implement. Nearby was a pile of seedlings ready to go into the ground. One of the CCC men raised the tool and rammed it into the earth, but he hit a big rock. Pipe asked, "How come that rock wasn't in your book?"

Another teaching opportunity for Pipe was when lawyers from the State of Wisconsin took depositions from tribal elders on the subject of treaty rights and asked Pipe to testify. Although he spoke fluent English, he insisted on answering only in Ojibwe, using his nephew Eugene Begay as an interpreter. They asked him to put his hand on a Bible and swear to tell the truth. He refused, insisting instead that they get tobacco and present it to him in the proper way before he would talk.

It took a long time for the lawyers' assistant to go to town, purchase tobacco, and come back. All the while, the lawyers kept looking at their watches, but Pipe held his ground. Finally he was satisfied, and they talked for almost two hours. The last question they put to him was, "What do you think will be the future for the Ojibwe?"

Pipe told them through his interpreter, "I don't have to think what will be the future of our people. I know. It is foretold in our prophecies."

The lawyer replied, "Good, tell us what is in the future."

Pipe then summarily ended the interview by saying, "I won't tell you that because it is a sacred teaching. To learn that, it's going to cost you a lot more than a couple of hours."

There were some people willing to spend years, even decades, learning what Pipe had to teach. As he was a protégé of older keepers of medicine, many came to work under Pipe as an *oshskaabewis*, or student. Learning from Pipe could take a long time. He would say, "A philosophy student could bring me a résumé and I would just throw it in the garbage. Go get me a coffee, black with one sugar, and empty this ashtray. Make my life more comfortable, and maybe after a year I'll tell you who and what you are."

One student, gaiashkibos, eventually grew up to become tribal chairman. "We'd plan some doings or other," gaiashkibos said, "and it was important that Pipe lead us in prayer to open the event. I'd go and give him tobacco a week in advance, then would come the day of the event. Well, if I told him I'd be there at 9:00 a.m. and I was late—say I got there at 9:20—he'd be closing one eye, then the other, looking at the clock.

"Pipe would say 'I have a damned good notion not to go.' Then he'd push back his coffee cup and allow that, 'All right, let's get going.' We'd get out the door and into the car, and he'd say it again. 'I have a damned good notion not to go.' We'd drive along a little further and he'd

say, 'Maybe we should just turn around and go back.' He'd punish me like that all the way to where we were going," said gaiashkibos, "and I knew enough not to pull on his sleeve, or he would have just gone back home."

Another of Pipe's students, later in his life, was Paul DeMain. An Oneida with Ojibwe relatives at Lac Courte Oreilles, Paul was in college in Eau Claire when he first met Pipe, who was on a speaking circuit, going to colleges and universities teaching the public about Indian culture.

Later, when Paul worked in the office of Wisconsin Governor Tony Earl, he arranged for Pipe to meet with the governor. Earl wasn't the only governor to welcome Pipe into his office—he had also met governors Martin Schreiber and Lee Dreyfus. One time when Tony Earl was at Lac Courte Oreilles, he and Pipe decided they were thirsty and ended up at The Clubhouse for a taste of beer and schnapps. Pipe could be that casual.

At Hayward's National Fresh Water Fishing Hall of Fame, there is a four-story fiberglass musky that houses the "Shrine to Anglers." Pipe was asked to speak at its dedication. He wrote a solemn poem for the occasion, thanking everyone for so honoring the spirit of the powerful fish. He was a dignitary in the truest sense. He had been to Washington, D.C. several times, and had always come back with the same impression—he couldn't understand why people there were all afraid and angry. No one smiled. Congressmen and Senators were stern and serious. "Those people must have big problems," he once proclaimed upon his return to the reservation.

"Pipe liked to live life to its extremes," Paul remembered. "He would tell me that is the only way you can live an Ojibwe spiritual life. He didn't understand how people could keep regular, full-time jobs and still tend to their spiritual side. Pipe was a human being who was at peace with the many sides of his nature. He could give the opening prayer at a conference with bishops and deacons present, and the next day he might be at the local pool hall, shooting a few games, smoking Pall Malls, and sipping a 7 and 7."

Pipe was a sports fan, too. He memorized batting averages and remembered the teams' season records. Another friend of his, Mike Dukin recalled, "As he grew older and his sight began to fail, he'd sit in Hayward's Angler's restaurant and bar and listen to a game on TV. One time he said to me 'Mike, I'm getting just like you now.'" Mike is blind.

"We just sat and sipped our beers, enjoyed the air conditioning, and listened to a Cubs' game. He knew all of the players by name. I'll always remember that time."

As he grew older, Pipe maintained a hectic schedule, seeing eight or nine people a day. He said toward the end that he wished he'd taken on more students at an earlier age. Friends helped Pipe with his business, driving him where he needed to go. Often he discussed aspects

of life with his helpers, from naming ceremonies to the possible existence of UFOs.

Once when *Life* magazine ran a spread on the phenomenon of crop circles in England, Paul thought Pipe would find this interesting. Pipe was already losing his sight, but he held the *Life* magazine close and looked at the picture. Paul told him that some people thought maybe aliens had carved those circular designs in the cornfield. Paul asked Pipe what he thought of aliens, and Pipe replied, "We know about those beings from outer space. They're real. They probably are doing that."

Paul asked why aliens would do that. Pipe replied, "Maybe they like corn!"

Pipe was a man with a powerful spirit. He could interpret dreams. Some swear that when he sang and prayed he could part the clouds and make the sun come out. He hailed back to a time when life was complete, whole. As he grew older, he gave away as much as he could— possessions, knowledge, and language.

Before he died, he gave his 100-year-old ceremonial drum to his nephew Eugene Begay, and the spirit that entered his life at his first fast around age twelve to Sara Balbin. He went to live his last days with Jerry Smith and Beverly Bearheart, to whom he had taught much over the years. Pipe had Paul drive him around the reservation, recounting who was born here and who was buried there. He prepared himself to meet the Great Spirit and looked forward to walking on. He even drew up a living will, threatening to sue anybody who tried to resuscitate him when his time came. He was ready, and told others not to be afraid, that they should let go of him.

James Pipe Mustache died in 1992. He was buried at the traditional site near the shore of Lake Hayward, where Historyland had been. Pipe's extended family included one sister, Lucy Begay, a son, James Mustache Jr., twelve grandchildren, and thirty-three great-grandchildren.

"We held the funeral, and then lowered his body into the grave," said Eugene Begay. "I said the final prayer over Pipe, and someone tapped me on the shoulder, pointing skyward. There were three eagles circling above. Not way high up, either. They were right overhead. That was because of Pipe's power in the Grand Medicine Lodge."

Recalling one of the last times he saw Pipe, Paul said, "I was just looking at this old man with his magnificent face, wondering, 'What will we do without him?' Pipe knew what I was thinking. He told me, 'Let go, you're keeping me here. It's time for me to go.'"

"I know that when it's my time, and I walk on from this world, Pipe will be there waiting for me. He'll probably say 'Get me a coffee with one sugar, and empty this ashtray. Where have you been?'"

GEORGE OSHOGAY

CIRCA SEPTEMBER 19, 1914 - JUNE 4, 1996

A member of the *Awaazisii Doodem*, George Oshogay was a descendant of a headman of the Ojibwe, also named Oshogay. In the early nineteenth century, this earlier Oshogay went with a delegation from the Lac Courte Oreilles Reservation to Washington, D.C. with a petition from the tribe. Years later, he received a substantial land allotment in the south end of Reserve that came to be known as Shogaytown.

Jerry Smith, a distant relative of George's, recounted the story of how George's family received the name of Oshogay. "It seems that the government was conducting a census," Jerry said, "and was taking the last names of the Indian people. George's grandfather was a speaker of the English language, but his grandmother spoke and understood only *Ojibwemowin*. The grandfather was busy building a house, so the government official went to the grandmother and asked what their last name was. Thinking that the visitor was asking what her husband was doing, she answered '*o zhi gay*,' which means, 'he is building a house.' So they were written in the official books as the *O zhi gay* family." Later this was mispronounced as Oshogay.

George's parents, John and Margaret Winters Oshogay, reared two boys and one girl in the south end of Reserve. Their children were Joseph, Catherine (Dennis), and George, the youngest. All three children were reared speaking *Ojibwemowin*, and continued to speak it fluently throughout their lives.

As a child George attended many schools, including the Odanah Mission School, when he was six years old, and the Hayward Indian Training School, where he remembered having to repeat the second grade. He also attended the Whitefish School and, in the 1930s, the Tomah Indian School. George's niece Marie Kuykendall said George was reared by an extended family because he attended so many different schools and was often separated from his immediate family.

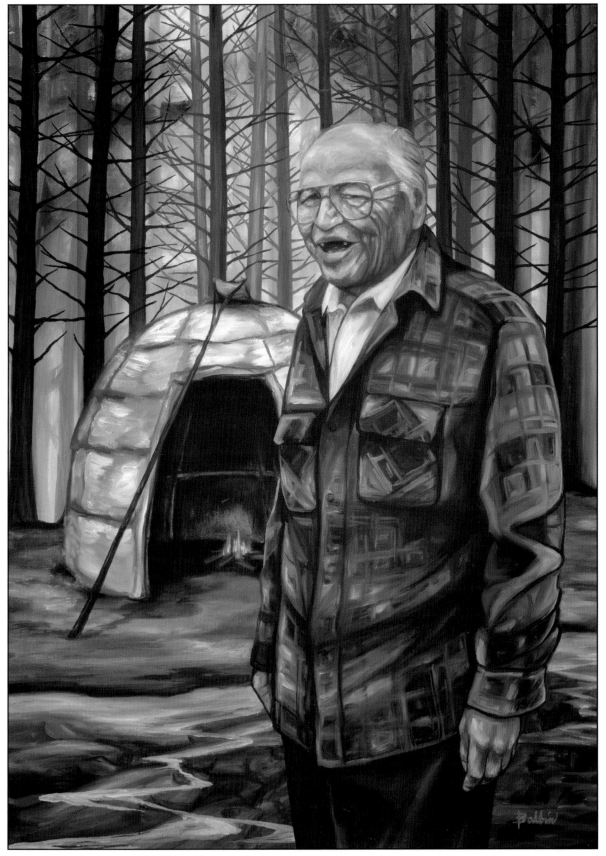

George Oshogay, oil on canvas, 30x42 inches, 1995, Lac Courte Oreilles Reservation

When he was a young boy living near the shore of Lac Courte Oreilles lake, George experienced spring log drives, during which he said he would "Run across the logs covered with water." Logging camps operated from late fall until the spring break-up, when some of the loggers stayed on for the log drives.

As an adult, George worked as a logger. He married Cecelia Nickence and the couple moved to the Chief Lake settlement, where they reared a family that included five sons and five daughters: John, Yvonne, Cecelia, Gretchen, Wavern, Ramsey, Bryon, Adrian, Stanley, and Steven. The family attended the St. Francis Solanis Church in Reserve. George enjoyed entertaining his family and community members by playing the fiddle, guitar, and harmonica.

To financially support his large family, George developed his carpentry skills. Known for his talent as a house builder, he helped entrepreneur Tony Wise build and maintain an authentic Ojibwe village with *wiigiwaaman* and powwow grounds at the Historyland complex in Hayward.

George pursued a higher education, attending the Indian School in Haskell, Kansas and the University of Wisconsin's Madison and Milwaukee campuses. On May 23, 1976, he earned certification in the Wisconsin American Indian Language and Culture Project Certification Program for grades K-12 from the University of Wisconsin–Milwaukee. Bringing to bear a talent that he'd had in language since first beginning to speak *Ojibwemowin*, George taught the Ojibwe language in Milwaukee area schools while still a student at the university. Later, he taught at Millstone High School in St. Croix, Unity High School in Balsam Lake, Mt. Senario College in Ladysmith, and at the Lac Courte Oreilles Ojibwe Community College and grade school. George's niece Rita Corbine said, "Because of his command of the Ojibwe language, my uncle was critical of people who spoke the language but didn't pronounce it correctly." She also recalled George's wit and humor, remembering that he and her mother, Catherine, often told funny stories together.

According to Jerry Smith, one of George's favorite stories involved a group of dancers from Lac Courte Oreilles, known as Froemel's Dance Group, who were taken to Milwaukee to put on a show for tourists in the 1930s. Sadly, and typically for the time, on this trip the Indian people were locked in behind a fence at night. One day the dancers were taken to a carnival where they were seated in a roller coaster in full dance regalia to pose for pictures. Thinking the Indians would enjoy a ride, the roller coaster was set in motion. Frightened, the Indians screamed all through the ride. As the ride coasted into a stop, the operator mistakenly assumed that the riders had enjoyed themselves and set the roller coaster in motion once again. This would be a story that the Lac Courte Oreilles people would remember for a long time.

In his later years George was a familiar figure walking along the roadsides, wearing a dark blue jacket and brown hat. In the Lac Courte Oreilles community he is well remembered for his jaunts down the road, usually on his way to the Lac Courte Oreilles Ojibwe School, the Community College, or the Convenience Center. George had no aversion to walking, and according to local lore, even if you passed George walking on the road, he would still arrive before you did. As well known as he was, George often didn't get far before a friend or neighbor would stop and offer a ride. When the Oshogay family relocated to the Six Mile corner area, George became friends with a bread truck driver who often gave him rides to Hayward while driving his route.

The familiar and reassuring sight of George Oshogay trekking down the roadside is missed by many of his Lac Courte Oreilles neighbors.

TOM QUADERER SR.

CIRCA JULY 3, 1895 - JANUARY 7, 1982

Tom Quaderer Sr. (pronounced "quarter") was reared in the Whitefish community, the child of John Quaderer Jr. and Julie Couvillion-Bracklin. His grandfather, John Quaderer Sr., born in 1829, was a Swiss immigrant of German descent. Crossing the Atlantic Ocean as a young man and settling for a time in New Orleans, he moved up the Mississippi River and found work in the lumber business in Wisconsin. He is credited with founding the town of Barron, Wisconsin, approximately sixty miles southwest of Lac Courte Oreilles, when he developed a lumber camp near the location of the present courthouse square. At the time he was an employee of the Stout-Knapp Lumber Company. He married three times and fathered twelve children. With his first wife, a native woman named Mamajik, he fathered John Quaderer Jr., who was born around 1860. John Quaderer Jr. moved to the Whitefish community in the 1880s and built a general store and house on a site that came to be known as Sholtz's place. Eventually he moved the store across Potato Road to a site later occupied by the Richard and Ida Wolfe family.

John Jr. was a short, heavy-set man of pleasant disposition with sound business practices. He sold basic goods including salt pork, tea, coffee, and tobacco, dishing everything out of sacks, including the coffee, which had to be ground at home. He married Julie Couvillion-Bracklin, Ogimaabinesikwe. A son, Tom Quaderer, was born to the couple in 1895. John Jr. died at Lac du Flambeau in 1943 at the age of eighty-three. He was buried in the small cemetery near the Whitefish dance ring.

In 1918 Tom went to Germany as a U.S. soldier to fight during World War I. Decades later, his son John went to Germany as an American serviceman in World War II. After John returned from the war, father and son traded war stories comparing, for example, the wreckage of Munich after both World War I and II.

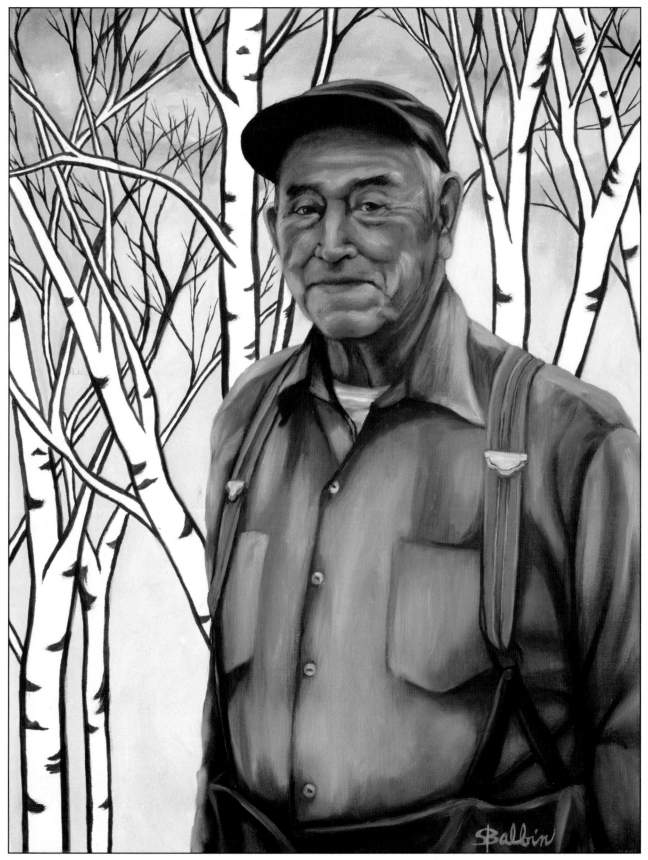

Tom Quaderer Sr., oil on canvas, 19x25 inches, 1980, Lac Courte Oreilles Reservation

During World War I, Tom was a sharpshooter, utilizing skills honed while deer hunting in the northwoods of Wisconsin. A big man, Tom stood six feet one-inch tall, and even at the peak of his military fitness he weighed in at about 210 pounds. John remembers his father teaching him and his brothers to use a rifle, and said that Tom was a shooting instructor who demanded discipline. John also recalled his father's advice to him before going off to World War II—"You'll need to pray a lot." Indeed, John found himself praying constantly during the war. He also realized that his father had not fully warned him about war's horrors, which Tom later said was because he didn't want to scare his son too badly.

During World War I, many American Indians volunteered for service in the armed forces, and their record of wartime heroism produced a wave of public feeling that such patriotism should be recognized. In 1924 all Indian people were granted full United States citizenship.

In the early 1920s Tom married Frances Oshogay. Over the years, they had fourteen children: Bert, Annie, Veronica, Vincent ("Beggie"), Ignatius ("Doc"), John, Tommie, Robert, Esther, Betty, Lucille, Judy, Flavia, and Louie.

After he married Frances, Tom embraced both Christianity and *Midewiwin*, the beliefs and ceremonial practice of the *Anishinaabe*. *Midewiwin* songs, stories, and rituals embody the traditional spiritual heritage of the *Anishinaabe*.

Tom and his family lived on a small farm where they grew vegetables and raised animals. To help support his large family, he got involved in the family owned general store in Whitefish and also worked in the lumber camps.

During the Great Depression of the 1930s, the Work Projects Administration (WPA) began to hire people in the Hayward area. An enterprising man, Tom used a discharge bonus from the army, which he had put away for a rainy day, to buy a large flatbed truck in 1936 and used it to haul men from the reservation to WPA job sites like the Smith Lake Creek dam site in Hayward. That contract paid better than manual labor.

Tom retired at age sixty-two and drew on both Social Security and his veteran's pension. The pensions afforded him more time with his family for fishing, hunting, harvesting, and living the *Midewiwin* belief. As an *Anishinaabe* elder, Tom understood the importance of passing the traditional Ojibwe knowledge and skills he learned from his elders. He always made time in his later years for those who sought it, and kept tradition alive.

SAXON GRACE BENJAMIN ST. GERMAINE

NOVEMBER 14, 1914 – SEPTEMBER 17, 2006

S axon Grace (Benjamin) St. Germaine's true identity is Bidaabinookwe, meaning At the Dawn Woman, or that moment when dawn is precisely upon us. She was born on November 14, 1914 in Winifred, Montana to Julia Corbine Benjamin, from Reserve, and Ernest Benjamin, from Mondovi, Wisconsin. They met at Lake Andes, South Dakota, where they were both working for the Bureau of Indian Affairs (BIA). The couple moved to Montana, homesteading twenty miles from Winifred, near the Missouri River. Saxon was the middle child, between her older sister Clarissa and her younger brother Bill. Saxon and her siblings are of the *Ajijaak Doodem*.

The doctor arrived late to deliver Saxon because his car kept breaking down. Although this was the first automobile the family had ever seen, Saxon's uncle, Moses Corbine, tinkered with the car while the doctor was delivering Saxon. Moses was successful in getting the car to run, which amazed the doctor. He knew that Corbine had never even seen a car. Moses, it seems, had worked in his father's blacksmith shop and knew quite a bit about machinery in general.

About the same time, Moses's wife, Carrie, a Sioux from South Dakota, gave birth to her own baby, a boy named Elmer. Saxon's mother nursed her own daughter and Elmer Corbine because Elmer's mother didn't have adequate milk.

Julia and Ernest Benjamin moved several more times, first to Forest Grove, Oregon, in 1917, and to South Dakota near the Missouri River, in 1919, before settling on the Lac Courte Oreilles reservation from 1921 to 1926. During this time Saxon became acquainted with her grandparents Louis Vincent Corbine and Mary Quagon Corbine, Bimigiizhigookwe, All Through the Day Woman.

Bimigiizhigookwe spoke only *Ojibwemowin* and was skilled in the use of medicinal plants. She practiced the *Midewiwin* faith, and her daughter Lizzie assisted her in doctoring and

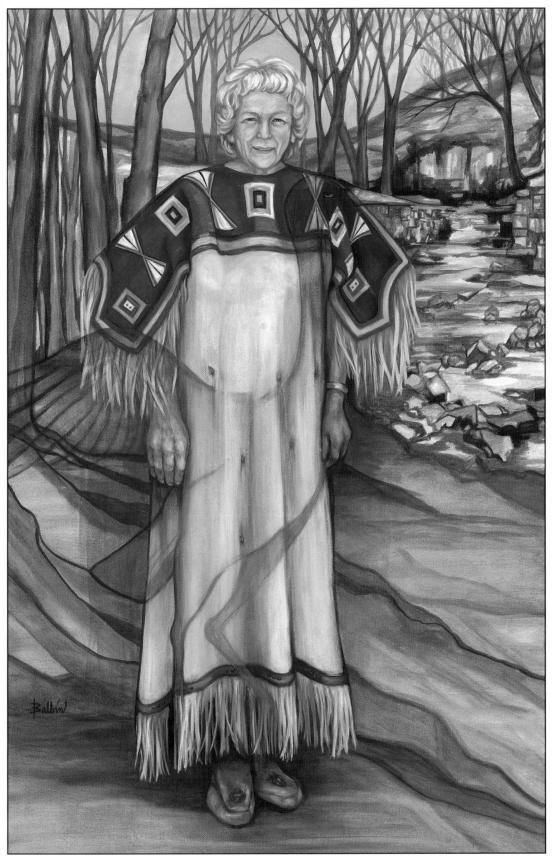

Saxon Grace Benjamin St. Germaine, oil on canvas, 39x60 inches, 1996, Lac Courte Oreilles Reservation

delivering babies.

Saxon's grandfather Louis spoke a mixture of Ojibwe, French, and English. He loved to tell stories to his grandchildren, who would climb onto his big bed and happily listen to *Wenabozho* stories. All the while, his wife Mary sputtered and shushed him when she thought the stories were too earthy. Using "by 'n by" as a common refrain, he seemed to delight in telling stories his wife didn't want repeated. Louis was popular for calling square dances in his mixed languages at community gatherings. His friend Peasoup Guibord loved to imitate Louis's creative speech.

There was a dance ring near what is now County Highway E, where large powwows were held every Fourth of July. There, the oldest men sang and drummed while the younger men danced. The women danced only when special women's songs were sung.

Saxon and her cousins often helped Louis at his blacksmith shop by pumping the bellows on the forge. He also kept horses, tended two gardens, and kept a little store, all despite having a crooked leg caused by falling off a chair in early childhood. Saxon remembered that, as an old man, Louis found a branch of wood with a vine twisting around it, which became his cane. It was unique, and others would borrow it for special occasions.

As a child, Saxon spent a great deal of time at her grandparents' home at the eastern edge of Reserve on Little Lac Courte Oreilles lake, enjoying the fruit trees, berry bushes, and the surrounding forest. The lake provided the perfect place for swimming, she recalled.

Drying beans were placed between tarps, and the girls danced on them to the sound of Louis singing and drumming, thrashing the legumes from the dried vines. The Corbines raised root vegetables like potatoes and carrots, storing them in a root cellar carved from a nearby hillside. They also had an icehouse, where they stored ice cut from Little Lac Courte Oreilles lake, which, covered with sawdust, would last through most of the summer.

Saxon and her sister Clarissa had to walk quite a distance to the public school in the Whitefish community. She went there one autumn, and then her father spearheaded the creation of a public school at the Presbyterian Church near Little Lac Courte Oreilles lake, much closer to home. The families of Tom Miller, Charlie Coons, and Henry LaRush joined the Benjamin's in this endeavor. Saxon's family lived in a house nearby known as The Manse, and one teacher, Gladys Markstead, boarded with them. The main teacher there was Thomas Reid. In winter the students took a shortcut across the lake ice to the school, which operated about ten years, until the St. Francis Solanus Indian Mission School reopened, after having been destroyed in a fire.

Some of Saxon's childhood memories centered on the historical pageants presented at Red Cliff, near Bayfield, and in Chicago, near the Field Museum, at Soldier's Field. Saxon was

impressed when they were told the director of the Bayfield pageant was from Hollywood. Fine athletes took part in these pageants in impressive lacrosse tournaments using small, circular laced lacrosse sticks. Always nearsighted, Saxon couldn't see the action very well herself, so her mother narrated a play-by-play of the lacrosse games to her. She remembered vividly her mother telling her about a player who landed on his headdress of wood and porcupine quills, spun on his head several times, and jumped back to his feet.

At these events, contrived "historical" dramas were staged in which Indians chased soldiers and covered wagons. Saxon's mother was strong and dark, and played a role which included stabbing a soldier in the back. She had to make a new cardboard knife for each performance. In the same shows, Saxon's brother, Bill, was asked to wear a wig because his natural hair wasn't dark enough for the producer's taste.

Not everything was so stereotypical during these shows. Saxon recalls wonderful eagle dancers from the BIA's Haskell Institute at Lawrence, Kansas. It seemed to her they really became eagles as they swooped and flew.

The Indians made a camp while practicing and performing at the pageant, and tourists paid a nickel to walk through it. Event organizers asked the Ojibwe people to speak only their native language to add authenticity for the paid visitors. Saxon's mother and Aunt Babe had to stifle their laughter when one man assumed they couldn't understand English and said, "That woman (pointing at Babe) is quite a babe!" (That is not, however, how Babe got her nickname—she was the youngest child in her family.)

The pageants lasted two weeks, one for rehearsal and one for performance. The Indian performers were fenced in, Saxon told researchers, and locked in the area while in Chicago. They were not allowed to go out into the city by themselves.

Through these pageants, Saxon received early training in music, dance, and theater. In adulthood, she built on these experiences as a teacher, acting as playwright, musical director, and choreographer for presentations at schools throughout her community.

Saxon's family next moved to North Dakota, settling in 1926 at Fort Totten. By the age of fifteen, she was cooking for the family and responsible for milking a cow with sharp horns. She had to herd it to and from the pasture with a stick, causing her brother and other young men to laugh and tease her each time she and the ornery cow went through their daily antics.

As she grew to maturity, Saxon's parents wisely insisted that she go to college, a decision which played a major role in her adult life. She studied at the University of North Dakota, becoming its second American Indian graduate. Her sister, Clarissa, was the first.

She recalled an initial interview with the academic dean in which he asked her what subject she planned to major in. Her reply, "What's a major?" prompted the dean to inquire, "Would

you like to be a teacher?" Saxon was relieved to have a choice she had heard of and said, "Yes." She told him she would like to teach physical education and music, but he encouraged her to consider teaching English instead. Strong in her desire to pursue teaching the subjects that interested her most, she did end up teaching both music and physical education. She earned a bachelor's degree in education from the University of North Dakota.

At a summer school for Indian service teachers in Salem, Oregon, she met Augie Wilson, a Nez Perce from Idaho. They married and had a daughter, Julie. Saxon and Augie divorced. She later met and married Francis St. Germaine from Lac du Flambeau, Wisconsin. They had two boys, Rick and Ernie St. Germaine. Saxon and Francis then divorced, after which he remarried and fathered ten more children. Both Francis and his second wife died, and two of their children, Terry and Jeff, lived with Saxon. The rest were scattered and placed in various foster homes, although Saxon eventually located all of them. Two other children, Cynthia and Rudy Tudjen, also became part of her family when their grandmother and only caregiver, Charlotte Braklin Corbine, died.

After teaching in North Dakota and Oklahoma, Saxon came home to Lac Courte Oreilles in 1951. She wanted to reestablish her roots and to protect the family's cabin in the woods on the shores of Big Lac Courte Oreilles lake. She taught in the upper grades at the Kinnamon School for one year, at the Spring Lake School for three years, and at the Hayward Community Schools for four years.

In her physical education classes she employed student squad leaders to develop leadership among the students. She was a bridge between the Indian students and the faculty. She also taught music and French, writing the first French curriculum for the Hayward schools.

In addition to teaching, Saxon started a youth center at Reserve. The youngsters danced to a jukebox and played basketball and other team sports. Some of the girls were responsible for pop and food sales, and the money earned went to help pay for recreational equipment. Parents and community members, including Sawyer County sheriff's deputies, donated time and food and took part in many of the activities.

Saxon's strong leadership abilities were often required in her role as a leader of youth. Once when she learned from the girls that a fight between members of two different communities was going to take place at the Youth Center, she had a meeting with the young people and told them that if a fight took place, she would close down the center for good. The fight never took place. The Youth Center lasted until a basket factory took over the building, which was later destroyed by fire.

Saxon earned her master's degree in 1957 and joined the Lac Courte Oreilles Tribal Governing Board for two terms beginning in 1958. At that time the BIA agent from Ashland came

to Lac Courte Oreilles one Friday evening each month, insisting that all business be transacted that night. Attorney Eugene Ward Winton, an advisor to the tribe and a man of native heritage, had warned Saxon that the council should refuse to sign any document ever put to it by Wisconsin-Minnesota Power & Light Company regarding the Winter Dam and the flooding of the Chippewa Flowage until he could review it. Late one Friday night, Saxon remembered, the BIA official produced such a document and asked the members of the governing board to sign it. Despite her tiredness and the late hour, Saxon saw that it was a power company contract. Remembering Winton's admonition, she and the other members of the council delayed signing it until changes could be made that were more favorable to the tribe.

Saxon taught at Winter, Wisconsin for six years. Unfortunately, the Winter Board of Education did not renew her contract because her master's degree would have entitled her to an upgrade in her annual salary to $10,000. She began fighting a legal battle that wasn't settled until 1971. Due to the precedent set by her lawsuit, teachers are now better protected from unfair employment practices.

Saxon's teaching career was interrupted by a serious bout with cancer in 1961. She had surgery at the University Hospital in Madison, where she spent six months. At the time, her daughter Julie was at school in the West and sons Rick and Ernie were fending for themselves at their trailer home in Slinger, Wisconsin. Saxon remembered being told that the milkman kept delivering milk products, eggs, and bread to their home even when there wasn't money to pay him.

At this very trying point in her life, unable to take care of the boys, Saxon made a pact with her Creator. She promised God that if he would let her live to return to her children, she would see to it that they each received a college education. She remained true to her word, and each of her children has one or more college degrees. She continued this practice by helping her grandchildren get college educations.

Saxon went on to help set up the American Indian Movement school in Milwaukee, teaching there half-time and half-time at the University of Wisconsin–Milwaukee. Later, Saxon taught "Literature of the American Indian" at the University of Wisconsin–Eau Claire for eight years. After retirement, she returned to Lac Courte Oreilles and taught courses at the Lac Courte Oreilles Ojibwa Community College.

Like her great-great-grandfather, John Baptiste Corbine, Saxon enjoyed writing. For many years she wrote "Saxon's Corner" for the *LCO Journal*, covering political issues like efforts to eliminate the popular use of the word "squaw," recalling her memories of life on the reservation, and commenting on modern life.

While in her eighties, she started and published the elder-oriented newspaper *Bimikawe*,

to which she contributed articles and photographs.

Throughout her life Saxon had been a warrior, fighting for causes she believed in. She continued to learn and to teach, attending ceremonies and cultural events, and receiving visitors at her cabin on Big Lac Courte Oreilles lake into her last years.

She regularly drove old friends like Marcella Guibord, Bea Stewart, and Liz (Denomie) Norem to local community circles and to the Reserve Elderly Center while in her mid-eighties.

When her always-poor eyesight worsened at the age of eighty-three, she made a characteristically brave decision to have laser eye surgery. Like a reward for a dedicated and courageous life, Saxon could see into the distance without glasses, only needing them for reading. She was thrilled to be able to look out into the woods and see clearly what her Creator has wrought.

Energized and inspired by her new vision, she continued to be socially and politically active in the Lac Courte Oreilles community.

Eventually, when Saxon's health began to seriously fail at age ninety-one, her daughter, Julie Wilson, tended to her mother's medical and personal needs. Julie wrote, "My Mom was happy to know that she would remain at home and close to us until she walked on. We were all with her, her children, grandchildren, great-grandchildren, relatives, and friends."

On September 21, 2006, *Midewiwin* funeral traveling ceremonies were held in honor of Saxon's Ojibwe heritage. These ceremonies were a special time, as they provided family members and friends the opportunity to celebrate her walking on to the spirit world.

Saxon was put to rest near her beloved cabin facing Big Lac Courte Oreilles.

ELIZABETH RUTH GOUGÉ BUTLER SCHMOCK

CIRCA AUGUST 11, 1916 - MAY 9, 2005

Elizabeth Ruth (Gougé) Butler Schmock was born about a mile south of Billyboy Dam in the village of Signor to Susie Butler Cadotte and George Gougé Jr. A member of the *Migizi Doodem*, she was given the Ojibwe name Giizhigookwe. Elizabeth was the couple's firstborn child, followed by Ernest, Art, Richard, Gerald, Louis, Joseph, William, Elmer, Heloise, Hazel, Delores, and Roy. (Ernest, Joseph, and Roy died as infants.)

Both of Elizabeth's parents worked to support the family. George worked as a painter, and Susie was a seamstress and waitress. The family moved from place to place as George sought employment, including Ladysmith, Campia, and other small towns in Wisconsin. Although the family found it essential to travel in order to make a living, they always returned home to Susie's parents' homestead in Signor.

During the Great Depression, Elizabeth's parents eventually went their separate ways. Her grandparents Mary Allan and Ben Butler then reared her. They spoke only *Ojibwemowin*, so Elizabeth did not speak English when she was young. Her mother's first cousin Mamie Setter Perkins, a high school English teacher, took Elizabeth in to teach her English.

Elizabeth recalled attending school in a building in the Whitefish community, which was located across the lake from the St. Francis Solanus Indian Mission School in Reserve, where Ernest Benjamin (the father of Saxon St. Germaine, whose portrait and biography are also included in this book) taught. She also attended the Hayward Indian Training School. Elizabeth later completed the eleventh and twelfth grades at the Flandreau Indian School in South Dakota.

On the reservation, Elizabeth's mother, Susie, and grandmother, Mary, were primary food gatherers for the household—true, strong *Anishinaabekwe*. In spring, they processed maple syrup and made sugar cakes, gathered wild berries, and fished. They also gathered *manoomin*

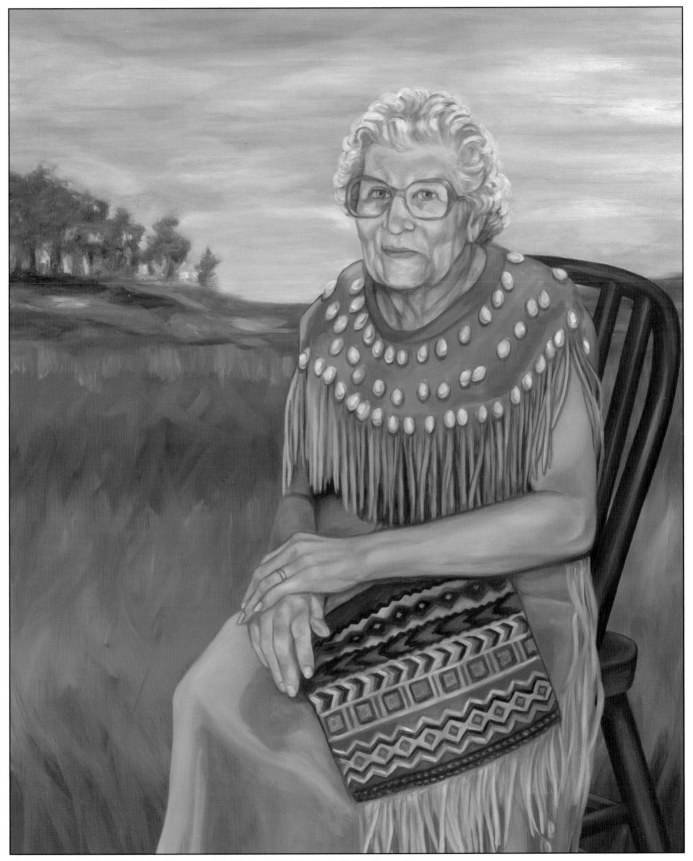

Elizabeth Ruth Gougé Butler Schmock, oil on canvas, 29x42 inches, 2000, Lac Courte Oreilles Reservation

each autumn. The two women were practitioners of the *Midewiwin* belief. This belief offers a code of conduct, keeping the Ojibwe culturally rooted as well as physically and spiritually healthy. Elizabeth was baptized a Catholic, as her father had been, but practiced the *Midewiwin* belief as well as Christianity.

Of her childhood Ojibwe memories, one story that she was always fond of recalling was of a time when her grandfather Ben came upon a dead female bear while looking for an area to set up an *iskigamizigan*. Following is the story, as Elizabeth told it, about the orphaned cubs left behind, who were hungry and helpless:

In early spring, while the snow was still on the ground, my grandfather Ben took a walk through the woods looking for a good camp site with lots of hard maple trees around so they could set up their maple sugar camp. He came across two little bear cubs lying by their dead mother. The cubs followed my grandfather Ben home. As they were almost starved, my grandmother made a soft mush of bread and soup for the cubs. They were very messy eaters, but they got full. The cubs both went to sleep after their meal. My grandfather named the cubs: the female's name was Ikwezens and the male's name was Makoons.

After my grandparents and my mother moved up to the sugar camp, the cubs became very naughty. They spilled the sap out of the containers that were placed by the trees. They also climbed the trees in their play, but they fell into the barrels of sap that had been gathered for boiling to make the syrup and sugar. Those two naughty cubs one day got into the grocery box and scattered the contents all over. They also got into the flour barrel—the cubs looked funny covered all over with flour. Those two cubs also dragged the blankets from the wigwam and up into the trees.

One evening, when my grandmother was cooking supper over the fire that was built outside, one of the cubs stepped onto the hot coals and burned the bottom of his foot. The cub climbed onto my grandmother's lap while she was peeling potatoes; his foot was really hurting. My grandmother then put some tallow on the burn and wrapped up the foot. The cub hopped around lifting that foot up for a few days, but that taught the cubs to stay away from the fire.

One nice day, my grandmother was washing clothes outside. She went to hang some clothes on the line, when she heard one of the cubs choking. She found one of the cubs had taken her soap and was trying to eat it. He had soap suds all over his face, and the other cub had tipped the tub of water all over the ground.

The cubs slept at the very end of the wigwam at night; they were good at night.

The cubs also loved to ride in the boat. Early one evening, my grandfather took his traps down to the river and put them into the boat. He then got into the boat, but of course who else jumped into the boat? The two cubs. They were very good at first, until my grandfather stopped the boat to set his traps. The cubs started wrestling in the boat, and it went over. My grandfather had to look for his traps in the water. He had to scold the cubs, as they understood when someone talked very loud to

them that they did something wrong.

When the cubs were about a year and a half old, my grandparents sold the female, Ikwezens, to the zoo up in Duluth, and they took the other one to Squaw Bend when he was two years old, as he was getting hard to handle. Once in a while my mother would go up to Squaw Bend to see Makoons and he always knew her. So, I guess bears have a good memory.

In 1938 Elizabeth married Ray Schmock. They moved to a farm on Boylan Road, near the reservation and the town of Stone Lake, where they lived in a log house and kept a herd of thirty-five cows. To sustain their young family, they sold milk to the owner of a dairy in Rice Lake. In 1949 the Schmock family built a house made of concrete blocks. While living on this homestead, most of the couple's nine children were born: Roger, Yvonne, Wanda, Eldon (who died as an infant), Mildred, Sylvia, Arthur, Verna, and Norma. Struggling to support their large family on the farm, in 1959 the Schmock's sold their cattle, gave up farming, and moved to Minneapolis, where Ray worked for a die-casting company. The children all graduated from South High School. After fifteen years in the city, Ray retired, and once again the family moved back to their home on Boylan Road, which they had never sold. On their return, a neighbor bought a cow and gave it to them as a "welcome home" gift. They were once again in the dairy business, although on a smaller scale.

While Ray took care of the farm, Elizabeth shared her knowledge of the Ojibwe culture and was employed by the Hayward Community Schools for four years. She passed on the knowledge of traditional crafts, including making yarn bags in the round without seams, creating reed mats, quilt making, bead working, needlepointing, processing deer hides, gardening, canning fruits and vegetables, and preparing Ojibwe cuisine. (The photograph on page 221 of the Lac Courtes Oreilles Photographs section of this book shows Elizabeth weaving a yarn hand bag.)

Elizabeth was very proud of her Ojibwe traditional arts and heritage. One of her cherished possessions was a collection of early photographs depicting historic Ojibwe people and practices. One picture in particular was important to her because it included her great–grandmother, Niizhoodenh, her grandmother, Ataagekwe, her mother, Ogidibii'ikwe, and an aunt, Waaboos. It is dated 1896. Another prized photo depicts her grandparents Mary and Ben Butler in full ceremonial dress, complete with beaded bandolier bags.

With her honorable Ojibwe heritage, Elizabeth spent her last years proudly talking about her children and their families. When she walked on in 2005, she was grandmother to twenty-one, great–grandmother to forty-three, and great–great grandmother to seven.

When asked her philosophy of life, Elizabeth recalled her mother's advice: "You work hard, and you forget everything else. You keep your mind clear."

HENRY F. "HANK" SMITH

JANUARY 10, 1905 - AUGUST 5, 1983

Henry F. Smith was born in a *wiigiwaam* in the village of Paquayawong, or Post, to Fred Smith, a member of the *Makwa Doodem*, and Esther Siginegey, on January 10, 1905. In this remote village on the Lac Courte Oreilles Reservation, he was reared by his parents in the Ojibwe culture, practicing their traditions. The village of Paquayawong was part of a twenty-six-square-mile area containing not only the settlement, but also wild rice beds and Ojibwe cemeteries, which was flooded in early 1923 when the gates of the newly constructed Winter Dam were closed. Disregarding the protests of the Lac Courte Oreilles Tribe, the Federal Power Commission granted the Wisconsin–Minnesota Light & Power Company a license to construct a dam on the Chippewa River and create the 15,300-acre Chippewa Flowage.

When Hank was about seven years old, he was sent from his family settlement to live in Indian boarding schools. Hank's sister, Doris Garvey, said he studied at both the Hayward Indian Training School and the Flandreau Indian Boarding School in South Dakota.

The Hayward Indian Training School was opened by the Bureau of Indian Affairs (BIA) in 1901, offering free boarding and education for approximately 180 students. According to Elder Rita Corbine, who studied at the school, the number of students who attended were equally divided between girls and boys. The Lac Courte Oreilles children were forcibly removed from their homes and sent to boarding schools where they were to be assimilated into the ways of white culture.

The parents of Lac Courte Oreilles had no authority over the destiny of their own children, and families were divided for extended periods of time. The Flandreau School, where Hank was sent, is located between Sioux Falls and Brookings, South Dakota. It opened on March 7, 1893, and today is the oldest federal Indian boarding school in continuous operation in the United States. The BIA established the school in the expectation that off-reservation

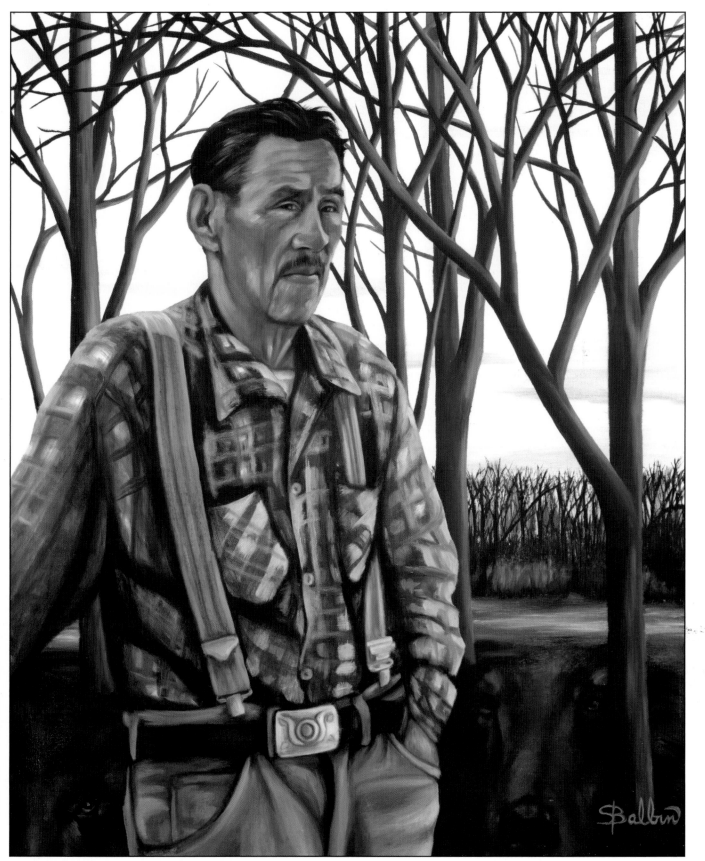

Henry F. "Hank" Smith, oil on canvas, 25x31 inches, 1980, Lac Courte Oreilles Reservation

education would break down tribalism and assimilate Indian youth, offering instruction in agriculture as as far as the eighth grade. A domestic science building was added in 1908 and a manual training program in 1912. The manual arts department was organized with courses in woodworking, carpentry, and mechanical drawing. Later, sheet metal work, mechanics, and other courses were added.

After completing his training at the Indian Boarding Schools, Hank returned to Lac Courte Oreilles. He was in his late teens when the village of Post was flooded. This was a tragic time for all Lac Courte Oreilles Tribal members. Once again they lost land belonging to their ancestors and important cultural sites, in spite of the federal enactment in 1916 requiring approval of the tribe for such action. Some residents of Post were relocated to other parts of the reservation, and some were relocated to a new village named New Post. When Post was flooded, residents of that settlement were given a choice by the Wisconsin-Minnesota Light & Power Company of either free electricity for the lifetime of the person being relocated or a new house.

The first house Hank lived in with his wife, Agnes, was in New Post, east of the Catholic Church. Their first born was named Henry, followed by thirteen more children: Edward (resides at Lac Courte Oreilles), Myrtle (deceased, mother of Jerry Smith), Selma, (resides in Green Bay, Wis.), Bernice (died at birth), Theodore (died at the age of four months), Doris (resides in Neenah, Wis.), Donald (Lac Courte Oreilles Health Department Director), Linda Lu (died at birth), Robert (died at the age of twelve years), and William, Lawrence, John, and Thomas, all of whom reside at Lac Courte Oreilles.

The creation of the Chippewa Flowage brought some benefit with the advent of tourism on the Lac Courte Oreilles Reservation. This opened the door for some employment, and Henry took full advantage of the situation by becoming a guide.

A renowned maker of carved wooden lures, Henry could carve a wooden frog so realistic that it looked like a real frog swimming in the water. At one point, Henry told his fishing partners, "I want to try out a new bait." He attached it to his line, let fly with a cast, and immediately got a bite. He tried again and right away got another bite. He paused and then said, "I think this will be good bait. Now I'll put some hooks on it." This was typical of his approach to life—he did things his own way. Instead of showing off his expertise as a fisherman and guide, he tested his skill at creating fishing lures. His family remembers that he invented what is today known as the bucktail lure. Unfortunately, he did not patent this invention. Others duplicated it, and it is now a staple for game fishermen in North America.

Carving a striking lure for the *maashkinoozhe* was a personal challenge. The muskellunge, or musky, is a large fish, dwarfed in the region only by the sturgeon. Unlike the bottom feeding

sturgeon, the musky is a feisty and courageous fish, a real fighter. Muskies are known as "the fish of 10,000 casts" because they are so difficult to entice to strike. The Lac Courte Oreilles Reservation and the Hayward area are recognized for big-game fresh water fishing. Hayward, known as the "Home of World Record Muskies," is home to the National Fresh Water Fishing Hall of Fame and Museum. On the museum property stands a three-story fiberglass sculpture of a musky, known as The Shrine to Anglers. Visitors climb a staircase inside the fish to stand in the musky's mouth and view the surrounding Namekagon River landscape.

Hank was also a fine carpenter, who built his own house at New Post around 1945. With sturdy oak flooring, the house was made to last. With his marvelous carpentry craftsmanship skills, he helped build Moody's Camp, now known as the Spider Lake Lodge, which endures to this day. Present owners of the Spider Lake Lodge, Jim Kerkow and Craig Mason, disclose the legend, and offer a synopsis of what they know of industrious Henry "Hank" Smith:

> The legend goes that Ted Moody, who was the original owner and general contractor of Moody's Camp, hired Hank Smith to be his right hand man. Hank was an exceptional craftsman and knew exactly what wood to use for what purpose and how to fashion wood to amazing uses.
>
> Ted Moody is given credit for envisioning the great camp that was Moody's Camp, but Hank is the man who brought it all to life. We actually have an old moving picture with Hank sliding astride the ridge beam of what is believed to be the living room addition of our lodge.
>
> We understand that Hank lived at Moody's Camp with his wife, Agnes, and many (eight or nine) children in a small cabin behind our garage. His wife was responsible for tending the resort's gardens and stables. She was also responsible for schooling her children and those of the other workers at the camp. At that time, the camp was nearly self-sufficient for food and sustenance.
>
> In the meantime, Hank was responsible for providing leadership to the substantial crew of mainly Native American workers who built Moody's Camp and nearly all of the lodges and cabins along the north shore of Big Spider Lake and North Lake, as well as some other buildings in the area. The workers demonstrated a level of craftsmanship, art, and architecture that was unheard of at the time and that we consider timeless treasures now.
>
> Most notable was the incredible detail of the tamarack chinking displayed in the two great rooms of the lodge. It is our understanding that the chinking was done by Hank himself and took about one hour per foot to complete. We haven't done the math, but there are a lot of feet in this building! An old resident of the lake shared with us that one of his favorite boyhood memories was watching Hank work on the chinking. He told us that Hank had thousands of pieces of wood cut and laying in the yard. He would eye up the section he was working on and then go out into the yard and find just the right piece. When he found the piece, he dumped it in a huge iron cauldron of boiling water and oil, which would soften it. Hank would then pull the hot piece from the water and quickly press it into place, carefully molding it to the contours of the surrounding logs and trimming the excess as needed.

Another interesting piece of lore we heard after we moved in was that one of Hank's grandsons living at the Lac Court Oreilles Reservation used to come to our lodge and place his hands on the logs to commune with his grandfather's spirit. We've not met him personally or experienced this, but have no doubt that it is also true.

Finally, we have an implement hanging about the fireplace mantle in the living room of the lodge that was reportedly a gift from Hank Smith to Ted Moody, as a memento from his family upon completion of the addition. We believe the tool was used in the harvesting of wild rice from the shores of the lake and was meaningful because wild rice was a staple of life for the *Anishinaabe* and represented fulfilling the basic sustenance of life at the time.

The Smith family is proud of their father's history and accomplishments. Don Smith recalled, "My father was very inventive. Before the electric power company came, he converted an automobile engine to a generator for electricity. He used the generator to supply electricity to the house, which he wired himself. At this time, we had a water pump and an outhouse. It wasn't until the power company came through that we got inside plumbing and running water at the New Post house."

Next to the house was a shed for storing firewood, tanning hides, and doing other seasonal work. Hank's mother, who lived with her son and his family, tanned the hides. Eventually they expanded the building and turned it into a general store. They made *zhooniyaa* by selling basic foods like oatmeal, potatoes, salt pork, and common items necessary for running a household.

Earning a living for his large family was a constant challenge. The selling of minnows was another source of income stemming from Hank's awareness of the environment. He was an ecologically-minded man many decades before ecology became a widespread concern. Being a respected guide, he was in a position to encourage others to fish only with minnows caught locally at Lac Courte Oreilles, rightly believing that bringing live bait from outside of the area could be dangerous to local species of fish.

Hank watched his money closely but still extended credit to many of the residents of New Post when work and food were scarce. Many residents in the village owed him money, and he did not always collect what was owed to him, as he was a caring and generous neighbor. After he passed on, his family found boxes of uncollected promissory notes from residents who had not paid him for merchandise purchased at the family's general store. Affirming his father's outlook on life and people, Don stated, "My father sold minnows to fishermen, and once observed a customer stealing some minnows. He later told our family about the incident, saying, 'Well, if they need something bad enough to steal it, let them have it.'"

Generosity was Hank Smith's hallmark. He supported the baseball team at New Post by driving the team to games in the area. His community spirit was evident when he became a

member of the Tribal Governing Board at a time when this was a voluntary, unpaid position. In this role, he gave invaluable input toward controversial issues like the impoundment of the Chippewa Flowage and the battle to preserve the historic fishing, hunting, and gathering rights of the Ojibwe.

Hank made a noble effort to survive financially on the reservation with his carpentry skills, general store, and guiding service. He could always count on a number of vacationing Midwest businessmen to ask for his guiding services when they stayed in the Hayward area. Even though Hank was established in Lac Courte Oreilles, for a short period of time during the 1960s, Hank and his wife left the reservation and participated in the American government's program to relocate rural Indian people to big cities, first living in Chicago, then California. They did not take to the change, and moved back to Lac Courte Oreilles just over a year later. Back home on the reservation, Hank continued with his independence as an entrepreneur, carpenter, and also became an avid musher, engaging in the sport of sledding through the wintry woods towed by specially trained sled dogs.

Hank's passion for mushing began when he and his youngest son Lawrence went with their neighbor Don Gayle to an event in St. Paul known as Winter Fest, where dog sled racing was featured. A race participant was so distraught at losing that he gave his team of dogs to the Smiths. Hank and Lawrence took the dogs back to Lac Courte Oreilles and began their pursuit of the hobby.

With their many children, Hank and Agnes managed to live a meaningful, active, productive life during one of the most devastating eras for the Ojibwe. Using their intelligence and resources, they made a positive difference in their community, in the region, and to all anglers.

MARY FROGG SUTTON

CIRCA DECEMBER 18, 1915 - JULY 14, 2002

Mary Frogg Sutton was a woman of small stature, standing approximately five feet tall, but stood tall as a cultural teacher at Lac Courte Oreilles. Her Ojibwe names were Gii-zhigookwe and Giniwibiikwe. Mary's quiet presence was a constant reminder of her traditional Ojibwe heritage. An elder member of the Lac Courte Oreilles Band of Lake Superior Ojibwe and a member of the Makwa Doodem, she provided a living history of her people.

The daughter of John Frogg and Elizabeth Carroll Kagigebi, Mary was born around 1915 in their wiigiwaam on the Chippewa River. Births were mentally recorded, and primarily referred to by the seasons in oral stories. The majority of the elders' birth dates in Spirit of the Ojibwe were given to them when they registered with the Bureau of Indian Affairs (BIA).

She had vivid memories of the time when, as a little girl in the early 1920s, she and her family were forced to relocate to Little Round Lake. They were displaced by the rising flood when the river was dammed by Wisconsin-Minnesota Power & Light Company, creating what is now the Chippewa Flowage. At Little Round they lived at her great-grandfather's home. She recalled her great-grandfather Kagigebi's long, white, braided hair and his stories of going to Washington, D.C. to assist in the negotiation of treaties.

In the way she lived her life, Mary showed how love and human decency can overcome adversity. She lived much of her life at Little Round Lake and was very involved with her large and closely-knit family. Married first to John Nayquonabe of Mille Lacs, they had six daughters: Marlene (deceased), Doris, Ethel, Thelma, Trixie (deceased), and Carolyn. A son, John (Bud), walked on after contracting polio.

Later, she and lifelong companion Bill Sutton had a daughter, Debra. Together they reared the children, and four of the daughters still live in the Lac Courte Oreilles community.

Through her daughters, Mary was involved with the education of tribal youth. She was a

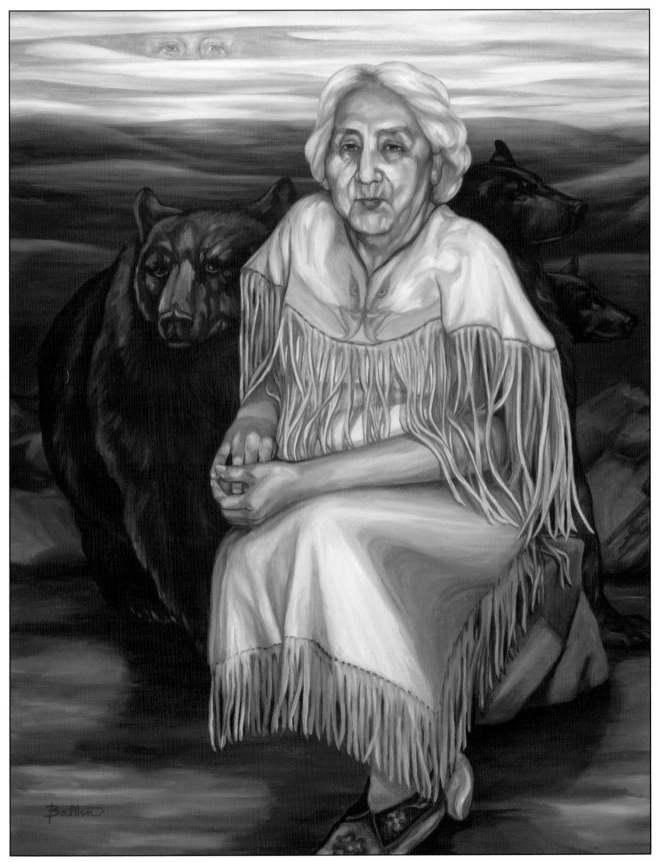

Mary Frogg Sutton, oil on canvas, 32x47 inches, 1979, Lac Courte Oreilles Reservation

cultural treasure, having grown up with Ojibwe as her first language. Although she had difficulty getting around in her later years, she still went to the Lac Courte Oreilles Ojibwe School, where her grandchildren attended, to teach Ojibwemowin.

As a little girl, Mary had known a very different world. She attended the one-room Kinnamon School in Reserve, at Four Corners—the intersection of County Roads K and E. The school served the first through sixth grades. The students were taken to school by horse-drawn wagon during the warm months and by sleigh in the winter. Later, school buses were used.

At first Mary understood no English and was therefore educated by immersion. The teacher's mouth moved, but as far as Mary was concerned, no meaningful sounds came out. Eventually she grew to understand English, partly because the children were punished for speaking their native language. They whispered to each other when they spoke their own tongue.

Still, Mary had many wonderful memories of her youth. In her home, Ojibwemowin was the only language spoken and sung. Her father's aunt would tell animal legends and stories like the tale of Hiawatha during winter. She remembers the energetic hand movements of the elderly woman, made to illustrate parts of the stories.

In spring, her family always worked the soil, planting potatoes, corn, squash, cucumbers, and beans to feed the family. They canned, dried, and stored the produce in various ways to see them through the long winter months.

Depending on the season, when they needed groceries they took the wagon or the sleigh to town, hitched to a team of horses driven by her father, John. "It was always a big day," Mary recalled. They bought sacks of flour and sugar, lard in big wooden buckets, yeast, salt, and other staples.

"Those were the good old days," she reminisced, describing how her mother used both yeast and sourdough cultures to make bread, biscuits, and pancakes on the family's wood-burning cook stove.

Every year in the late winter, they began the process of tapping the maple trees, collecting sap and then boiling it down in a big cast iron kettle over a crackling fire. First the syrup came, then the taffy, and finally the sugar cakes. The syrup was canned. The children ate plenty of the taffy right away, in spite of being warned by their parents not to eat too much. The sugar cakes were stored in birch bark baskets, the covers sewn on with basswood fibers.

All her life, Mary gathered the bounty of the earth to sustain herself and her family. The harvesting of *manoomin* was another important season. She and Bill gathered as many as five hudred pounds of *manoomin* annually, traveling to the Totagatic Fowage, Clam Lake, Rice Lake, and local rivers.

Mary explained:

> We'd get so sore from knocking the rice off the stalks with sticks into the bottom of the boat. It was hard work. The person pushing the boat with a pole has to stand all day in the hot sun. Sometimes a boat would tip, and people would fall out. The first couple of days of ricing, we'd get so sore we almost couldn't move. We'd sit at noon, getting a little rest, eating our lunch. Then we'd go right back at it. And you have to dress properly, with scarves and such, or the dust from the rice gets all in your skin and makes you itch when you sweat.

> You can go back day after day and keep harvesting if you're careful not to break the stalks. If you break them it takes years for them to grow back. And it's good if some falls in the water. That helps to reseed the rice.

In days past, rice was parched over a fire in the same giant cast iron kettle used for syrup boiling. Making careful rocking motions with her hands, Mary described how the moccasin-clad people danced on the parched rice to thrash out the husks. In her childhood, this was done in a wooden bucket like the ones that lard came in. They buried the bucket partway into the ground to keep it from moving. Up to their knees in the delectable grain, they sang as they danced.

In later years, her husband Bill fashioned a machine to do these tasks. Using a barrel, a blower, and heat (a wood fire at first, then propane gas flames later on), this machine parched the green rice, thrashed the grains, and then blew away the husks.

Between seasonal harvests of manoomin, zhiiwaagamizigan, and berries, throughout their entire married life, Bill and Mary traveled the powwow circuit. They attended social and spiritual Midewiwin gatherings from Grand Portage to St. Croix, from Red Cliff and Bad River to Lake Lena near Hinkley, Minnesota, where Bill was reared. They lived in both Grand Marais and Grand Portage, Minnesota. "We lived back in the woods with the bears. Sometimes they'd come right up on the porch and look in the windows," said Mary.

"I'm proud to be a grandma and great-grandma," she stated. "I've got more than thirty grandchildren and great-grandchildren." This gentle woman was precious to her family. They were devoted to each other and often gathered together. Passed from generation to generation, this devotion is the best hope for perpetuating an age-old heritage.

WILLIAM "BILL" SUTTON

CIRCA MARCH 22, 1906 - MARCH 29, 1994

William "Bill" Sutton—Manidoo Gwiiwizens or Na`aabanwe—was born in a wigwam in Pine County, Minnesota, at a time when his parents' lives were ordered by the changing seasons. He was born in early spring, during the start of the maple syrup and sugar season, when temperatures start to rise above freezing during the day and the trees seem to come alive with running sap. At this time of year, families would move to their sugar bush encampments to render the sap into syrup and sugar, utilizing a time-consuming and labor-intensive process. They used axes to notch the trees, and shoulder yokes to carry the buckets of sap from the trees to boilers.

Bill was born in the town of Ogema, to John and Mary Nickiboine Sutton. He had three brothers—Jim, Jack, and Joey, and four sisters—Lizzie, Maggie, Grace, and Ann. He belonged to the *Migizi Doodem*, like his father.

From his parents he learned *Ojibwemowin*, along with the culture and traditions of the Ojibwe. When he was only thirteen years old, he labored as a logger to help his father, for whom he had a great love and unfaltering respect. As an adult he continued to work as a logger and laborer, while participating in the seasonal harvests, as he learned from his parents.

In 1956, he took a job as a night watchman and laborer at entrepreneur Tony Wise's two enterprises—Historyland in Hayward and Telemark Resort, Cable, Wisconsin. Between the seasonal jobs, Bill recalled the times that he and his friends were "bumming around" in Duluth, Minnesota. Many Ojibwe ended up in the missions there for temporary shelter and food. "After spending time in the mission," he recalled, "We had to boil our clothes and underwear to get rid of bedbugs."

In his travels, Bill met Mary Frogg of Lac Courte Oreilles. She became his lifelong companion and they had a child, Debra. Together they reared Debra and Mary's children: Marlene

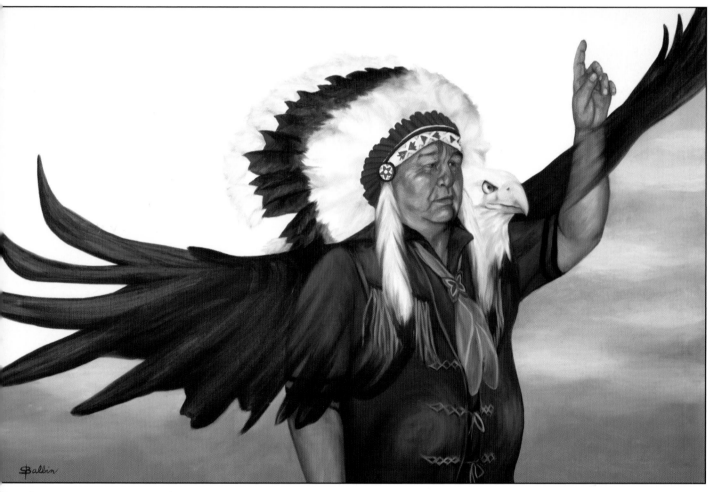

William "Bill" Sutton, oil on canvas, 32x47 inches, 1979, Lac Courte Oreilles Reservation

(deceased), Doris, Ethel, Thelma, Trixie (deceased) and Carolyn. Bill also had a son Glen from a previous marriage. In addition there were many grandchildren and great-grandchildren.

Because of Bill's knowledge of the Ojibwe culture and traditions, he was employed in 1975 by the Lac Courte Oreilles Ojibwa School system as a cultural advisor and teacher. He often traveled to ceremonies and speaking engagements, where he lectured on Ojibwe traditions. Bill also conducted workshops on building wigwams, crafting drum sticks, and making drums. For his family, he built whatever was necessary to perpetuate his culture. For example, when his grand-daughter Caroline was born, Bill worked diligently to create a traditional *dikinaagan* for the infant girl to be carried in. Bill's family remembers that no matter what task Bill undertook, he made it look easy.

Many family members and students also benefited from Bill's knowledge and love of the outdoors. Children tanned deer hides, processed *ziinzibaakwad*, and hundreds of pounds of *manoomin* under his watchful eyes. "He made machines that could process the wild rice," Mary proudly recalled. "These machines were the result of many years of dreaming and planning." Another yearly outdoor activity was the picking of blueberries in the summer near Minong, Wisconsin.

According to Mary, an important part of Bill's life was his ability to "talk to the spirits in *Ojibwemowin*." Reared as a Christian in his early years, he was often perplexed by the conflict between the *Midewiwin* way of life and Christianity. Bill, later in life, participated in Big Drum ceremonies at Lac Courte Oreilles, Lake Lena, Mille Lacs, and St. Croix.

A life-changing event occurred in the late 1970s when Bill went to the hospital for emergency surgery. After facing death, Bill's views about spirituality and the "Indian way of life" became more defined and uncompromising as he aged. All visitors to his residence in Dog Town, and later to his home in Round Lake, were welcomed. However, they were first subjected to a lecture on the importance of abstinence from alcohol and gambling. He understood the dangers, because as a young adult he admitted to drinking too much. Eventually, Bill found it easier to live a good life without the negative influence of alcohol. He taught both by lecture and by example. Bill was a role model of the old-time, traditional way of life.

He and Mary were often asked to be namesakes for newborn Ojibwe babies and conducted many naming ceremonies. On several occasions he gave baby boys one of his own names—Manidoo Gwiiwizens. This name refers to the little spirit beings that can only be seen by a few exceptional people.

Bill and Mary attended many powwows and social gatherings every year, where they were a familiar and welcome sight. At the powwow campgrounds, early risers found Bill and Mary's campsite friendly and comforting. Even far from home, they always offered freshly brewed

coffee and breakfast to guests.

Bill's nurturing nature extended to animals as well. Over the years, he cared for numerous dogs and cats, all of which had distinctive personalities. In fact, many expressed amazement that Bill, known to be very strong willed, seemed to let the animals run his life. Among the many pets that received a high level of care and love were Susie the bulldog, Mackie the arrogant Airedale terrier, Animosh, a white husky, Peanut the Shetland pony that refused to be ridden, and Gaylord, an enormous Manx cat.

Ojibwe social gatherings were important to Bill after he fell ill with lung cancer and could no longer teach. His presence alone was a reflection of his culture. In some ways he taught until he walked on at age eighty-eight in the season of his birth, the maple sugar season. Friends and relatives came from near and far to pay respect to the man who had shared his knowledge with so many. Bill was sent on his final journey with love and respect.

Four years later, in 1997, a Bill Sutton Honoring Ceremony was held at the Honor the Earth Pow Wow grounds. Bill's family and community provided many beautiful items for a *miigiwe* to friends and visitors. Numerous guests of diverse backgrounds, including fluent speakers of *Ojibwemowin* and ceremonial leaders, traveled great distances to show that they had not forgotten him.

Throughout his life, Bill was regarded as a hard worker. He was a spiritual leader, friend, father, grandfather, and great-grandfather who made significant contributions to *Anishinaabe izhitwaawin*.

EDWARD "ED" TAYLOR

CIRCA AUGUST 8, 1902 - MARCH 16, 1980

Late summer is traditionally the season of abundance. Fish, especially whitefish and sturgeon, were an important element of the traditional diet, and families often came together to visit and to fish with hooks, spears, and nets. Inland from the south shore of Lake Superior, berries were plentiful. Wild rice grew in abundance in many lakes and marshes, and the Ojibwe people harvested it in great quantities to prepare for the coming winter.

In this season of abundance, Ed Taylor was born to Max and Mary (Everson) Taylor in the community of Reserve.

Ed, like his father, was a member of the *Migizi Doodem*. Ed was the second eldest of the Taylors' five sons; his brothers were Charlie, Frank, Steve, and George.

Ed's family lived a traditional Ojibwe life and spoke *Ojibwemowin*. His nephew Bruce Taylor remembered that "Ed was a true *Anishinaabe*. He lived the *Midewiwin* belief and practiced it by himself, like many of the elders of his generation. With the *Midewiwin* belief, the elders could fit in any time at ceremonies when the need arose."

Mary Taylor died when Ed was a young child, and her five sons were fortunate to be able to be reared by their grandparents: Otis Taylor (a non-Indian) and Mary Makamokwe. Several of the Taylor children attended the Whitefish School, which was within walking distance of their home in Reserve.

Ed, however, was sent to the Indian Boarding School in Hayward. His nephew Bruce explained, "At the time, some Lac Courte Oreilles parents felt the boarding school was the best place for their children. There they knew their children would at least be fed, clothed, and educated." Ed learned English and the ways of Euro-American culture.

Even though the Indian School had these benefits, Bruce continued, "My uncle Ed told me stories of how he always ran away from the school to work in logging camps. School offi-

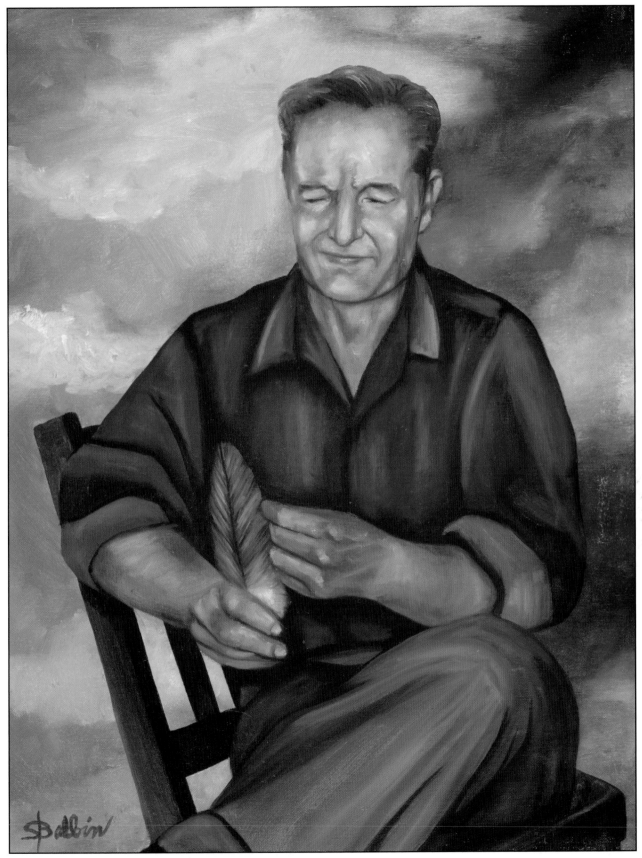

Edward "Ed" Taylor, oil on canvas, 20x25 inches, 1980, Lac Courte Oreilles Reservation

cials always found him, though, and brought him back."

Eventually Ed left the boarding school for good and went to work in the logging camps, which operated from late fall until the spring thaw. By the time Ed was eighteen, the virgin forests were nearly gone and the logging boom was ending.

Like many of his fellow tribal members, Ed left the reservation in search of employment. By the 1930s jobs were scarce as the country suffered through the Great Depression. During this period Ed was on the move, finding work where he could. For a time he worked a number of odd jobs in the Milwaukee area. Then, in Chicago, Ed was hired at the Dr. Scholl's foot products manufacturing facility, where he worked until his retirement.

Frank Taylor, Ed's nephew, lived with him for a time in Milwaukee. Ed helped him find employment with H.O. Stenzel, a large auto shop that specialized in tire, car, and truck repair. Frank remembered that Ed's nephews and nieces enjoyed spending time with him because he was so much fun, describing his uncle as "a funster, a joker."

Ed returned to his home in Reserve whenever he could. During these visits he always made time to play with his nephews and nieces. For many native people living in urban areas, visits such as these to their home reservations provided cultural renewal and a reconnection to family.

Wilma Mankiller, author and former principal chief of the Cherokee Nation, reflects on this life style in her book, *Every Day is a Good Day*. She writes:

> Community is not always a specific geographic space shared by people with common interests and values; it is sometimes a larger community of culture in which people share values and a sense of responsibility for one another. In urban areas, Native people from diverse tribal nations do not always have their own physical community, but they maintain a strong community of culture, of relationships, of shared experiences and kinship. Many regularly travel back and forth to their homelands for spiritual, social, and cultural sustenance. They have also built impressive Indian centers and friendship houses in urban areas to provide services, socialize, and hold meetings and cultural events. But no matter how long Native people live away, many continue to derive their identity from their homelands. One could ask a Sicangu Lakota woman whose family has lived in an urban area for several generations where she is from, and she will respond, "I am from Rosebud," or wherever her homelands may be.

Ed retired from Dr. Scholl's in 1964 and returned to Reserve, living just down the road from the St. Francis Solanus Mission. Once again he immersed himself in his Ojibwe culture and took great joy in participating in seasonal harvests, as his ancestors had done.

"During winter," his nephew Louis Taylor recalled, "Ed would go ice fishing between Couderay Lake and Little Couderay Lake by the Thoroughfare Bridge. I can still see him

pulling home the fish he caught that day on a sled."

In the summer, Ed would join his friends Steve Taylor and Ed Martin after church on Sunday afternoons to play cards. If the weather cooperated they spread a blanket on the lawn. If it didn't, they met in Steve's garage, where they played cribbage, penny-ante poker, and talked about events in their community.

Ed never married, but he had a great love for family and was devoted to his nephews and nieces. He is remembered by his family as a considerate, caring man.

"You could have no more loyal friend than my uncle Eddie," his nephew Frank said, "He was reliable, meant what he said, and stuck by those that he loved."

GEORGE TAYLOR

CIRCA JUNE 15, 1913 - MAY 27, 1998

George Taylor was born in the small settlement of Reserve, where many of the families still spoke *Ojibwemowin* and lived the Ojibwe culture. Like many elders of his time he was born at home, to Max and Mary (Everson) Taylor, and was a member of the *Migizi Doodem*.

Shortly after his birth, his mother died unexpectedly, leaving George and his brothers Charlie, Edward, Steve, and Frank to be reared by their grandparents Otis Taylor (a non-Indian) and Mary Makamokwe. The loss of his mother was tragic, but having the opportunity to live with his *Anishinaabe* grandmother was a blessing. In her home the Taylor brothers continued to learn the culture of the Ojibwe. George didn't begin to learn English until he attended elementary school in the Whitefish community. He and his brothers walked approximately two miles from their home to the school. George got along well, making many friends who shared in his struggle to learn a new language and Euro-American culture.

When he was a young boy, George was taken to Babe Trepania's house for a visit. The unfamiliar people and surroundings scared him and he began to cry. Babe instructed her daughter Ruth to give him an orange to calm his fears. It not only worked, but it also served as the seminal memory shared between George and Ruth, who were later married.

While living at home, he helped his family with the seasonal harvesting and processing of *manoomin*, berry picking, hunting, and cutting firewood with a bow saw and axe. On the reservation, wood-burning stoves were the only source of heat. To cut, split, and stack the firewood was an arduous and time consuming job. However, the wood was a natural resource that was free and available at all times during the winter months, when temperatures can drop to forty or fifty degrees below zero.

As a young adult he left the family settlement to serve in the military. There his talent for

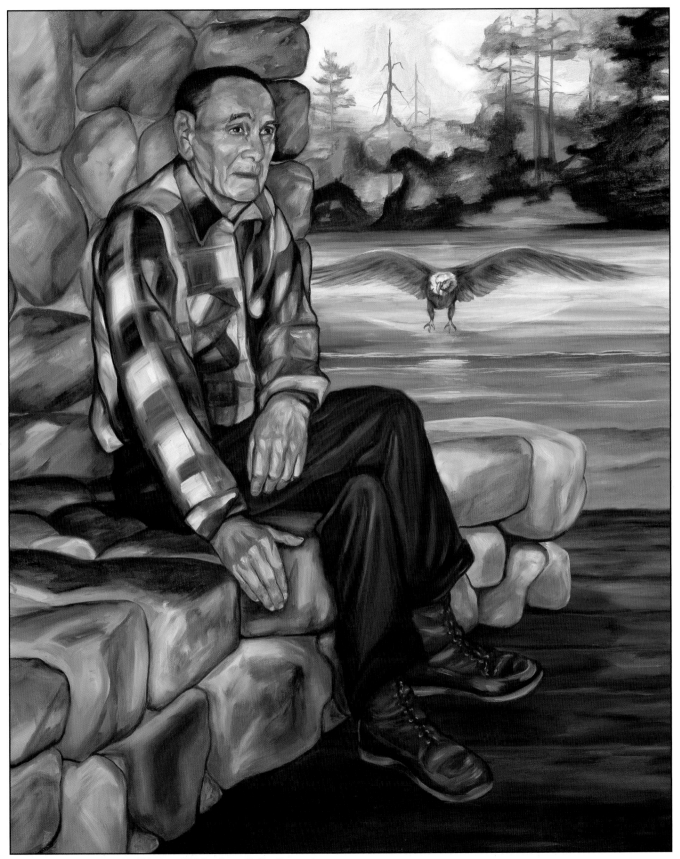

George Taylor, oil on canvas, 39x49 inches, 1996, Lac Courte Oreilles Reservation

baseball was discovered, and he played the position of catcher. After serving in the military he played for a team in Reserve for many years. Some of those who played ball with him included Bill Conger, William Belille, and Antoine Dennis. George's love of baseball kept him playing every weekend. After he quit playing for the Reserve team, he was often called upon to be an umpire. In his later years, when his eyesight began to fail, he stopped umpiring but still attended games. George often stood behind the crowd of spectators so he could watch his son George play without drawing attention. He never lost his passion for baseball or the childhood memories of his brothers and himself playing beside the house, heedless of the inevitable broken window.

George married Ruth Trepania July 24, 1946 and they had seven children: Richard, George, Debra, Donna, Kenny, Alfred, and William. The couple worked and lived at the Hayward Indian Hospital, where Ruth was as a nurse's aid and George was a janitor. According to Barbara Peickert, the director of the Hayward Area Memorial Hospital, the Indian hospital was the only hospital in the Hayward area, and, except for emergencies, served only American Indians. Non-Indians traveled to other hospitals in the region, like Rice Lake, Wisconsin, and Duluth, Minnesota for medical care.

After the Taylor's employment at the Hayward Indian Hospital, the family moved back to the Lac Courte Oreilles Reservation. Ruth recalled the homes that they lived in over the years, including a house by a bridge and the Larson house in Reserve, which they purchased. They also had a home near the present day Honor the Earth powwow grounds. The children in the family have many happy and loving memories of their lives with their parents in these various homes.

George worked a variety of jobs throughout his life, but was known primarily as a hunter and fishing guide in the Hayward area. The lakes, rivers, and streams of Northwest Wisconsin, with their abundant game fish, have attracted many well-known celebrities, including Al Capone, Dinah Shore, Bing Crosby, Oprah Winfrey, and John Ringling North, and in their youth, CBS news anchor Walter Cronkite, and Ellmore C. Patterson, chief executive officer of J.P. Morgan & Co. and Morgan Guarantee Trust Company. Many of these individuals hired Ojibwe fishing guides.

Among the private clubs on Lac Courtes Oreilles Lake, the Chicago-Lac Court d'Oreilles Hunting and Fishing Club was founded, around 1904, by two socially prominent Jewish businessmen, Julius Rosenwald (co-owner, president, and chairman of Sears, Roebuck) and Isaac Rosenfield, of the Kentucky-distillery family, and included members of the Adler family, who established the Adler Planetarium in Chicago. On their fishing expeditions, members of the Chicago Club hired Ojibwe guides, including George Taylor's brother Frank and Ben and Oliver Isham. Another club, the Lake Shore Fishing Club, had members including the Mandell family, owners of Mandell Brothers department store in Chicago, and the philantropist, Irving

B. Harris, who established the Harris Graduate School of Public Policy at the University of Chicago. Elmer Corbine and Nora Isham were co-caretakers of the Lake Shore Fishing Club, and its members hired many Ojibwe guides, including George Taylor, his brothers, and several members of the Corbine and Isham families.

George always used the skills he learned as a child no matter where they resided, and continued to cut firewood with a bow saw to heat the family home. "When my dad finally got enough money to buy a chainsaw, he thought it was a miracle," his son George recalled. "I saw my dad pack heavy logs from the woods on his shoulders. When I tried to carry logs like that I couldn't do it because it hurt too much."

Eventually the family purchased a tractor and trailer for transporting wood. His daughter Debra related this story "One day, my dad was hauling wood with a tractor and trailer. While coming down a steep hill near Reserve, he noticed a movement at his side. The heavy load of wood on the trailer had come unhitched, and was passing him on his left side." She laughed about this story because her father, the tractor, and the trailer survived unharmed. Humor is very important to the *Anishinaabe*, and incidents that amuse live on long after the events themselves. Debra continued with the following tale, "Another time my father accidentally locked himself out of his house. He had little choice but to crawl through a window to get in. Once inside he got what he needed, went straight out the front door, and locked himself out again."

Stories of bravery are equally enduring. "My father was also a hero, because he saved the lives of three people," Debra recalled. "The first life he saved was that of his brother Charlie. They were walking together, Charlie close behind, across an ice-covered lake late at night. When he noticed that Charlie was no longer following him, he ran back to find him. Charlie had fallen through the ice. Miraculously, a lantern that he had been carrying was still lit under the water. My dad pulled his brother from the icy water."

"The second rescue was that of my brother Kenny." According to Debra, who was four years old at the time, "Kenny fell from a dock into muddy and weed infested water. My father happened to be nearby, and heard the other children cry for help. He dove deep into the water several times before pulling my brother from the water."

The third incident of courage involved George's grandson Virgil, who had fallen from a bridge and was being carried away by the swift current. "George jumped into the dangerous waters and pulled Virgil to safety" Debra stated. These stories of bravery, courage, and humor will always be cherished by the family of George Taylor.

The enduring love for his four brothers was the basis for his perennial admonition to his children: "When I am not around, your uncles are in charge."

MARY "BABE" THERESA CORBINE TREPANIA

CIRCA AUGUST 4, 1896 - FEBRUARY 26, 1983

Mary "Babe" Trepania was born during summer, the season of abundance, to Louie and Mary (Quagon) Corbine. She had seven older brothers and sisters—Elizabeth, Joe, Julia, Louis, Moses, Anna, and Esther. Because she was the youngest, she was given the nickname Babe. Her father, Louie, was a man of many talents. He was the town constable and a blacksmith, and was also known to perform minor dental surgery.

Babe was reared in the small village of Reserve, comprised of just a few *Anishinaabe* families at the time, speaking *Ojibwemowin*.

When she was approximately five years old, Babe was removed from her home by the Bureau of Indian Affairs and sent to the Flandreau Indian School in South Dakota for assimilation. The Flandreau Indian School is the oldest continually operated federal Indian boarding school maintained by the Bureau of Indian Affairs (BIA). It opened with ninety-eight pupils and twelve staff members on March 7, 1893. At first, instruction was offered only as far as the eighth grade. Agriculture was the main vocational work. Babe was approximately twelve when the school added domestic science in 1908.

While a student at Flandreau, Babe was recognized for her talent as a singer and often asked to sing solo in school programs. She also played the piano.

The physical distance between the BIA schools and the reservation caused great hardship for Ojibwe families. Administrators discouraged visits home, seeing them as threats to assimilation, and this sometimes led to three- or four-year separations. They also intercepted letters from children documenting homesickness and health problems to prevent parental requests for visits. Many requests made by parents to send their children home were denied.

Yet separation proved unable to break the emotional bonds between parents and children, or bonds between children and their tribal communities and traditions. Parents loved their

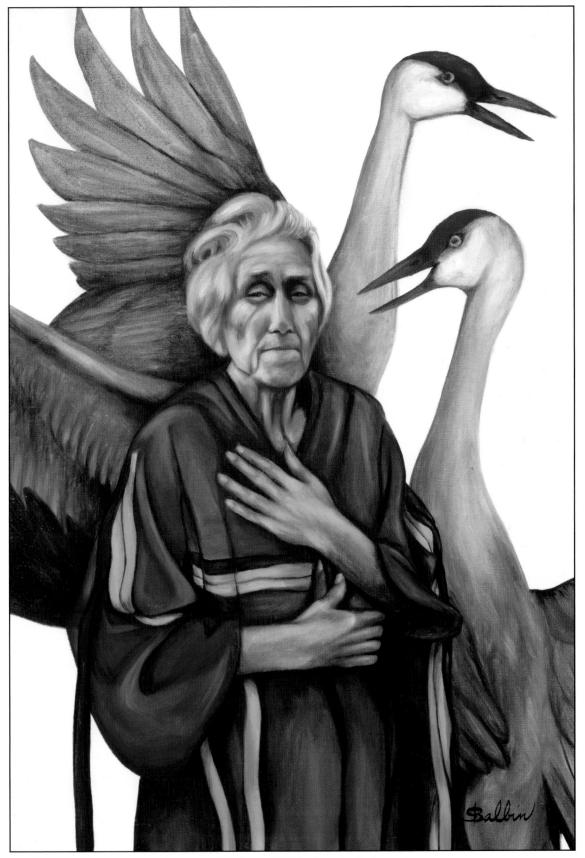

Mary "Babe" Theresa Corbine Trepania, oil on canvas, 23x34 inches, 1980, Lac Courte Oreilles Reservation

children deeply, worried about their health and safety, and found ways to influence their educational experiences. They learned which arguments would convince administrators to send their children home for the summer, and they visited them at school whenever possible. Furthermore, they kept their children informed of local births, deaths, and ceremonies, thus anchoring them in community life and tribal culture.

After Babe completed her studies at Flandreau, she returned home to her parents in Reserve, where she met Joe Trepania. They were married on December 5, 1916. Babe enjoyed married life, spending most of it at home caring for her five children—Ruth, Joan, Joe, Joyce, and LaVerne.

When the children were young, the family lived at the Hayward Indian Training School where Joe worked as a dairyman. The school had a large barn where cows and other animals were kept. Joe cared for the cows and oversaw milk production. When the family moved back to Reserve, Babe found part time employment at the Kinnamon School, situated on the corner of County Roads E and K, and at Sheffield's Resort as a cook and a housekeeper. Her seasonal part time employment left her with time to spend with family and friends. She enjoyed fishing, berry picking, and canning vegetables. Quilting intricate designs on blankets was one of her great passions. For the quilting bees, Joe installed hooks at their home from which the women could hang their works in progress.

Babe used her culinary talents to benefit both her family and her Catholic Church congregation. She was always appointed head cook for the annual Corpus Christi Harvest Dinner, at which everyone looked forward to her special way of preparing venison. At home, Babe learned to be frugal, and she developed a specialty soup called "refrigerator soup," which she also served at the Harvest Dinner. It was made from whatever ingredients happened to be found in the refrigerator at the time.

She was a devout member of the Franciscan Order and served her congregation at every opportunity. Before the St. Francis Indian Mission in Reserve was built, local community members regularly attended mass at Babe and Joe's home. Once the church had been built, the whole family attended regularly. Ruth remembered that each Christmas Eve, the children went Christmas caroling, and then attended midnight mass at the church.

Babe's devotion to the Catholic Church didn't deter her from living the *Anishinaabe* culture and traditions. Ruth recalled that her mother avidly took part in the annual *manoomin* harvest. Wild rice was harvested regularly from Tranus Lake in Reserve, Lac Courte Oreilles lake, and in lakes which existed before the flooding of the Chippewa Flowage, including Grindstone Lake, Whitefish Lake, the Totagatic Flowage, and Odabassa Village by the Namekagon River, north of Hayward.

The Trepania family was adventurous and enjoyed the outdoors, spending a great deal of time in the wilderness on hunting, fishing, harvesting, or canoeing excursions. These outings gave Babe experiences she could later tell stories about.

As the years passed, in fact, Babe became known as a gifted storyteller. Her grandchildren cherished her narratives. Especially in the winter, the time of storytelling, Babe told *Wenabozho* stories, describing the Ojibwe culture and way of life. In the Ojibwe story of *Wenabozho* and the Great Flood, for example, the Creator purified Mother Earth with water. Then *Wenabozho*—half spirit, half man—found himself, along with the animals, clinging to a log. *Wenabozho* and the animals took turns diving under the water to try to bring up some earth. After better divers failed, Muskrat gave his life in a successful effort to retrieve a few grains of sand. From that bit of earth, *Wenabozho* created a new world which Turtle offered to carry on his back. In honor of Turtle's sacrifice, some native people today refer to North America as Turtle Island.

Many people sought Babe's knowledge of Creation stories, Ojibwe traditions, and medicines. She collected and stored roots, herbs, and pine pitch for medicinal uses. The pitch, a sticky resin exuded from pine trees, was useful for healing cuts. She often gave the bitter-tasting substance to her grandchildren to chew on, teaching them its value as a dentifrice and tonic, as Babe herself and countless generations before her had been instructed.

One time Ruth was injured and hospitalized for six months with a serious cut on her leg. The leg did not respond to the doctor's treatment. Finally Babe, afraid that her daughter could lose the leg, chose to bring her home to try Ojibwe medicines. The methods and medicines she applied worked, and Ruth recovered from the injury. Learning of Babe's reputation as an effective traditional Ojibwe healer, a research team from the University of Wisconsin contacted her and expressed their desire to examine the medicines for a study. Perhaps because of the way in which they approached her, Babe refused to share her knowledge with them. It is known only that she said of the incident, "It will never work for people who don't believe in it."

Babe and Joe lived and practiced the Ojibwe traditions, helping to secure the history of their people for future generations, while also embracing Christianity. In 1966, the people of Lac Courte Oreilles celebrated together as the couple marked their golden wedding anniversary by renewing their wedding vows at the St. Francis Solanus Catholic Church, celebrating the enduring nature of their relationship for all to see. The couple's relationship, like the church itself, was as solid as a rock.

ODAWASAGAEGUN: A BRIEF HISTORY OF LAC COURTE OREILLES

RICK ST. GERMAINE
MIGIZI

Lac Courte Oreilles is an ancient woodlands Indian crossroads and settlement site with both pre-Columbian and pre-French occupancies. The abundance of lakes, streams, natural shelter, and ample food sources attracted travelers, hunting parties, and later on, fur traders in a quest for survival in the harsh environment of the Lake Superior region.

The "big lake" (Lac Courte Oreilles lake), as it was once popularly known, was heavily forested with monstrous white and red pine trees. Because of a thick pine needle cover, very little grew beneath the huge trees. The tall hills just east of the big lake and its drainage pond, Little Lac Courte Oreilles lake, were forested with maple and birch, the mainstay of woodland tribes.

This combination of pine shelter on one side, deciduous forest on the other, a dizzying number of lakes and rivers with abundant species of fresh water fish, wild rice, and game made Lac Courte Oreilles an ideal location for tribal hunters and gatherers.

Ottawa Indians took up residency in the Lac Courte Oreilles area about 1650, arriving to this forest site from the Lake Michigan region as refugees from the east in flight from the enemy Iroquois Indians. The Ottawa, who explored the region for fur pelts, came to Lac Courte Oreilles by way of the rivers—Wisconsin, Mississippi, and Chippewa. They camped along a series of lake chains until they found a large grassy field on the east side of Little Lac Courte Oreilles lake. The field, dotted with large blackened stumps, had in decades past been burned over. The Ottawa settled the site as a camp base for hunting and trapping, and even to cultivate small gardens.

In the winter of 1659–1660, this small band of Ottawa Indians was stumbled upon by the first Europeans to enter the *Gichigami* territory, Pierre Esprit Radisson and Medard Chouart des Grossielliers, who were searching for a passageway to the west and for fresh fur markets

for trade.

It is believed that the French coureurs de bois named this site Lac Courte Oreilles (Lake of the Short Ears) for the numerous small bays located on the grand lake. The little bays resembled rounded ears. Others believe this site was named for the manner in which the Ottawa residents surgically trimmed their ears.

While they were visiting the Ottawa village, a severe winter storm set in, dumping feet of snow, paralyzing any means of travel within the entire area. More blizzards ensued and soon the village was in serious danger of famine. Ottawa hunters were unable to negotiate the chest deep snow and starvation rapidly gripped the villagers, including the French explorers. Death took many Indians during the weeks that followed, plummeting villagers to acts of desperation—boiling the bark from their wigwams, chewing their own moccasins, and even eating their buckskin hides. Just when Radisson and Grossielliers thought they would die, a spring heat wave melted the snow, bringing relief to the situation, and they continued on their way south.

The calamity so marred the sensibilities of the Ottawa band that they soon left the site, moving on to Chequamegon Bay, where they lived for a short time before eventually leaving the Wisconsin area to rejoin their relatives to the east.

After 1720, Ojibwe hunting parties ventured inland, off the safety of Madeline Island in Lake Superior, in search of game, birch bark, and wild rice. The hunting parties camped a day or two at Lac Courte Oreilles, remembering stories of the Ottawa settlement and the natural resource bounty found at this important site. Wary of Fox Indians, the Ojibwe carefully negotiated every bend of the river and clump of bushes because of the danger at this inland place, about one hundred miles from Madeline Island.

During the fall of 1741, a small group of hunters traveled from Madeline Island to Lac Courte Oreilles, heartened by the lifting of a fur trade moratorium imposed by the French governor in Montreal. On arrival, the hunters found the body of a frozen Ottawa Indian lying along the eastern shore of Little Lac Courte Oreilles lake. They wondered why he was here. After burying the corpse in a respectful manner, the hunters explored the vicinity, assessing the resource wealth that had been used eighty years earlier by the Ottawa band. Upon their return to Madeline Island, they shared their story of this place of lakes where deer, fish, and wild rice abounded in the maple forest above "*Odawasagaegun*," the place where they found the dead Ottawa.

The following autumn, a Bear Clan party journeyed to *Odawasagaegun* to establish a hunting camp for the winter. Resource depletion in the region for miles around Madeline Island and encouragement from French voyageurs led to several expeditions—inland exploration off Lake Superior. Despite the ongoing fear of Fox warriors and Dakota hunters who frequented

the area west and south of Lake Superior, the group crept tentatively into the contested region to the south.

On this occasion, Eshpaion, the teenage son of the Bear Clan headman, brought his young wife who was pregnant with their first child. Unexpectedly, the girl gave premature birth to a son. The couple devotedly nurtured the newborn but, to their sorrow, the baby died. The young couple buried the infant above the north shore of Little Lac Courte Oreilles lake and held vigil over the gravesite. When it came time for the family to scurry back to Madeline Island, the young parents refused to leave. There was sign of Fox Indians in the area, they were warned, but they would not abandon their baby. His father ordered him to go, promising they would return next fall, but the youngsters wouldn't hear of it.

As the Bear Clan hunters walked away from *Odawasagaegun*, they looked back at Eshpaion and his grieving wife holding steadfast by the little grave next to their wigwam.

The summer passed with some trepidation. When the clan head returned the next autumn with a larger hunting party, to their relief the young couple was still there. Eshpaion related stories of waterways to the east and south, each holding fabulous rice fields and beaver dams, and of narrow encounters with Fox and Dakota hunters. The family celebrated, gave offerings, and set about to explore the areas to learn more about this isolated outpost.

Early spring arrived. This time, when Eshpaion's father organized the departure from *Odawasagaegun*, several other families decided to remain. Soon, more Chequamegon Bay (Madeline Island) families journeyed to this little outpost with plans to settle and to trap the rivers. They portaged their way back to Madeline Island each spring, where they traded their fur pelts for metalware, blankets, and muskets. With advanced technology and larger numbers of villagers, this remote outpost became more secure from wandering Fox and Dakota hunters.

Soon, the families established outlying camps to the east and south and *Odawasagaegun* became a permanent Ojibwe settlement. When a *Midewiwin* ceremony was finally held here in the summer of 1750, the village had matured. It also became an important stopping place for journeying Ojibwe visitors and traders in search of more lucrative waters to the south, the homeland of enemy tribesmen.

In 1736, the Dakota and Ojibwe went to war. Northern Wisconsin waterways between Lake Pepin on the Mississippi River all the way to Odawasagaegun and places west to the St. Croix River and beyond to Mille Lacs became known as "the War Road." Ojibwe hunters were deeply embroiled in a 120 year war, creating stressful, uncontrollable conditions throughout the territory. The war thwarted the attempts of French agents to use this region as a fur trapping ground for new markets with Montreal, New France.

In 1760, the French flag came down at La Pointe (Madeline Island) and at military forts

throughout the Great Lakes. Fur companies on Lake Superior shifted to British ownership, but trade with French coureurs de bois at *Odawasagaegun* continued with little disruption.

Seven years later, Jonathan Carver, an American explorer and veteran of the French and Indian War, journeyed up the Chippewa River from Lake Pepin in a search for a passageway to the Pacific Ocean. He found the village of *Odawasagaegun*, a settlement with "forty cabbons." Now a man of forty-four and surrounded by grown children, Eshpaion listened to Carver's criticism of the French as corrupt agents of ruin. Carver's mission was to transfer allegiance among the tribes from the French to the British.

Eshpaion's grandson Nenaangabi was perhaps the most spectacular figure of the first 150 years of *Odawasagaegun* history. The subject of family lore, he was born, according to one account, in 1779, the son of Gekek and the heir of Eshpaion. Another, more probable, version marked his birth in 1794, a twin son of Yellow Head, an influential war chief.

Despite the historic inconsistencies, his early life was marked with mysterious occurrences and events that appeared to signal his course as one destined to lead. Eventually, he gained renown as a fearless hunter and a warrior in strikes against the Dakota.

Nenaangabi likely journeyed with his uncles and cousins down the Chippewa River to a site above the falls (now Chippewa Falls, Wisconsin) in the company of Michel Cadotte, the French-Indian trader from Madeline Island, where annual autumn truces were negotiated between the Mississippi River Dakota and Ojibwe from *Odawasagaegun* and *Waswaaganing* (Lac du Flambeau).

Cadotte negotiated terms of the autumn parleys with the Mississippi River French trader, LaRoque, which resulted in a temporary cessation of hostilities. Annually, Ojibwe and Dakota hunters for a time came together near the falls and then set out together to hunt and gather game and hides. As hunting brothers, they shared stories and accounts of previous battles and formed tentative bonds. But the following summers, after their spring departures, they once again took up arms and resumed their bloody strikes against one another.

In 1798, John Baptiste Corbin, a 22 year old French Canadian from Montreal, established a permanent trading post at the narrows between big Lac Courte Oreilles and Little Lac Courte Oreilles lakes. In the employ of Michel Cadotte, Corbin timidly traded manufactured goods for fur pelts, building a defensive palisade around his little cabin to protect himself from the "wild Indians." Eventually, the wary trader gained more courage and ventured out to face the villagers. He married Gakabishikwe, the daughter of Wabiziwisid, an influential headman at *Odawasagaegun*. Following her death, he married her sister, Chewabakasie. Nine mixed-blood, bilingual children were born of the unions, some of whom stayed at Lac Courte Oreilles while others moved downstream along the Chippewa River and eventually out of the region.

Corbin, Canadian educated and devoutly Catholic, became perhaps the single most potent force in the westernization of northwest Wisconsin. As agent of change, he dealt in European manufactured goods—metalware, cloth, traps, blankets, and weaponry—for fur pelts. Other Frenchmen stopped at Lac Courte Oreilles. But Corbin was the first and only European to live among them during the early nineteenth century, setting into motion the rapid transformation of life from that of seminomadic hunter and gatherer to trapper and village dweller.

Dakota Indian raiding parties frequently struck Ojibwe settlements throughout the Chippewa and Red Cedar river areas near *Odawasagaegun*, inflicting moderate casualties upon warriors, women, and even children. Invariably, young Ojibwe men planned retaliatory attacks, sometimes waiting as long as several months or a year in preparation for a return strike upon the Dakota. In some cases, an *Odawasagaegun* war party journeyed all the way down the Chippewa River to wreak havoc upon an unsuspecting Dakota village, killing or maiming people who had nothing to do with the earlier attack. The 120 year war between the two foes produced unyielding hardship and obstructed trade in the region.

Elsewhere in the Northwest Territory, Tecumseh and his brother, the Shawnee prophet, mobilized a confederation of Algonquian tribes in Indiana Territory to quell the massive invasion of white settlers into their lands. The prophet Tenskwatawa sent messengers north on both sides of Lake Michigan to generate support from the Great Lakes tribes. The messengers, whose faces were painted black and behaviors were considered bizarre, arrived at *Odawasagaegun* early in the summer of 1807. Impassioned by the preaching of the mysterious messengers, the prominent warrior Nig-gig turned on Corbin, ransacking his storehouse and chasing him out of the village and all the way back to LaPointe. Undeterred by this temporary setback, Corbin rallied and during his seventy-seven year residency at *Odawasagaegun* embedded the French language to the area, established Catholicism, modeled intermarriage, and lived to see a reservation created for the tribe with the French name, Lac Courte Oreilles.

Odawasagaegun in the early nineteenth century became a major Lake Superior Ojibwe settlement with outlying villages just to the east at *Paquayawong* on the Chippewa River, to the south at Lake Chetac, Long Lake, Red Cedar, and Prairie Rice Lake, and to the west on the Yellow and St. Croix rivers. Clan leaders from *Odawasagaegun* settled these hunting camp sites as permanent offshoot villages.

Mosojeed (1760–1839), Catfish Clan, was an articulate orator and the son of Shiaab, whose brother was an original settler of *Odawasagaegun*. Because of his prowess in the forest, charismatic personality, and curative powers with plant medicines, Mosojeed became a clan headman and eventual spokesman for all of *Odawasagaegun*. Mosojeed represented Lac Courte Oreilles at one U.S. treaty negotiation, leading his tribe through the bewildering transition

period of competing British and American interests for trade, and finally through the death of the international fur market in Europe and its devastating aftermath in the Great Lakes area.

The Ojibwe, who once roamed large sectors of forest and lakes, were now trapped in a growing, but stagnant Indian settlement with a shrinking forest resource to sustain themselves. Starvation and suffering became wintertime woes. Harsh winters and European epidemics only created more misery for the once active nomads, who now found themselves more tightly anchored to a pattern of village life. After 1815, rumors of American payments for the use of Ojibwe land and resources offered some glimmer of hope.

With hundreds of thousands and ultimately millions of American pioneers pouring into the Northwest Territory and a second war with Great Britain, U.S. interest turned to the acquisition of raw materials to build a growing nation. Wisconsin held the greatest of those resources—pine timber around *Odawasagaegun* and valuable minerals south of Lake Superior. The United States needed these resources to build cities like Chicago, Detroit, and St. Louis. The Northwest Ordinance of 1787, federal trade laws, and court rulings obligated the government to fairly negotiate the purchase of Indian lands.

Prior to becoming a territory, Wisconsin was a tangle of woodland tribes with divergent customs, languages, and hunting grounds. In order to define the tribal boundaries in the western Northwest Territory, the United States conducted a treaty conference in August 1825 with a thousand leaders from thirteen Indian tribes at Fort Crawford (Prairie du Chien), along the Mississippi River. Advertised as a treaty of peace and friendship, U.S. interests entailed establishing Indian allegiance to America and diverting trade away from Canada. Follow-up treaty conferences were held with tribes near Green Bay and with Ojibwe bands at Fond du Lac. Boundaries were established and the tribes were now positioned for the transfer of their lands into American ownership. After Prairie du Chien, it took only seventeen years for the United States to complete the legal larceny.

Cession treaties were scheduled throughout the region with promises of payment in the form of annuities spread out over multiple years. The Lake Superior lands were taken from the Ojibwe in 1837 and 1842 treaty conferences. Vanquished was title to 21.5 million acres of land, with prospects of removal despite the efforts of headmen to reserve and continue their rights to hunt, fish, and gather products like wild rice and birch bark from the lands they sold.

Representing *Odawasagaegun* at the five treaty conferences were a brace of headmen, some with prominent patriarchy and others who were merely clan headmen. At Prairie du Chien in 1825 were: Tukaubishoo (crouching lynx), Miskwamatchimanitou (red devil), and Bimikawe (the track). The only headman to represent "Ottoway Lake" at the Fond du Lac treaty conference in 1826 was Paybaumikoway (the track), who was also at Prairie du Chien.

Only one headman, Paquaamo (woodpecker), represented "Lake Courteoville" at the 1837 cession treaty conference at Fort Snelling, perhaps the most nefarious of the events. Paquaamo arrived late to the proceedings, probably because the interior chiefs weren't earlier notified, although it was the interior bands who were losing their lands. Only three headmen—Nenanangeb (Dressing Bird), Ki uen zi (Old Man), and Bebokonuen, from "Lac Courtulle"—attended the 1842 cession treaty meeting at La Pointe, on Madeline Island.

In the fifty years of cession treaty conferences, headmen in the Northwest Territory were overnight transformed into bona fide "chiefs," laden with large bronze medals and U.S. flags to testify to the authenticity of their royalty.

Rumors of removal circulated during the Wisconsin logging boom years. Euro-American woodsmen flooded into Wisconsin, making it in mid-century the state with the largest and most diverse population of European immigrants in the nation. Ojibwe families worked for logging camps as hunters, cooks, and caretakers. Numbers of Lac Courte Oreilles women married the European loggers, acquiring names like Quaderer, Tainter, Thayer, Belille, and Guibord. Within forty years, about twenty-two million acres of virgin pine trees, the finest stand anywhere in the United States, were clear cut, floated downriver on their way to lumber mills in Eau Claire, Menominee, and Wausau. Lumber barons made millions of dollars on the transactions while the Ojibwe became expendable paupers in their own land.

President Zachary Taylor issued an order of removal in early 1850. To accomplish the order, the Bureau of Indian Affairs (BIA) and Minnesota territorial governor conspired to move the Wisconsin Ojibwe to northern Minnesota for a treaty annuity payment and census count in the fall. Thousands of nervous Wisconsin Ojibwe made the trek to distant Sandy Lake, including hundreds from Lac Courte Oreilles, led there by Akiwenzi (1807–1891), Catfish Clan chief at *Odawasagaegun*. Nenaangebi of the Long Lake area refused to go.

Hundreds died of exposure and starvation in the late autumn season when a killer snow storm trapped the Ojibwe at Sandy Lake. No provisions had been made by the BIA to shelter or feed the throng of Indian migrants who had been tricked into the journey. Although hundreds fled back to their Wisconsin homes, away from the death camp, some, like Akiwenzi and his Lac Courte Oreilles band, dutifully remained, destined to turn Sandy Lake into their new environ.

A year and a half later, in 1852, Chief Bizhiki made an historic trip by birchbark canoe to Washington, D.C. to intercede with President Millard Fillmore, who rescinded the removal order and allowed the Lac Courte Oreilles Indians to return home. The President then ordered one more treaty council to establish reservations for the Lake Superior Ojibwe bands.

This was held in September 1854 at La Pointe. A seventy-thousand acre reservation was authorized for Lac Courte Oreilles. Signators of the treaty included: Awkewainze (Old

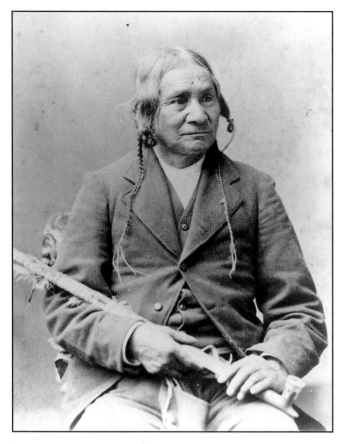

Awkewainze (Old Man)

Awkewainze (Akiwenzi) was the headman of the Lac
Courte Oreilles Tribe. He was a signator of the Treaties of
1842 and 1854. Akiwenzi and his people were removed from
Lac Courte Oreilles in 1850 when President Zachary Taylor
revoked the promises made in the Treaties of 1837 and 1842.
Akiwenzi languished in exile with members of his band at
Sandy Lake, Minnesota for two years before President Mil-
lard Fillmore rescinded the removal order.

Photo courtesy of Milwaukee Public Museum

Man), 1st chief; Naynawongaybe (Dress-
ing Bird), 1st chief; and Ozhawwawsco-
gezhick (Blue Sky), 2nd chief. Despite
the legality of this treaty, it took nine-
teen years and several more Congressio-
nal threats of removal before reservation
boundaries were finally established in 1873
by a government surveyor and Akiwenzi.

Following the 1854 treaty, yearly
annuity payments were made to hun-
dreds of Lake Superior Ojibwe heads-
of-household at La Pointe. Each Lac
Courte Oreilles patriarch received dry
rations, a bit of cloth, some coin, and
plugs of tobacco. At the September 1855
census and annuity payment meeting in
La Pointe, Nenaangebi arrived to Mad-
eline Island in a small sailboat used to
transport Ojibwe Indians.

Dr. Richard E. Morse, a visitor
from Detroit, described Nenaangebi as
"rather less than medium height and
size, an intelligent face and very keen
eye, and when animated in speaking, a
sort of fiery look or twinkle." He wore
"an elaborate turban of feathers over his
head," as he addressed BIA Commis-
sioner George W. Manypenny—who
traveled all the way to northern Wiscon-
sin for this special census event—about
the crippling poverty wrought by the taking of their hunting lands and failure of payments to
the Indians:

"I am not like your red children that live on these shores of the Lake, he desired you to bring him
the irons to spear the fish, and small twine he uses in dropping his hook into the water. I told you my
Father, I live principally in traveling through my home in the forest, by carrying the iron on my shoul-

der, that, whenever I aim at the wild animal, he falls before me. I have come with my young men, and we have brought most of our families on the strength of your promise last year, that you would give us good portions for our want this year, and like all your children, my Father, after a hard day's labor, or a long walk, I am hungry and my people need something to give them strength and comfort. It is so long since a gun was given us, we have only a few stubs, bound together by leather strings with which to kill our game, and to defend ourselves against our enemies. My Father, look around you, upon the faces of my poor people, sickness and hunger, whiskey and war, are killing us off fast. We are dying and fading away; we drop to the ground like trees before the ax of the white man, we are weak, you are strong. We are but foolish Indians, you have the knowledge and wisdom in your heads; we want your help and protection. We have no homes, no cattle, no lands, and we will not long need them. In a few short winters, my people will be no more. The winds shall soon moan around the last lodge of your red children."

About a month later, Chief Nenaangebi was dead, cut down in a Dakota ambush along the Hay River just south of Prairie Farm, Wisconsin. Several variations on the story of Nenaangebi's death were recorded. He was killed by a war club, hit in the head from behind as his family fled the initial attack, according to one account. His scalp was displayed the next day by the Dakota victors at Shoo Fly near Durand, Wisconsin. In another version, the Dakota ambushers shot him in the forehead as he raised his rifle to repel the attack. His daughter, Hanging Cloud, shot his assassin and prevented his scalp from being taken. Even in death, the old warrior Nenaangebi made history as the last casualty of the 120 year war between the Ojibwe and Dakota Indians.

In 1855 a noted Ojibwe leader died and another nearby was being reared an infant. Zhooniyaagiizhig, noted Ojibwe medicine man, in 1851 entered a tribal world transformed by the loss of its hunting and trapping lifestyle and faced with the uncertainty of a money economy steeped in schedules around a workday.

The spiritual world view of the tribal people was fertile, personal, and a daily pre-

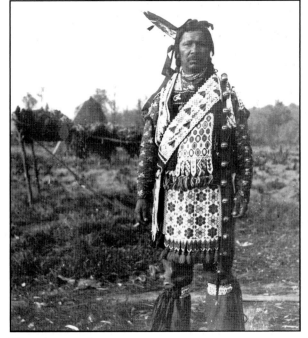

Zhooniyaagiizhig
Zhooniyaagiizhig in his younger years, circa turn of the century.
Photo courtesy of Smithsonian Institution, Anthropology Division

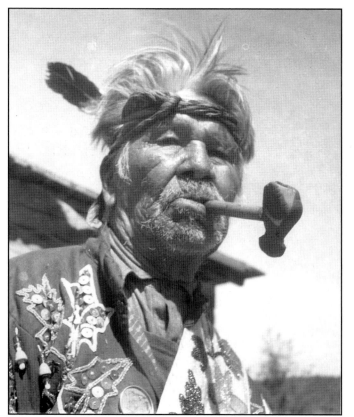

Zhooniyaagiizhig

Zhooniyaagiizhig standing in front of his house, circa 1941, at age ninety.

Photo courtesy of Milwaukee Public Museum

occupation with manitou (spirits). Manitou inhabited both animate and inanimate objects. They were appeased, honored, or summoned by Ojibwe through prayers or offerings of tobacco and food, or sometimes by medicine people (shamans). A tobacco offering was essentially a sacred duty in the ritual life of the Ojibwe. The *Midewiwin* was a spiritual curative society in which ceremony was devoted to elaborate initiation rites. While the *Midewiwin* spiritual culture flourished in dozens of Ojibwe settlements throughout the Lake Superior region, Lac Courte Oreilles in the nineteenth century became its heart and nerve center after the transformation of Madeline Island to a European market place. *Mide* medicine lodges stood as prominent spiritual structures in villages throughout Lac Courte Oreilles up until the mid-twentieth century.

Then, in May of 1878, BIA Indian agent Isaac Mahan reported a troubling disturbance underway on the Bad River and Lac Courte Oreilles reservations. Mahan warned that mysterious visitors from the Mille Lacs tribe in Minnesota were teaching the peaceful Indians here the "Sioux dance." Earlier in the year, St. Paul and Eau Claire newspapers reported an "uprising in Burnett County" among the St. Croix Ojibwe in which Minnesota Indians were inciting them to strike against white settlers. Mahan and agent Walker attempted to stop the Sioux dances, calling on U.S. marshals to arrest the instigators, imprison them at hard labor, and withhold annuity rations to any adherents. Despite the clamor and government threats, the movement took hold at Lac Courte Oreilles and elsewhere in Wisconsin.

The troubling disturbance was actually the passing from one Ojibwe tribe to another of the "peace drum" after it was given to the Mille Lacs settlement a year earlier by the vision-

ary Santee Sioux, Winanikwe (Tail Feather Woman) and her relatives, as a religious instrument of peace. The survival of Winanikwe's Santee hunting camp from a murderous attack by U.S. military soldiers induced the intercession of the Creator with instructions to build the "dream drum," and the singing of a repertoire of ceremonial songs as prayers to instill peace and health to those who follow its "teachings." As the twentieth century arrived, there were numerous Dream Drum societies at Lac Courte Oreilles headed by Zhooniyaagiizhig, Steve Grover, Ogishtan, John Quaderer, and John Apple Kekek. The *Chi dewe'igan* (Dream Drum) became a way of life among the Minnesota and Wisconsin Ojibwa, and the Potawatomi and Menominee tribes, even into the twenty-first century.

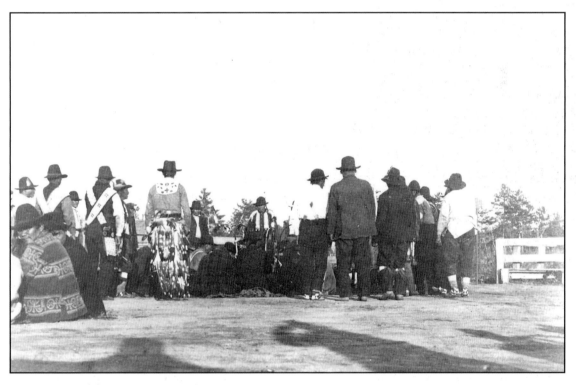

Chi dewe'igan, **The Dream Drum Ceremony, 1899**
The *Chi dewe'igan* Society, a deeply spiritual movement among the Ojibwe Indians of Wisconsin and Minnesota, came to Lac Courte Oreilles in 1878 from the West. The Dream Drum Ceremony was passed on to the Ojibwe, who in turn complied with a request from Winanikwe—that they use the ceremony for purposes of spiritual peace and health. This photograph, taken at the turn of the century in the village of Whitefish on the Lac Courte Oreilles Reservation, records the members of *Chi dewe'igan* during a ceremony which sometimes lasted for more than a week.
Photo Courtesy of Milwaukee Public Museum

After 1854, the Bureau of Indian Affairs became obsessed with the Americanization of Lake Superior Ojibwe Indians. Unsuccessful again in removing the Lac Courte Oreilles band, Indian agents resorted to agriculture training, the sale of Indian lands, and schooling as means of transforming Ojibwe Indians into American farmers. By 1873, the only significant timber stands remaining anywhere in Wisconsin were located at Lac Courte Oreilles, Lac du Flambeau, and Menominee Indian settlements. Logging companies desperately wanted these tribal stands.

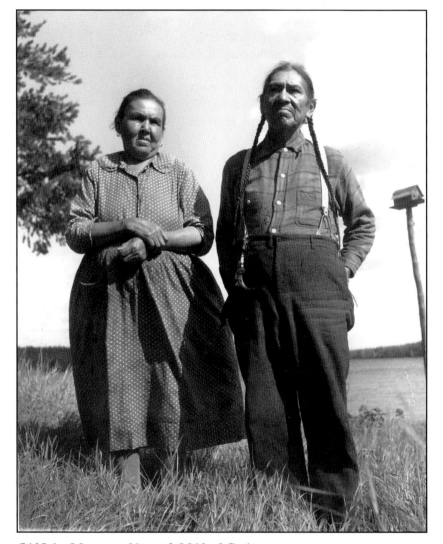

Old John Martin and his wife Mildred Corbine
The couple is viewed on their allotted tribal land.
Photo courtesy of Milwaukee Public Museum

1873 was a significant year. A survey of the exterior boundary lines of the 77,842 acre Lac Courte Oreilles Reservation was conducted by Albert Stuntz and Chief Akiwenzi in the summer of 1873. A census and annuity payment was conducted on the reservation in September, counting "1,255 souls," making this reservation the most populous of the Lake Superior bands. And finally, a post office was installed in the main village of *Odawasagaegun* at the request of lumber company officials, officially changing its name to "Reserve." Akiwenzi, the legendary headman of *Odawasagaegun*, about six foot six in height, and a *Mide* leader, would live to see the reservation allotted. His son Chingwe and grand-

nephew Maingen became headmen of the reservation but never commanded the prestige and influence that he, Nenaangebi, or Blueskye once held. The old days were gone.

Individual plots were surveyed in 1877, readying the reserve for individual assignment of small parcels of tribal lands to be used for subsistence farming purposes. Over the next thirty years, BIA agents dispensed 1,003 allotments of about 58,000 acres of tribal lands to tribal members, setting into motion an exhaustive pattern of deception—timber sales of reservation pinewood to aggressive lumber company officials.

Federal investigations into timber theft at Lac Courte Oreilles conducted during the period 1888–1896 revealed widespread irregularities and fraudulent harvesting of Ojibwe resources. In their first experience with BIA supervised logging operations, tribal members were swindled. They received no protection from inexperienced BIA agents. For example, in 1887, the most productive year of tribal logging operations, 88.4 million board feet of timber was removed by white loggers with a stumpage payment of $472,762, or about one-half cent per board foot. BIA agents and lumbermen like William Rust of Eau Claire were investigated for fraud and theft of Indian payments and timber. Ira O. Isham, "the interpreter," son of the first sheriff of Chippewa County and son-in-law of Nenaangebi, testified against Rust about this and other timber swindles.

An investigator in 1896 reported that: "The entire reservation is cut over . . . fires have destroyed what's left . . . burnt trunks with decaying wood on the ground and thick under-growth gives all a desolate appearance" Reservation logging was completed and there were no more pine trees. Starvation was reported in some areas of the reservation. The 210 one-room log cabins on the reservation replaced birch bark wigwams. Wisconsin game wardens in 1898 began enforcing state fish and game laws against Lac Courte Oreilles Indians who attempted to exercise their off-reservation reserved treaty rights. Famine befell the reservation and high infant mortality rates further reduced the populace.

John Baptiste Corbin, the aging Canadian trader, recruited Jesuit priests to *Odawasagaegun* to serve mass and convert the Indians. Some visited, held mass in Corbin's small frame wood house, but saw no profit in establishing a church at the reservation. In 1887, though, a dozen years after Corbin's death, a permanent Catholic church was built in Reserve. With obligations at other Lake Superior towns, circuit riding priests made irregular visits until nuns were able to establish a mission with an elementary school. Incredibly high absenteeism at the mission schools, like at several government day schools elsewhere on the reservation, made the schools of little consequence in the government's goal of acculturation, as families took their children to wild rice, hunting, and sugar maple camps. The BIA built two dozen boarding schools nationwide to alleviate the ineffectiveness of tribal day schools, and Ojibwe students

were enrolled in them at distant places.

A Hayward businessman, R. L. McCormick, lobbied to have a federal school for Indians stationed in his new city. It took considerable effort, but the Congress finally authorized construction. The Hayward Indian Boarding School, located fifteen miles from Reserve, opened in the fall of 1901 with about 180 Lac Courte Oreilles students. Some of the best livestock in Wisconsin furnished the school with its food and served as the vocational curriculum for the elementary students. A Hayward historian noted that, even though the students were in grade school, ". . .well do I remember playing against the Indians when I was in high school in the first two football games I ever saw—we lost both! . . ." The Indian school also sponsored student marching bands with superb musical talent. The school was closed in 1933. In the first forty-five years of the twentieth century, tribal students also attended boarding schools in Pipestone, Minnesota and Tomah, Wisconsin. Additionally, there were BIA day schools in Reserve, *Paquayawong*, and Kinnamon, but absenteeism there continued to be a problem.

The day after the U.S. entered World War 1 in 1917, young Lac Courte Oreilles Ojibwe enlisted in the 127th Infantry Company and some into the 32nd Division. Eventually, seventy-three tribal men volunteered for military service, more than from any other Wisconsin Ojibwe tribe; most of the volunteers were not U.S. citizens and ineligible for the draft. They were introduced to new world experiences, technology, and war machinery never before imagined. In late 1918, returning U.S. soldiers brought with them a European influenza epidemic that devastated North American communities. By October, schools, businesses, and community centers were closed as the illness raged for several winter months across northern Wisconsin. American Indians were especially hard hit, as they lacked natural immunities to European diseases. John Frogg was one of the few individuals unaffected and spent his days and evenings tending to households where medical care was nonexistent, meals were not prepared, and chores went undone. Daily gunshots could be heard as a customary Ojibwe signal that tribal people were dying by the dozens. Frogg and Jim Butler went around burying the dead, sometimes in shallow graves, working hard just to keep up with the digging. Nuns from St. Francis Solanus mission also traveled around the reservation, day and night, pulling carts to feed and tend to the sick.

The village of *Paquayawong*, the next oldest settlement at Lac Courte Oreilles, was in 1919 teetering on a course of destruction. The Wisconsin-Minnesota Light & Power Company was at the time of the great flu epidemic negotiating with the U.S. Congress for a license to construct a dam on the Chippewa River that would inundate and destroy *Pahquahwong* village and a twenty-six square mile area that included the tribe's wild rice beds. Even though a federal enactment in 1916 required the approval of the tribe, its objections were overruled by the

Federal Power Commission and approval was granted in 1921 for construction of the Winter Dam. American corporate interests took precedent over federal promises made to the tribe in the Treaty of 1854. As the gates of the new dam were closed in early 1923, village residents were relocated to other parts of the reservation, old graves were dug up and re-interred to another cemetery in a new village, New Post, and some reparations were promised. But in the end, as the reservoir filled and waters rose to the door steps of stubborn villagers who refused to leave, one old woman was forcefully removed and excited horses were led to safety through watery ravines. Americanization brought with it a newfound Indian sense of skepticism and distrust.

The Indian Reorganization Act (IRA) was enacted in 1934 as an Indian reform showcase of the recently elected Franklin D. Roosevelt administration. The IRA ended the reservation allotment program, guaranteed freedom of Indian religion, transferred Indian students from boarding schools to local public schools, and offered tribes an opportunity for "home rule," or constitutional government. Public works programs provided seasonal jobs for men, like the construction of small Works Progress Administration (WPA) frame houses, built on rock and mortar foundations and sold to Indians for twenty-five dollars. Some of these small 1930s houses still remain on the reservation in the twenty-first century.

Despite its appeal, the Lac Courte Oreilles tribe rejected IRA government and chose instead to continue tribal rule through BIA consultation with clan or village headmen. After World War II, the BIA farmer (Indian agent) organized a tribal business committee and arranged for tribal elections every four years for tribal members to popularly elect their representatives. Community leaders like John Billyboy, Norman Guibord, and Henry Smith were often elected to the Lac Courte Oreilles Business Committee with a meager voter turnout of twenty-five to forty. The BIA farmer dominated committee meetings with right-of-way easements and resolution approvals, and actually managed the business of the tribe until about 1965.

Robert Ritzenthaler, a Wisconsin anthropologist, conducted extensive field research during 1939–1943 at Lac Courte Oreilles in the villages of Signor and Whitefish, searching the spiritual customs of the Ojibwe. He and others, like Joseph Casagrande and Victor Barnouw, conducted widespread interviews in the corner of the reservation where the *Midewiwin* and *Chi dewe'igan* societies still flourished. The scientists used interpreters like Prosper Guibord to translate the Ojibwe descriptions of *Mide* and Dance Drum secrets, ritual, prayer songs, and ceremony. Zhooniyaagiizhig, now well into his nineties, provided a window into the spirit realm of the *Anishinaabe*, sharing stories about tribal history through his personal portal. The old man was asked in 1932 by Joe and Nancy Benton to "name" their son, Eddie. He named the boy Bawdwaywidun-Banaisee, meaning "the sound of a thunderbird approaching." Young Benton was raised as an apprentice of the custom ways of the traditional people. Eleven years

later, in 1943, Ritzenthaler wrote that young Eddie Benton was the most knowledgeable young boy of the *Midewiwin* rituals that he had ever encountered and was destined for a leadership role. Indeed, Lac Courte Oreilles maintained the distinction through this period as the heart and nerve center of *Anishinaabe Midewiwin* life. But after World War II, things would change.

The outbreak of World War II brought an impressive response of volunteers. Most young Ojibwe served in both the European and Pacific theatres, again separated from their tribes, exposed to world cultures and American technology, and forced to use English exclusively in their communications with others. This war had a brutal impact on Ojibwe soldiers, and their return brought them into intimate contact with cities reaching to both coasts. The transition back to Lac Courte Oreilles was difficult, with many staying in cities to find work opportunities. The war also generated Congressional interest in the termination of trust responsibility for the Indian tribes. Wisconsin tribes were thought to be the most ready for this relinquishment and were placed on the docket for withdrawal of trust protections on the reservation. After the Korean Conflict, the federal government transferred criminal and civil jurisdiction over the Wisconsin tribes to the State of Wisconsin and created a program to relocate reservation families to places like Minneapolis, Chicago, and Milwaukee, where they were expected to find employment. Hundreds of Lac Courte Oreilles Indians moved to the cities, where they struggled to adjust to the demands of urban circumstances.

Just when searing conditions of poverty and abandonment seemed to empty all chances of hope for the reservation, the Johnson Administration in 1964 declared war on poverty and pumped millions of dollars into economically depressed communities throughout America. Federal funds for Head Start, manpower training, economic development planning, and low-income housing were offered to Indian tribes. The BIA encouraged the Lac Courte Orielles Business Committee to adopt an Indian Reorganization Act constitutional form of government, which it said would facilitate their eligibility for federal housing. The issue was placed as a referendum before the tribal membership in 1966. With the usual small voter turnout, the referendum passed and the tribe broadened its scope of authority with expanded duties and responsibilities as a federally recognized tribe. Eventually, the tribe joined a confederation of Wisconsin tribes, the Great Lakes Inter-Tribal Council, Inc., which managed federal funding into the reservation for community-action and economic-opportunity grants. Peter Larson, a retired electronics technician, returned home to the reservation to assist with the poverty programs. He started a reservation newspaper—*Wasamidong*—and organized youth training services. Eventually, numerous tribal newspapers sprang up with names like *Anishenabe Aki*, *LCO Journal*, and *News From Indian Country*.

Peter's young son, Stony Larson, collaborated with Lewis White to start a modern Indian

drum group known as the Badger Singers. The boys traveled throughout the Midwest learning powwow songs with a plains Indian flavor. Using a marching band drum, rather than the more traditional Ojibwe instrument, the Badger Singers enchanted some locals and irritated others. They performed weekly alongside the older drum groups at Historyland, a Hayward tourism complex. The entrepreneur behind Historyland, Tony Wise, employed many of the Indians who were most knowledgeable about the old customs and traditions—the *Midewiwin* people. Bill Barber, Sam Frogg, Nancy Hart Benton, James Pipe Mustache, and Bill Bineshi Baker were among the mainstays of the tourist shows. Tom Vennum, a Wisconsin anthropologist, spent two years researching and filming the construction of an Ojibwe dance drum by Bill Bineshi Baker. Vennum expanded the project into a book that was later published by the Smithsonian Institution, making Baker a recognizable cultural treasure among the Lake Superior tribes.

In 1969, the BIA notified the Lac Courte Oreilles (LCO) tribal government that the license for renewal of the Chippewa Reservoir Project #108 was due for approval in 1971. The Board retained a law firm and explored its options for renegotiation of the 1921 licensing terms. When Eddie Benton-Banai entered the conversation with the LCO Tribal Governing Board in late 1970, the stakes for relicensing took on a more heightened profile. Benton-Banai, an American Indian Movement (AIM) leader in the Twin Cities, emboldened tribal leaders with oratorical challenges against the power company and the Federal Power Commission. When negotiations appeared to fail, Benton-Banai and other activists stormed the Winter Dam, occupying it for several days in a highly visible show of Indian civil disobedience. The occupation of the Winter Dam in August 1971 raised the attention of Wisconsin political leaders, who assisted in the scheduling of long term negotiations. In a final settlement in 1984, 4,500 acres of land was returned to the tribe, along with a large money settlement and ownership of a hydroelectric power generation plant at the dam. Benton-Banai in 1973 founded the Honor the Earth Pow Wow, an annual summer cultural gathering dedicated to the caretaking of Mother Earth and as a memorial to the spirit of *Paquayawong*.

The 1970s and 1980s were an era of Indian self-determination, a federal policy that encouraged Indian tribes to take responsibility and control of federal program services. At Lac Courte Oreilles, buoyant tribal government leaders created a large construction company that trained and employed professional Indian tradespersons. The company built over three hundred low-income houses for tribal members, significantly raising the standard of living and reducing serious medical problems. Lac Courte Oreilles operated the only tribally owned cranberry marsh in the nation. A commercial mini-mall was built in 1979, with an auto gasoline and service station, a grocery store, and a small but popular cafe. A tribally owned and operated 100,000 watt radio station, WOJB-FM, launched the tribe into public broadcasting. A degree-granting

tribal community college was founded in 1983 that consolidated both academic and vocational training services to tribal members.

In late 1975, racial conflict between Ojibwe and white students provoked a walkout of the Hayward public high school by 150 Indian students. This act of civil disobedience by tribal students led to an emergency drive by the LCO tribal government to remodel a condemned factory building in the village of New Post to be used as a makeshift K-12 school. Lacking resources to hire teachers, administrators, or to purchase classroom furniture, text books, or supplies, the tribe mobilized volunteers to teach academic courses of study to eager students. Eventually the tribe contracted with the BIA for self-determination funding to operate a bilingual, bicultural school for three hundred students. Decade by decade, the tribe invested millions of dollars to upgrade school facilities and employed esteemed elders like James Pipe Mustache (grandson of Zhooniyaagiizhig) and Bill Sutton to advise and teach Ojibwe language and culture. The tribal school preserved the *Anishinaabe* culture and language and petitioned a young artist, Sara Balbin, to inspire its students by painting the portraits of dozens of its elder matriarchs and patriarchs.

Lac Courte Oreilles in 1974 brought legal action in federal court against the State of Wisconsin for curtailing the treaty hunting and fishing rights of Lake Superior Ojibwe Indians in the ceded territory. The case was instigated when AIM activist Mike Tribble and his brother Fred purposely violated state fishing laws to get arrested by Wisconsin game wardens. This pushed the matter into court and opened tribal litigation to restore usufructuary rights reserved in treaty negotiations over one hundred years earlier. The tribe's case was lost in lower court rulings in 1978, but then supported by the Seventh Circuit Court of Appeals in 1983. The case was remanded back to the lower federal court to determine the permissible scope of the treaty hunting and fishing exercise.

Almost immediately, resort owners, sports hunters and fishers, and anti-treaty groups rose up to protest against the Indian treaty rights practice in northern Wisconsin. Anti-treaty organizations argued that highly efficient Ojibwe hunting and spearfishing methods would result in the destruction of the natural resource of forests and lakes, causing irreparable damage to the northern Wisconsin economic base—tourism. Hundreds and even thousands of white protesters gathered at lakes where they intimidated Ojibwe spearfishers who attempted to launch their fishing boats in cold April evenings. Eventually, cooler heads prevailed. A consortium of Ojibwe tribes organized a natural resource co-management role with the State Department of Natural Resources (DNR) and publicized information about treaty hunting and fishing that helped calm the public's fears. Ojibwe hunting and spearfishing had little impact on the health of the natural resource. One hundred and forty years after Ojibwe chiefs bargained to preserve

their hunting and fishing rights, Lac Courte Oreilles led the fight to restore them.

Multimillion dollar federal housing grants supported the construction of several hundred low-rent, two and three bedroom units, each with indoor plumbing and automobile garages. Quality housing nearly eliminated infant mortality and infectious diseases and produced much needed jobs and trade skills. Soon, the tribal construction company built government and school buildings, roads, and sewer lines, significantly raising the living conditions of Ojibwe Indians who had grown up deep in the woods in small log cabins with one and two seat outhouses.

Electricity, television, and old cars hastened cultural change at Lac Courte Oreilles. The K-12 school, community college, and radio station increased job skills, brought tribal people into greater contact with whites, and moved tribal government closer to its self-determination goals. But modern progress on the reservation came at a price. The housing development created many new villages in places that once served as forested hunting grounds. Six Mile Corner, Dry Town, Bacon Square, and K-Town became new living centers on the reservation, and shopping at the Hayward Wal-Mart was only a short fifteen minute drive, a trip that once took an entire day. By 1985, less than fifty tribal members spoke the Ojibwe language and the tribe moved further away from the old traditions and cultural values once deemed essential to their identity as "beings of the spirits."

To quell the loss, tribal educators embedded the school and college curriculum with Ojibwe culture and language units and hired tribal elders to teach about history, values, and customs. Great efforts were made to preserve the language, as elders warned that its loss meant doom for the tribe. Ojibwe syllabary, double vowel, and memorization of nouns accentuated classroom instruction, but without a utilitarian purpose or conversational practice, language acquisition made little headway.

By the 1990s, Indian powwows had become iconoclastic institutions throughout the Lake Superior region. The tribe's three big inter-tribal powwows annually brought thousands of celebrants and spectators together in June, July, and November to promote Ojibwe heritage through music, dance, and celebration. Lac Courte Oreilles' Honor the Earth Pow Wow featured nearly twenty drum groups and hundreds of woodlands and plains dancers, most of whom traveled a weekly summer circuit from one celebration to the next, occupied by audiotape drum music, tent camping by lakes or streams, and sewing repairs to woodlands dance regalia. The Badger Singers became grandparents and their sons started several other drum groups, including the Pipestone Singers and Grindstone Singers.

Ojibwe ceremonial dress at Lac Courte Oreilles evolved from tanned buckskin hide to dark blue or black broadcloth coverings, decorated with small ornaments and quills. Later,

208 SPIRIT OF THE OJIBWE

European beads added distinctive colorful floral design on black cotton fabric. Late twentieth-century regalia combined traditional *Anishinaabe* floral emblems onto an expanded number of dance dress styles—traditional, jingle, and fancy shawl. Colors moved from faded primary, to brighter secondary, and finally neon. Each dance style carried with it a customary story and interpretive pantomime—for young girls, possibly a dance of the butterfly, and for young men, the patting down of tall grass in preparation for a tribal gathering. Contest powwows provoked leaps beyond the boundaries of accepted custom, transforming dance and dress styles to newer and bolder changes in songs, dance steps, and dress, as the "individual" psyche won out in an internal struggle with tribal norm. Indian casino revenue raised the stakes in the summer powwow business, with drum and dance prize money now approaching $75,000 per weekend event.

Lac Courte Oreilles in 1981 cautiously entered the world of Indian gaming, following the lead of other tribes like the Florida Seminoles and Minnesota Shakopee. Starting with charity and privately owned bingo games, the LCO government eventually moved beyond Class II to Class III gaming in 1991, after a federal regulatory act restricted gaming to tribal-government authorized businesses. In 1994, the tribe negotiated its first state compact and then opened a multi-million dollar gambling facility. By 2001, the tribe had about $3 million net gaming revenue, earnings from which it used to support tribal government services. A neighboring tribe, the Mille Lacs Band, albeit closer to Minneapolis-St. Paul, that year had about $127 million net revenue from two casinos.

Tribal government in the twentieth century broadened its responsibilities in health and medical services, business development, and justice systems. Lac Courte Oreilles operated a civil court system since the early 1970s and eventually expanded it to include some elements of criminal jurisdiction. The tribe originally limited its law enforcement arm to natural resource regulation and protection, and recently assumed criminal law enforcement of certain state and tribal codes within the boundaries of the reservation.

At the same time, religion became a contemporary topic of controversy. The number of active members of Catholic and Protestant reservation congregations fluctuated. The St. Francis Solanus Mission in 1985 surpassed a century of pastoral service in the village of Reserve, operating an elementary school for about one hundred children. A *Midewiwin* grand chief resides on the reservation and conducts seasonal lodge ceremonies for hundreds of Algonquian members residing across a broad range of Great Lakes territory. An increasing number of tribal members have returned to the *Midewiwin* society as they face a century of ambiguity—what is the good life, hidden away deep in the forest, in the Internet age?

As Lac Courte Oreilles nears its three hundredth year of continuous Ojibwe residency, the tribe faces formidable ideological issues of sovereignty, cultural survival, and economic suste-

nance. Firmly positioned now in the global economy and information age, struggles with identity, heritage, and health continue to challenge the best efforts of tribal leaders to appropriately guide its six thousand members into the future.

BIBLIOGRAPHY

Armstrong, Benjamin G. *Early Life Among the Indians*. Ashland, Wis.: Press of A. W. Bowron, 1892.

Barnouw, Victor. *Wisconsin Chippewa Myths & Tales and Their Relation to Chippewa Life*. Madison: University of Wisconsin Press, 1977.

Benton-Banai, Edward. *The Mishomis Book: The Voice of the Ojibway*. St. Paul: Red School House, 1988.

Blessing, Fred K. *The Ojibway Indians Observed*. St. Paul: Minnesota Archaeology Society, 1977.

Buffalohead, Roger, and Priscilla Buffalohead. *Against the Tide of American History: The Story of the Mille Lacs Anishinabe*. Cass Lake, Minn.: The Minnesota Chippewa Tribe, 1985.

Campbell, Henry Colin. *Wisconsin in Three Centuries, 1634–1905*. 5 vols. New York: Century History Company, 1906.

Chippewa Treaty Rights: Hunting, Fishing and Gathering on Ceded Territory. Odanah, Wis.: Great Lakes Indian Fish & Wildlife Commission, 1988.

Cleland, Charles E. *A Brief History of Michigan Indians*. Lansing: Michigan History Division, Michigan Department of State, 1975.

Danziger, Edmond Jefferson, Jr. *The Chippewas of Lake Superior*. Norman: University of Oklahoma Press, 1979.

Densmore, Frances. *Chippewa Music*. Smithsonian Institution, Bureau of American Ethnology, Bulletin 45. Washington, D.C.: U.S. Government Printing Office, 1910.

_____. *Chippewa Music*–II. Smithsonian Institution, Bureau of American Ethnology, Bulletin 53. Washington, D.C.: U.S. Government Printing Office, 1913.

_____. *Chippewa Customs*. St. Paul: Minnesota Historical Society Press, 1979. (First published in Washington, D.C. as Smithsonian Institution, Bureau of American Ethnology, Bulletin 86, by the U.S. Government Printing Office in 1929.)

Dewdney, Selwyn, ed. *Legends of My People: The Great Ojibway*. Toronto: Ryerson Press, 1965.

Eggan, Fred, ed. *Social Anthropology of North American Tribes*. Enlarged ed. Chicago: University of Chicago Press, 1955.

Erdman, Joyce M. *Handbook of Wisconsin Indians*. Madison: Governor's Commission on Human Rights, 1966.

Fries, Robert F. *Empire in Pine: The Story of Lumbering in Wisconsin, 1830-1900*. Madison: State Historical Society of Wisconsin, 1951.

Garte, Edna. *Circle of Life: Cultural Continuity in Ojibwe Crafts*. Duluth, Minn.: St. Louis County Historical Society, 1984.

Hickerson, Harold. "The Feast of the Dead Among the 17th Century Algonkians of the Upper Great Lakes." *American Anthropologist* 62 (1960): 81-107.

_____. *The Southwestern Chippewa: An Historical Study*. American Anthropological Association, Memoir, Vol. 64, No. 92. Menasha, Wis.: The Association, 1962.

_____. *The Chippewa and Their Neighbors: A Study in Ethnohistory*. New York: Holt, Rinehart and Winston, 1970.

Hilger, M. Inez, Sister. *Chippewa Child Life and its Cultural Background*. Smithsonian Institution, Bureau of American Ethnology, Bulletin 146. Washington, D.C.: U.S. Government Printing Office, 1951.

Hoffman, Walter James. "The Mide'wiwin or Grand Medicine Society of the Ojibwa." In *Seventh Annual Report of the Bureau of Ethnology to the Secretary of the Smithsonian Institution* (1885-1886), 143-300. Washington, D.C.: U.S. Government Printing Office, 1891.

Hyde, George E. *Indians of the Woodlands: From Prehistoric Times to 1725*. Norman: University of Oklahoma Press, 1962.

Kellogg, Louise Phelps. *The French Régime in Wisconsin and the Northwest*. State Historical Society of Wisconsin, 1925.

Kidd, Kenneth E. "Burial of an Ojibwa Chief, Muskoka District, Ontario." *Pennsylvania Archaeologist* 21, 1-2 (1951): 3-8.

Kinietz, W. Vernon. *The Indians of the Western Great Lakes, 1615-1760*. Ann Arbor: University of Michigan Press, 1965.

Kohl, Johann Georg. *Kitchi-Gami: Life Among the Lake Superior Ojibway*. Translated by Lascelles Wraxall. St. Paul: Minnesota Historical Society Press, 1985. (First Published in London by Chapman and Hall in 1860.)

Landes, Ruth. *The Ojibwa Woman*. New York: Columbia University Press, 1938.

_____. *Ojibwa Religion and the Midéwiwin*. Madison: University of Wisconsin Press, 1968.

Leekley, Thomas B. *The World of Manabozho: Tales of the Chippewa Indians*. New York: Vanguard Press, 1965.

Levi, Carolissa. *Chippewa Indians of Yesterday and Today*. New York: Pageant Press, 1956.

Lurie, Nancy Ostreich. *Wisconsin Indians: Lives and Lands*. Madison: State Historical Society of Wisconsin, 1970.

McNickle, D'Arcy, et al. *Captive Nations: A Political History of American Indians*. Washington, D.C.: American Indian Policy Review Commission, 1977.

The Minnesota Chippewa Tribe, John Schaaf, and Charles Robertson, eds. *Minnesota Chippewa Tribal Government*. Bemidji, Minn.: Bemidji Pioneer, 1978.

Minnesota Historical Society. *Chippewa and Dakota Indians: A Subject Catalog of Books, Pamphlets, Periodical Articles, and Manuscripts in the Minnesota Historical Society*. St. Paul: The Society, 1969.

Newton, Stanley. *The Story of Sault Ste. Marie and Chippewa Country*. Grand Rapids, Mich.: Black Letter Press, 1975.

Nute, Grace Lee. *Lake Superior*. Indianapolis: Bobbs-Merrill, 1944.

Peake, Ora Brooks. *A History of the U.S. Indian Factory System, 1795-1822*. Denver: Sage Books, 1954.

Quimby, George Irving. *Indian Life in the Upper Great Lakes, 11,000 B.C. to A.D 1800*. Chicago: University of Chicago Press, 1960.

Radin, Paul. "Ethnological Notes on the Ojibwa of South Eastern Ontario." *American Anthropologist* 30, 4 (1928): 659-68.

Redsky, James (Esquekesik). *Great Leader of the Ojibway: Mis-quona-queb*. Edited by James R. Stevens. Toronto: McClelland and Stewart, 1972.

Ritzenthaler, Robert E., and Pat Ritzenthaler. *The Woodland Indians of the Western Great Lakes*. Garden City, N.Y.: Natural History Press, 1970.

Robinson, Percy James. *Toronto During the French Regime: A History of the Toronto Region from Brûlé to Simcoe, 1615-1793*. Toronto: University of Toronto Press, 1965.

Ross, Hamilton Nelson. *La Pointe: Village Outpost*. St. Paul: North Central Publishing Co., 1960.

Satz, Ronald. *Chippewa Treaty Rights: The Reserved Rights of Wisconsin's Chippewa Indians in Historical Perspective*. Revised. Madison: University of Wisconsin Press for the Wisconsin Academy of Sciences, Arts and Letters, 1994.

Schoolcraft, Henry Rowe. *The Literary Voyager, or Muzzeniegun*. Edited by Phillip P. Mason. East Lansing: Michigan State University Press, 1962.

Smith, Alice E. *From Exploration to Statehood.* Vol. 1, *The History of Wisconsin*, ed. William Fletcher Thomson. Madison: State Historical Society of Wisconsin, 1973.

Tanner, Helen Hornbeck. *The Ojibwa.* New York: Chelsea House, 1991.

Tanner, Helen Hornbeck, ed. *Atlas of Great Lakes Indian History.* Norman: University of Oklahoma Press, 1986.

Tobola, Thomas Henry, comp. *Cadotte Family Stories.* Cadott, Wis.: Cadott Printing, 1974.

Trigger, Bruce G., ed. *Northeast.* Vol. 15, *Handbook of North American Indians*, ed. William C. Sturtevant. Washington, D.C.: Smithsonian Institution, 1978.

United States Commission on Civil Rights. *Indian Tribes: A Continuing Quest for Survival.* Washington, D.C.: The Commission, 1981.

Vennum, Thomas, Jr. *The Ojibwa Dance Drum: Its History and Construction.* Washington, D.C.: Smithsonian Institution Press, 1982.

Verwyst, P. Chrysostomus. *Life and Labors of Rt. Rev. Frederic Baraga.* Milwaukee, M. H. Wiltzius, 1900.

Waldman, Carl. *Atlas of the North American Indian.* New York: Facts on File, 1985.

Warren, William W. *History of the Ojibway People.* St. Paul: Minnesota Historical Society Press, 1984. (Written in 1852 and first published in St. Paul by the Minnesota Historical Society in 1885.)

Waukau, Anne. *The Lake Superior Anishinabe.* Edited by Jim Thannum. Odanah, Wis.: Great Lakes Indian Fish & Wildlife Commission, 1987.

Rick St. Germaine is a professor of history at the University of Wisconsin–Eau Claire and formerly held faculty positions at the University of California–Berkeley, Harvard University, and Bemidji State University. A former tribal chairman of the Lac Courte Oreilles Tribe, St. Germaine serves as a correspondent for the *Indian Country Today* newspaper and was once, in the mid 1980s, editor of the *LCO Journal*, the newspaper produced by the tribe. He used this monthly to continue his research and publication of historic vignettes about LCO elders, tribal villages and communities, and the need for tribal schools and a college. Today, St. Germaine teaches courses for four colleges and universities, writes about the history and culture of the Ojibwe and Navajo Indians, and works to help Ojibwe tribes preserve the Ojibwe language.

Lac Courte Oreilles Photographs

Sara Balbin

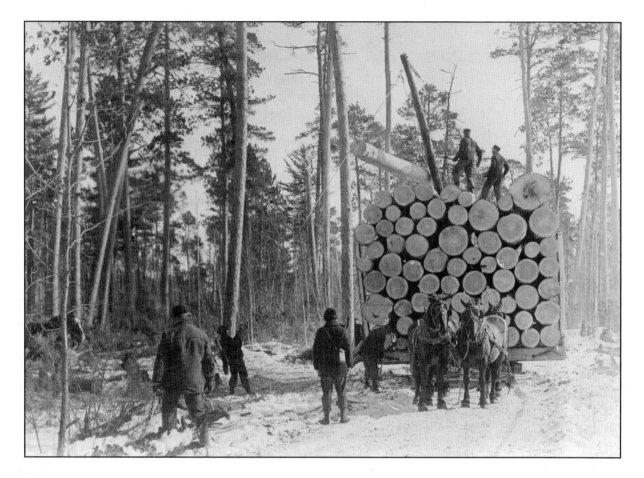

Logging

Tribal members from the Lac Courte Oreilles Reservation traveled by foot to work in regional logging camps as early as the 1870s. A few sites of the logging camps and sawmills included Signor, Hayward, Seeley, Cable, and Drummond. There was also a mill at Eddy Creek on the reservation that was later moved to Couderay. Temporary dams and mills were built throughout the region as the timber was depleted. The jobs varied from working in the camp's cook shanty (kitchen-dining), sawing, liming, debarking, log-driving on the river, stacking, loading, and hauling. Winter, Wisconsin resident Jess Ross, quoted in *Where the River is Wide* and referring to Lac Courte Oreilles loggers from the village of Post, said: "Post Indians were good workers and always on time. We worked ten-hour days then, in the woods by dawn until sundown—every day but Sunday." Logging continues to have a significant presence in northwest Wisconsin.

Photo courtesy of Drummond Historical Museum

Rust Owen Lumber Co. of Drummond, Wisconsin

Founded in 1882, the company sawed its last log in 1930. The Rust Owen Lumber & Mfg. Co. bought the timber holdings of North Wisconsin Lumber Co. of Hayward in 1898. The logging industry offered American Indians employment in the region. Clear cutting of timber was not customary in the Ojibwe culture. Their use of wood was limited, sustainable, and functional for housing, heating, cooking utensils, canoes, fishing, hunting, harvesting, and games.

Photo courtesy of Drummond Historical Museum

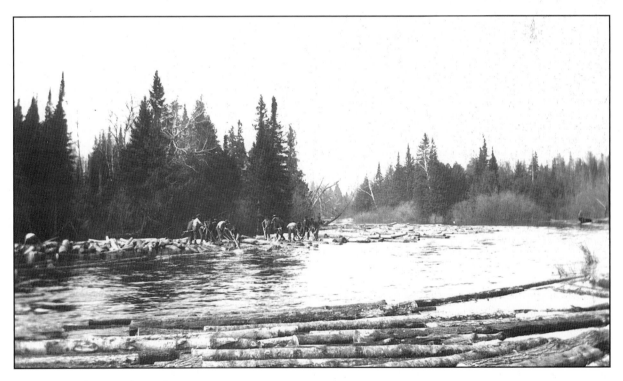

Log drive on the Namekagon River

In the late 1800s, northern Wisconsin log drives were an efficient way to move pine logs to the sawmills. Log drivers wearing spike boots used long pike poles to prevent and break up log jams. Logs were floated down the Namekagon River to the North Wisconsin Lumber Co. mill in Hayward. In the early 1900s, after the big timber was gone, a proliferation of small lumber mills operated in the region. Mills north of Hayward to Drummond along the Namekagon River and its tributaries included the Soderburg at Phipps, Vortanz at Seeley (still operating), Jack Thompson, John Welch, Rogan Brothers, John Fink, Radloff Brothers, and Carl Rasmussen in the Cable area. Camping in the forest along the way, the Ojibwe from Lac Courte Oreilles would walk for days to the logging camps and mills seeking work.

Photo courtesy of Robert K. Olson

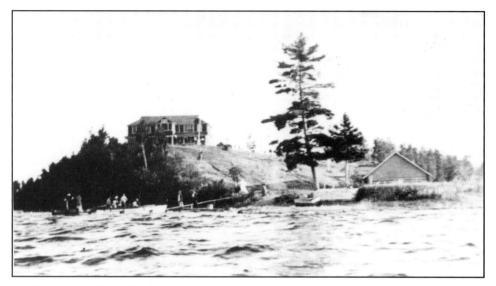

The Wisconsin Missouri Angling Club (WISMO)

The WISMO Club is located on the Big Lac Courte Oreilles lake near the town of Reserve, Wisconsin. Dr. E. P. Cronkite, grandfather of CBS news anchor Walter Cronkite, and other prominent families of St. Joseph, Missouri founded the club in 1906. Members of the Studebaker automobile, Kroehler furniture, and Bradley newspaper families belonged to the club. Abundant pan and game fish are found in the numerous Lac Courte Oreilles Reservation lakes and streams including *maashkinoozhe* (muskellunge), *ogaa* (walleye), *namegos* (trout), *name* (sturgeon), and *ashigan* (small and large mouth bass). Tribal members from the Lac Courte Oreilles Reservation who lived on or around the lake were frequently hired as fishing and hunting guides.

Photo courtesy of Wisconsin Missouri Angling Club (WISMO)

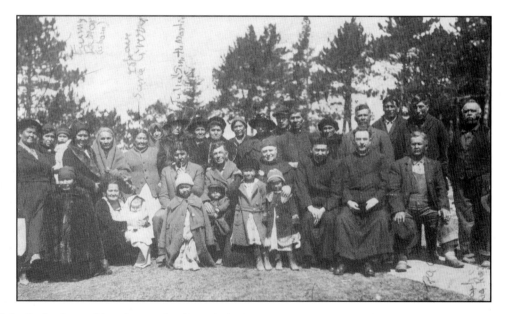

Father Philip B. Gordon and Lac Courte Oreilles tribal members

Father Philip Gordon, diocesan priest and first American Indian Catholic priest in Wisconsin, is seated front row, third from the right. Father Gordon was in charge of the St. Francis Solanus Indian Mission on the Lac Courte Oreilles Reservation in Reserve, Wisconsin from 1918 until early 1924. He was instrumental in the reconstruction of the church that was destroyed by lightning in 1921.

Photo courtesy of Sawyer County Historical Society

St. Francis Solanus Indian Mission
The Mission is located on the Lac Courte Oreilles
Reservation in the village of Reserve. Franciscan
priests took charge of the Mission in 1878. A small
log church, a school, and a convent were begun in
1881 and completed in 1885. Sisters of St. Fran-
cis from Milwaukee, Wisconsin came to teach at
the school in 1886. The original log church was
destroyed by lightning in 1921. The present church
was built with stone from the Pipestone Falls area in
1923–1924.
Photo courtesy of Sara Balbin

**Interior of the St. Francis Solanus
Indian Mission Church**
The interior design of the St.
Francis Solanus Indian Mis-
sion Church on the Lac Courte
Oreilles Reservation in the village
of Reserve blends Ojibwe culture
with Catholicism. The Wigwam
Repository on the altar was con-
structed by Alice Lynk White, her
daughter Beverly Cadotte Gougé,
and Louis Erwin Gougé using
twenty-one of their hand-tanned
deer hides and bead work.
Photo courtesy of Sara Balbin

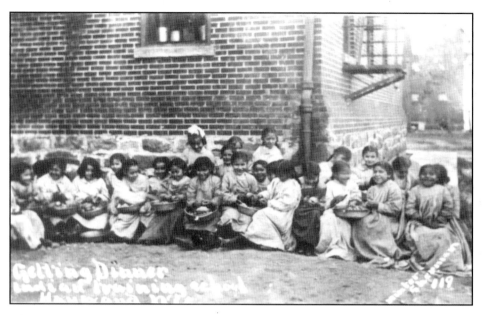

Young girls at the Hayward Indian Boarding School
Opened in 1901, the school was operated by the Indian Service for thirty-two years. It offered free boarding and grammar school education for about 180 American Indian students per year, most of whom were from the Lac Courte Oreilles Reservation. The students seldom went home to their parents due to school policy and lack of transportation on the reservation.
Photo courtesy of Sawyer County Historical Society

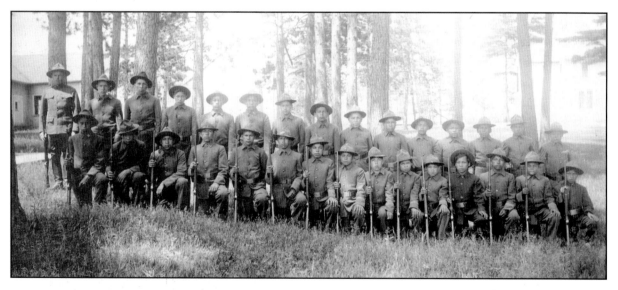

Young boys at the Hayward Indian Boarding School
The school had athletic teams, a band, and a marching corps made up of fully-uniformed platoons graded according to size and gender.
Photo courtesy of Sawyer County Historical Society

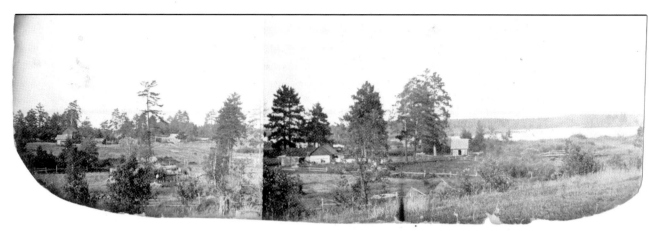

Town of Post on the Lac Courte Oreilles Reservation
The Town of Post, or *Bakẇeyawaa*, meaning "a bay or lake on a river," prior to the flooding in 1923 by the Wisconsin-Minnesota Light & Power Company. Before being flooded, Post was a thriving community, with more than two dozen homes in the village center, Catholic and Presbyterian churches, a government day school, a hotel, a store, and a trading post. After the creation of the flowage, the village was reconstructed at a new location and is now called New Post.
Photo courtesy of Sawyer County Historical Society

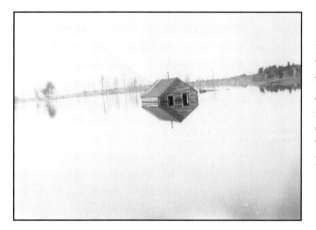

Flooded homestead
When the gates were closed at the Winter Dam by the Wisconsin-Minnesota Light & Power Company in March of 1923, many homesteads were flooded. The area became a massive reservoir known as the Chippewa Flowage, or Lake Chippewa, with 15,300 acres, the third largest inland lake in Wisconsin.
Photo courtesy of Sawyer County Historical Society

Members of the Belille family
Lac Courte Oreilles tribal member Frank Belille (adult, center), and family members from left to right: Charles Belille Jr., Jonny Buck, George A. Belille (front row); Mary Ann Belille, Vivian Belille Cloud (back row). Photograph was taken in the early 1930s at the O'Hare Lumber Mill on Minnie Avenue, Hayward, Wisconsin.
Photo courtesy of Vivian Belille Cloud

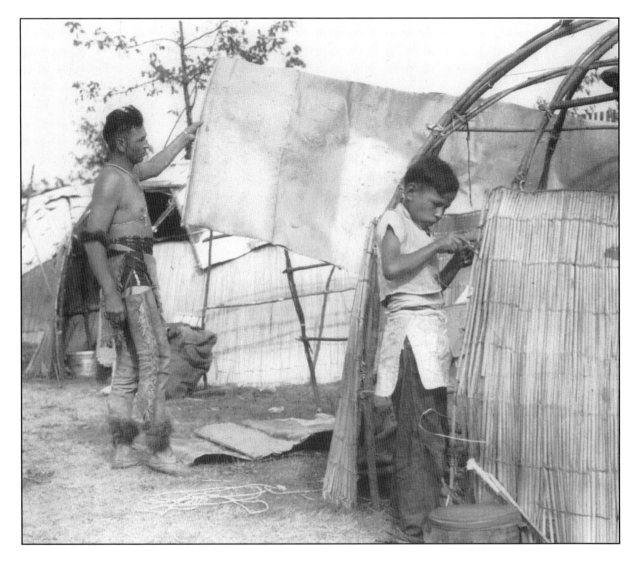

Wiigiwaam (wigwam), or Ojibwe lodge

William and Louis Bisonette working on a *wiigiwaam* in 1933. The frame of a *wiigiwaam* is built of small flexible poles that are placed in the ground and tied together in a latticework to form a dome. The frame is covered with mats made of cattails, birch bark, or, on occasion, elm bark. Frequently a hole is left in the top as a smoke exit. Facilitating the migratory lifestyle of the Ojibwe, separate frames and coverings made the wigwam relatively easy to transport.

Photo courtesy of Milwaukee Public Museum

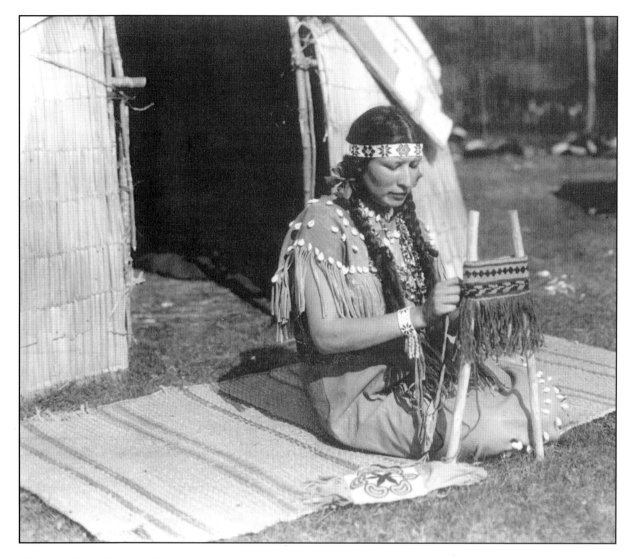

Elizabeth Gougé Butler Schmock
Elizabeth Schmock, demonstrating the Ojibwe culture to visitors seated in front of a *wiigiwaam*, weaving a handbag in 1933. Known for her ability to weave in the round and use of colorful patterns, Schmock is one of the elders featured in the Milwaukee Public Museum group photograph and in *Spirit of the Ojibwe*.
Photo courtesy of Robert Ritzenthaler, Milwaukee Public Museum

Lac Courte Oreilles tribal members at the former Milwaukee Public Museum in 1933
Tribal members of Lac Courte Oreilles photographed at the former location of the Milwaukee Public Museum, currently the Milwaukee Public Library. Several of the Lac Courte Oreilles elders in *Spirit of the Ojibwe* and their families are depicted in the photograph. Names were hand written by tribal elder Elizabeth Gougé Butler Schmock (top row). Her portrait and biography are featured in *Spirit of the Ojibwe*.
Photo courtesy of Elizabeth Schmock and photographer James Conklin, Milwaukee Public Museum

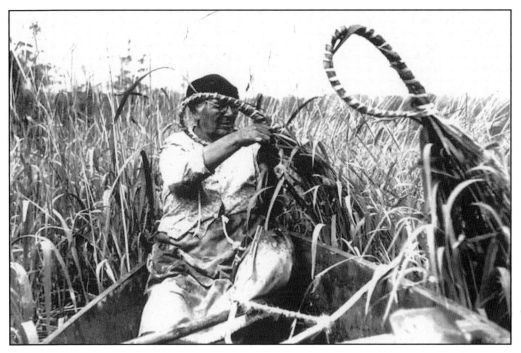

Waboos ricing
Lac Courte Oreilles Reservation tribal member Waboos binding, or tying the ends, of wild rice stalks for future harvest in 1942. Binding indicated ownership, protected the grain from birds, and made it easier to harvest. Wild rice stores well and was a staple food of the Ojibwe. The traditional late summer harvest is still observed by members of the Lac Courte Oreilles Reservation. Photo courtesy of Robert Ritzenthaler, Milwaukee Public Museum

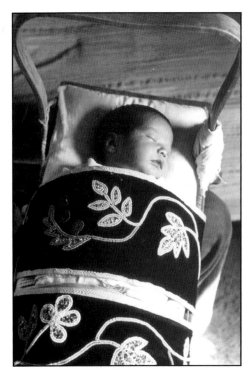

Lac Courte Oreilles Reservation infant in cradle board
The bead work on the cradle board demonstrates the floral artistry of the Ojibwe. Photographed by Fred Morgan in the 1960s.
Photo courtesy of Fred Morgan family

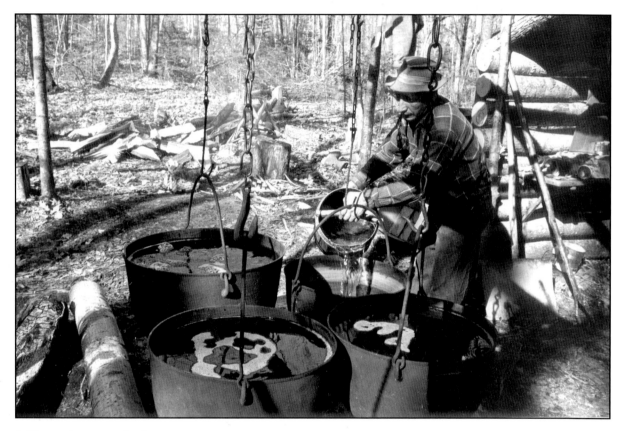

***Izhitwaawin,* or sugar bush**
Lac Courte Oreilles Reservation tribal member Walter Bennett rendering maple sap into syrup and sugar at his *izhit-waawin,* or spring encampment. Photographed by Fred Morgan in the 1960s.
Photo courtesy of Fred Morgan family

Pipestone Quarry, New Post

After five years of negotiations and after the Boy Scouts of America kept raising the price, the Lac Courte Oreilles tribal elders persisted and raised $20,000 by 1989 to purchase and reclaim the sacred site known today as the Pipestone Quarry. Their guidance and wisdom is still an inspiration. Those most responsible for reclaiming this sacred land included: Joe Homesky, Pipe Mustache, Bill Sutton, Lucy Begay, Louis Barber, Saxon St. Germaine, Lizzie DeMarr, Eugene Begay, Marilyn Benton, Jerry Smith, Gary Quaderer, Paul DeMain, Ernie St. Germaine, gaiashkibos, David Kellar, Hazel Jonjak Kellar, Leslie Ramczyk, Jim Keller, and Eldon Marple. The quarry is now used in a traditional manner for spiritual gatherings, healings, and traditional Ojibwe education. Photo courtesy of Sara Balbin

Spider Lake Lodge

The Lodge, located near Hayward, Wisconsin, is a showcase of elder Henry Smith's wood craftsmanship. His attention to detail and precision carving is clearly seen in the hand-carved wooden slats used to fill the spaces between the logs. Lodge construction started in 1923 and was completed in 1935. Henry Smith and his family resided at this location while the lodge was under construction. Smith is one of the elders featured in the *Spirit of the Ojibwe*. Barbara Grossi is in the center of the photo, taken in 1992. Present owners of the lodge are Jim Kerkow and Kraig Mason.

Photo courtesy of Grossi family (former owners)

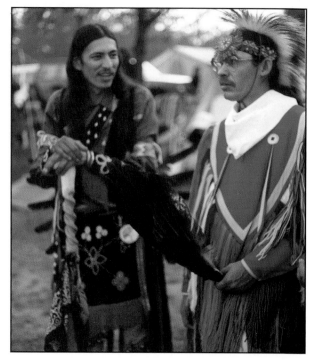

Jerry Smith and Donald White

Lac Courte Oreilles tribal historian, storyteller, and spiritual guide Jerry Smith (grandson of Henry Smith) with traditional Ojibwe cultural instructor Donald White at the Honor the Earth Pow Wow in 1997. Smith wears traditional Ojibwe regalia, whereas White is outfitted with grass dance regalia and an Ojibwe head dress, or roach.

Photo courtesy of Sara Balbin

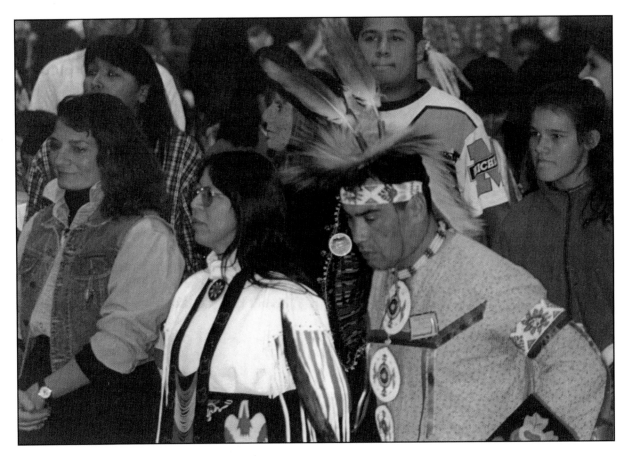

Veterans Day Powwow
From left to right, Sara Balbin, Thelma Nayquonabe, and Russell "Rusty" Barber dancing at the 1997 Veterans Day pow-wow on the Lac Courte Oreilles Reservation. Held annually on Veterans Day, the powwow recognizes and honors veterans and tribal elders.
Photo courtesy of John Skye

Statement by James "Pipe" Mustache Sr.

I am writing this with great pride, on behalf of the many members of the "Fishing hall of fame" whom I am very proud to be a part of.

I am also writing this on behalf of another special group of people who for so long I have tried to represent to inform the public of our traditions, of our culture, and of our way of life in order that you might better understand the ways of the Anishinabe, the American Indian.

Here I am a very small man, visualizing myself, surrounded by monuments you have erected, whose origins you may think began here a few years ago, with a world record musky. Stories of tremendous fishing waters, all of which have brought many people to our area.

But the real story — an underlying story goes far beyond records and most of your memories.

Back to a time when there were no books — let alone record books.

Back to when the Anishinabe inhabited this area.

And it was many generations before that when the traditions of clans began.

Thus, I am writing with great pride representing the "Water Spirit" clan of my people, the Anishinabe, the Oji bwe Indians, a clan in which you have unknowingly honored.

It seems a very fitting location for these monuments to be in the Heart of the east oji bwe nation

You have brought great honor to my People, — to the Lac Courte Oreilles tribe and to all of the Water Spirit clan.

For that I am Thankful.

The hearts of my people are lifted.

Now, may the Great Spirit grant you the power to greater achievements and to help to build and strengthen the bond between all men.

Spiritual Leader
Tribal Elder

James W. Mustache. Sr.
Lac Courte Oreilles Ojibwe Tribe
Member, Fishing Hall of Fame
Delegate- Lac Courte Oreilles Honor the
Earth Education Foundation

James "Pipe" Mustache statement
This missive was written to the National Freshwater Fishing Hall of Fame, Hayward, Wisconsin, by James "Pipe" Mustache Sr. to congratulate them on the dedication of their new buildings in 1979. Pipe writes on behalf of his people, the *Anishinaabe*, and of his Water Spirit Clan. He trusts that the Great Spirit, working through people, will "help to build and strengthen the bond between all men."
Document courtesy of Sara Balbin

The Ojibwe Language

John Carr and Sara Balbin

THE OJIBWE LANGUAGE, or *Ojibwemowin*, as spoken in northern Minnesota, northern Wisconsin, central and southern Ontario, and adjacent areas, is comprised of seven of the eight dialects of *Anishinaabemowin*, the language of the Ojibwe and Ottawa. *Anishinaabemowin* itself is a member of the Algonquian language subfamily, which is widespread in eastern and some western regions of the United States and in central and southern Canada. These languages existed in verbal form long before the first Europeans came to America. Genetic linguistic analysis has indicated that the predecessor language, Proto-Algonquian, was spoken at least three thousand years ago, at around the time of the early Egyptian pharaohs. Later, during the French fur trade era, *Anishinaabemowin* became the trade language of the Great Lakes region. Important information was also recorded, stored, and conveyed by the Ojibwe in iconic form by pictographs on rocks and birchbark scrolls.

Estimates of the number of speakers of *Ojibwemowin* vary widely and depend on the extent of vocabulary and fluency of those considered to be speakers. According to the 2000 United States and Canadian censuses, *Ojibwemowin* is spoken to some extent by fifty-six thousand people. However, a 1990s survey indicated that in Michigan, Minnesota, and Wisconsin, fewer than five hundred people were truly fluent in *Ojibwemowin*, many of them elders.

The language and culture of most American immigrant groups will persevere in their overseas country of origin. This is not the case for Ojibwe Indians. If their language and culture is not maintained in the United States and Canada, it will not survive.

The Lac Courte Oreilles Reservation has worked diligently to preserve and advance the Ojibwe language in its schools and enterprises. Courses in the Ojibwe language are taught at the tribal K-12 school and at Lac Courte Oreilles Ojibwa Community College. In addition, the tribe's public radio station, WOJB, 88.9 FM, and its corresponding Web site, http://www.wojb.org/index, offer many interesting programs on Ojibwe culture and traditions.

There is no mutually agreed upon writing system that is used for the Ojibwe language in all of its locales. However, the double-vowel system, developed by Charles E. Fiero, has been increasingly utilized throughout Ojibwe country in education programs and in publication. This system employs seven commonly used vowels and fifteen consonants, including a glottal stop.

The double-vowel Ojibwe alphabet is:

a, aa, b, d, e, g, h,',i, ii, j, k, m, n, o, oo, p, s, t, w, y, z.

Pronunciation of the Ojibwe vowels, consonants, and three other sounds (ch, sh and zh) is displayed in the following adapted table, which is used here by permission of tribal radio station WOJB, and is presented on its Web site. The sounds below, which correspond to the underlined letters in the adjacent English and Ojibwe words, are only approximations and should be supplemented by consultation with fluent speakers.

Phonemics of the Ojibwe Language

Vowel		Phonemic	English	Ojibwe
a	(short vowel)	uh	about	asemaa
aa	(long vowel)	aah	father	aanin
e	(long vowel)	ay	cafe	memengwaa
i	(short vowel)	ih	pin	gimiwan
ii	(long vowel)	ee	seen	niiwin
o	(short vowel)	oh	open	ojibwemo
oo	(long vowel)	oo	boot	googii

Consonant	Ojibwe	Meaning	Similar sound in English
b	bakade	s/he is hungry	book, speak
ch	chi-ogin	tomato	cheese
d	dagoshin	s/he arrives	do, stop
g	gaazhagens	cat	geese, ski
h	hay'	oops! darn!	hi
'	bakite'an	hit it!	uh-oh
j	jiimaan	canoe	jump
k	makazin	shoe	pick
m	miinan	blueberries	man
n	namebin	sucker	name
p	baapiwag	they are laughing	rip
s	wiisini	s/he is eating	miss
sh	nishkaadizi	s/he is angry	bush
t	mitig	tree	pit
w	waabang	tomorrow	way
y	babagiwayaan	shirt	yellow
z	ziibi	river	zebra
zh	zhaangaswi	nine	measure

The double-vowel notation provides a means to distinguish among Ojibwe vowels that are pronounced differently. By contrast, in English, a vowel represented by one letter often has different pronunciations: (pipe, piquant), (lone, move). Unlike the situation in English, use of the Fiero notation provides a good match between the visual forms (letters) of *Ojibwemowin* and their corresponding audio sounds (phonemes).

A greater challenge for English-speaking students of *Ojibwemowin* is that the sounds represented by the Ojibwe consonants *b, d,* and *g* are not the same as the English language sounds represented by the corresponding letters, leading to difficulty in both recognition and pronunciation of the sounds. The Ojibwe sounds have no direct English equivalent and must be formed anew. (Doing this well will help one avoid speaking *Ojibwemowin* with an accent.) Also, there are four nasal vowels which have no English equivalent and are not listed in the table.

In addition to the alphabet and pronunciation, the Ojibwe language has an interesting grammatical structure. Grammar involves syntax, the relation among words of a sentence, and inflection, or variations in the forms or sounds of the words that show their functions in a sentence. Prefixes and suffixes are added to Ojibwe words much more extensively than in English to indicate their grammatical role in a sentence. There are well over one thousand inflected forms of some Ojibwe word stems. Because of this, it is often possible to speak or write the words of an Ojibwe sentence in any order, and the resulting sentences will be comprehensible and convey the same meaning.

Several other differences exist. For example, *Ojibwemowin* has an extensive gender system, but unlike French, in which nouns and adjectives have matching masculine or feminine genders, in Ojibwe the genders are animate (beings) and inanimate (things), and are characteristic of corresponding nouns and verbs.

The information provided here is only a cursory description of *Ojibwemowin,* using the double-vowel writing system. In order to gain a better understanding of the language, students will need to seek advice from Ojibwe speakers and additional published sources. Three very useful books are: Patricia M. Ningewance, *Talking Gookom's Language: Learning Ojibwe* (Lac Seul, Ont.: Mazinaate Press, 2004); John D. Nichols and Earl Nyholm [Otchingwanigan], *A Concise Dictionary of Minnesota Ojibwe* (Minneapolis: University of Minnesota Press, 1995); and Rick Gresczyk (Gwayakogaabo), *Our Ojibwe Grammar: A Reference Grammar in the Chippewa Language,* vol. 1 (Minneapolis: Eagle Works, 1997).

GLOSSARY

COMPOSED BY JOHN CARR AND SARA BALBIN

WITH THE ASSISTANCE OF CATHY BEGAY AND ERNIE ST. GERMAINE

ALL OJIBWE-LANGUAGE WORDS in this book that are not names of people are printed in italics and defined in this Glossary. Some English-language words whose exact meanings may not be known to the reader are also defined. The definitions of words provided here are not necessarily complete, as they primarily express the meanings employed in this book.

In addition to being divided into seven dialects, there are local variations in the pronunciations and written forms of *Ojibwemowin* because speakers are geographically separated and the language continues to develop. The words in this Glossary are those of the southwestern dialect of *Ojibwemowin* as spoken at Lac Courte Oreilles.

In academic and formal writing, it is customary to italicize foreign words and phrases. The application of italics to Ojibwe words in this book is not meant to imply that the Ojibwe are foreigners in their own land, but rather to foster an interest in learning the Ojibwe language through use of the corresponding entries in this Glossary.

The Ojibwe words listed here are written using the "double vowel" orthography, with *aa*, *ii*, and *oo* considered as individual letters. In alphabetical order, these letters follow the letters *a*, *i*, and *o*, respectively, so that, for example, *maang* follows *manoomin* in the Glossary listing.

Several Ojibwe-language words are fairly long, which reflects the polysynthetic nature of the language. Words are commonly constructed by stringing together morphemes, short, multi-letter components, each of which conveys a particular meaning. In this respect, Ojibwe resembles German, which has many similarly constructed long words.

The plurals of Ojibwe words are shown when applicable. Unlike English, in which plurals are usually formed by adding *s* to a word, in Ojibwe the plural form depends on the word's gender, either animate or inanimate. Plurals of nouns with animate gender usually take an ending of the *ag* form, such as *makwag*, while for inanimate nouns, the ending takes an *an* form, such as *dikinaaganan*.

Nearly all Ojibwe people have an English or Euro-American derived name and may also have one or more Ojibwe names, one of which may be an Ojibwe name given in a naming ceremony. Often, the Ojibwe names cannot easily be translated. They may come from several sources, such as dreams, fasts, forefathers, legends, and life circumstances. The translations do not necessarily offer the rich stories and symbolism that are part of the culture. This is particularly true of names given in naming ceremonies, which are sometimes kept confidential to respect their integrity.

ajijaak • Crane, sandhill crane; plural: *ajijaakwag*. Crane Clan (listed under *doodem*).

akwawewining • The place where they fish through a hole in the ice.

Algonquian • Subfamily of American Indian languages, which includes *Anishinaabemowin*, spoken by many, but not all, people from Labrador to the Carolinas and westward to the Rocky Mountains.

American Indian • A member of the aboriginal peoples of the Western Hemisphere except the Aleut and Eskimo (Inuit). See also Native American. Informally, the terms American Indian and Native American are often used interchangeably, although American Indian is preferred by most indigenous people. For further consideration of ethnic and tribal naming issues, see Charles C. Mann, "Loaded Words," Appendix A of *1491: New Revelations of the Americas Before Columbus* (New York: Alfred A. Knopf, 2005), 387-92.

animosh • Dog; plural: *animoshag*.

Anishinaabe • Ojibwe or Ottawa Indian, one whose ancestors spoke a dialect of *Anishinaabemowin*. In the Ojibwe language, *Anishinaabe*, or *Shinaabe*, can mean either Ojibwe or American Indian. It is often used by people as a way to acknowledge each other, as in *"A haw, boozhoo Shinaabe!"* Spontaneous or original people. Plural: *Anishinaabeg*.

Anishinaabekwe • *Anishinaabe* woman; plural: *Anishinaabekweg*.

anishinaabemo • He or she speaks the *Anishinaabe* language.

Anishinaabemowin • Ojibwe and Ottawa language, currently spoken to some extent by about fifty-six thousand people in the United States and Canada. There are eight primary dialects of *Anishinaabemowin*. The two United States based dialects are Southwestern Ojibwe (Chippewa) and Odaawaa (Ottawa). Southwestern Ojibwe is spoken in northern Minnesota, northern Wisconsin, and adjacent areas. Although the Ojibwe, Ottawa, and Potawatomi are historically related, the Potawatomi language, which is currently spoken by only about fifty people, is considered to be a separate language.

apaakozigan • Kinnikinnick. Tobacco and bark (usually sumac or dogwood) smoking mixture.

ashigan • Largemouth bass, bass; plural: *ashiganag*.

awaazisii • Bullhead; plural: *awaazisiig*. Bullhead Clan (listed under *doodem*). Fish Clan.

aadizookaan • Traditional story; plural: *aadizookaanan*. Protagonist of a legend or myth; plural: *aadizookaanag*.

aaniin • Greetings! Hello. See *boozhoo*.

bakweyawaa • At, on, or in a bay or lake on a river. See *Paquayawong*.

band • One of a number of sub-groups of a tribe, as in "Lac Courte Oreilles Band of Lake Superior Chippewa." Wisconsin Ojibwe bands and their reservations are:

> Bad River – *Tigitigaaning*: Place of Gardens.
>
> Lac Courte Oreilles – *Odaawaa Zaaga'igan*: Ottawa Lake.
>
> Lac du Flambeau – *Waswaaganing*: Place of the Torch People.

> Red Cliff – *Miskwaabikaaning*: Place of the Red Banks.
>
> St. Croix – *Manoominikeshiinyag-ziibi*: Rice-bird River.
>
> Mole Lake – *Zaka'aaganing*: Post Lake.

biboon • Winter.

bandolier bag • *Gashkibidaagan.* Bag with a closable top, tobacco bag, pipe bag.

Big Drum • *Chi dewe'igan.* A ceremonial religious society based on the peace-making gift of a drum presented to the Ojibwe by the Lakota Sioux in 1877.

bigiw • Pine pitch. A sticky resin that leaks out of pine tree bark, used medicinally and also as a sealant. Plural: *bigiwan.*

bimikawe • Leave tracks going along; elder-oriented newspaper published by Saxon St. Germaine.

bine • Partridge, ruffed grouse; plural: *binewag.*

bizindam • Listen.

boozhoo • Hello! Greetings. A word adapted by the *Anishinaabe* from the French greeting "bonjour." The French Canadian pronunciation of bonjour is boo'zhoo. See *aaniin.*

chi • (Prefix); big, great, large, old; a shortened version of *gichi.*

Chi dewe'igan • Big Drum. A ceremonial religious society based on the peace-making gift of a drum presented to the Ojibwe by the Lakota Sioux in 1877.

chi mookomaan • Non-Indian American person, literally "big knife"; also *gichi mookomann.* The word originated from the swords that soldiers carried. Plural: *chi mookomaanag.*

Chippewa • (A mispronunciation of Ojibwe.) A word for Ojibwe commonly used in the United States, but seldom in Canada, from the 1800s to the mid-1900s. The word Chippewa was used in treaties and became the legal designator of tribes and bands in the United States. See Ojibwe.

clan • An American Indian extended family group descended through the female line. See *doodem* and gen.

Couderay • A village south of the Lac Courte Oreilles Reservation (a corruption of "Courte Oreilles").

dikinaagan • Cradle board; plural: *dikinaaganan.*

doodem • Totem, clan, gen, extended family group; plural: *doodemag.* Some prominent Ojibwe clans mentioned in this book, with their traditional functions, are:

> *Ajijaak* – Crane (leadership, oratory).
>
> *Awaazisii* – Bullhead (learning, philosophy).
>
> *Gekek* – Hawk (leadership, oratory).
>
> *Ma'iingan* – Wolf (defense, knowledge of plants).

Makwa – Bear (defense, knowledge of plants).

Maang – Loon (leadership, oratory).

Migizi – Eagle (leadership, oratory).

Name – Sturgeon (learning, philosophy).

Waabizheshi – Marten (sustenance, hunting).

Waawaashkeshi – Deer (sustenance, hunting).

gashkibidaagan • Bandolier bag. Bag with a closable top, tobacco bag, pipe bag; plural: *gashkibidaaganag*.

gaag • Porcupine; plural: *gaagwag*.

gekek • Hawk; plural: *gekekwag*. Hawk Clan (listed under *doodem*).

gen • An American Indian extended family group descended through the male line. By definition, Ojibwe *doodem* are gens, but they are usually referred to as clans.

gichi • (Prefix); big, great, large, old; also *chi*, a shortened version.

Gichigami • Lake Superior. Great Lake; plural: *Gichigamiin*.

Gichi-manidoo • Great Spirit, Creator, God.

gichi mookomaan • Non-Indian American person, literally "big knife"; also *chi mookomaan*. The word originated from the swords that soldiers carried. Plural: *gichi mookomaanag*.

gidoodem • Your totem, your clan. See *doodem*.

giga-waabamin miinawaa • "I'll see you again"; traditional parting phrase.

iskanawong • *Skunawong*; literally, "a lake that dries up."

iskigamizigan • Sugar bush. Encampment where maple tree sap is rendered into maple syrup and sugar. Plural: *iskigamiziganan*.

izhitwaawin • Ojibwe belief or custom.

kinnikinnick • *Apaakozigan*. Tobacco and bark (usually sumac or dogwood) smoking mixture.

koobide • Great-grandmother; from *aanikoobijigan*, or "ancestor"; plural: *koobideg*.

Lac Courte Oreilles • (Pronounced la-coo-dah-ray.) French version of *Odaawaa Zaaga'igan* (Ottawa Lake); literally "Lake Short Ears." A band of Ojibwe and their reservation, in northwest Wisconsin.

ma'iingan • Wolf; plural: *ma'iinganag*. Wolf Clan (listed under *doodem*).

makowiiyaas • Bear meat; plural: *makowiiyaasan*.

makwa • Bear; synonym of *noka*; plural: *makwag*. Bear Clan (listed under *doodem*).

manidoo • Spirit, manitou; plural: *manidoog*.

manoomin • Wild rice. (Menominee: people of the wild rice.)

maang • Loon; plural: *maangwag*; also spelled *mahng*. Loon Clan (listed under *doodem*).

maashkinoozhe • Muskellunge, or muskie. A barracuda-like game fish that may reach fifty pounds or more, found in the Chippewa Flowage and other area waters; plural: *maashkinoozheg.*

Midewiwin • Medicine Lodge Society; traditional healers; plural: *midewiwinan.*

migizi • Eagle, bald eagle; plural: *migiziwag.* Eagle Clan (listed under *doodem*).

migiziwigwan • Eagle feather; plural: *migiziwigwanag.*

miigiwe • Give away. A person gives gifts during ceremonies or powwows; the family or person being honored gives gifts to those honoring them.

miigwech, miigwetch • Thank you.

mii iw • That's all.

Mole Lake • Sokaogon Lake; see band.

naboob • Soup; plural: *naboobiin.*

name • Sturgeon; plural: *namewag.* Sturgeon Clan (listed under *doodem*).

namegos • Trout; plural: *namegosag.*

Namekagon River • Namekagon: Place of Sturgeon. A river that runs through Hayward, Wisconsin.

Native American • A member of the aboriginal peoples of the Western Hemisphere, including the Aleut and Eskimo (Inuit). In the context of the United States, the term Native American is usually construed to include Native Hawaiians. See also American Indian. Informally, the terms Native American and American Indian are often used interchangeably, although American Indian is preferred by most indigenous people.

niiyawen'enh • (Often shortened to *wen'enh*.) Namesake. Fellow body, myself. The reciprocal relationship between a sponsor and a person given a name; plural: *Niiyawen'enhyag.*

niimi'idiwin • Powwow, literally "dancing together." A social gathering and dance of North American Indians. There are two dance formats: traditional and contest; plural: *niimi'idiwinan.*

noodin • Wind.

noka • Bear; synonym of *makwa*; plural *nokag.*

nookomis • My grandmother; plural: *nookomisag.*

Odabassa • Village near the Namekagon River and Totagatic Flowage, north of Hayward, Wisconsin.

Odawasagaegun • See *Odaawaa Zaaga'igan.*

Odaawaa Zaaga'igan • (Alternative form: *Odawasagaegun*.) Ottawa Lake; Lac Courte Oreilles. Name of the lake and of the reservation of the Lac Courte Oreilles Band of Chippewa, in northwest Wisconsin.

ogaa • Walleye, pickerel; plural: *ogaawag.*

ogichidaa • Warrior, ceremonial headman.

ogichidaag • Warrior men.

ogichidaakwe • Ceremonial headwoman, warrior woman, wife of ceremonial headman.

ogichidaakweg • Warrior women.

Ojibwa • (Pronounced oh-jib-way.) See Ojibwe. Although most writers have used the Ojibwe spelling for the past thirty years, Ojibwa is used occasionally and is still presented as the preferred or only spelling in virtually all current editions of English-language dictionaries.

Ojibway • See Ojibwe. In the United States, Ojibway is an archaic form of Ojibwe. However, the Ojibway spelling is currently used in Canada outside southern Ontario.

Ojibwe • (Pronounced oh-jib-way.) A North American Indian people who traditionally speak dialects of *Anishinaabemowin* and live in areas around lakes Huron and Superior, west to North Dakota and Saskatchewan, and north to central Ontario. See also Ojibwa, Ojibway, and Chippewa. Ojibwe is both an English and *Ojibwemowin* word: *Ojibwe*; plural: *Ojibweg*.

Ojibwemowin • The Ojibwe language, consisting of seven of the eight dialects of *Anishinaabemowin*.

omashkooz, • Elk, running elk; plural: *omashkoozoog*.

opwaagan • Pipe (for smoking); plural: *opwaaganag*.

oshkaabewis • Ceremonial attendant, student, messenger, spiritual leader; often shortened to *skaabewis*; plural: *oshkaabewisag*.

Paquayawong • *Bakweyawaang*, *Pokegama*, also commonly known as *Pah-quah-wong*. The Ojibwe name of the original town of Post, flooded when the Chippewa Flowage was created in 1923. See *bakweyawaa*.

partridge • Ruffed grouse; *bine*.

pine pitch • *Bigiw*. A sticky resin that leaks out of pine tree bark: used medicinally and also as a sealant.

Pokegama • See *Paquayawong*.

powwow • *Niimi'idiwin*; literally, "dancing together." A social gathering and dance of North American Indians. There are two dance formats: traditional and contest.

sauna • A Finnish steam bath.

skiff • A small, flat-bottomed boat.

skunawong • *Iskanawong*; literally, "a lake that dries up."

Sokaogon Lake • Mole Lake; see band.

tribe • A Native American sovereign nation (sometimes referred to as a band).

wazhashk • Muskrat; plural: *wazhashkwag*.

wazhashkiwiiyaas • Muskrat meat.

waabizheshi • Marten; plural: *waabizheshiwag*. Marten Clan (listed under *doodem*).

waabooz • Snowshoe hare, rabbit; plural: *waaboozoog*.

waawaashkeshi • Deer, white-tailed deer; plural: *waawaashkeshiwag*. Deer Clan (listed under *doodem*).

waawaashkeshiwiwiiyaas • Deer meat; venison.

wegonen gidoodem • What is your clan?

Wenabozho, Waynaboozhoo, Nenabozho • Name of *aadizookaan* (traditional story) character viewed as culture hero and trickster.

wewaagayin • Fern, fiddlehead fern; plural: *wewaagayinag*.

wiigiwaam • Wigwam, lodge. An American Indian dwelling having an arched or conical framework of poles covered with bark, mats, or hides. Plural: *wiigiwaaman*.

wiishkobaaboo • Maple tree sap; plural: *wiishkobaaboon*.

zaasakokwaan • Fry bread; plural: *zaasakokwaanag*.

zhiiwaagamizigan • Maple syrup, syrup; plural: *zhiiwagamiziganan*.

zhooniyaa • Money, silver.

ziinzibaakwad • Maple sugar, sugar; plural: *ziinzibaakwadoons*.

REFERENCES AND SUGGESTIONS
FOR FURTHER READING

JOHN CARR AND SARA BALBIN

IN DOING RESEARCH ON OJIBWE ECONOMICS, politics, and culture, and in finding and selecting the suggestions for further reading, I was fortunate to be able to draw on the research skills of my friend John Carr. His Norwegian grandparents, Andrew and Louise Gulleson, who immigrated to Hayward in 1887, were friends of John Frogg and other Lac Courte Oreilles tribal members. In the nineteen-twenties, his mother, Ann, taught at the Round Lake School near Hayward and at the public school in Odanah, Wisconsin, on the Bad River Reservation. Both were small woodland schools with a mix of Indian and non-Indian students. In 1988, John was made a *niiyawen'enh*, or namesake, in the Ojibwe tradition, by Pipe Mustache Sr. at my daughter Melissa's naming ceremony. He has co-directed research projects and done public policy research at Harvard University's John F. Kennedy School of Government and has been a planning policy adviser to the World Health Organization.

We decided, early on, to divide the references into categories to ease the task of the reader looking for information on a specific subject. This division of knowledge, however, goes against the grain of Ojibwe thought patterns, which emphasize interconnectedness and relationships among seemingly disparate topics. Those seeking a fuller understanding will thus have to reconnect the threads. For example, S. A. Barrett's Dream Dance book in the Powwows section is closely related to both religion and music. Although this and many other publications could have easily been placed in more than one section, we did not use cross references.

Many of the publications listed here cover geographic areas that extend beyond the Lac Courte Oreilles vicinity, and even Wisconsin. It is the Federal Government which is primarily concerned with tribal relations, and thus its policies, laws, and activities have had an important local effect. Likewise, Ojibwe culture is largely homogeneous over many states and Canada, although regional and local variations do exist.

The reader seeking more knowledge on a particular subject will find numerous additional sources in the bibliography and reference sections of the publications listed both here and for Dr. St. Germaine's history essay. In addition, the researcher is referred to the bibliographic reference books by the Minnesota Historical Society, Timothy G. Roufs, and Helen Hornbeck Tanner listed in the General section below.

Sara Balbin

Anthropology, Ethnology, Sociology

Barnouw, Victor. *Wisconsin Chippewa Myths & Tales and Their Relation to Chippewa Life.* Madison: University of Wisconsin Press, 1977.

Black, Mary B. "Ojibwa Power Belief System." In *The Anthropology of Power: Ethnographic Studies from Asia, Oceania, and the New World*, edited by Raymond D. Fogelson and Richard N. Adams, 141–51. New York: Academic Press, 1977.

Boggs, Stephen T. "Culture Change and the Personality of Ojibwa Children." *American Anthropologist* 60, 1 (1958): 47–58.

Brown, Paula. "Changes in Ojibwa Social Control." *American Anthropologist* 54 (1952): 57–70.

Buffalohead, Priscilla K. "Farmers, Warriors, Traders: A Fresh Look at Ojibway Women." In *The American Indian: Past and Present*, 3rd ed., edited by Roger L. Nichols, 28–38. New York: Alfred A. Knopf, 1986.

Densmore, Frances. *Chippewa Customs.* St. Paul: Minnesota Historical Society Press, 1979. (First published in Washington, D.C. as Smithsonian Institution, Bureau of American Ethnology, Bulletin 86, by the U.S. Government Printing Office in 1929.)

Eggan, Fred, ed. *Social Anthropology of North American Tribes.* Enlarged ed. Chicago: University of Chicago Press, 1955.

Friedl, Ernestine. "Persistence in Chippewa Culture and Personality." *American Anthropologist* 58, 5 (1956): 814–25.

Hallowell, A. Irving. *Contributions to Anthropology: Selected Papers of A. Irving Hallowell.* Chicago: University of Chicago Press, 1976.

Landes, Ruth. *Ojibwa Sociology.* New York: AMS Press, 1969. (First published in New York by Columbia University Press in 1937.)

————. *The Ojibwa Woman.* Lincoln: University of Nebraska Press, 1997. (First published in New York by Columbia University Press in 1938.)

Mankiller, Wilma. *Every Day is a Good Day: Reflections by Contemporary Indigenous Women.* Golden, Colo.: Fulcrum Publishing, 2004.

Medicine, Beatrice. *Learning to Be an Anthropologist and Remaining "Native": Selected Writings.* Urbana: University of Illinois Press, 2001.

Nagel, Joane. *American Indian Ethnic Renewal: Red Power and the Resurgence of Identity and Culture.* New York: Oxford University Press, 1996.

Peacock, Thomas D., Priscilla A. Day, and Robert B. Peacock. "At What Cost? The Social Impact of American Indian Gaming." *Journal of Health & Social Policy* 10, 4 (1999): 23–34.

Ritzenthaler, Robert E., and Pat Ritzenthaler. *The Woodland Indians of the Western Great Lakes.* Milwaukee: Milwaukee Public Museum, 1983.

Vizenor, Gerald. *The Everlasting Sky: Voices of the Anishinabe People.* St. Paul: Minnesota Historical Society Press, 2001. (First published in New York by Crowell–Collier Press in 1972.)

Wright, J. V. "A Regional Examination of Ojibwe Culture History." *Anthropologica* 7, 2 (1965): 189–227.

Art

Alden, Jill. *Contemporary American Indian Beadwork: The Exquisite Art.* Millwood, N.Y.: Dolph Pub., 1999.

A'nicina'be Manido' minesikan: Chippewa Beadwork. Bismarck: State Historical Society of North Dakota, 1996.

The Art of the Great Lakes Indians. Flint, Mich.: Flint Institute of Arts, 1973.

Brasser, Ted J. "Pleasing the Spirits: Indian Art around the Great Lakes." In *Pleasing the Spirits: A Catalogue of a Collection of American Indian Art*, edited by Douglas C. Ewing, 17–31. New York: Ghylen Press, 1982.

Furtman, Michael. *Magic on the Rocks: Canoe Country Pictographs.* Duluth, Minn.: Birch Portage Press, 2000.

Garte, Edna. *Circle of Life: Cultural Continuity in Ojibwe Crafts.* Duluth, Minn.: St. Louis County Historical Society, 1984.

Grand Rapids Public Museum. *Beads: Their Use by Upper Great Lakes Indians.* Grand Rapids, Mich.: The Museum, 1977.

Johnston, Patricia Condon. *Eastman Johnson's Lake Superior Indians.* Afton, Minn.: Johnston Publishing, 1983.

Lyford, Carrie A. *Ojibwa Crafts.* Stevens Point, Wis.: R. Schneider, 1982. (First published in Phoenix, Ariz. by the Printing Department of the Phoenix Indian School in 1943.)

Morgan, Fred. *Song of the Namakagon: A Picture Book of the Hayward, Wisconsin Area.* Hayward, Wis.: Fred Morgan, 1962.

On the Border: Native American Weaving Traditions of the Great Lakes and Prairie. Moorhead, Minn.: Plains Art Museum, 1991.

Phillips, Ruth B. "Quilled Bark from the Central Great Lakes: A Transcultural History." In *Studies in American Indian Art: A Memorial Tribute to Norman Feder*, edited by Christian F. Feest, 118–31. Altenstadt, Ger.: European Review of Native American Studies, 2001.

Southcott, Mary E. (Beth). *The Sound of the Drum: The Sacred Art of the Anishnabec.* Erin, Ont.: Boston Mills Press, 1984.

Thayer, B. W. "'Black' as a Preferred Color in Ojibway Art." *Minnesota Archaeologist* 8, 2 (1942): 42–45.

White, Dennis. "Ojibwe Art and Mathemetics." In *Contemporary Art and the Mathematical Instinct*, 38–40. Duluth, Minn.: Tweed Museum of Art, 2004.

Art: Design

Coleman, Bernard, Sister. *Decorative Designs of the Ojibwa of Northern Minnesota.* Washington, D.C.: Catholic University of America Press, 1947.

Conn, Richard. "Floral Design in Native North America." In *Native American Art From the Permanent Collection*, 78–81. Claremont, Calif.: Galleries of the Claremont Colleges, 1979.

Fischer, J. L. "Art Styles as Cognitive Maps." *American Anthropologist* 63, 1 (1961): 79–93.

Penney, David W. "Floral Decoration and Culture Change: An Historical Interpretation of Motivation." *American Indian Culture and Research Journal* 15, 1 (1991): 53–77.

Whiteford, Andrew Hunter. "Floral Beadwork of the Western Great Lakes." *American Indian Art Magazine* 22, 4 (1997): 68–79.

Art: Materials and Techniques

Armour, David A. "Beads of the Upper Great Lakes: A Study in Acculturation." In *Beads: Their Use by Upper Great Lakes Indians*, 9–26. Grand Rapids, Mich.: Grand Rapids Public Museum, 1977.

Barth, Georg J. *Native American Beadwork: Traditional Beading Technique for the Modern-Day Beader.* Stevens Point, Wis.: R. Schneider, 1993.

Hensler, Christy Ann. *Guide to Indian Quillworking.* Blane, Wash.: Hancock House Publishers, 1989.

Orchard, William C. *The Technique of Porcupine-Quill Decoration Among the North American Indians.* 2nd ed. New York: Museum of the American Indian, Heye Foundation, 1971. (First published in New York by the Museum in 1916.)

————. *Beads and Beadwork of the American Indians.* 2nd ed. New York: Museum of the American Indian, Heye Foundation, 1975. (First published in New York by the Museum in 1929.)

Pannabecker, Rachel K. "Ribbonwork of the Great Lakes Indians: The Material of Acculturation." Ph.D. dissertation, Ohio State University, 1986. Ann Arbor, Mich.: UMI, 1986. (Available from ProQuest Information and Learning. http://proquest.com.)

Art: Symmetry

Berken, Bernadette, and Kim Nishimoto. "Symmetry and Beadwork Patterns of Wisconsin Woodland Indians." In *Perspectives on Indigenous People of North America*, edited by Judith Elaine Hankes and Gerald R. Fast, 209–24. Reston, Va.: National Council of Teachers of Mathematics, 2002.

Conway, John H., Heidi Burgiel, and Chaim Goodman-Strauss. *The Symmetries of Things.* Wellesley, Mass.: A K Peters, 2008.

Livio, Mario. *The Equation That Couldn't Be Solved: How Mathematical Genius Discovered the Language of Symmetry.* New York: Simon & Schuster, 2005.

Molnar, V., and F. Molnar. "Symmetry-Making and -Breaking in Visual Art." *Computers and Mathematics with Applications* 12B, 1/2 (1986): 291–301.

Speck, Frank G. *The Double-Curve Motive in Northeastern Algonkian Art.* Canada Department of Mines, Geological Survey, Memoir 42. Ottawa: Government Printing Bureau, 1914.

Thayer, B. W. "The Algonquian Trait of Asymmetry in Ojibway Art." *Minnesota Archaeologist* 8, 2 (1942): 56–71.

Washburn, Dorothy K., and Donald W. Crowe. *Symmetries of Culture: Theory and Practice of Plane Pattern Analysis.* Seattle: University of Washington Press, 1987.

Clans and Gens

"Clans and Gens." In *Encyclopedia of Indians of the Americas*, Vol. 4, edited by Harry Waldman, 240–42. St. Clair Shores, Mich.: Scholarly Press, 1974.

Johnston, Basil. "Man's World." In *Ojibway Heritage*, 59–79. Lincoln: University of Nebraska Press, 1990.

Landes, Ruth. "Gens Organization." In *Ojibwa Sociology*, 31–52. New York: AMS Press, 1969. (First published in New York by Columbia University Press in 1937.)

Medicine, Beatrice. "Families." In *Native America in the Twentieth Century: An Encyclopedia*, edited by Mary B. Davis, 193–95. New York: Garland Publishing, 1994.

Miller, Jay. "Families." In *Encyclopedia of North American Indians*, edited by Frederick E. Hoxie, 192–97. Boston: Houghton Mifflin, 1996.

Ritzenthaler, Robert E. "Totemic Insult Among the Wisconsin Chippewa." *American Anthropologist* 47, 2 (1945): 322–24.

Warren, William W. "Totemic Division of the O-jib-ways." In *History of the Ojibway People*, 41–53. St. Paul: Minnesota Historical Society Press, 1984. (Written in 1852 and first published in St. Paul by the Minnesota Historical Society in 1885.)

General

Baker, Brian, and Rick Eckert. "Ojibwa: Anishinabe in Wisconsin." In *Native America in the Twentieth Century: An Encyclopedia*, edited by Mary B. Davis, 402–404. New York: Garland Publishing, 1994.

Dorris, Michael. "Indians on the Shelf." In *The American Indian and the Problem of History*, edited by Calvin Martin, 98–105. New York: Oxford University Press, 1987.

Editors of Time-Life Books. *People of the Lakes.* American Indians Series. Alexandria, Va.: Time-Life Books, 1994.

Harvard Project on American Indian Economic Development, et al. *The State of the Native Nations: Conditions under U.S. Policies of Self-Determination.* New York: Oxford University Press, 2007.

Johnston, Basil. *Ojibway Heritage.* Lincoln: University of Nebraska Press, 1990.

The Lac Courte Oreilles Band of Ojibwe. http://www.lco-nsn.gov/.

Lac Courte Oreilles Ojibwa Community College. http://www.lco.edu.

Minnesota Historical Society. *Chippewa and Dakota Indians: A Subject Catalog of Books, Pamphlets, Periodical Articles, and Manuscripts in the Minnesota Historical Society.* St. Paul: The Society, 1969.

Morrison, Eliza. *A Little History of My Forest Life: An Indian-White Autobiography.* Edited by Victoria Brehm. Tustin, Mich.: Ladyslipper Press, 2002.

Northrup, Jim. *Rez Road Follies: Canoes, Casinos, and Birch Bark Baskets.* Minneapolis: University of Minnesota Press, 1999.

"Ojibwa." *Wikipedia.* http://en.wikipedia.org/wiki/Ojibwa.

Paap, Howard D. *A Northern Land: Life with the Ojibwe.* Oregon, Wis.: Badger Books, 2001.

Peacock, Thomas, and Marlene Wisuri. *Ojibwe Waasa Inaabidaa: We Look in All Directions.* Afton, Minn.: Afton Historical Society Press, 2001.

_____. *The Good Path: Ojibwe Learning and Activity Book for Kids.* Afton, Minn.: Afton Historical Society Press, 2002.

_____. *The Four Hills of Life: Ojibwe Wisdom.* Afton, Minn.: Afton Historical Society Press, 2006.

Ritzenthaler, Robert E. "Southwestern Chippewa." In *Handbook of North American Indians,* edited by William C. Sturtevant, Vol. 15, *Northeast,* edited by Bruce G. Trigger, 743–59. Washington, D.C.: Smithsonian Institution, 1978.

Roufs, Timothy G. *Working Bibliography of Chippewa/Ojibwa/Anishinabe and Selected Related Works.* (Index, 1983; Supplement A, 1984; Supplement B, 1988.) Duluth: University of Minnesota, Duluth, 1981.

Tanner, Helen Hornbeck. *The Ojibwas: A Critical Bibliography.* Bloomington: Indiana University Press, 1976.

_____. *The Ojibwa.* New York: Chelsea House, 1991.

WOJB, 88.9 FM, Woodland Community Public Radio. http://www.wojb.org.

Government Relations

Brown, Michael F. *Who Owns Native Culture?* Cambridge, Mass.: Harvard University Press, 2003.

Canby, William C., Jr. *American Indian Law in a Nutshell.* 4th ed. St. Paul: Thomson/West, 2004.

Deloria, Vine, Jr., and Cifford M. Lytle. *American Indians, American Justice.* Austin: University of Texas Press, 1983.

Honoring our Ancestors: Chippewa Flowage Joint Agency Management Plan. Lac Courte Oreilles Band of Lake Superior Chippewa Indians (Hayward, WI). http://www.innovations.harvard.edu/awards.html?id=6162.

Hoxie, Frederick E. *A Final Promise: The Campaign to Assimilate the Indians, 1880–1920.* Lincoln: University of Nebraska Press, 1984.

Pevar, Stephen L. *The Rights of Indians and Tribes: The Authoritative ACLU Guide to Indian and Tribal Rights.* 3rd ed. New York: New York University Press, 2004.

Philp, Kenneth R., ed. *Indian Self-Rule: First-Hand Accounts of Indian-White Relations from Roosevelt to Reagan.* Logan: Utah State University Press, 1995.

Spicer, Edward H. "American Indians, Federal Policy Toward." In *Harvard Encyclopedia of American Ethnic Groups*, edited by Stephan Thernstrom, 114–22. Cambridge, Mass.: Harvard University Press, 1980.

White, Bruce M. "The Regional Context of the Removal Order of 1850." In *Fish in the Lakes, Wild Rice, and Game in Abundance*, edited by James. M. McClurken. East Lansing: Michigan State University Press, 2000.

Wilkins, David E. *American Indian Politics and the American Political System.* 2nd ed. Lanham, Md.: Rowman & Littlefield, 2006.

Government Relations: Treaty Rights

Great Lakes Indian Fish & Wildlife Commission. http://www.glifwc.org.

A Guide to Understanding Ojibwe Treaty Rights. Odanah, Wis.: Great Lakes Indian Fish & Wildlife Commission, 2006.

Nesper, Larry. *The Walleye War: The Struggle for Ojibwe Spearfishing and Treaty Rights.* Lincoln: University of Nebraska Press, 2002.

Rasmussen, Charlie Otto. *Ojibwe Journeys: Treaties, Sandy Lake & The Waabanong Run.* Odanah, Wis.: Great Lakes Indian Fish & Wildlife Commission Press, 2003.

Satz, Ronald. *Chippewa Treaty Rights: The Reserved Rights of Wisconsin's Chippewa Indians in Historical Perspective.* Revised. Madison: University of Wisconsin Press for the Wisconsin Academy of Sciences, Arts and Letters, 1994.

Whaley, Rick, with Walter Bresette. *Walleye Warriors: An Effective Alliance against Racism and for the Earth.* Philadelphia: New Society Publishers, 1994.

Wilkinson, Charles F. "To Feel the Summer in the Spring: The Treaty Fishing Rights of the Wisconsin Chippewa." *Wisconsin Law Review* (1991): 375–414.

History

Baker, Brian Alan. "A Nation in Two States: The Annishnabeg in the United States and Canada, 1837–1991." Ph.D. dissertation, Stanford University, 1996. Ann Arbor, Mich.: UMI, 1996. (Available from ProQuest Information and Learning. http://proquest.com.)

Burgess, Sue, and Tom Burgess, eds. *Tales of Lac Courte Oreilles: Recollections from Those Who Settled Its Shorelines.* Hayward, Wis.: Courte Oreilles Lakes Association, 2002.

Clifton, James A. "Wisconsin Death March: Explaining the Extremes in Old Northwest Indian Removal." *Transactions of the Wisconsin Academy of Sciences, Arts and Letters* 75 (1987): 1–39.

Danziger, Edmund Jefferson, Jr. *The Chippewas of Lake Superior.* Norman: University of Oklahoma Press, 1979.

Hickerson, Harold. *The Chippewa and Their Neighbors: A Study in Ethnohistory.* Rev. ed. Prospect Heights, Ill.: Waveland Press, 1988.

Kohl, Johann Georg. *Kitchi-Gami: Life Among the Lake Superior Ojibway.* Translated by Lascelles Wraxall. St. Paul: Minnesota Historical Society Press, 1985. (First published in London by Chapman and Hall in 1860.)

Loew, Patty. *Indian Nations of Wisconsin: Histories of Endurance and Renewal.* Madison: Wisconsin Historical Society Press, 2001.

Lurie, Nancy Oestreich. *Wisconsin Indians.* Revised ed. Madison: Wisconsin Historical Society Press, 2002.

Marple, Eldon M. *The Visitor Who Came to Stay: Legacy of the Hayward Lakes Area.* Hayward, Wis.: Country Print Shop, 1971.

_____. *A History of the Hayward Lakes Region: Through the Eyes of the Visitor Who Came and Stayed.* Hayward, Wis.: Chicago Bay Grafix, 1976.

_____. *The Visitor Writes Again.* Hayward, Wis.: Country Print Shop, 1984.

Mason, Carol I. *Introduction to Wisconsin Indians: Prehistory to Statehood.* Salem, Wis.: Sheffield Publishing, 1988.

Ojibwe Curriculum Committee, American Indian Studies Department, University of Minnesota. *Land of the Ojibwe, Secondary Booklet.* St Paul: Minnesota Historical Society, 1973.

Rasmussen, Charlie Otto. *Where the River is Wide: Pahquahwong and the Chippewa Flowage.* Odanah, Wis.: Great Lakes Indian Fish & Wildlife Commission Press, 1998.

Satz, Ronald. "'Tell Those Gray Haired Men What They Should Know': The Hayward Indian Congress of 1934." *Wisconsin Magazine of History* 77, 1 (1994): 196–224.

Schenck, Theresa M. *"The Voice of the Crane Echos Afar": The Sociopolitical Organization of the Lake Superior Ojibwa, 1640–1855.* New York: Garland Publishing, 1997.

Tanner, Helen Hornbeck, ed. *Atlas of Great Lakes Indian History.* Norman: University of Oklahoma Press, 1986.

Warren, William W. *History of the Ojibway People.* St. Paul: Minnesota Historical Society Press, 1984. (Written in 1852 and first published in St. Paul by the Minnesota Historical Society in 1885.)

Wilson, James. *The Earth Shall Weep: A History of Native America.* New York: Atlantic Monthly Press, 1999.

Language, Mathematics

Baraga, Frederic. *A Dictionary of the Ojibway Language.* St. Paul: Minnesota Historical Society Press, 1992. (First published in Montreal by Beauchemin & Valois in 1878.)

Closs, Michael P. "Tallies and the Ritual Use of Number in Ojibway Pictography." In *Native American Mathematics*, edited by Michael P. Closs, 181–211. Austin: University of Texas Press, 1986.

Denny, J. Peter. "Cultural Ecology of Mathematics: Ojibway and Inuit Hunters." In *Native American Mathematics*, edited by Michael P. Closs, 129–80. Austin: University of Texas Press, 1986.

Fiedel, Stuart J. "Algonquian Origins: A Problem in Archaeological-Linguistic Correlation." *Archaeology of Eastern North America* 15 (1987): 1–11.

Freelang: Ojibwe–English and English–Ojibwe Dictionary. http://www.freelang.net/online/ojibwe.php?lg=gb.

Goddard, Ives. "The West-to-East Cline in Algonquian Dialectology." In *Papers of The 25th Algonquian Conference*, edited by William Cowan, 187–211. Ottawa: Carleton University, 1994.

Gresczyk, Rick (Gwayakogaabo). *Our Ojibwe Grammar: A Reference Grammar in the Chippewa Language.* Vol. 1. Minneapolis: Eagle Works, 1997.

Johnston, Basil H. *Anishinaubae Thesaurus.* East Lansing: Michigan State University Press, 2007.

Nichols, John D., and Earl Nyholm. *A Concise Dictionary of Minnesota Ojibwe.* Minneapolis: University of Minnesota Press, 1995.

Ningewance, Patricia M. *Talking Gookom's Language: Learning Ojibwe.* Lac Seul, Ont.: Mazinaate Press, 2004.

"Ojibwe language." *Wikipedia.* http://en.wikipedia.org/wiki/Ojibwe_language.

Pimsleur. *Learn to Speak and Understand Ojibwe with Pimsleur Language Programs.* New York: Simon & Schuster, 2006. (Multiple-CD spoken Ojibwe lesson sets.)

Rhodes, Richard A. *Eastern Ojibwa-Chippewa-Ottawa Dictionary.* New York: Mouton Publishers, 1985.

Rhodes, Richard A., and Evelyn M. Todd. "Subarctic Algonquian Languages." In *Handbook of North American Indians*, edited by William C. Sturtevant, Vol. 6, *Subarctic*, edited by June Helm, 52–66. Washington, D.C.: Smithsonian Institution, 1981.

Treuer, Anton, ed. *Living Our Language: Ojibwe Tales & Oral Histories.* St. Paul: Minnesota Historical Society Press, 2001.

Treuer, David. "A Language Too Beautiful To Lose." *Los Angeles Times*, February 3, 2008. Available online. http://www.articles.latimes.com/2008/feb/03/books/bk-treuer3.

Literature: Louise Erdrich

Erdrich, Louise. *Love Medicine.* New York: Holt, Rinehart, and Winston, 1984.

————. *The Beet Queen.* New York: Henry Holt, 1986.

————. *Tracks.* New York: Henry Holt, 1988.

————. *The Plague of Doves.* New York: Harper Collins, 2008.

Jacobs, Connie A. *The Novels of Louise Erdrich: Stories of Her People.* New York: Peter Lang, 2001.

Purdy, John Lloyd. "(Karen) Louise Erdrich." In *Handbook of Native American Literature*, edited by Andrew Wiget, 423–29. New York: Garland Publishing, 1994.

Wong, Hertha D. Sweet, ed. *Louise Erdrich's Love Medicine: A Casebook.* New York: Oxford University Press, 2000.

Literature: Gerald Vizenor

Blaeser, Kimberly M. *Gerald Vizenor: Writing in the Oral Tradition.* Norman: University of Oklahoma Press, 1996.

Lee, A. Robert, ed. *Loosening the Seams: Interpretations of Gerald Vizenor.* Bowling Green, Ohio: Bowling Green State University Popular Press, 2000.

Velie, Alan R. "Gerald Vizenor." In *Handbook of Native American Literature*, edited by Andrew Wiget, 519–25. New York: Garland Publishing, 1994.

Vizenor, Gerald. *Wordarrows: Indians and Whites in the New Fur Trade.* Minneapolis: University of Minnesota Press, 1978.

————. *Griever: An American Monkey King in China.* Normal: Illinois State University Press, 1987.

Vizenor, Gerald, ed. *Summer in the Spring: Anishinaabe Lyric Poems and Stories.* New ed. Norman: University of Oklahoma Press, 1993

Literature: Other Authors

Benton-Banai, Edward. "The Great Flood." In *Wisconsin Indian Literature: Anthology of Native Voices*, edited by Kathleen Tigerman, 92–94. Madison: University of Wisconsin Press, 2006.

Blaeser, Kimberly M., ed. *Traces in Blood, Bone, & Stone: Contemporary Ojibwe Poetry.* Bemidji, Minn.: Loonfeather Press, 2006.

Hornett, Danielle M. *Sage Dreams, Eagle Visions.* East Lansing: Michigan State University Press, 2004.

Johnston, Basil. *Ojibway Ceremonies.* Lincoln: University of Nebraska Press, 1990.

LaDuke, Winona. *Last Standing Woman.* Stillwater, Minn.: Voyageur Press, 1997.

Northrup, Jim. *Walking the Rez Road.* Stillwater, Minn.: Voyageur Press, 1993.

Osborn, Chase S., and Stellanova Osborn. *"Hiawatha" with Its Original Indian Legends.* Lancaster, Pa.: Jaques Cattell Press, 1944.

Sweet, Denise. "Mapping the Land (for James Pipe Moustache)." In *Traces in Blood, Bone, & Stone: Contemporary Ojibwe Poetry*, edited by Kimberly Blaeser, 181–83. Bemidji, Minn.: Loonfeather Press, 2006.

Tigerman, Kathleen, ed. *Wisconsin Indian Literature: Anthology of Native Voices.* Madison: University of Wisconsin Press, 2006.

Treuer, David. *The Hiawatha.* New York: Picador USA, 2000.

————. *Native American Fiction: A User's Manual.* St. Paul: Graywolf Press, 2006.

————. *The Translation of Dr. Apelles: A Love Story.* St. Paul: Graywolf Press, 2006.

Waasaagoneshkang. "The Birth of Nenabozho." Translated by Rand Valentine. In *Voices from Four Directions: Contemporary Translations of the Native Literatures of North America*, edited by Brian Swann, 486–514. Lincoln: University of Nebraska Press, 2004.

Wroble, Lisa A. "Basil H. Johnston." In *Notable Native Americans*, edited by Sharon Malinowski, 212–13. Detroit: Gale Research, 1994.

Music

Bierhorst, John. *Songs of the Chippewa.* New York: Farrar, Straus and Giroux, 1974.

Burton, Frederick R. *American Primitive Music: With Especial Attention to the Songs of the Ojibways.* Kila, Mont.: Kessinger Publishing, 2006. (First published in New York by Moffat, Yard in 1909.)

Densmore, Frances. *Chippewa Music.* Smithsonian Institution, Bureau of American Ethnology, Bulletin 45. Washington, D.C.: U.S. Government Printing Office, 1910.

————. *Chippewa Music–II.* Smithsonian Institution, Bureau of American Ethnology, Bulletin 53. Washington, D.C.: U.S. Government Printing Office, 1913.

Vennum, Thomas, Jr. "Ojibwa Origin-Migration Songs of the *mitewiwin*." *Journal of American Folklore* 91, 361 (1978): 753–91.

_____. "A History of Ojibwa Song Form." In *The Traditional Music of North American Indians*, edited by Charlotte Heth. (Selected Reports in Ethnomusicology 3, 2.) Los Angeles: University of California, Los Angeles, 1980.

_____. *The Ojibwa Dance Drum: Its History and Construction.* Washington, D.C.: Smithsonian Institution Press, 1982.

Music: CDs

Baker, Maryellen. *Songs & Stories for Healing.* Hayward, Wis.: Maryellen Baker, 2004.

Honor the Earth Powwow: Songs of the Great Lakes Indians. Salem, Mass.: Ryko, 1991.

Lac Courte Oreilles Badger Singers. *Songs of King Eagle.* Escanaba, Mich.: Noc Bay Publishing, 1998.

The Learning Circle. *Learn to Hear PowWow Songs.* Escanaba, Mich.: Noc Bay Publishing, 2005.

Pipestone. *Good Ol' Fashioned NDN Lovin.'* Phoenix, Ariz.: Canyon Records, 2006.

Pipestone Singers. *Pipestone.* Winnipeg, Man.: Arbor Records, 2002.

Periodicals

American Indian Art Magazine. Address: 7314 East Osborn Drive, Scottsdale, AZ 85251. Telephone: (480) 994–5445. Web site: http://www.aiamagazine.com.

The Circle. Address: P.O. Box 6026, Minneapolis, MN 55406. Telephone: (612) 722-3686. Web site: http://www.thecirclenews.org.

Indian Country Today. Address: 3059 Seneca Turnpike, Canastota, NY 13032. Telephone: (888) 327-1013. Web site: http://www.indiancountrytoday.com.

Mazina'igan: A Chronicle of the Lake Superior Ojibwe. Address: P.O. Box 9, Odanah, WI 54861. Telephone: (715) 682-6619. E-mail: pio@glifwc.org.

Native Peoples. Address: P.O. Box 18449, Anaheim, CA 92817-8449. Telephone: (800) 999-9718. Web site: http://www.nativepeoples.com.

Native Wisconsin: Official Guide to Native American Communities in Wisconsin. Telephone: (715) 588-3324. Web site: http://www.natow.org.

News From Indian Country. Address: 8558N County Road K, Hayward, WI 54843-5800. Telephone: (715) 634-5226. Web site: http://www.indiancountrynews.com.

The Ojibwe Times. Address: P.O. Box 1021, Hayward, WI 54843. Telephone: (715) 634-0577. Web site: http://www.LCOTimes.com.

Oshkaabewis Native Journal. Address: Indian Studies Program, Sanford Hall, Box 19, Bemidji State University, 1500 Birchmont Drive NE, Bemidji, MN 56601-2699.

Powwows, Dance, Clothing

Barrett, S. A. *The Dream Dance of the Chippewa and Menominee Indians of Northern Wisconsin.* New York: Garland Publishing, 1979. (First published in *Bulletin of the Public Museum of the City of Milwaukee* 1, 4 (1911): 251–406.)

Blessing, Fred K. "Contemporary Costuming of Minnesota Chippewa Indians." *Minnesota Archeaologist* 20, 4 (1956): 1–8.

Browner, Tara. *Heartbeat of the People: Music and Dance of the Northern Pow-wow.* Urbana: University of Illinois Press, 2002.

Campisi, Jack. "Powwow: A Study of Ethnic Boundary Maintenance." *Man in the Northeast* 9 (1975): 33–46.

Hartman, Sheryl. *Indian Clothing of the Great Lakes: 1740–1840.* Rev. ed. Liberty, Utah: Eagle's View Publishing, 2000.

MacDowell, Marsha, ed. *Contempory Great Lakes Pow Wow Regalia: "Nda Maamawigaami (Together We Dance)."* East Lansing: Michigan State University Museum, 1997.

Mason, Bernard S. *Dances and Stories of the American Indian.* New York: A. S. Barnes, 1944.

"Pow-wow." *Wikipedia.* http://.en.wikipedia.org/wiki/Powwow.

Rossina, Kim Lindsay. "History of the Jingle Dress." M.A. thesis, University of Minnesota, 2000. (Available at University of Minnesota–Twin Cities, Wilson Library: MnU-M00-140.)

Rynkiewich, Michael A. "Chippewa Powwows." In *Anishinabe: 6 Studies of Modern Chippewa*, edited by J. Anthony Paredes, 31–100. Tallahassee: University Press of Florida, 1980.

Silverstein, Cory Carole. "Clothed Encounters: The Power of Dress in Relations Between Anishnaabe and British Peoples in the Great Lakes Region, 1760–2000." Ph.D. dissertation, McMaster University, 2000. Ann Arbor, Mich.: UMI, 2000. (Available from ProQuest Information and Learning. http://proquest.com.)

Religion, Philosophy

Benton-Banai, Edward. *The Mishomis Book: The Voice of the Ojibway.* St. Paul: Red School House, 1988.

Boatman, John. *My Elders Taught Me: Aspects of Western Great Lakes American Indian Philosophy.* Lanham, Md.: University Press of America, 1992.

Callicott, J. Baird, and Michael P. Nelson. *American Indian Environmental Ethics: An Ojibwa Case Study.* Upper Saddle River, N.J.: Pearson Prentice Hall, 2004.

Dewdney, Selwyn. *The Sacred Scrolls of the Southern Ojibway.* Toronto: University of Toronto Press, 1975.

Johnston, Basil. *The Manitous: The Spiritual World of the Ojibway.* St. Paul: Minnesota Historical Society Press, 2001.

Landes, Ruth. *Ojibwa Religion and the Midéwiwin.* Madison: University of Wisconsin Press, 1968.

McNally, Michael D. *Ojibwe Singers: Hymns, Grief, and a Native Culture in Motion.* New York: Oxford University Press, 2000.

————. *Honoring Elders: Aging, Authority, and Ojibwe Religion.* New York: Columbia University Press, 2009.

Vecsey, Christopher. *Traditional Ojibwa Religion and Its Historical Changes.* Philadelphia: American Philosophical Society, 1983.

Vecsey, Christopher, and John F. Fisher. "The Ojibwa Creation Myth: An Analysis of Its Structure and Content." *Temenos: Studies in Comparative Religion* 20 (1984): 66–100.

Social Services: Education, Medicine

Adams, David Wallace. *Education for Extinction: American Indians and the Boarding School Experience, 1875–1928.* Lawrence: University Press of Kansas, 1995.

Child, Brenda J. *Boarding School Seasons: American Indian Families, 1900–1940.* Lincoln: University of Nebraska Press, 1998.

Reyhner, Jon, ed. *Teaching American Indian Students.* Norman: University of Oklahoma Press, 1992.

Reyhner, Jon, and Jeanne Eder. *American Indian Education: A History.* Norman: University of Oklahoma Press, 2004.

Rhoades, Everett R., ed. *American Indian Health: Innovations in Health Care, Promotion, and Policy.* Baltimore: Johns Hopkins University Press, 2000.

Rhoades, Everett R., and Dorothy A. Rhoades. "Traditional Indian and Modern Western Medicine." In *American Indian Health: Innovations in Health Care, Promotion, and Policy,* edited by Everett R. Rhoades, 401–17. Baltimore: Johns Hopkins University Press, 2000.

Rieder, Hans L. "Tuberculosis Among American Indians of the Contiguous United States." *Public Health Reports* 104, 6 (1989): 653–57. Available online. http://www.pubmedcentral.nih.gov/articlerender.fcgi?artid=1580139.

Ritzenthaler, Robert E. "Chippewa Preoccupation With Health; Change in a Traditional Attitude Resulting From Modern Health Problems." *Bulletin of the Public Museum of the City of Milwaukee* 19, 4 (1953): 175–258.

Severtson, Dolores J., Linda C. Baumann, and James A. Will. "A Participatory Assessment of Environmental Health Concerns in an Ojibwa Community." *Public Health Nursing* 19, 1 (2002): 47–58.

Technology, Innovation, Business

Anderson, Terry L., Bruce L. Benson, and Thomas E. Flanagan. *Self-Determination: The Other Path for Native Americans.* Stanford, Calif.: Stanford University Press, 2006.

Densmore, Frances. *Strength of the Earth: The Classic Guide to Ojibwe Uses of Native Plants.* St. Paul: Minnesota Historical Society Press, 2005. (First published as "Uses of Plants by the Chippewa Indians" in the Forty-fourth Annual Report of the U.S. Bureau of American Ethnology, 1926–1927: 277–397. Washington, D.C.: U.S. Government Printing Office, 1928.)

Diamond, Jared. *Guns, Germs, and Steel: The Fates of Human Societies.* New York: W. W. Norton, 2005.

Famous Dave's Biography. http://www.famousdaves.com/biograph.cfm.

Gillin, John. "Acquired Drives in Culture Contact." *American Anthropologist* 44 (1942): 545–54.

Keoke, Emory Dean, and Kay Marie Porterfield. *Encyclopedia of American Indian Contributions to the World: 15,000 Years of Inventions and Innovations.* New York: Facts on File, 2001.

"Lac Courte Oreilles." In *Tiller's Guide to Indian Country: Economic Profiles of American Indian Reservations,* edited by Veronica E. Velarde Tiller, 1038–42. Albuquerque, N.M.: BowArrow Publishing Company, 2005.

Light, Steven Andrew, and Kathryn R.L. Rand. *Indian Gaming & Tribal Sovereignty: The Casino Compromise.* Lawrence: University Press of Kansas, 2005.

Mann, Charles C. *1491: New Revelations of the Americas Before Columbus.* New York: Alfred A. Knopf, 2005.

Mason, W. Dale. *Indian Gaming: Tribal Sovereignty and American Politics.* Norman: University of Oklahoma Press, 2000.

Ritzenthaler, Robert E. *Building a Chippewa Indian Birchbark Canoe.* Revised ed. Milwaukee: Milwaukee Public Museum, 1984.

Shiffered, Patricia A. "A Study of Economic Change: The Chippewa of Northern Wisconsin, 1854–1900." *Western Canadian Journal of Anthropology* 6, 4 (1976): 16–41.

Smith, Dean Howard. *Modern Tribal Development: Paths to Self-Sufficiency and Cultural Integrity in Indian Country.* Walnut Creek, Calif.: AltaMira Press, 2000.

Stein, Wayne J. "American Indians and Gambling: Economic and Social Impacts." In *American Indian Studies: An Interdisciplinary Approach to Contemporary Issues,* edited by Dane Morrison, 145–66. New York: Peter Lang, 1997.

Thomas, Matthew M. "Historic American Indian Maple Sugar and Syrup Production: Boiling Arches in Michigan and Wisconsin." *Midcontinental Journal of Archaeology* 30, 2 (2005): 299–326.

Thompson, William, Ricardo Gazel, and Dan Rickman. *The Economic Impact of Native American Gaming in Wisconsin.* Milwaukee: Wisconsin Policy Research Institute, 1995.

Vennum, Thomas, Jr. *Wild Rice and the Ojibway People.* St. Paul: Minnesota Historical Society Press, 1988.

Weatherford, Jack. *Indian Givers: How the Indians of the Americas Transformed the World.* New York: Random House, 1990.

Author Biographies

Sara Balbin

SARA BALBIN WAS BORN in Cuba and reared in Chicago, Illinois where, as a young adult, she studied at the Art Institute of Chicago. She received a Bachelor of Fine Arts and a Master of Art Therapy degree from the University of Wisconsin–Superior. Balbin pursues her artistic passion and art therapy profession from her Dragonfly Studio, nestled in the Chequamegon–Nicolet National Forest in northwest Wisconsin.

With the assistance of grants from the National Endowment for the Arts and the Wisconsin Arts Board, and support from the Lac Courte Oreilles Tribal Governing Board, Balbin painted the thirty-two portraits of the Lac Courte Oreilles tribal elders in a series known as the *Hall of Elders*. The paintings of the *Anishinaabe* of Lac Courte Oreilles were begun in 1979 and are being continued by Balbin. The portraits have been exhibited widely, including showings at the Smithsonian Institution, Washington D.C., and the Albrecht-Kemper, Pony Express National Museum, and Historical Museum in St. Joseph, Missouri. A grant from the Outagamie Charitable Foundation of Wisconsin enabled Balbin to publish *Spirit Of The Ojibwe: Images of Lac Courte Oreilles Elders*. The book preserves the history of the Lac Courte Oreilles Ojibwe through biographical sketches that accompany the *Hall of Elders* oil portraits, an essay by Dr. Rick St.Germaine, maps, and historical photographs.

As an accomplished multi-media artist, Balbin also creates steel sculptures. Support for this work has been received from the National Endowment for the Arts, Wisconsin Arts Board, the Chequamegon Bay Area Arts Council, the Experimental Aircraft Association, the Wisconsin Department of Natural Resources (DNR), community institutions, and patrons. Her public sculptures grace museums, libraries, hospitals, parks, municipal buildings, cemeteries, schools, resorts, and an airport. Her dedication to the arts won her recognition at the 2001 annual conference of the Washington, D.C.-based National Council of La Raza, an organization serving the Latino community.

The art process is most important to Balbin. Sculptures and paintings are always in progress at her studio. Balbin's past and current artistic developments at Dragonfly Studio can be viewed at http://www.sarabalbin.com or http://www.portalwisconsin.org. Balbin's interests in nurturing all the disciplines of the arts, mentoring, and preserving history positively impact northwest Wisconsin. She is an advocate for individuals with disabilities and has co-founded two not-for-profit card businesses to market their art. She co-founded the Cable-Hayward

Area Arts Council and has served on the board of directors of the Clear Water Folk School, Washburn, Wisconsin, and the Telemark Educational Foundation, Cable, Wisconsin. Balbin is the curator for the Cable-Namakagon Historical Museum, a co-founder and associate member of the Lac Courte Oreilles Arts and Culture Association, Hayward, Wisconsin.

Balbin's Dragonfly Studio overlooks Picture Lake in the town of Drummond, where she and her husband, Gary Crandall, and children, Eric and Melissa, reside. In the words of the artist, "This serene, isolated natural setting, surrounded by wildlife, century-old white pines, and the ever changing seasons of the Lake Superior Highlands, is a constant inspiration that motivates me to incorporate nature's elements and artifacts into my artistic creations. Each piece, arising from Mother Earth, reflects the *Nature of Mankind and Mankind in Nature*."

JAMES BAILEY

James Bailey has been an Indian Country reporter, writer, and researcher for twenty-five years. As managing editor of the Hayward-based *Four Seasons News* during the mid to late 1980s Bailey extensively covered the struggle of Wisconsin Ojibwe bands to exercise their rights to hunt, fish, and gather on off-reservation public lands. His strong public stand in support of the tribes' rights was less than popular among the non-Native population. He was the development director at WOJB, 88.9 FM, the Lac Courte Oreilles Band's 100,000 watt public radio station for seven years (1992-1999).

Bailey was a reporter for *News From Indian Country* and *Ojibwe Akiing*, both of which are owned and operated by Indian Country Communications, a private business headquartered on the Lac Courte Oreilles Ojibwe Reservation. He also wrote for the *Lake Superior Sounder*.

Bailey attended Carthage College in his hometown of Kenosha, Wisconsin, where he completed a major in speech and theater arts. He then attended the University of Wisconsin–Parkside, where he graduated with a bachelor's degree in communications. Bailey also studied photography at Santa Monica City College in Los Angeles, California.

His home is in the Chequamegon National Forest town of Grand View, on family property where he roamed as a child. He grew up spending summer vacations there, sometimes attending powwows staged for the benefit of tourists near downtown Hayward. Indian culture was imbued in him at an early age. Childhood dreams of living "up north" did not even come close to the reality of life in the forest lane.

THELMA NAYQUONABE

Thelma Nayquonabe (Asiniiwibiikwe) is an educator, a mother, and a grandmother, and an enrolled member of the Lac Courte Oreilles Ojibwe tribe. She was born near the Mille Lacs Reservation in Minnesota, her father's home, and was brought up in her mother's home

at Lac Courte Oreilles. Nayquonabe was employed by the Lac Courte Oreilles Ojibwe School for twenty-five years in several capacities, including elementary teacher, preschool director, community involvement facilitator, and elementary school principal. She also served as Ojibwe language teacher and curriculum consultant for Hayward Public Schools for three years, and was the kindergarten teacher for Waadookodaading, an Ojibwe language immersion school, for a year. She is currently director and instructor for the Early Childhood Program at the Lac Courte Oreilles Ojibwa Community College, and she owns a part-time business: Ma'iingan Prints Digital Photography.

Having studied and taught the Ojibwe language for several years, she was a coordinator for several Ojibwe language camps and Ojibwe language immersion seminars, including Niibino Gabeshiwin Ojibwemowin and Anishinaabe Izhitwaawin.

Nayquonabe directed and assisted with several projects involving elders, including the 1999 Elders Calendar, and Me Waynji Bimahdiziyahn Wa'ow Daywayi'an, a compact disc project that features children and elders from Lac Courte Oreilles. She coordinated the Elders Program at the Lac Courte Oreilles School for three years, and she continued her friendship with the elders after moving on to other jobs.

Thelma's education includes a Bachelor of Science degree in Elementary Education, Mount Senario College, Ladysmith, Wisconsin, 1980, a Child Development Associate Degree, University of Wisconsin–River Falls, 1982, and a Master of Arts in Education Degree, Silver Lake College, Manitowoc, Wisconsin, 2000. She currently serves on the board of directors of Grassroots Educational Multimedia, Northfield, Minnesota and Community Celebration of Place, Minneapolis, Minnesota, and in past years she was on the board of directors of Waadookodaading Ojibwe Language Immersion School, Hayward, Wisconsin and Ain Dah Ing, Inc. of Shell Lake, Wisconsin.

In 1982, she was a recipient of the University of Wisconsin–River Falls Chancellor's Award for Community Service. Locally, she has been honored as Head Woman Dancer for several Lac Courte Oreilles area powwows.

Her family includes four children, Caroline (Naa'igaabawiikwe), Adele (Wenaangaashikwe), George (Manidoo Gwiiwizens), and John (Minogiizhig), and seven grandchildren, Joshua (Gebe'aandawekamig), Chelsea (Biidaasigekwe), Obizaan, Marcus (Miskogiizhig), Alex (Bagonegiizhig), Jesse Lee (Manidoo Gaabaw), and Maurianna Rain. Her life is centered around family activities, ceremonies, and powwows, as well as her work at the Lac Court Oreilles Community College.